Knit Stitch
Dictionary

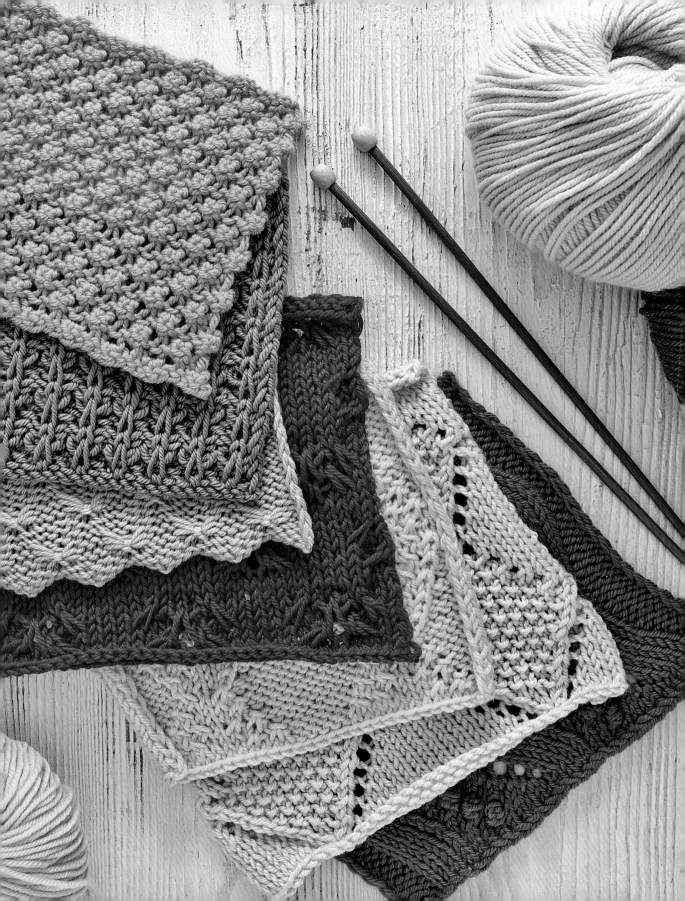

Knit Stitch
Dictionary

250 Essential Stitches

Debbie Tomkies

 Interweave

A Quarto Book

 Interweave®

An imprint of
Penguin Random House LLC
penguinrandomhouse.com

Copyright © 2015
Quarto Publishing plc.

Conceived, designed, and
produced by
Quarto Publishing plc
The Old Brewery
6 Blundell Street
London N7 9BH

QUAR.KNSD

ISBN 978-1-62033-884-1

Senior Editor Lily de Gatacre
Senior Art Editor Emma Clayton
Designer Julie Francis
Photographer Phil Wilkins
Pattern Checker Rachel Vowles
Illustrator Kuo Kang Chen
Indexer Helen Snaith
Art Director Caroline Guest
Creative Director Moira Clinch
Publisher Paul Carslake

Library of Congress Cataloging-in-
Publication Data available
on request

Color separation in Singapore
by Pica Digital Pte Limited
Printed in China

10 9 8 7 6 5 4 3

Contents

Meet the Author 10
About This Book 10
Directory of Stitches **12**

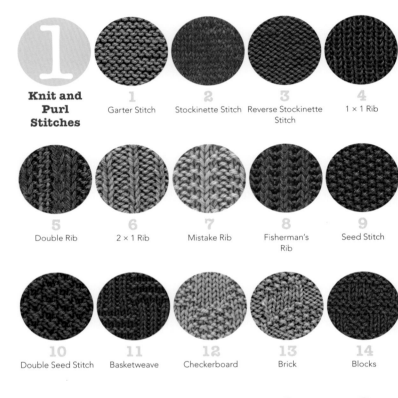

1

Knit and Purl Stitches

1 Garter Stitch
2 Stockinette Stitch
3 Reverse Stockinette Stitch
4 1 × 1 Rib

5 Double Rib
6 2 × 1 Rib
7 Mistake Rib
8 Fisherman's Rib
9 Seed Stitch

10 Double Seed Stitch
11 Basketweave
12 Checkerboard
13 Brick
14 Blocks

15 Lozenges and Triangles
16 Moss Stitch Zigzags
17 Diamonds
18 Garter Diagonals
19 Steps

20 Dragon's Teeth
21 Diagonal Moss Stitch
22 Pennants

2

Twisted and Traveling Stitches

23 Asymmetric Cable

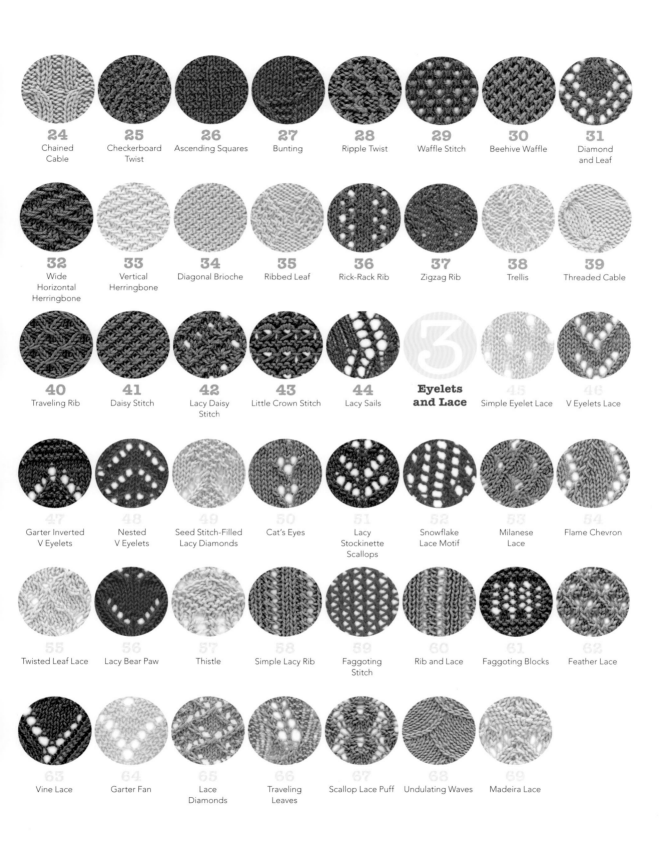

24 Chained Cable

25 Checkerboard Twist

26 Ascending Squares

27 Bunting

28 Ripple Twist

29 Waffle Stitch

30 Beehive Waffle

31 Diamond and Leaf

32 Wide Horizontal Herringbone

33 Vertical Herringbone

34 Diagonal Brioche

35 Ribbed Leaf

36 Rick-Rack Rib

37 Zigzag Rib

38 Trellis

39 Threaded Cable

40 Traveling Rib

41 Daisy Stitch

42 Lacy Daisy Stitch

43 Little Crown Stitch

44 Lacy Sails

3 Eyelets and Lace

45 Simple Eyelet Lace

46 V Eyelets Lace

47 Garter Inverted V Eyelets

48 Nested V Eyelets

49 Seed Stitch-Filled Lacy Diamonds

50 Cat's Eyes

51 Lacy Stockinette Scallops

52 Snowflake Lace Motif

53 Milanese Lace

54 Flame Chevron

55 Twisted Leaf Lace

56 Lacy Bear Paw

57 Thistle

58 Simple Lacy Rib

59 Faggoting Stitch

60 Rib and Lace

61 Faggoting Blocks

62 Feather Lace

63 Vine Lace

64 Garter Fan

65 Lace Diamonds

66 Traveling Leaves

67 Scallop Lace Puff

68 Undulating Waves

69 Madeira Lace

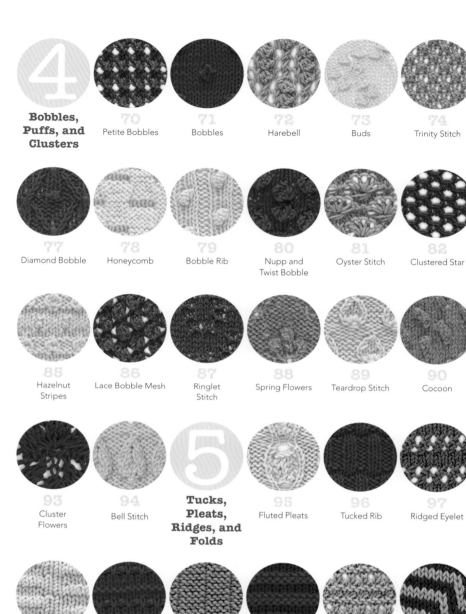

4

Bobbles, Puffs, and Clusters

70 Petite Bobbles

71 Bobbles

72 Harebell

73 Buds

74 Trinity Stitch

75 Ridged Trinity Stitch

76 Twining Bobbles

77 Diamond Bobble

78 Honeycomb

79 Bobble Rib

80 Nupp and Twist Bobble

81 Oyster Stitch

82 Clustered Star

83 Puff Stitch

84 Lace Puffs

85 Hazelnut Stripes

86 Lace Bobble Mesh

87 Ringlet Stitch

88 Spring Flowers

89 Teardrop Stitch

90 Cocoon

91 Tassel

92 Twin Leaf

93 Cluster Flowers

94 Bell Stitch

5

Tucks, Pleats, Ridges, and Folds

95 Fluted Pleats

96 Tucked Rib

97 Ridged Eyelet

98 Garter Ridges

99 Double Garter Stitch

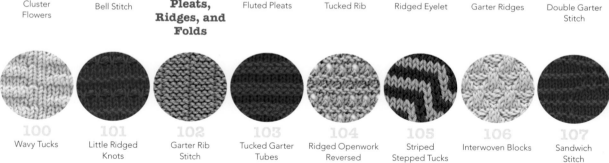

100 Wavy Tucks

101 Little Ridged Knots

102 Garter Rib Stitch

103 Tucked Garter Tubes

104 Ridged Openwork Reversed

105 Striped Stepped Tucks

106 Interwoven Blocks

107 Sandwich Stitch

108 Tucked Slipped Honeycomb

6

Loops and Textures

109 Fur Stitch

110 Cut Fur Stitch

111 Double Faced Loop Stitch

112 Pillar Stitch

113 Cellular Stitch

114 Ridged Openwork

115
Open
Basketweave

116
Granite Stitch

117
Ascending
Seed Stitch

118
Slipped Diagonal
Basketweave

119
Broken Seed Stitch

120
Bee Stitch

121
Jumping Jacks

122
Grapevine

123
Simple
Open Mesh

124
Little Tent
Stitch

125
Knot Mesh

126
Nupps and
Dimples

127
Garter Lace
Cubes

128
Cartridge
Belt Rib

129
Lacy Twist
Blocks

130
Stockinette Lacy
Smocking

131
Stockinette
Smocking

132
Open Star
Stitch

133
Dimple Stitch

134
Shower
Stitch

7
**Wrapped
and Dropped
Stitches**

135
Rippled Pillar
Stitch

136
Lifted Ladder
Rib

137
Lacy Diagonal
Brioche

138
Pyramid Clusters

139
Vertical Drop Stitch

140
Bamboo
Stitch

141
Short Drop
Stitch

142
Long Drop
Stitch

143
Rungs of
the Ladder

144
Ladder Rib

145
Zigzag
Swag Stitch

146
Dropped Garter
Diamonds

147
Knots in
Bark

148
Crochet-Style
Shell

149
Crochet-Style
Trellis

150
Bows

151
Honeybee

152
Stockinette
Waffle

153
Dimpled
Diamonds

154
Offset
Clusters

8
Slip Stitches

155
Heel Stitch

156
Pine Cone

157
Flickering Flames

158
Ridged
Slip Stitch

159
Reverse Wrapped
Rib Stitch

160
Birds in Flight

161 Garter Slip Stitch

162 Garter Brick Stitch

163 Corn on the Cob

164 Venetian Blind Lattice

165 Mountain Peaks

166 Wicker Fence

167 Woven Stitch

168 Reverse Stockinette and Seed Stitch Slipped Blocks

169 Wicker Basket Lattice

170 Small Quilted Lattice

171 Right Cross Stitch

172 Offset Left Cross Stitch

173 Alternating Cross Stitch

174 Crossed Seed Slip Stitch

9 Chevrons, Ripples, and Waves

175 Stockinette Chevron

176 Garter Chevron

177 Embossed Chevron

178 Feather and Fan

179 Ridged Feather and Fan

180 Waves at Sea

181 Lacy Wave

182 Garter Old Shale

183 Lacy Garter Ripple

184 Waves and Pebbles

185 Cabled Chevron

186 Cabled Chevron 2

187 Ripple Chevron

188 Vertical Ripple

189 Seed Stitch Zigzag

190 Traveling Steps

191 Traveling Garter Blocks

192 Crashing Waves

193 Seafoam

194 Teepees

195 Lacy Teepees

196 Wobbly Peaks

197 Herringbone Leaf

198 Deep Rippled Waves

199 Chevron and Feather

10 Colorwork

200 Two-Color Brioche Rib

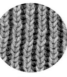

201 Two-Color Half Brioche Rib

202 Yin Yang

203 Greek Key Fretwork

204 Two-Color Garter Steps

205 Two-Color Diagonal Dropped Stitch

206 Woven Band

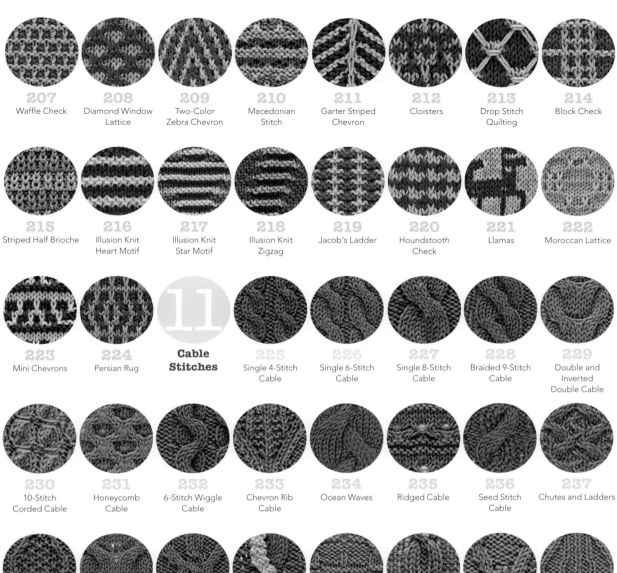

207 Waffle Check

208 Diamond Window Lattice

209 Two-Color Zebra Chevron

210 Macedonian Stitch

211 Garter Striped Chevron

212 Cloisters

213 Drop Stitch Quilting

214 Block Check

215 Striped Half Brioche

216 Illusion Knit Heart Motif

217 Illusion Knit Star Motif

218 Illusion Knit Zigzag

219 Jacob's Ladder

220 Houndstooth Check

221 Llamas

222 Moroccan Lattice

223 Mini Chevrons

224 Persian Rug

11
Cable Stitches

225 Single 4-Stitch Cable

226 Single 6-Stitch Cable

227 Single 8-Stitch Cable

228 Braided 9-Stitch Cable

229 Double and Inverted Double Cable

230 10-Stitch Corded Cable

231 Honeycomb Cable

232 6-Stitch Wiggle Cable

233 Chevron Rib Cable

234 Ocean Waves

235 Ridged Cable

236 Seed Stitch Cable

237 Chutes and Ladders

238 Filled Chain Cable

239 Rib-Eye Cable

240 Chain and Rope Cable

241 Two-Color Garter and Stockinette Cable

242 Cathedral Windows Cable

243 Knotted Cable

244 Acrobats Cable

245 Lantern Cable

246 10-Stitch Slalom Cable

247 Basketweave Cable

248 Braided Triple Cable

249 Diamond Cable

250 Rope and Diamond Cable

Glossary of Techniques 168

The Language of Yarn 170

Know Your Needles 172

Essential Techniques 174

Gauge 180

How to Read a Chart 182

Symbols and Abbreviations 186

Index and Credits 190

Meet the Author

When I began knitting my first Doctor Who scarf (at the tender age of 6 and a half), I little imagined that one day I'd be publishing my own designs, let alone writing books and helping other people learn to knit. I'm not even sure I knew such books existed!

By the time I sold my first designs at 14, it was my dream to be a knitwear designer but I had to wait until I'd been through school, college, and a regular day job for my opportunity. A chance meeting with the editor of a major knitting magazine who'd seen one of my designs (a knitted golf club cover no less!), led to many more commissions, tutorial features, and—eventually—two books.

Working on this latest title has been a real adventure. In the course of my research I have learned much about knitting traditions around the globe and have, I hope, included something for everyone. There are the essential stitches for newer knitters, as well as more challenging stitches for experienced knitters, historical traditional stitches from around the world, and exciting new stitches from my design portfolio.

I hope my book will interest and inspire you, and that it will accompany you on your own knitting and designing adventures.

About This Book

The heart of this book is the Directory of Stitches (pages 12–167) in which you will learn to work a huge variety of knit stitches (see right for details). The Glossary of Techniques, which follows on pages 168–185, is packed full of useful information on knitting basics, from choosing the right yarn and needles, and mastering those essential stitches, to measuring gauge and reading charts. With written instructions and clear illustrations, this is a perfect resource for learning new skills and for refreshing your memory on the basics.

Swatches provide a great visual reference for how the finished stitch will look.

Stitches are clearly named and numbered. Use the visual glossary on pages 4–9 to easily pick out the stitches that excite you.

Clear, written patterns guide you through the creation of the stitch. At the end of the pattern you will see the rows that you should repeat to continue building the pattern to the desired size.

Abbreviations or specialist stitches are explained with clear instructions when they are needed. A full list of symbols and abbreviations can be found on pages 186–189.

Directory of Stitches

Two hundred and fifty knitting stitches make up the comprehensive stitch directory, with written instructions and charts to help you to master a wide range of knitting skills. Organized into 11 families of stitches and clearly numbered, you can dip in and out of the directory or work your way through a particular section to develop your skills in that area.

Recommended yarn weights help you to plan how you will use the stitches in real-life knitting projects.

Stitches are divided into 11 stitch families to aid navigation. These are indicated here.

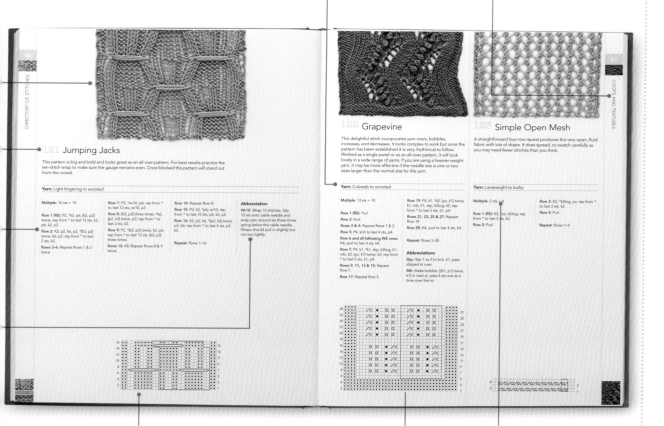

121 Jumping Jacks

This pattern is big and bold and looks great as an all-over pattern. For best results practice the ten-stitch wrap to make sure the gauge remains even. Once blocked this pattern will stand out from the crowd.

Yarn: Light fingering to worsted

Multiple: 16 sts + 14

Row 1 (RS): P2, *k2, p6, [k2, p2] twice; rep from * to last 12 sts, k2, p6, k2, p2.

Row 2: K2, p2, k6, p2, *[k2, p2] twice, k6, p2; rep from * to last 2 sts, k2.

Rows 3–6: Repeat Rows 1 & 2 twice.

Row 7: P2, *wr10, p6; rep from * to last 12 sts, wr10, p2.

Row 8: [K2, p2] three times, *k6, [p2, k2] twice, p2; rep from * to last 2 sts, k2.

Row 9: P2, *[k2, p2] twice, k2, p6; rep from * to last 12 sts, [k2, p2] three times.

Rows 10–13: Repeat Rows 8 & 9 twice.

Row 14: Repeat Row 8.

Row 15: P2, *p6, wr10, rep from * to last 10 sts, p6, k2, p2.

Row 16: K2, p2, k6, *[p2, k2] twice, rep from * to last 4 sts, p2, k2.

Repeat: Rows 1–16

Abbreviation
W10: Wrap 10 stitches. Slip 10 sts onto cable needle and wrap yarn around sts three times going below the cable needle. Wraps should pull in slightly but not too tightly.

122 Grapevine

This delightful stitch incorporates yarn overs, bobbles, increases, and decreases. It looks complex to work but once the pattern has been established it is very rhythmical to follow. Worked as a single panel or as an all-over pattern, it will look lovely in a wide range of yarns. If you are using a heavier weight yarn, it may be more effective if the needle size is one or two sizes larger than the normal size for the yarn.

Yarn: Cobweb to worsted

Multiple: 13 sts + 10

Row 1 (RS): Purl.

Row 2: Knit.

Rows 3 & 4: Repeat Rows 1 & 2.

Row 5: P4, knit to last 4 sts, p4

Row 6 and all following WS rows: K4, purl to last 4 sts, k4.

Row 7: P4, k1, *k1, skp, k2tog, k1, mb, k2, [yo, k1] twice, k2; rep from * to last 5 sts, k1, p4.

Rows 9, 11, 13 & 15: Repeat Row 7.

Row 17: Repeat Row 5.

Row 19: P4, k1, *k2, [yo, k1] twice, k1, mb, k1, skp, k2tog, k2; rep from * to last 5 sts, k1, p4.

Rows 21, 23, 25 & 27: Repeat Row 19.

Row 28: K4, purl to last 4 sts, k4.

Repeat: Rows 5–28

Abbreviations
Skp: Slip 1 as if to knit, k1, pass slipped st over.

Mb: Make bobble. [(K1, p1) twice, k1] in next st, pass 4 sts one at a time over first st.

123 Simple Open Mesh

A straightforward four-row repeat produces this very open, fluid fabric with lots of drape. It does spread, so swatch carefully as you may need fewer stitches than you think.

Yarn: Laceweight to bulky

Multiple: 2 sts

Row 1 (RS): K2, *yo, k2tog; rep from * to last 2 sts, k2.

Row 2: Purl.

Row 3: K2, *k2tog, yo; rep from * to last 2 sts, k2.

Row 4: Purl.

Repeat: Rows 1–4

Symbol charts provide a visual map for working the stitch. Symbols indicate the different stitches and a full list of these can be found on pages 186–189. Charts show the right-side of the work. Right-side (RS) rows are numbered on the right and read from right to left. Wrong-side (WS) rows are numbered on the left and read from left to right.

Each chart shows the same number of pattern repeats as the corresponding swatch and only 1 set of repeated rows. The pattern repeat is indicated with a red box.

Guidelines for the number of stitches you should cast on to begin this stitch are indicated here.

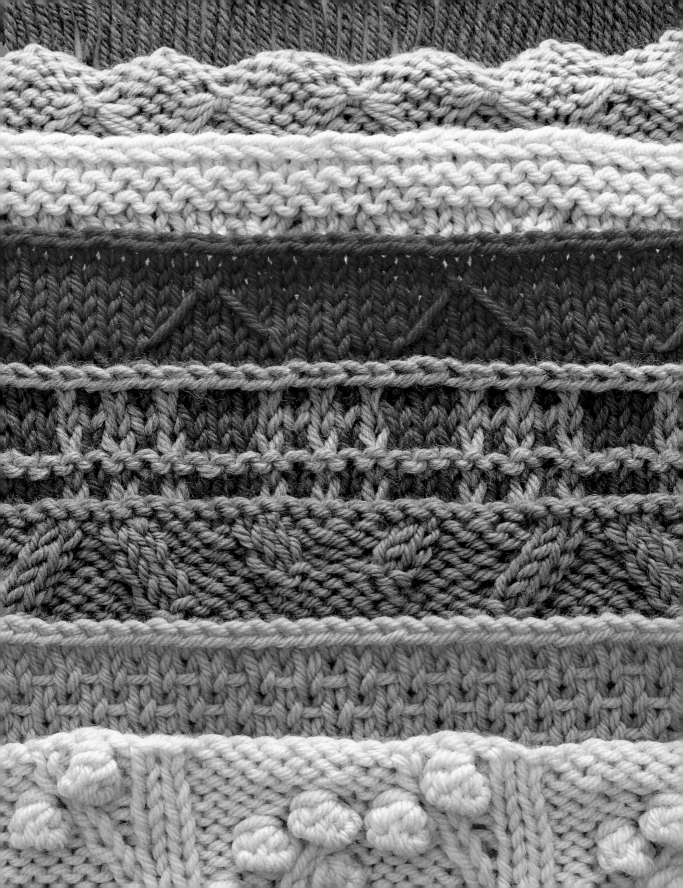

1

Directory of Stitches

Dive straight into the Directory of Stitches where you'll find 250 knitting stitches. The directory is divided into 11 stitch families, so whether you're looking for classic knit and purl stitches or intricate, delicate lace stitches; twists or textures; ripples or ridges; cables or colorwork—you'll find it here.

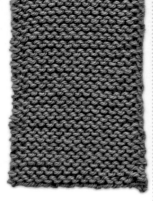
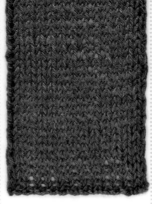
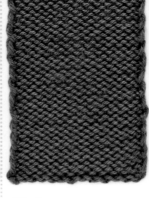

1 Garter Stitch

The mainstay of knitting, this stitch produces a simple but interesting fabric that has a plump texture and lays nice and flat.

Yarn: Cobweb to super bulky

Multiple: 1 st

Row 1 (RS): Knit.

Repeat: Row 1

2 Stockinette Stitch

Alternating rows of knit and purl stitches produce this extremely versatile fabric. It is often used in colorwork and wherever a smooth, even surface is required. The knit side faces you on the right side of the work.

Yarn: Cobweb to bulky

Multiple: 1 st

Row 1 (RS): Knit.
Row 2: Purl.

Repeat: Rows 1–2

3 Reverse Stockinette Stitch

This stitch also uses alternating rows of knit stitches and purl stitches, but the right side of the work is the purl side, which gives a bumpier look. It is smoother and less springy than garter stitch, with less pronounced ridges.

Yarn: Cobweb to bulky

Multiple: 1 st

Row 1 (RS): Purl.
Row 2: Knit.

Repeat: Rows 1–2

4 1 × 1 Rib

This simple two-stitch pattern produces a stretchy, elastic fabric, ideally suited to trims on garments for welts, cuffs, and necklines.

Yarn: Cobweb to bulky

Multiple: 2 sts

Row 1 (RS): *K1, p1; rep from * to end.

Repeat: Row 1

1

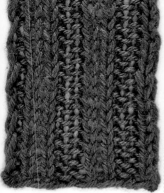
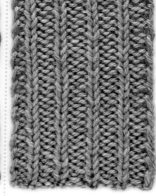
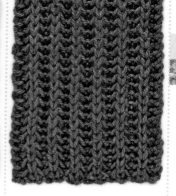

5 Double Rib

This wider rib is worked by alternating two knit and two purl stitches. This stitch is elastic, making it suitable for cuffs, edgings, and necklines. It looks particularly effective in bulkier yarns and patterns where you want a bolder look.

Yarn: Cobweb to bulky

Multiple: 4 sts

Row 1 (RS): *K2, p2; rep from * to end.

Repeat: Row 1

6 2 × 1 Rib

Two purl stitches flank a single knit stitch in this variation on a standard rib. The purl stitches recede and make an elegant stripe of knit stitches. This stitch can be worked in a wide range of yarns and is a good rib for sock cuffs.

Yarn: Cobweb to bulky

Multiple: 3 sts

Row 1 (RS): *K1, p2; rep from * to end.
Row 2: *K2, p1; rep from * to end.

Repeat: Rows 1–2

7 Mistake Rib

So called because, unlike standard ribs, the knit and purl stitches do not align above each other. A single vertical line of knit stitches with mismatched stitches either side creates an interesting texture. This has a little less elasticity than more standard rib stitches.

Yarn: Cobweb to bulky

Multiple: 4 sts + 1

Row 1 (RS): K1, *[k1, p1, k2]; rep from * to end.
Row 2: *[P1, k3]; rep from * to last st, p1.

Repeat: Rows 1–2

8 Fisherman's Rib

This two-stitch pattern produces a lovely elastic fabric, ideal for using on trims on garments, cuffs, and necklines.

Yarn: Cobweb to bulky

Multiple: 2 sts + 3

Row 1 (RS): Knit.
Row 2: *[K1, k1b]; rep from * to last st, k1.
Row 3: K1, *[k1, k1b]; rep from * to last 2 sts, k2.

Repeat: Rows 2–3

Abbreviation

K1b: Knit 1 below. Insert RH needle from front to back into the st one row directly below the one on the LH needle. Knit this new st together with the st directly above it (the next st you would have been knitting) on LH needle.

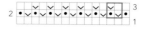

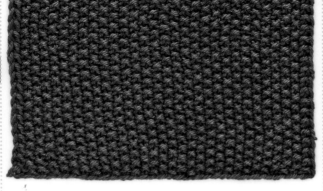

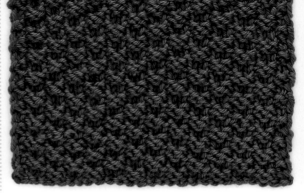

9 Seed Stitch

Alternating knit and purl stitches creates an attractively textured fabric that lays flat without curling.

Yarn: Cobweb to super bulky

Multiple: 2 sts

Row 1 (RS): *K1, p1; rep from * to end.
Row 2: *P1, k1; rep from * to end.

Repeat: Rows 1–2

10 Double Seed Stitch

A straightforward pattern of small knit and purl blocks, worked in pairs to give a checkerboard effect.

Yarn: Cobweb to super bulky

Multiple: 4 sts

Row 1 (RS): *K2, p2; rep from * to end.
Row 2: *K2, p2; rep from * to end.
Row 3: *P2, k2; rep from * to end.
Row 4: *P2, k2; rep from * to end.

Repeat: Rows 1–4

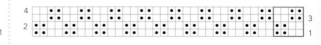

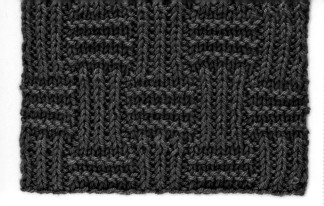

11 Basketweave

This stitch exploits the difference in gauge between rib and garter stitch. Rib contracts the fabric and garter spreads it out, creating the illusion of curved lines. It makes an excellent, springy all-over fabric, and looks much more difficult than it is.

Yarn: Light fingering to bulky

Multiple: 14 sts + 7

Row 1 (RS): *K7, [p1, k1] three times, p1; rep from * to last 7 sts, k7.

Row 2: P7, *[k1, p1] three times, k1, p7; rep from * to end.

Row 3: *P7, [p1, k1] three times, p1; rep from * to last 7 sts, p7.

Row 4: Repeat Row 2.

Row 5: Repeat Row 1.

Row 6: K7, *[k1, p1] three times, k8; rep from * to end.

Row 7: Repeat Row 1.

Row 8: Repeat Row 2.

Row 9: Repeat Row 3.

Row 10: Repeat Row 2.

Row 11: Repeat Row 1.

Row 12: [K1, p1] three times, k1, *p7, k1, [p1, k1] three times; rep from * to end.

Row 13: *[P1, k1] three times, p1, k7; rep from * to last 7 sts, [p1, k1] three times, p1.

Row 14: [K1, p1] three times, k1, *k8, [p1, k1] three times; rep from * to end.

Row 15: Repeat Row 13.

Row 16: Repeat Row 12.

Row 17: *[P1, k1] three times, p8; rep from * to last 7 sts, [p1, k1] three times, p1.

Row 18: Repeat Row 12.

Row 19: Repeat Row 13.

Row 20: Repeat Row 14.

Row 21: Repeat Row 13.

Row 22: Repeat Row 12.

Repeat: Rows 1–22

12 Checkerboard

Blocks of stockinette and seed stitch create a textured stitch that makes an excellent all-over pattern. The stitch will work in a wide range of yarns, but choose a smooth yarn with good stitch definition to show off the block structure to its best.

Yarn: Light fingering to bulky

Multiple: 10 sts

Row 1 (RS): *K6, [p1, k1] twice; rep from * to end.

Row 2: *[K1, p1] three times, p4; rep from * to end.

Rows 3–8: Repeat Rows 1 & 2 three times.

Row 9: *[K1, p1] twice, k6; rep from * to end.

Row 10: *P4, [p1, k1] three times; rep from * to end.

Rows 11–16: Repeat Rows 9 & 10 three times.

Repeat: Rows 1–16

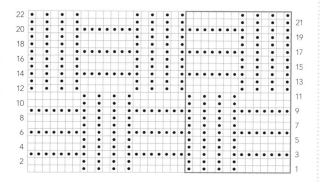

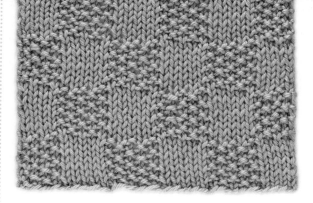

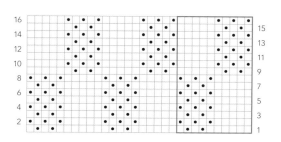

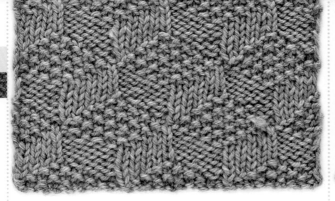

13 Brick

An illusion of 3D light and shade is created in this stitch by combining stockinette and reverse stockinette lozenges with seed stitch diamonds. A smooth yarn will maximize the effect.

Yarn: Light fingering to bulky

Multiple: 10 sts

Row 1 (RS): *P1, k1; rep from * to end.

Row 2: *P2, [k1, p1] three times, k2; rep from * to end.

Row 3: *P3, [k1, p1] twice, k3; rep from * to end.

Row 4: *P4, k1, p1, k4; rep from * to end.

Row 5: *P5, k5; rep from * to end.

Row 6: *P5, k5; rep from * to end.

Row 7: *K1, p4, k4, p1; rep from * to end.

Row 8: *P1, k1, p3, k3, p1, k1; rep from * to end.

Row 9: *K1, p1, k1, p2, k2, p1, k1, p1; rep from * to end.

Row 10: *[P1, k1] five times; rep from * to end.

Row 11: *[K1, p1] five times; rep from * to end.

Row 12: *P1, k1, p1, k2, p2, k1, p1, k1; rep from * to end.

Row 13: *K1, p1, k3, p3, k1, p1; rep from * to end.

Row 14: *P1, k4, p4, k1; rep from * to end.

Row 15: *K5, p5; rep from * to end.

Row 16: *K5, p5; rep from * to end.

Row 17: *K4, p1, k1, p4; rep from * to end.

Row 18: *K3, [p1, k1] twice, p3; rep from * to end.

Row 19: *K2, [p1, k1] three times, p2; rep from * to end.

Row 20: *[K1, p1] five times; rep from * to end.

Repeat: Rows 1–20

14 Blocks

This stitch uses the gauge difference between the stockinette stitch blocks and garter stitch rows and blocks to create an illusion of a rippling fabric. It could be an all-over pattern or an interesting edging or trim.

Yarn: Light fingering to bulky

Multiple: 6 sts + 3

Rows 1 (RS) and all RS rows: Knit.

Row 2: Knit.

Rows 4 & 6: P3, *k3, p3; rep from * to end.

Rows 8 & 10: Knit.

Rows 12 & 14: P3, *k3, p3; rep from * to end.

Row 16: Knit.

Repeat: Rows 1–16

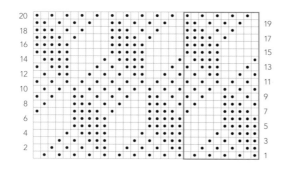

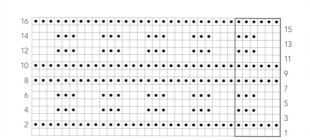

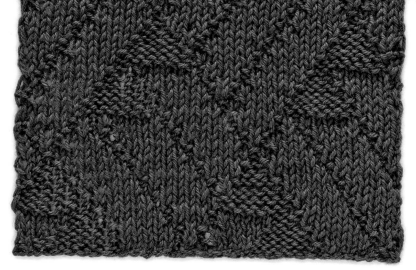

15 Lozenges and Triangles

This dramatic pattern only uses knit and purl stitches. The large repeat will work best as an all-over pattern, on a garment or a soft furnishing. To show off the strong pattern lines to their best advantage choose a yarn with good stitch definition.

Yarn: Laceweight to bulky

Multiple: 18 sts

Row 1 (RS): *K2, p1, k5, p7, k3; rep from * to end.

Row 2: *P3, k7, p5, k1, p2; rep from * to end.

Row 3: *[K1, p1] twice, k5, p5, k4; rep from * to end.

Row 4: *P4, k5, p5, [k1, p1] twice; rep from * to end.

Row 5: *P1, k3, p1, k5, p3, k5; rep from * to end.

Row 6: *P5, k3, p5, k1, p3, k1; rep from * to end.

Row 7: *K5, p1, k5, p7; rep from * to end.

Row 8: *K7, p5, k1, p5; rep from * to end.

Row 9: *[P1, k5] twice, p5, k1; rep from * to end.

Row 10: *P1, k5, [p5, k1] twice; rep from * to end.

Row 11: *K1, [p1, k5] twice, p3, k2; rep from * to end.

Row 12: *P2, k3, [p5, k1] twice, p1; rep from * to end.

Row 13: *K2, [p1, k5] twice, p1, k3; rep from * to end.

Row 14: *P3, [k1, p5] twice, k1, p2; rep from * to end.

Row 15: *K3, p1, k5, p1, k3, p1, k1, p1, k2; rep from * to end.

Row 16: *P2, k1, p1, k1, p3, k1, p5, k1, p3; rep from * to end.

Row 17: *K4, p1, k5, p1, k1, p1, k3, p1, k1; rep from * to end.

Row 18: *P1, k1, p3, k1, p1, k1, p5, k1, p4; rep from * to end.

Row 19: *K5, p7, k5, p1; rep from * to end.

Row 20: *K1, p5, k7, p5; rep from * to end.

Row 21: *P1, k5, p5, k5, p1, k1; rep from * to end.

Row 22: *P1, k1, p5, k5, p5, k1; rep from * to end.

Row 23: *K1, p1, k5, p3, k5, p1, k2; rep from * to end.

Row 24: *P2, k1, p5, k3, p5, k1, p1; rep from * to end.

Row 25: *K2, p7, k5, p1, k3; rep from * to end.

Row 26: *P3, k1, p5, k7, p2; rep from * to end.

Row 27: *K1, p1, k1, p5, k5, p1, k4; rep from * to end.

Row 28: *P4, k1, p5, k5, p1, k1, p1; rep from * to end.

Row 29: *P1, k3, p3, k5, p1, k5; rep from * to end.

Row 30: *P5, k1, p5, k3, p3, k1; rep from * to end.

Row 31: *[K5, p1] three times; rep from * to end.

Row 32: *[K1, p5] three times; rep from * to end.

Row 33: *K4, p1, k1, p1, k3, p1, k5, p1, k1; rep from * to end.

Row 34: *P1, k1, p5, k1, p3, k1, p1, k1, p4; rep from * to end.

Row 35: *[K3, p1] twice, k1, p1, k5, p1, k2; rep from * to end.

Row 36: *P2, k1, p5, k1, p1, [k1, p3] twice; rep from * to end.

Repeat: Rows 1–36

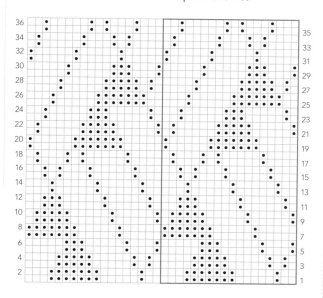

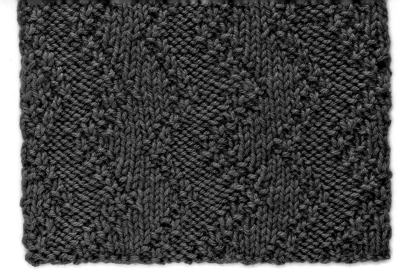

16 Moss Stitch Zigzags

Zigzags of stockinette and reverse stockinette combine to create this richly textured fabric. It works well as an all-over fabric, ideally in a smooth yarn so that the zigzags are clearly defined. The zigzags also offer some elasticity so it could be used as a large-scale rib or edging.

Yarn: Light fingering to bulky

Multiple: 12 sts

Row 1 (RS): *K4, p1, k1, p4, k1, p1; rep from * to end.

Row 2: *K1, p1, k4, p1, k1, p4; rep from * to end.

Row 3: *K3, p1, k1, p4, k1, p1, k1; rep from * to end.

Row 4: *P1, k1, p1, k4, p1, k1, p3; rep from * to end.

Row 5: *K2, p1, k1, p4, k1, p1, k2; rep from * to end.

Row 6: *P2, k1, p1, k4, p1, k1, p2; rep from * to end.

Row 7: *K1, p1, k1, p4, k1, p1, k3; rep from * to end.

Row 8: *P3, k1, p1, k4, p1, k1, p1; rep from * to end.

Row 9: *P1, k1, p4, k1, p1, k4; rep from * to end.

Row 10: *P4, k1, p1, k4, p1, k1; rep from * to end.

Row 11: Repeat Row 7.

Row 12: Repeat Row 8.

Row 13: Repeat Row 5.

Row 14: Repeat Row 6.

Row 15: Repeat Row 3.

Row 16: Repeat Row 4.

Repeat: Rows 1–16

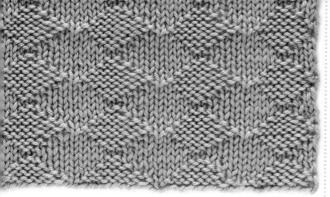

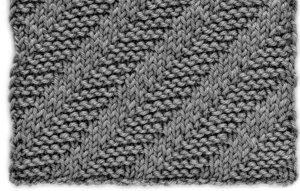

17 Diamonds

Using stockinette with reverse stockinette gives an interesting texture and a striking pattern, but with a consistent gauge across the fabric. This makes it a great choice for an all-over fabric that is stable and even.

Yarn: Cobweb to bulky

Multiple: 9 sts

Row 1 (RS): *P1, k8; rep from * to end.

Row 2: *K1, p6, k2; rep from * to end.

Row 3: *P3, k4, p2; rep from * to end.

Row 4: *K3, p2, k4; rep from * to end.

Row 5: Purl.

Row 6: Repeat Row 4.

Row 7: Repeat Row 3.

Row 8: Repeat Row 2.

Repeat: Rows 1–8

18 Garter Diagonals

This works well as an all-over pattern and could be mirrored to produce an interesting chevron, perhaps down the back of a jacket. It is suited to a wide range of yarn weights—to get the most from the pattern, choose a yarn with good stitch definition.

Yarn: Laceweight to bulky

Multiple: 8 sts

Row 1 (RS) and all RS rows: Knit.

Row 2: *K5, p3; rep from * to end.

Row 4: *P1, k5, p2; rep from * to end.

Row 6: *P2, k5, p1; rep from * to end.

Row 8: *P3, k5; rep from * to end.

Row 10: *K1, p3, k4; rep from * to end.

Row 12: *K2, p3, k3; rep from * to end.

Row 14: *K3, p3, k2; rep from * to end.

Row 16: *K4, p3, k1; rep from * to end.

Repeat: Rows 1–16

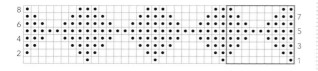

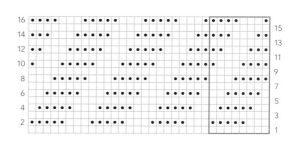

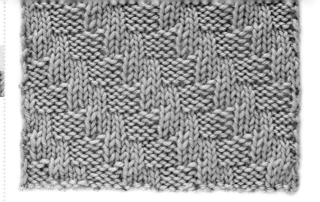

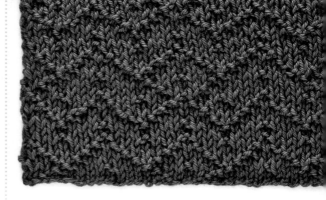

19 Steps

Offset blocks of stockinette and reverse stockinette create this fascinating step stitch. It could be reversed to create a zigzag pattern or chevron. It has a nice, balanced gauge and has texture without added bulk, so it would suit a variety of yarns.

Yarn: Light fingering to bulky

Multiple: 8 sts

Rows 1 (RS): *K4, p4; rep from * to end.

Rows 2–4: Repeat Row 1.

Row 5: *K2, p4, k2; rep from * to end.

Row 6: *P2, k4, p2; rep from * to end.

Rows 7 & 8: Repeat Rows 5 & 6.

Rows 9–12: *P4, k4; rep from * to end.

Row 13: *P2, k4, p2; rep from * to end.

Row 14: *K2, p4, k2; rep from * to end.

Rows 15 & 16: Repeat Rows 13 & 14.

Repeat: Rows 1–16

20 Dragon's Teeth

Here, knit and purl chevrons are arranged in peaked ridges that are reminiscent of rows of sharp teeth. This is a great all-over pattern, particularly when worked in a yarn with good stitch definition.

Yarn: Laceweight to bulky

Multiple: 16 sts

Row 1 (RS): *K1, p1, k11, p1, k2; rep from * to end.

Row 2: *P3, k1, p9, k1, p2; rep from * to end.

Row 3: *[K3, p1] four times; rep from * to end.

Row 4: *P3, k1, p1, k1, p5, k1, p1, k1, p2; rep from * to end.

Row 5: *K1, [p1, k3] three times, p1, k2; rep from * to end.

Row 6: *[P1, k1, p5, k1] twice; rep from * to end.

Row 7: *[K3, p1] four times; rep from * to end.

Row 8: Purl.

Row 9: Repeat Row 7.

Rows 10–13: Repeat Rows 4–7.

Repeat: Rows 1–13

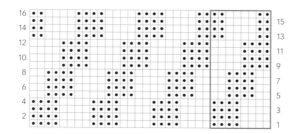

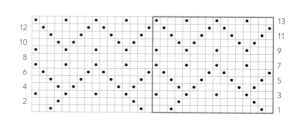

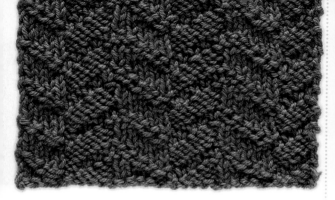

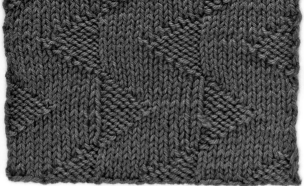

21 Diagonal Moss Stitch

A richly textured pattern that looks impressive as an all-over pattern. It will work well in a wide range of yarns weights. A smooth yarn with good stitch definition will show off the pattern best.

Yarn: Cobweb to bulky

Multiple: 10 sts

Row 1 (RS): *P4, k1, p1, k4; rep from * to end.

Row 2: *P3, k2, p2, k3; rep from * to end.

Row 3: *P2, k2, p1, k1, p2, k2; rep from * to end.

Row 4: *P1, [k2, p2] twice, k1; rep from * to end.

Row 5: *K2, p3, k3, p2; rep from * to end.

Row 6: *K1, p4, k4, p1; rep from * to end.

Repeat: Rows 1–6

22 Pennants

The careful arrangement of triangles of reverse stockinette against a background of stockinette creates an impression of flags waving in the breeze. The pattern has a good, stable gauge, and could be an all-over pattern, an edging, or a panel.

Yarn: Light fingering to bulky

Multiple: 11 sts

Row 1 (RS): *P1, k10; rep from * to end.

Row 2: *P9, k2; rep from * to end.

Row 3: *P3, k8; rep from * to end.

Row 4: *P7, k4; rep from * to end.

Rows 5–7: *P5, k6; rep from * to end.

Row 8: Repeat Row 4.

Row 9: Repeat Row 3.

Row 10: Repeat Row 2.

Row 11: Repeat Row 1.

Row 12: *K1, p10; rep from * to end.

Row 13: *K9, p2; rep from * to end.

Row 14: *K3, p8; rep from * to end.

Row 15: *K7, p4; rep from * to end.

Rows 16–18: *K5, p6; rep from * to end.

Row 19: Repeat Row 15.

Row 20: Repeat Row 14.

Row 21: Repeat Row 13.

Row 22: Repeat Row 12.

Repeat: Rows 1–22

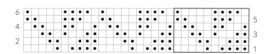

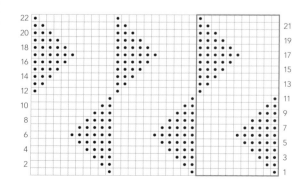

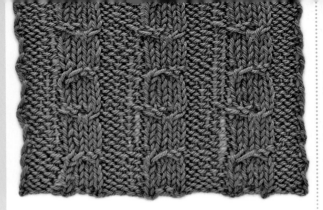

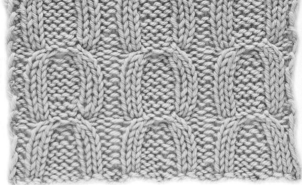

23 Asymmetric Cable

Paired twisted stitches are used to create this cable-like pattern. However, there is an added twist. Rather than the more usual knit-facing twists, this cable alternates a knit twist with a purl twist for an offbeat look. A smooth yarn will show off this pattern at its best.

Yarn: Light fingering to bulky

Multiple: 8 sts + 4

Row 1 (RS): *P4, k4; rep from * to last 4 sts, p4.

Row 2: *K4, p4; rep from * to last 4 sts, k4.

Row 3 & 4: Repeat Rows 1 & 2.

Row 5: Repeat Row 1.

Row 6: K4, *1/1 RPT, 1/1 LT, k4; rep from * to end.

Row 7–11: Repeat Rows 1–5.

Row 12: K4, *1/1 LT, 1/1 RPT, k4; rep from * to end.

Repeat: Rows 1–12

Abbreviations

1/1 RPT: 2-stitch right purl twist. Skip 1 st (leave on LH needle) and purl the second st in front loop, then purl the skipped st in front loop; slip both sts from needle together.

1/1 LT: 2-stitch left twist. Skip 1 st (leave on LH needle) and knit the second st in back loop, then knit the skipped st in front loop; slip both sts from needle together.

24 Chained Cable

This stitch uses a pair of four-stitch cables to create a large cable that looks like a giant knit stitch. It is straightforward to work and is set on a reverse stockinette stitch background to emphasize the structure of the cables. It can be worked in a wide range of yarn weights—a smooth yarn will work best.

Yarn: Light fingering to bulky

Multiple: 10 sts + 2

Row 1 (RS): *P2, k2, p4, k2; rep from * to last 2 sts, p2.

Row 2: K2, *p2, k4, p2, k2; rep from * to end.

Rows 3–8: Repeat Rows 1 & 2 three times.

Row 9: *P2, 2/2 LPC, 2/2 RPC; rep from * to last 2 sts, p2.

Row 10: Repeat Row 2.

Repeat: Rows 1–10

Abbreviations

2/2 LPC: 4-stitch left purl cable. Slip 2 sts to cable needle and hold in front, p2, k2 from cable needle.

2/2 RPC: 4-stitch right purl cable. Slip 2 sts to cable needle and hold in back, k2, p2 from cable needle.

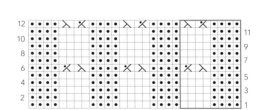

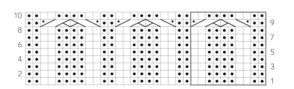

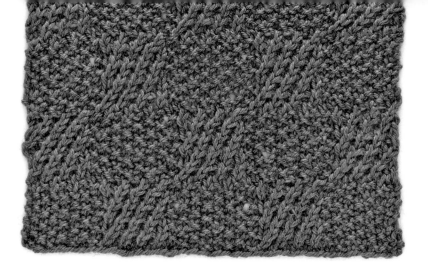

25 Checkerboard Twist

This is a combination of twisted stitches and seed stitch blocks worked to form a firm, richly textured fabric. If you are working this stitch in a thicker yarn, it may be preferable to use a larger needle than normal for the yarn to reduce the thickness of the fabric. It would make a lovely, warm throw or, if worked on a finer needle than normal in a sturdy yarn, it would make a terrific rug.

Yarn: Light fingering to bulky

Multiple: 16 sts + 8

Row 1 (WS): [P1, k1] four times, *p8, [p1, k1] four times; rep from * to end.

Row 2: *[K1, p1] four times, [RT] four times; rep from * to last 8 sts, [k1, p1] four times.

Row 3: Repeat Row 1.

Row 4: *[K1, p1] four times, k1, [RT] three times, k1; rep from * to last 8 sts, [k1, p1] four times.

Rows 5–8: Repeat Rows 1–4.

Rows 9 & 10: Repeat Rows 1 & 2.

Row 11: P8, *[p1, k1] four times, p8; rep from * to end.

Row 12: *[RT] four times, [k1, p1] four times; rep from * to last 8 sts,

[RT] four times.

Row 13: Repeat Row 11.

Row 14: *K1, [RT] three times, k1, [k1, p1] four times; rep from * to last 8 sts, k1, [RT] three times, k1.

Rows 15–18: Repeat Rows 11–14.

Rows 19 & 20: Repeat Rows 11 & 12.

Repeat: Rows 1–20

Abbreviation

RT: 2-stitch right (k2tog) twist. K2tog leaving sts on needle, insert RH needle between sts just worked and knit first st again, slip both sts from needle together.

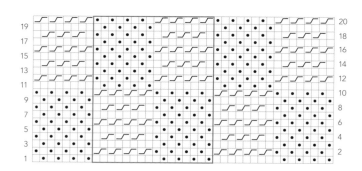

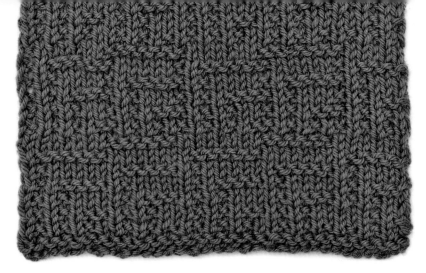

26 Ascending Squares

This pattern appears complex but uses just knit and purl stitches. It is quite a lengthy pattern repeat so requires a little concentration when working.

Yarn: Fingering to bulky

Multiple: 13 sts + 8

Row 1 (RS) and all RS rows: Knit.

Row 2: Knit.

Row 4: [K1, p1] four times, *[p1, k1] six times, p1; rep from * to end.

Row 6: P4, [k1, p1] twice, *[p1, k1] twice, p5, [k1, p1] twice; rep from * to end.

Row 8: [K1, p1] twice, k1, p3, *p1, k1, p1, k3, [p1, k1] twice, p3; rep from * to end.

Row 10: P2, k1, p1, k4, *p1, k1, p5, k1, p1, k4; rep from * to end.

Row 12: K1, p1, k1, p5, *p1, k5, p1, k1, p5; rep from * to end.

Row 14: P2, k6, *p7, k6; rep from * to end.

Row 16: K1, p7, *k6, p7; rep from * to end.

Row 18: [P1, k1] four times, *[k1, p1] six times, k1; rep from * to end.

Row 20: K2, [p1, k1] twice, p2, *[k1, p1] twice, k3, [p1, k1] twice, p2; rep from * to end.

Row 22: [P1, k1] twice, p1, k3, *k1, p1, k1, p3, [k1, p1] twice, k3; rep from * to end.

Row 24: K2, p1, k1, p4, *k1, p1, k5, p1, k1, p4; rep from * to end.

Row 26: P1, k1, p1, k5, *k1, p5, k1, p1, k5; rep from * to end.

Row 28: K2, p6, *k7, p6; rep from * to end.

Repeat: Rows 3–28

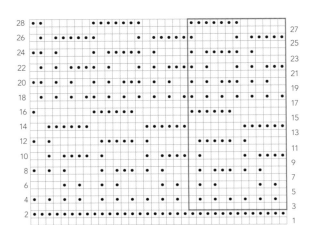

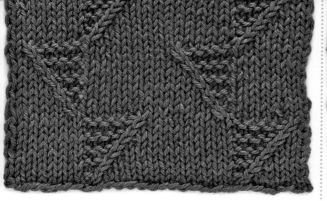

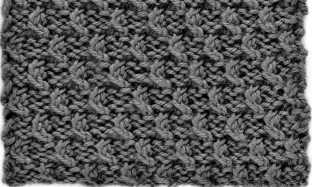

27 Bunting

Swinging from side to side, this combination of garter stitch diamonds accented with twisted stitches looks very festive. There is a lot of scope to play with the positioning of the motif to create different, interesting patterns.

Yarn: Cobweb to bulky

Multiple: 14 sts + 2

Row 1 (WS) and all WS rows: Purl.

Row 2: *K6, 1/1 RPC, k6; rep from * to last 2 sts, k2.

Row 4: *K5, 1/1 RPC, p1, k6; rep from * to last 2 sts, k2.

Row 6: *K4, 1/1 RPC, p2, k6; rep from * to last 2 sts, k2.

Row 8: *K3, 1/1 RPC, p3, k6; rep from * to last 2 sts, k2.

Row 10: *K2, 1/1 RPC, p4, k6; rep from * to last 2 sts, k2.

Row 12: *K8, 1/1 LPC, k4; rep from * to last 2 sts, k2.

Row 14: *K8, p1, 1/1 LPC, k3; rep from * to last 2 sts, k2.

Row 16: *K8, p2, 1/1 LPC, k2; rep from * to last 2 sts, k2.

Row 18: *K8, p3, 1/1 LPC, k1; rep from * to last 2 sts, k2.

Row 20: *K8, p4, 1/1 LPC; rep from * to last 2 sts, k2.

Repeat: Rows 1–20

Abbreviations

1/1 RPC: 2-stitch right purl cable. Slip 1 st to cable needle and hold in back, k1, p1 from cable needle.

1/1 LPC: 2-stitch left purl cable. Slip 1 st to cable needle and hold in front, p1, k1 from cable needle.

28 Ripple Twist

This fabric of criss-crossed twists takes a little patience as it is quite slow-growing. It uses twisted stitches rather than cables and this does make it easier to work. It also creates a lovely textured fabric that is surprisingly soft and pliable.

Yarn: Fingering to worsted

Multiple: 4 sts + 4

Row 1 (RS): P1, *p2, 1/1 LT; rep from * to last 3 sts, p3.

Row 2: K3, *p2, k2; rep from * to last st, k1.

Row 3: K1, *k2, 1/1 RT; rep from * to last 3 sts, k3.

Row 4: P3, *k2, p2; rep from * to last st, p1.

Row 5: P1, *1/1 LT, p2; rep from * to last 3 sts, 1/1 LT, p1.

Row 6: K1, p2, *k2, p2; rep from * to last st, k1.

Row 7: K1, *1/1 RT, k2; rep from * to last 3 sts, 1/1 RT, k1.

Row 8: K3, *p2, k2; rep from * to last st, k1.

Repeat: Rows 1–8

Abbreviations

1/1 LT: 2-stitch left twist. Skip 1 st (leave on LH needle) and knit the second st in back loop, then knit the skipped st in front loop; slip both sts from needle together.

1/1 RT: 2-stitch right twist. Skip 1 st (leave on LH needle) and knit the second st in front loop, then knit the skipped st in front loop; slip both sts from needle together.

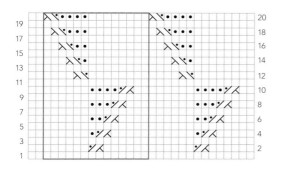

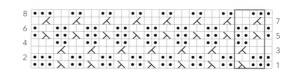

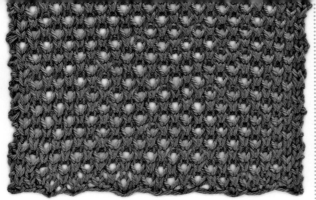

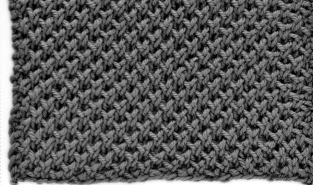

29 Waffle Stitch

Waffle stitch is a lovely, springy pattern that is open enough to be light but is still warm because the air is trapped in the layers. It works particularly well in a medium-weight yarn but can be used in a range of weights.

Yarn: Fingering to bulky

Multiple: 2 sts + 3

Repeat: Rows 1–4

Row 1 (WS): K2, *p1, k1; rep from * to last st, k1.

Row 2: K1, *k1b, k1; rep from * to end.

Row 3: *K1, p1; rep from * to last st, k1.

Row 4: K1, *k1, k1b; rep from * to last 2 sts, k2.

Abbreviation

K1b: Knit 1 below. Insert RH needle from front to back into the st one row directly below the one on the LH needle. Knit this new st together with the st directly above it (the next st you would have been knitting) on LH needle.

30 Beehive Waffle

A deep, soft texture with strong diagonal lines characterizes this pattern stitch. With only four rows and a simple three-stitch pattern, it is relatively quick to knit and, unusually, the diagonals do not create a particular bias in the fabric.

Yarn: Laceweight to bulky

Multiple: 2 sts + 3

Row 1 (WS): Knit.

Row 2: K1, *k1b, k1; rep from * to last 2 sts, k1b, k1.

Row 3: Knit.

Row 4: K1, *k1, k1b; rep from * to last 2 sts, k2.

Repeat: Rows 1–4

Abbreviation

K1b: Knit 1 below. Insert RH needle from front to back into the st one row directly below the one on the LH needle. Knit this new st together with the st directly above it (the next st you would have been knitting) on LH needle.

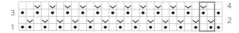

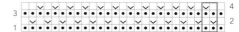

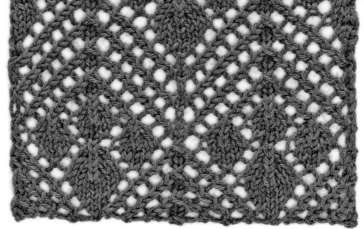

31 Diamond and Leaf

This complex combination of traveling stitches and lace creates a beautiful, dramatic pattern that shows its true beauty when blocked. A single-height pattern repeat would look fantastic as an edging. A series of vertical repeats could be used to great effect as a panel or part of a larger panel.

Yarn: Cobweb to light worsted

Multiple: 16 sts + 1

Row 1 (RS): K2tog, *[yo, k2tog] three times, yo, k1, yo, [skp, yo] three times**, sk2p; rep from * to ** to last 2 sts, k2tog.

Row 2 and all WS rows: Purl.

Row 3: K1, *[k2tog, yo] three times, k3, [yo, skp] three times, k1; rep from * to end.

Row 5: K2tog, *[yo, k2tog] three times, yo, k1, yo, [skp, yo] three times**, sk2p; rep from * to ** to last 2 sts, k2tog.

Row 7: K1, *[k2tog, yo] twice, k7, [yo, skp] twice, k1; rep from * to end.

Row 9: K2tog, *yo, k2tog, yo, k1, yo, k2, s2kp, k2, yo, k1, yo, skp, yo**, sk2p; rep from * to ** to last 2 sts, k2tog.

Row 11: K1, *k2tog, yo, k3, yo, k1, s2kp, k1, yo, k3, yo, skp, k1; rep from * to end.

Row 13: K2tog, *yo, k5, yo, s2kp, yo, k5, yo**, sk2p; rep from * to ** to last 2 sts, k2tog.

Row 15: K1, *k1, yo, k1, s2kp, k1, yo, k3, yo, k1, s2kp, k1, yo, k2; rep from * to end.

Row 17: K1, *yo, skp, yo, s2kp, yo, k5, yo, s2kp, yo, k2tog, yo, k1; rep from * to end.

Row 19: K1, *k1, [yo, skp] twice, yo, k1, s2kp, k1, [yo, k2tog] twice, yo, k2; rep from * to end.

Row 21: K1, *[yo, skp] three times,

yo, s2kp, yo, [k2tog, yo] three times, k1; rep from * to end.

Row 23: K1, *k1, [yo, skp] three times, k1, [k2tog, yo] three times, k2; rep from * to end.

Row 25: K1, *[yo, skp] three times, yo, sk2p, yo, [k2tog, yo] three times, k1; rep from * to end.

Row 27: K1, *k1, [yo, skp] three times, k1, [k2tog, yo] three times, k2; rep from * to end.

Row 29: K1, *k2, [yo, skp] twice, yo, sk2p, yo, [k2tog, yo] twice, k3; rep from * to end.

Row 31: K1, *k3, [yo, skp] twice, k1, [k2tog, yo] twice, k4; rep from * to end.

Row 33: K2tog, *k2, yo, k1, yo, skp, yo, sk2p, yo, k2tog, yo, k1, yo, k2**, s2kp; rep from * to ** to last 2 sts, k2tog.

Row 35: K2tog, *k1, yo, k3, yo, skp, k1, k2tog, yo, k3, yo, k1**, s2kp; rep from * to ** to last 2 sts, k2tog.

Row 37: K2tog, *yo, k5, yo, sk2p, yo, k5, yo**, s2kp; rep from * to ** to last 2 sts, k2tog.

Row 39: K1, *k1, yo, k1, s2kp, k1, yo, k3, yo, k1, s2kp, k1, yo, k2; rep from * to end.

Row 41: K1, *k2, yo, s2kp, yo, k2tog, yo, k1, yo, skp, yo, s2kp, yo, k3; rep from * to end.

Row 43: K2tog, *k1, [yo, k2tog] twice, yo, k3, [yo, skp] twice, yo, k1**, s2kp; rep from * to ** to last 2 sts, k2tog.

Row 45: K2tog, *[yo, k2tog] three times, yo, k1, [yo, skp] three times, yo, k1**, s2kp; rep from * to ** to last 2 sts, k2tog.

Row 47: K1, *[k2tog, yo] three times, k3, [yo, skp] three times, k1; rep from * to end.

Row 48: Purl.

Repeat: Rows 1–48

Abbreviations

Skp: Slip 1 as if to knit, k1, pass slipped st over.

Sk2p: Slip 1 as if to knit, k2tog, pass slipped st over.

S2kp: Slip 2 as if to k2tog, k1, pass 2 slipped sts over.

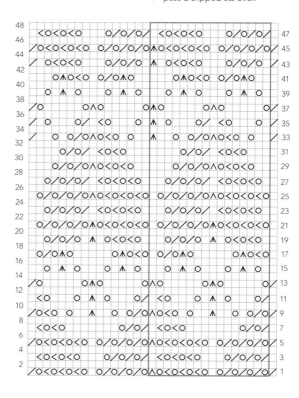

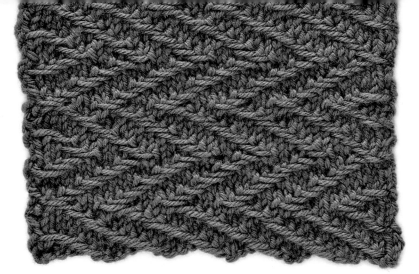

32 Wide Horizontal Herringbone

Slipped stitches over a background of stockinette stitch create a firm fabric with a bold zigzag pattern. With only six stitches in the pattern repeat, once the pattern is established it is really straightforward to follow.

Yarn: Fingering to bulky

Multiple: 6 sts + 8

Row 1 (RS): K1, [sl1 wyif] three times, *k3, [sl1 wyif] three times; rep from * to last 4 sts, k4.

Row 2: P3, sl1 wyib, *[sl1 wyib] twice, p3, sl1 wyib; rep from * to last 4 sts, [sl1 wyib] twice, p2.

Row 3: K3, sl1 wyif, *[sl1 wyif] twice, k3, sl1 wyif; rep from * to last 4 sts, [sl1 wyif] twice, k2.

Row 4: P1, [sl1 wyib] three times, *p3, [sl1 wyib] three times; rep from * to last 4 sts, p4.

Row 5: K4, *k1, [sl1 wyif] three times, k2; rep from * to last 4 sts, k4.

Row 6: P4, *p1, [sl1 wyib] three times, p2; rep from * to last 4 sts, p4.

Row 7: K1, [sl1 wyif] three times, *k3, [sl1 wyif] three times; rep from * to last 4 sts, k4.

Row 8: P3, sl1 wyib, *[sl1 wyib] twice, p3, sl1 wyib; rep from * to last 4 sts, [sl1 wyib] twice, p2.

Row 9: K3, sl1 wyif, *[sl1 wyif] twice, k3, sl1 wyif; rep from * to last 4 sts, [sl1 wyif] twice, k2.

Row 10: P1, [sl1 wyib] three times, *p3, [sl1 wyib] three times; rep from * to last 4 sts, p4.

Row 11: Repeat Row 9.

Row 12: Repeat Row 8.

Row 13: Repeat Row 7.

Row 14: Repeat Row 6.

Row 15: Repeat Row 5.

Row 16: Repeat Row 4.

Row 17: Repeat Row 3.

Row 18: Repeat Row 2.

Repeat: Rows 1–18

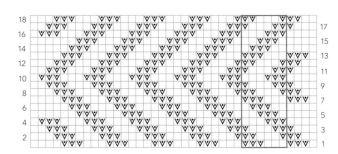

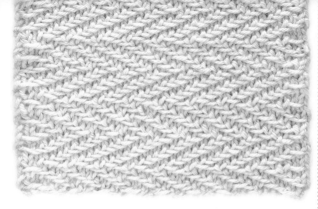

33 Vertical Herringbone

A straightforward chevron pattern utilizing slipped stitches to create the rhythmic waves. The fabric is firm so is suited to more tailored garments or soft furnishings.

Yarn: Fingering to bulky

Multiple: 4 sts + 6

Row 1 (RS): K2, sl1 wyif, *sl1 wyif, k2, sl1 wyif; rep from * to last 3 sts, sl1 wyif, k2.

Row 2: P1, [sl1 wyib] twice, *p2, [sl1 wyib] twice; rep from * to last 3 sts, p3.

Row 3: K3, *k1, [sl1 wyif] twice, k1; rep from * to last 3 sts, k3.

Row 4: P3, *[sl1 wyib] twice, p2; rep from * to last 3 sts, [sl1 wyib] twice, p1.

Row 5: K2, sl1 wyif, *sl1 wyif, k2, sl1 wyif; rep from * to last 3 sts, sl1 wyif, k2.

Row 6: P1, [sl1 wyib] twice, *p2, [sl1 wyib] twice; rep from * to last 3 sts, p3.

Row 7: K3, *k1, [sl1 wyif] twice, k1; rep from * to last 3 sts, k3.

Row 8: P3, *[sl1 wyib] twice, p2; rep from * to last 3 sts, [sl1 wyib] twice, p1.

Row 9: K3, *k1, [sl1 wyif] twice, k1; rep from * to last 3 sts, k3.

Row 10: P1, [sl1 wyib] twice, *p2, [sl1 wyib] twice; rep from * to last 3 sts, p3.

Row 11: K2, sl1 wyif, *sl1 wyif, k2, sl1 wyif; rep from * to last 3 sts, sl1 wyif, k2.

Row 12: P3, *[sl1 wyib] twice, p2; rep from * to last 3 sts, [sl1 wyib] twice, p1.

Row 13: K3, *k1, [sl1 wyif] twice, k1; rep from * to last 3 sts, k3.

Row 14: P1, [sl1 wyib] twice, *p2, [sl1 wyib] twice; rep from * to last 3 sts, p3.

Row 15: K2, sl1 wyif, *sl1 wyif, k2, sl1 wyif; rep from * to last 3 sts, sl1 wyif, k2.

Row 16: P3, *[sl1 wyib] twice, p2; rep from * to last 3 sts, [sl1 wyib] twice, p1.

Repeat: Rows 1–16

34 Diagonal Brioche

This pattern is unusual in that the yarn overs do not create a lacy fabric. Rather, by combining the yarn over closely with a slipped stitch and a decrease, an interesting, quite dense texture is created, well-suited to an all-over pattern. Note that the stitch count is variable between the rows.

Yarn: Laceweight to bulky

Multiple: 3 sts + 3

Row 1 (WS): P2, *sl1 wyib, yo, p1; rep from * to last st, p1.

Row 2: Sl1 wyib, *p1, sl1 wyib, p1; rep from * to last 2 sts, p2.

Row 3: P1, sl1 wyib, *yo, p2tog, sl1 wyib; rep from * to last st, yo, p1.

Row 4: P1, sl1 wyib, *p2, sl1 wyib; rep from * to last 2 sts, p2.

Row 5: Sl1 wyib, p2tog, *sl1 wyib, yo, p2tog; rep from * to last st, p1.

Repeat: Rows 2–5

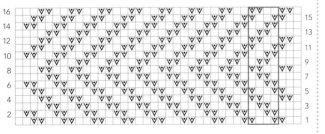

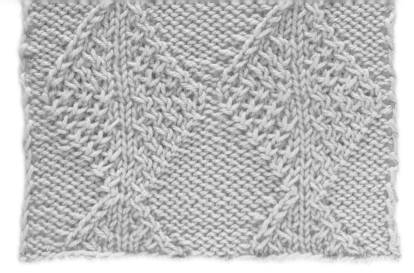

35 Ribbed Leaf

This is a large pattern that would be ideal as a feature on a large project. A single-width repeat also makes a good panel. The twists are worked without a cable needle, making progress quicker.

Yarn: Fingering to bulky

Multiple: 16 sts + 3

Row 1 (WS): K2, *k2, p11, k3; rep from * to last st, k1.

Row 2: P1, *p3, 1/1 LT, 1/1 RT, k3, 1/1 LT, 1/1 RT, p2; rep from * to last 2 sts, p2.

Row 3: K2, *k3, p9, k4; rep from * to last st, k1.

Row 4: P1, *p4, 1/1 LT, 1/1 RT, k1, 1/1 LT, 1/1 RT, p3; rep from * to last 2 sts, p2.

Row 5: K2, *k4, p7, k5; rep from * to last st, k1.

Row 6: P1, *p5, 1/1 LT, k3, 1/1 RT, p4; rep from * to last 2 sts, p2.

Row 7: K2, *k5, p5, k6; rep from * to last st, k1.

Row 8: P1, *p6, 1/1 LT, k1, 1/1 RT, p5; rep from * to last 2 sts, p2.

Row 9: K2, *k6, p3, k7; rep from * to last st, k1.

Row 10: P1, *p6, 1/1 LT, k1, 1/1 RT, p5; rep from * to last 2 sts, p2.

Row 11: K2, *k5, p5, k6; rep from * to last st, k1.

Row 12: P1, *p5, 1/1 LT, k3, 1/1 RT, p4; rep from * to last 2 sts, p2.

Row 13: K2, *k4, p7, k5; rep from * to last st, k1.

Row 14: P1, *p4, [1/1 LT] twice, k1, [1/1 RT] twice, p3; rep from * to last 2 sts, p2.

Row 15: K2, *k3, p9, k4; rep from * to last st, k1.

Row 16: P1, *p3, [1/1 LT] twice, k3, [1/1 RT] twice, p2; rep from * to last 2 sts, p2.

Row 17: K2, *k2, p11, k3; rep from * to last st, k1.

Row 18: P1, *p2, [1/1 LT] three times, k1, [1/1 RT] three times, p1; rep from * to last 2 sts, p2.

Row 19: K2, *k1, p13, k2; rep from * to last st, k1.

Row 20: P1, *p1, [1/1 LT] three times, k3, [1/1 RT] three times; rep from * to last 2 sts, p2.

Row 21: K2, *p15, k1; rep from * to last st, k1.

Row 22: P1, *p1, k1, [1/1 LT] three times, k1, [1/1 RT] three times, k1; rep from * to last 2 sts, p2.

Row 23: K2, *p15, k1; rep from * to last st, k1.

Row 24: P1, *p1, 1/1 LT, [1/1 RT] twice, k3, [1/1 LT] twice, 1/1 RT; rep from * to last 2 sts, p2.

Row 25: K2, *k1, p13, k2; rep from * to last st, k1.

Row 26: P1, *p2, 1/1 LT, [1/1 RT] twice, k1, [1/1 LT] twice, 1/1 RT, p1; rep from * to last 2 sts, p2.

Repeat: Rows 1–26

Abbreviations

1/1 LT: 2-stitch left twist. Skip 1 st (leave on LH needle) and knit the second st in back loop, then knit the skipped st in front loop; slip both sts from needle together.

1/1 RT: 2-stitch right twist. Skip 1 st (leave on LH needle) and knit the second st in front loop, then knit the skipped st in front loop; slip both sts from needle together.

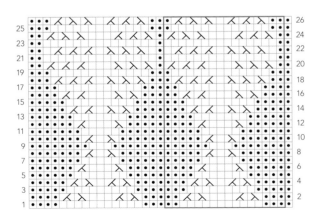

36 Rick-Rack Rib

Offset yarn overs and decreases are used to create this rib-effect stitch. It would make a nice all-over fabric. It could also be used as a traditional rib on the border of a garment, although it does not have the same elasticity if a snug fit is required.

Yarn: Sport to bulky

Multiple: 5 sts + 3

Row 1 (RS): K3, *k2tog, yo, k3; rep from * to end.

Row 2: Purl.

Row 3: K3, *yo, skp, k3; rep from * to end.

Row 4: Purl.

Repeat: Rows 1–4

Abbreviation

Skp: Slip 1 as if to knit, k1, pass slipped st over.

37 Zigzag Rib

An understated zigzag stitch, created using straightforward twisted stitches on a background of reverse stockinette stitch. Worked in a smooth yarn, this stitch could be used as an interesting all-over pattern or as a single repeat.

Yarn: Fingering to bulky

Multiple: 5 sts + 2

Row 1 (RS): K1, *1/1 LT, k3; rep from * to last st, k1.

Row 2 and all WS rows: Purl.

Row 3: K1, *k1, 1/1 LT, k2; rep from * to last st, k1.

Row 5: K1, *k2, 1/1 LT, k1; rep from * to last st, k1.

Row 7: K1, *k3, 1/1 LT; rep from * to last st, k1.

Row 9: K1, *k3, RT; rep from * to last st, k1.

Row 11: K1, *k2, RT, k1; rep from * to last st, k1.

Row 13: K1, *k1, RT, k2; rep from * to last st, k1.

Row 15: K1, *RT, k3; rep from * to last st, k1.

Row 16: Purl.

Repeat: Rows 1–16

Abbreviations

1/1 LT: 2-stitch left twist. Skip 1 st (leave on LH needle) and knit the second st in back loop, then knit the skipped st in front loop; slip both sts from needle together.

RT: 2-stitch right (k2tog) twist. K2tog leaving sts on needle, insert RH needle between sts just worked and knit first st again, slip both sts from needle together.

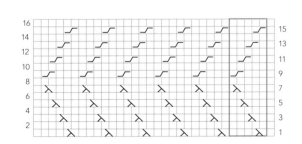

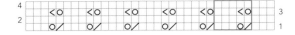

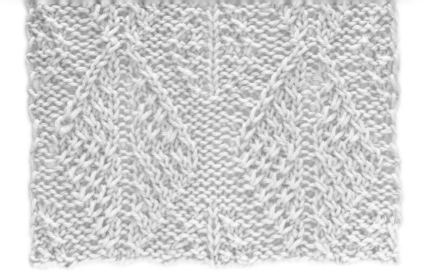

38 Trellis

This large-repeat pattern is striking and bold. When placing this pattern on a garment, consider whether to locate the small motifs or the larger motifs at the center, and try out where the pattern repeats end to get a balanced effect. For maximum impact, choose a smooth yarn.

Yarn: Light fingering to bulky

Multiple: 18 sts + 1

Row 1 (WS): K1, *k7, p1, k1, p1, k8; rep from * to end.

Row 2: *K1, [1/1 RT] twice, p2, 1/1 LT, p1, 1/1 RT, p2, [1/1 LT] twice; rep from * to last st, k1.

Row 3: P1, *k6, p2, k1, p2, k6, p1; rep from * to end.

Row 4: *K1, p1, 1/1 RT, p2, 1/1 LT, k1, p1, k1, 1/1 RT, p2, 1/1 LT, p1; rep from * to last st, k1.

Row 5: P1, *k5, p3, k1, p3, k5, p1; rep from * to end.

Row 6: *K1, 1/1 RT, p2, [1/1 LT] twice, p1, [1/1 RT] twice, p2, 1/1 LT; rep from * to last st, k1.

Row 7: P1, *k4, p4, k1, p4, k4, p1; rep from * to end.

Row 8: *P4, [1/1 LT] twice, k1, p1, k1, [1/1 RT] twice, p3; rep from * to last st, p1.

Row 9: K1, *k3, p5, k1, p5, k4; rep from * to end.

Row 10: *P3, [1/1 LT] three times, p1, [1/1 RT] three times, p2; rep from * to last st, p1.

Row 11: K1, *k2, p6, k1, p6, k3; rep from * to end.

Row 12: *P2, [1/1 LT] three times, k1, p1, k1, [1/1 RT] three times, p1; rep from * to last st, p1.

Row 13: K1, *[k1, p7] twice, k2; rep from * to end.

Row 14: *P2, k1, [1/1 LT] three times, p1, [1/1 RT] three times, k1, p1; rep from * to last st, p1.

Row 15: Repeat Row 13.

Row 16: *P2, 1/1 LT, [1/1 RT] twice, k1, p1, k1, [1/1 LT] twice, 1/1 RT, p1; rep from * to last st, p1.

Row 17: Repeat Row 11.

Row 18: *P3, 1/1 LT, [1/1 RT] twice, p1, [1/1 LT] twice, 1/1 RT, p2; rep from * to last st, p1.

Row 19: Repeat Row 9.

Row 20: *P4, 1/1 LT, 1/1 RT, k1, p1, k1, 1/1 LT, 1/1 RT, p3; rep from * to last st, p1.

Row 21: Repeat Row 7.

Row 22: *K1, 1/1 LT, p2, 1/1 LT, 1/1 RT, p1, 1/1 LT, 1/1 RT, p2, 1/1 RT; rep from * to last st, k1.

Row 23: Repeat Row 5.

Row 24: *K1, p1, 1/1 LT, p2, 1/1 LT, k1, p1, k1, 1/1 RT, p2, 1/1 RT, p1; rep from * to last st, k1.

Row 25: Repeat Row 3.

Row 26: *K1, [1/1 LT] twice, p2, 1/1 LT, p1, 1/1 RT, p2, [1/1 RT] twice; rep from * to last st, k1.

Repeat: Rows 1–26

Abbreviations

1/1 RT: 2-stitch right twist. Skip 1 st (leave on LH needle) and knit the second st in front loop, then knit the skipped st in front loop; slip both sts from needle together.

1/1 LT: 2-stitch left twist. Skip 1 st (leave on LH needle) and knit the second st in back loop, then knit the skipped st in front loop; slip both sts from needle together.

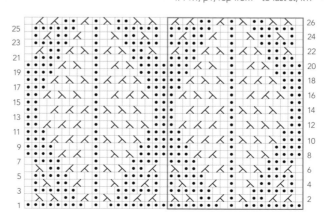

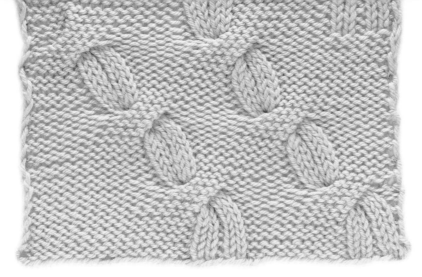

39 Threaded Cable

Three separate cables interlock to create an open, soft braid that meanders across the fabric. The reverse stockinette stitch background could be replaced with garter stitch for a different effect. Placing two braids together and adding a simple cable either side would create an interesting panel.

Yarn: Sport to bulky

Multiple: 15 sts + 9

Row 1 (WS): K7, *k10, p2, k1, p2; rep from * to last 2 sts, k2.

Row 2: P2, *k2, p1, k2, p10; rep from * to last 7 sts, p7.

Rows 3–8: Repeat Rows 1 & 2 three times.

Row 9: Repeat Row 1.

Row 10: P2, *5/5 RPRC, p5, p10; rep from * to last 7 sts, p7.

Row 11: K7, *k5, p2, k1, p2, k5; rep from * to last 2 sts, k2.

Row 12: P2, *p5, k2, p1, k2, p5; rep from * to last 7 sts, p7.

Rows 13–18: Repeat Rows 11 & 12 three times.

Row 19: Repeat Row 11.

Row 20: P2, *p5, 5/5 RPRC; rep from * to last 7 sts, p7.

Row 21: K7, *p2, k1, p2, k10; rep from * to last 2 sts, k2.

Row 22: P2, *p10, k2, p1, k2; rep from * to last 7 sts, p7.

Rows 23–28: Repeat Rows 21 & 22 three times.

Row 29: Repeat Row 21.

Row 30: P7, *p5, 5/5 RPRC; rep from * to last 2 sts, p2.

Repeat: Rows 1–30

Abbreviation

5/5 RPRC: 10-stitch right purl ribbed cable. Slip 5 sts to cable needle and hold in back, p5 from LH needle, k2, p1, k2 from cable needle.

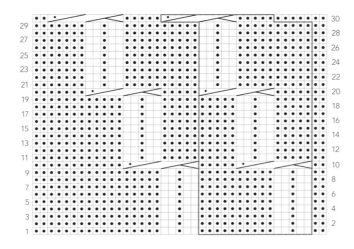

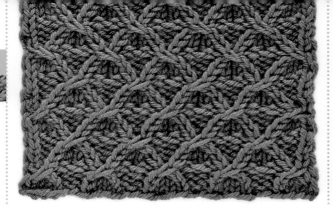

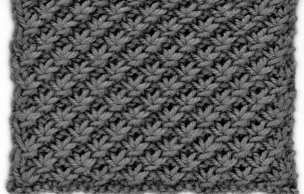

40 Traveling Rib

These four-stitch cables are worked so as to put the knit stitches firmly at the front, which creates a ribbed structure. Offsetting the cables gives a textured network of ribbed ridges and gives the impression of movement. The fabric looks great as an all-over pattern and is springy but soft enough for garments as well as soft furnishings.

Yarn: Fingering to worsted

Multiple: 6 sts + 6

Row 1 (WS): P5, *k2, p4; rep from * to last st, p1.

Row 2: K1, *k4, p2; rep from * to last 5 sts, k5.

Row 3: P5, *k2, p4; rep from * to last st, p1.

Row 4: K1, *1/2/1 RRC, p2; rep from * to last 5 sts, 1/2/1 RRC, k1.

Row 5: P2, k2, *p4, k2; rep from * to last 2 sts, p2.

Row 6: K2, *p2, k4; rep from * to last 4 sts, p2, k2.

Row 7: P2, k2, *p4, k2; rep from * to last 2 sts, p2.

Row 8: K2, *p2, 1/2/1 RRC; rep from * to last 4 sts, p2, k2.

Repeat: Rows 1–8

Abbreviation

1/2/1 RRC: 4-stitch right ribbed cable. Slip 3 sts to cable needle and hold in back, k1, slip 2 left-most sts from cable needle to LH needle, move cable needle with remaining st to front, p2 from LH needle, then k1 from cable needle.

41 Daisy Stitch

Once the basic daisy stitch has been mastered, this lovely fabric can be turned into a wide range of projects. It produces quite a firm fabric so, for more drape, try needles a couple of sizes larger than those recommended for the yarn.

Yarn: Laceweight to bulky

Multiple: 4 sts + 3

Row 1 (RS): Knit.

Row 2: K3, *Dst, k1; rep from * to end.

Row 3: Knit.

Row 4: K1, *Dst, k1; rep from * to last 2 sts, k2.

Repeat: Rows 1–4

Abbreviation

Dst: Daisy stitch. P3tog but keep the sts on LH needle. Yo, then purl the same 3 sts together again to complete the st.

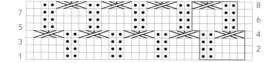

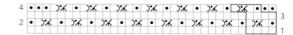

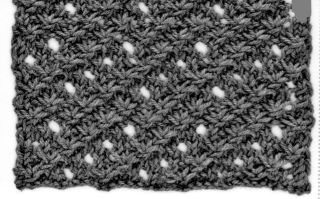

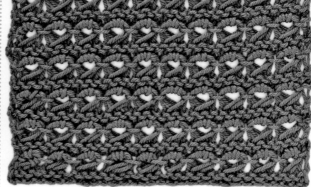

42 Lacy Daisy Stitch

This lacy daisy pattern is a more open and soft version of the daisy stitch. It has a super texture but is nicely balanced without any biasing. It works well in almost any smooth yarn with good stitch definition.

Yarn: Light fingering to bulky

Multiple: 8 sts + 10

Row 1 (RS) and all RS rows: Knit.

Row 2: *K1, Dst, p1, p2tog, yo, p1; rep from * to last 2 sts, k1, p1.

Row 4: P2, k1, Dst, p1, p2tog, *yo, p1, k1, Dst, p1, p2tog; rep from * to last st, yo, p1.

Row 6: *P1, p2tog, yo, p1, k1, Dst; rep from * to last 2 sts, p2.

Row 8: P3, p2tog, yo, p1, k1, *Dst, p1, p2tog, yo, p1, k1; rep from * to last 3 sts, p3.

Row 10: *K1, Dst; rep from * to last 2 sts, k1, p1.

Row 12: K1, p1, k1, *Dst, k1; rep from * to last 3 sts, p1, k1, p1.

Repeat: Rows 1–12. End with Row 1.

Abbreviation

Dst: Daisy stitch. P3tog but keep the sts on LH needle. Yo, then purl the same 3 sts together again to complete the st.

43 Little Crown Stitch

Cluster stitches create a lovely open but stable fabric, well suited to an all-over pattern. Individual crowns could also be worked and separated by bands of garter or stockinette to form an interesting rib, or used as a decorative edging.

Yarn: Laceweight to bulky

Multiple: 1 st + 2

Row 1 (RS): Knit.

Row 2: Knit.

Row 3: K1, *k1 elongated twice; rep from * to last st, k1.

Row 4: P1, *3CL; rep from * to last st, p1.

Repeat: Rows 1–4

Abbreviations

K1 elongated twice: Knit a st wrapping yarn around needle three times. On next row drop the extra wraps from needle.

3CL: 3-stitch cluster. Slip 3 sts letting extra wraps drop. Place slipped sts back onto LH needle, [k1, p1, k1] into all 3 sts.

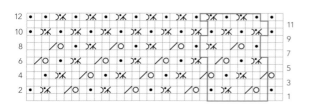

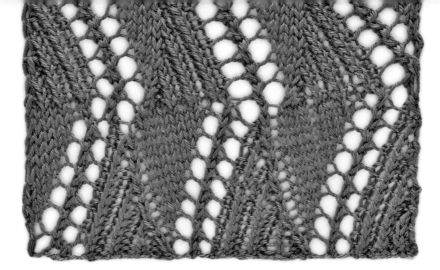

44 Lacy Sails

Small stockinette sails surrounded by lacy eyelets make an attractive fabric. This pattern would work well in a range of yarns. A smoother yarn will give more visible eyelets while a textured yarn may benefit from larger than normal needles for the yarn.

Yarn: Laceweight to worsted

Multiple: 11 sts + 2

Row 1 (RS): K1, *ssk, [p1, k1tbl] three times, p1, yo, k2tog, yo; rep from * to last st, k1.

Row 2: P1, *p3, [k1, p1tbl] three times, k1, p1; rep from * to last st, p1.

Row 3: K1, *ssk, [k1tbl, p1] three times, yo, k2tog, yo, k1; rep from * to last st, k1.

Row 4: P1, *p4, [k1, p1tbl] three times, p1; rep from * to last st, p1.

Row 5: K1, *ssk, [p1, k1tbl] twice, p1, yo, k2tog, yo, k2; rep from * to last st, k1.

Row 6: P1, *p5, [k1, p1tbl] twice, k1, p1; rep from * to last st, p1.

Row 7: K1, *ssk, [k1tbl, p1] twice, yo, k2tog, yo, k3; rep from * to last st, k1.

Row 8: P1, *p6, [k1, p1tbl] twice, p1; rep from * to last st, p1.

Row 9: K1, *ssk, p1, k1tbl, p1, yo, k2tog, yo, k4; rep from * to last st, k1.

Row 10: P1, *p7, k1, p1tbl, k1, p1; rep from * to last st, p1.

Row 11: K1, *ssk, k1tbl, p1, yo, k2tog, yo, k5; rep from * to last st, k1.

Row 12: P1, *p8, k1, p1tbl, p1; rep from * to last st, p1.

Row 13: K1, *ssk, p1, yo, k2tog, yo, k6; rep from * to last st, k1.

Row 14: P1, *p9, k1, p1; rep from * to last st, p1.

Row 15: K1, *ssk, yo, k2tog, yo, k7; rep from * to last st, k1.

Row 16: Purl.

Row 17: K1, *yo, ssk, yo, [p1, k1tbl] three times, p1, k2tog; rep from * to last st, k1.

Row 18: P1, *p1, [k1, p1tbl] three times, k1, p3; rep from * to last st, p1.

Row 19: K1, *k1, yo, ssk, yo, [p1, k1tbl] three times, k2tog; rep from * to last st, k1.

Row 20: P1, *p1, [p1tbl, k1] three times, p4; rep from * to last st, p1.

Row 21: K1, *k2, yo, ssk, yo, [p1, k1tbl] twice, p1, k2tog; rep from * to last st, k1.

Row 22: P1, *p1, [k1, p1tbl] twice, k1, p5; rep from * to last st, p1.

Row 23: K1, *k3, yo, ssk, yo, [p1, k1tbl] twice, k2tog; rep from * to last st, k1.

Row 24: P1, *p1, [p1tbl, k1] twice, p6; rep from * to last st, p1.

Row 25: K1, *k4, yo, ssk, yo, p1, k1tbl, p1, k2tog; rep from * to last st, k1.

Row 26: P1, *p1, k1, p1tbl, k1, p7; rep from * to last st, p1.

Row 27: K1, *k5, yo, ssk, yo, p1, k1tbl, k2tog; rep from * to last st, k1.

Row 28: P1, *p1, p1tbl, k1, p8; rep from * to last st, p1.

Row 29: K1, *k6, yo, ssk, yo, p1, k2tog; rep from * to last st, k1.

Row 30: P1, *p1, k1, p9; rep from * to last st, p1.

Row 31: K1, *k7, yo, ssk, yo, k2tog; rep from * to last st, k1.

Row 32: Purl.

Repeat: Rows 1–32

Abbreviation

Ssk: Slip, slip, knit. Slip 2 sts one at a time as if to knit, knit 2 slipped sts together.

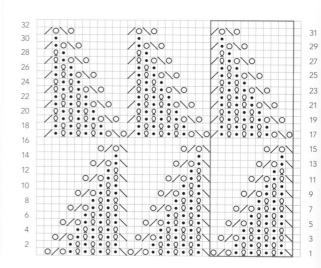

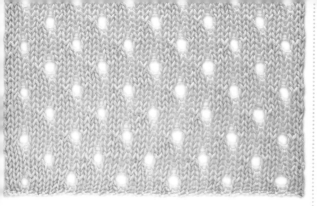

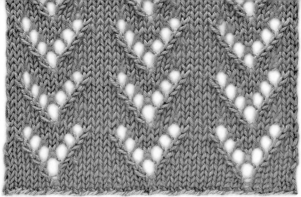

45 Simple Eyelet Lace

A classic lace worked as single eyelets in a simple, offset repeating pattern. This pattern has many variations depending on the placement of the individual eyelets.

Yarn: Light fingering to light worsted

Multiple: 6 sts + 7

Row 1 (RS): Knit.

Row 2: Purl.

Row 3: K3, *yo, k2tog, k4; rep from * to last 4 sts, yo, k2tog, k2.

Row 4: Purl.

Row 5: Knit.

Row 6: Purl.

Row 7: K3, *k3, yo, k2tog, k1; rep from * to last 4 sts, k4.

Row 8: Purl.

Repeat: Rows 1–8

46 V Eyelets Lace

A simple, rhythmical pattern with bold eyelets and strong shapes. Ideas for varying this simple motif could be to work additional rows between the "V"s, to place the "V"s closer together, or to add stitches between the motifs to increase the distance between the "V"s.

Yarn: Fingering to worsted

Multiple: 11 sts + 2

Row 1 (RS): Knit.

Row 2 and all WS rows: Purl.

Row 3: K1, *k5, yo, skp, k4; rep from * to last st, k1.

Row 5: K1, *k3, k2tog, yo, k1, yo, skp, k3; rep from * to last st, k1.

Row 7: K1, *k2, k2tog, yo, k3, yo, skp, k2; rep from * to last st, k1.

Row 9: K1, *k1, k2tog, yo, k5, yo, skp, k1; rep from * to last st, k1.

Repeat: Rows 2–9

Abbreviation

Skp: Slip 1 as if to knit, k1, pass slipped st over.

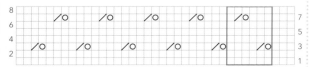

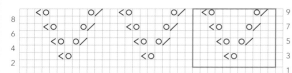

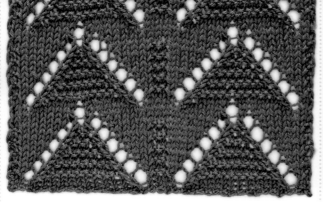

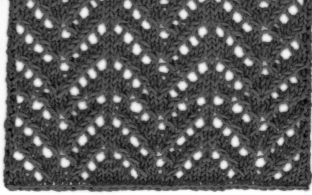

47 Garter Inverted V Eyelets

Bold stacks of garter stitch pyramids flanked by lacy eyelets create a dramatic pattern. For a more delicate effect, replace the garter stitch with stockinette.

Yarn: Cobweb to light fingering

Multiple: 18 sts + 2

Row 1 (RS): Knit.

Row 2: Purl.

Row 3: K1, *k2, yo, ssk, k10, k2tog, yo, k2; rep from * to last st, k1.

Row 4: P1, *k1, p3, k10, p3, k1; rep from * to last st, p1.

Row 5: K1, *k3, yo, ssk, k8, k2tog, yo, k3; rep from * to last st, k1.

Row 6: P1, *k1, p4, k8, p4, k1; rep from * to last st, p1.

Row 7: K1, *k4, yo, ssk, k6, k2tog, yo, k4; rep from * to last st, k1.

Row 8: P1, *k1, p5, k6, p5, k1; rep from * to last st, p1.

Row 9: K1, *k5, yo, ssk, k4, k2tog, yo, k5; rep from * to last st, k1.

Row 10: P1, *k1, p6, k4, p6, k1; rep from * to last st, p1.

Row 11: K1, *k6, yo, ssk, k2, k2tog, yo, k6; rep from * to last st, k1.

Row 12: P1, *k1, p7, k2, p7, k1; rep from * to last st, p1.

Row 13: K1, *k7, yo, ssk, k2tog, yo, k7; rep from * to last st, k1.

Row 14: Purl.

Row 15: K1, *k9, yo, ssk, k7; rep from * to last st, k1.

Row 16: Purl.

Repeat: Rows 3–16

Abbreviation

Ssk: Slip, slip, knit. Slip 2 sts one at a time as if to knit, knit 2 slipped sts together.

48 Nested V Eyelets

Rows of eyelets worked in "V"s and nested closely together create a lovely, rich texture without compromising suppleness or drape. Work a single panel repeat or combine several together for a dramatic all-over pattern.

Yarn: Cobweb to light fingering

Multiple: 11 sts + 3

Row 1 (WS): Purl.

Row 2 and all RS rows: Knit.

Row 3: P2, *yo, p2tog, p6, p2togtbl, yo, p1; rep from * to last st, p1.

Row 5: *P3, yo, p2tog, p4, p2togtbl, yo; rep from * to last 3 sts, p3.

Row 7: *P4, yo, p2tog, p2, p2togtbl, yo, p1; rep from * to last 3 sts, p3.

Row 9: P2, *yo, p2tog, p1, yo, p2tog, [p2togtbl, yo, p1] twice; rep from * to last st, p1.

Row 11: P2, *p1, yo, p2tog, [p2togtbl, yo, p2] twice; rep from * to last st, p1.

Row 13: P2, *p2, yo, p2tog, p2, p2togtbl, yo, p3; rep from * to last st, p1.

Row 14: Knit.

Repeat: Rows 9–14

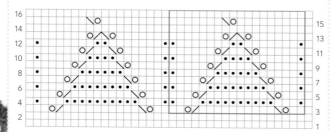

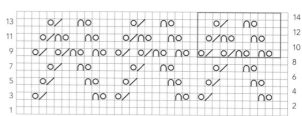

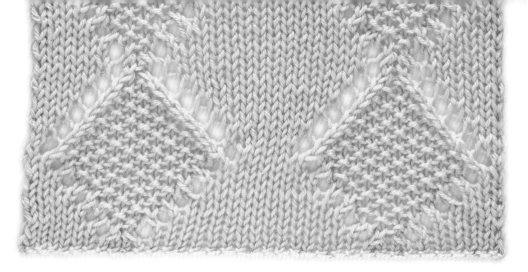

49 Seed Stitch-Filled Lacy Diamonds

This versatile pattern can be used as a single motif or you could combine several repeats in vertical panels or blocks. The seed stitch center adds interest, but could be simplified by replacing with stockinette for a different look.

Yarn: Cobweb to worsted

Panel: 16 sts

Row 1 (RS): K6, yo, ssk, k2tog, yo, k6.

Row 2: P8, k1, p7.

Row 3: K5, yo, ssk, k1, p1, k2tog, yo, k5.

Row 4: P6, [k1, p1] twice, k1, p5.

Row 5: K4, yo, ssk, [p1, k1] twice, k2tog, yo, k4.

Row 6: P4, [k1, p1] three times, k1, p5.

Row 7: K3, yo, ssk, [k1, p1] three times, k2tog, yo, k3.

Row 8: P4, [k1, p1] four times, k1, p3.

Row 9: K2, yo, ssk, [p1, k1] four times, k2tog, yo, k2.

Row 10: Repeat Row 8.

Row 11: K1, yo, ssk, [k1, p1] five times, k2tog, yo, k1.

Row 12: Repeat Row 8.

Row 13: Repeat Row 9.

Row 14: Repeat Row 6.

Row 15: Repeat Row 7.

Row 16: Repeat Row 4.

Row 17: Repeat Row 5.

Row 18: P6, k1, p1, k1, p7.

Row 19: Repeat Row 3.

Row 20: Purl.

Row 21: Repeat Row 1.

Row 22: Purl.

Repeat: Rows 1–22

Abbreviation

Ssk: Slip, slip, knit. Slip 2 sts one at a time as if to knit, knit 2 slipped sts together.

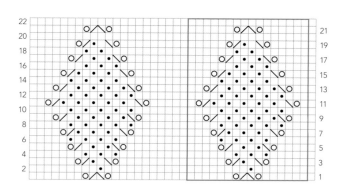

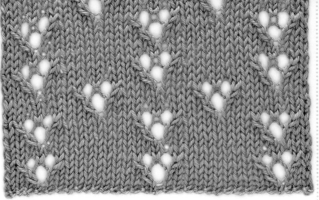
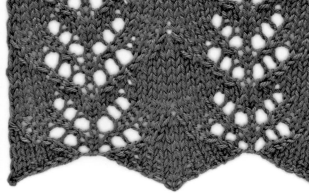

50 Cat's Eyes

A simple motif comprising just three eyelets worked in repeating blocks. There are many variations you could try: placing the motifs closer together, arranging them at random across the fabric, or working single motifs as part of a larger pattern.

Yarn: Cobweb to bulky

Multiple: 12 sts + 9

Row 1 (RS): Knit.

Row 2: Purl.

Row 3: K1, *k3, yo, skp, k7; rep from * to last 8 sts, k3, yo, skp, k3.

Row 4: Purl.

Row 5: K1, *k1, k2tog, yo, k1, yo, skp, k6; rep from * to last 8 sts, k1, k2tog, yo, k1, yo, skp, k2.

Row 6: Purl.

Row 7: Knit.

Row 8: Purl.

Rows 9–12: Repeat Rows 3–6.

Row 13: K1, *k9, yo, skp, k1; rep from * to last 8 sts, k8.

Row 14: Purl.

Row 15: K1, *k7, k2tog, yo, k1, yo, skp; rep from * to last 8 sts, k8.

Row 16: Purl.

Repeat: Rows 3–16

Abbreviation

Skp: Slip 1 as if to knit, k1, pass slipped st over.

51 Lacy Stockinette Scallops

A lovely textural pattern that works well on a wide range of yarn weights. To achieve maximum impact from the pattern, a smooth yarn will work well. For a subtler effect, a mohair or similar hazy yarn could be used.

Yarn: Laceweight to worsted

Multiple: 15 sts + 2

Row 1 (RS): K1, *k5, k2tog, yo, k1, yo, skp, k5; rep from * to last st, k1.

Row 2 and all WS rows: Purl.

Row 3: K1, *k4, k2tog, yo, k3, yo, skp, k4; rep from * to last st, k1.

Row 5: K1, *k3, [k2tog, yo] twice, k1, [yo, skp] twice, k3; rep from * to last st, k1.

Row 7: K1, *k1, k2tog, [k3, yo] twice, k3, skp, k1; rep from * to last st, k1.

Row 9: K1, *k2tog, k3, yo, k5, yo, k3, skp; rep from * to last st, k1.

Row 10: Purl.

Repeat: Rows 1–10

Abbreviation

Skp: Slip 1 as if to knit, k1, pass slipped st over.

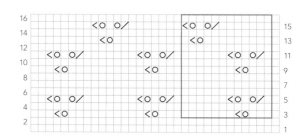

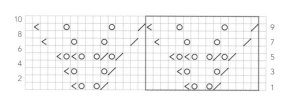

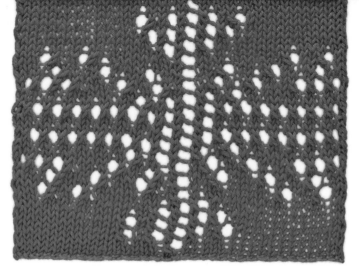

52 Snowflake Lace Motif

This large, dramatic motif is relatively simple to work, requiring only basic lace stitches. Block carefully to ensure that the motif shape is retained and to give the lace maximum visibility.

Yarn: Cobweb to bulky

Motif: 36 sts

Row 1 (RS): Knit.

Row 2 and all WS rows: Purl.

Row 3: *K17, yo, ssk, k17; rep from * to end.

Row 5: *K12, yo, ssk, k1, [yo, ssk] three times, k1, yo, ssk, k12; rep from * to end.

Row 7: *K13, [yo, ssk] five times, k13; rep from * to end.

Row 9: *K15, [yo, ssk] three times, k15; rep from * to end.

Row 11: *[K2, yo, ssk] twice, k9, yo, ssk, k8, yo, ssk, yo, k2, k2tog, yo, k3; rep from * to end.

Row 13: *[K3, yo, ssk] three times, k2, yo, ssk, k1, [k2tog, yo, k3] twice, k2tog, yo, k4; rep from * to end.

Row 15: *K1, [yo, ssk] three times, k3, yo, ssk, k2, yo, ssk, k1, yo, ssk, k2tog, yo, k2, k2tog, yo, k4, [k2tog, yo] three times, k1; rep from * to end.

Row 17: *K12, yo, ssk, k1, yo, ssk, yo, k2tog, yo, [k2tog] twice, yo, k13; rep from * to end.

Row 19: *K1, [yo, ssk] eight times, [yo, k2tog] nine times, k1; rep from * to end.

Row 21: *K15, yo, ssk, [yo, k2tog] twice, k15; rep from * to end.

Row 23: *K1, [yo, ssk] eight times, [yo, k2tog] nine times, k1; rep from * to end.

Row 25: *K12, yo, ssk, k1, yo, ssk, yo, k2tog, yo, [k2tog] twice, yo, k13; rep from * to end.

Row 27: *K1, [yo, ssk] three times, k3, yo, ssk, k2, yo, ssk, k1, yo, [k2tog] twice, yo, k2, k2tog, yo, k4, [k2tog, yo] three times, k1; rep from * to end.

Row 29: *[K3, yo, ssk] three times, [k2, yo, k2tog] twice, k3, yo, k2tog, k2, k2tog, yo, k4; rep from * to end.

Row 31: *[K2, yo, ssk] twice, k9, yo, k2tog, k8, k2tog, yo, k2, k2tog, yo, k3; rep from * to end.

Row 33: *K15, yo, ssk, [yo, k2tog] twice, k15; rep from * to end.

Row 35: *K13, [yo, ssk] twice, [yo, k2tog] three times, k13; rep from * to end.

Row 37: *K12, yo, ssk, k1, yo, ssk, yo, k2tog, yo, [k2tog] twice, yo, k13; rep from * to end.

Row 39: *K17, yo, k2tog, k17; rep from * to end.

Row 40: Purl.

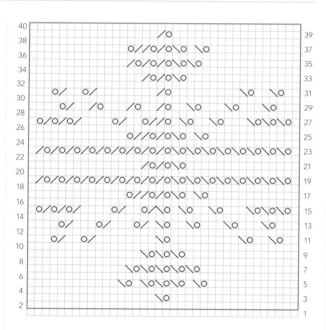

Repeat: Rows 2–40

Abbreviation

Ssk: Slip, slip, knit. Slip 2 sts one at a time as if to knit, knit 2 slipped sts together.

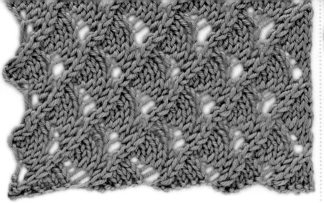

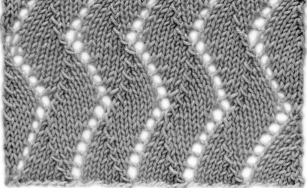

53 Milanese Lace

If not blocked too heavily, this lace pattern has a strong shape and rich texture, unlike many of the flatter, smoother lace patterns. The diagonals are very interesting and do not bias the fabric, which makes the pattern suitable as an all-over pattern as well as for panels.

Yarn: Laceweight to bulky

Multiple: 6 sts + 2

Row 1 (RS): K1, *k4, k2tog, yo; rep from * to last st, k1.

Row 2: P1, *yo, p1, p2tog, p3; rep from * to last st, p1.

Row 3: K1, *k2, k2tog, k2, yo; rep from * to last st, k1.

Row 4: P1, *yo, p3, p2tog, p1; rep from * to last st, p1.

Row 5: K1, *k2tog, k4, yo; rep from * to last st, k1.

Row 6: P1, *p2tog, p4, yo; rep from * to last st, p1.

Row 7: K1, *k1, yo, k3, k2tog; rep from * to last st, k1.

Row 8: P1, *p2tog, p2, yo, p2; rep from * to last st, p1.

Row 9: K1, *k3, yo, k1, k2tog; rep from * to last st, k1.

Row 10: P1, *p2tog, yo, p4; rep from * to last st, p1.

Repeat: Rows 1–10

54 Flame Chevron

This richly textured chevron with its lace edges makes a great all-over pattern. It will look great after blocking, particularly if a yarn with good stitch definition is used.

Yarn: Laceweight to bulky

Multiple: 7 sts + 2

Row 1 (WS) and all WS rows: Purl.

Row 2: K1, *ssk, k5, yo; rep from * to last st, k1.

Row 4: K1, *ssk, k4, yo, k1; rep from * to last st, k1.

Row 6: K1, *ssk, k3, yo, k2; rep from * to last st, k1.

Row 8: K1, *ssk, k2, yo, k3; rep from * to last st, k1.

Row 10: K1, *ssk, k1, yo, k4; rep from * to last st, k1.

Row 12: K1, *ssk, yo, k5; rep from * to last st, k1.

Row 14: K1, *yo, k5, k2tog; rep from * to last st, k1.

Row 16: K1, *k1, yo, k4, k2tog; rep from * to last st, k1.

Row 18: K1, *k2, yo, k3, k2tog; rep from * to last st, k1.

Row 20: K1, *k3, yo, k2, k2tog; rep from * to last st, k1.

Row 22: K1, *k4, yo, k1, k2tog; rep from * to last st, k1.

Row 24: K1, *k5, yo, k2tog; rep from * to last st, k1.

Repeat: Rows 1–24

Abbreviation

Ssk: Slip, slip, knit. Slip 2 sts one at a time as if to knit, knit 2 slipped sts together.

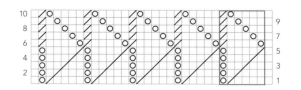

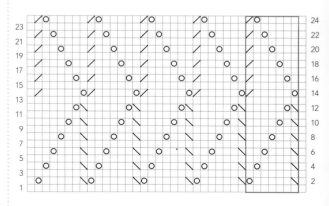

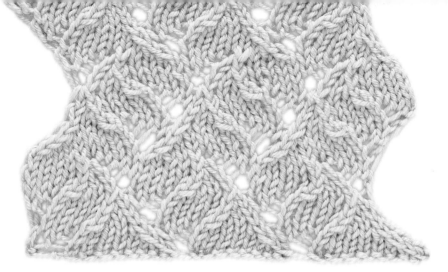

55 Twisted Leaf Lace

This interesting pattern creates a lovely undulating edge, ideally suited to a decorative edging, scarf, or other item where a shaped edging is desirable.

Yarn: Laceweight to bulky

Multiple: 9 sts + 2

Row 1 (RS): K1, *ssk, k7, yo; rep from * to last st, k1.

Row 2: P1, *p1, yo, p6, p2togtbl; rep from * to last st, p1.

Row 3: K1, *ssk, k5, yo, k2; rep from * to last st, k1.

Row 4: P1, *p3, yo, p4, p2togtbl; rep from * to last st, p1.

Row 5: K1, *k3, k2tog, k4, yo; rep from * to last st, k1.

Row 6: P1, *p1, yo, p4, p2tog, p2; rep from * to last st, p1.

Row 7: K1, *k1, k2tog, k4, yo, k2; rep from * to last st, k1.

Row 8: P1, *p3, yo, p4, p2tog; rep from * to last st, p1.

Row 9: K1, *yo, k3, k2tog, k4; rep from * to last st, k1.

Row 10: P1, *p4, p2tog, p2, yo, p1; rep from * to last st, p1.

Row 11: K1, *k2, yo, k1, k2tog, k4; rep from * to last st, k1.

Row 12: P1, *p4, p2tog, yo, p3; rep from * to last st, p1.

Row 13: K1, *yo, k7, k2tog; rep from * to last st, k1.

Row 14: P1, *p2tog, p6, yo, p1; rep from * to last st, p1.

Row 15: K1, *k2, yo, k5, k2tog; rep from * to last st, k1.

Row 16: P1, *p2tog, p4, yo, p3; rep from * to last st, p1.

Row 17: K1, *yo, k4, ssk, k3; rep from * to last st, k1.

Row 18: P1, *p2, p2togtbl, p4, yo, p1; rep from * to last st, p1.

Row 19: K1, *k2, yo, k4, ssk, k1; rep from * to last st, k1.

Row 20: P1, *p2togtbl, p4, yo, p3; rep from * to last st, p1.

Row 21: K1, *k4, ssk, k3, yo; rep from * to last st, k1.

Row 22: P1, *p1, yo, p2, p2togtbl, p4; rep from * to last st, p1.

Row 23: K1, *k4, ssk, k1, yo, k2; rep from * to last st, k1.

Row 24: P1, *p3, yo, p2togtbl, p4; rep from * to last st, p1.

Repeat: Rows 1–24

Abbreviation

Ssk: Slip, slip, knit. Slip 2 sts one at a time as if to knit, knit 2 slipped sts together.

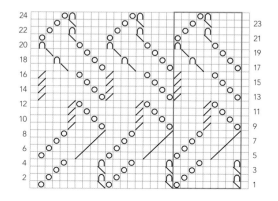

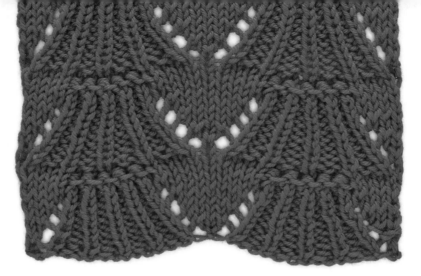

56 Lacy Bear Paw

A classic pattern that gives a lovely scalloped edge for the trim of a sleeve or garment hem. Spines of ribbing give structure and highlight the lovely shaping. For best results aim to work complete repeats as the stitch count varies throughout the pattern.

Yarn: Laceweight to bulky

Multiple: 14 sts + 1

Row 1 (RS): *K1, yo, [k1, p2] four times, k1, yo; rep from * to last st, k1.

Row 2: P1, *p2, [k2, p1] three times, k2, p3; rep from * to end.

Row 3: *K2, yo, [k1, p2] four times, k1, yo, k1; rep from * to last st, k1.

Row 4: P1, *p3, [k2, p1] three times, k2, p4; rep from * to end.

Row 5: *K3, yo, [k1, p2] four times, k1, yo, k2; rep from * to last st, k1.

Row 6: P1, *p4, [k2, p1] three times, k2, p5; rep from * to end.

Row 7: *K4, yo, [k1, p2] four times, k1, yo, k3; rep from * to last st, k1.

Row 8: P1, *p5, [k2, p1] three times, k2, p6; rep from * to end.

Row 9: *K5, yo, [k1, p2] four times, k1, yo, k4; rep from * to last st, k1.

Row 10: P1, *p6, [k2, p1] three times, k2, p7; rep from * to end.

Row 11: *K5, [p3tog] five times, k4; rep from * to last st, k1.

Row 12: Purl.

Repeat: Rows 1–12

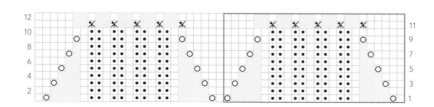

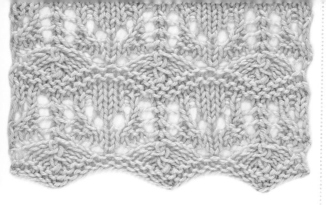

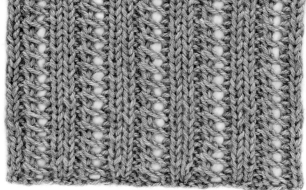

57 Thistle

These dainty lace thistles produce an attractive, scalloped edge and would make a very nice edging band or all-over pattern for a garment. Replace the garter rows with stockinette stitch for a different look.

Yarn: Laceweight to bulky

Multiple: 10 sts + 1

Row 1 (RS): Knit.

Rows 2–5: Knit.

Row 6: P1, *yo, p3, s2pp, p3, yo, p1; rep from * to end.

Row 7: *K2, yo, k2, s2kp, k2, yo, k1; rep from * to last st, k1.

Row 8: P1, *p2, yo, p1, s2pp, p1, yo, p3; rep from * to end.

Row 9: *K4, yo, s2kp, yo, k3; rep from * to last st, k1.

Row 10: P1, *p1, k2, p3, k2, p2; rep from * to end.

Row 11: *K1, yo, ssk, p1, yo, s2kp, yo, p1, k2tog, yo; rep from * to last st, k1.

Row 12: P1, *p2, [k1, p3] twice; rep from * to end.

Row 13: *K2, yo, ssk, yo, s2kp, yo, k2tog, yo, k1; rep from * to last st, k1.

Row 14: P1, *p1, k1, p5, k1, p2; rep from * to end.

Row 15: *K2, p1, k1, yo, s2kp, yo, k1, p1, k1; rep from * to last st, k1.

Row 16: P1, *p1, k1, p5, k1, p2; rep from * to end.

Repeat: Rows 1–16

Abbreviations

S2pp: Slip 2 sts, p1, pass 2 slipped sts over.

S2kp: Slip 2 as if to k2tog, k1, pass 2 slipped sts over.

Ssk: Slip, slip, knit. Slip 2 sts one at a time as if to knit, knit 2 slipped sts together.

58 Simple Lacy Rib

This is a soft, simple but interesting rib. Only a very slight bias presents in the fabric and this is easily adjusted during blocking. This would make a good rib where a softer edge is required. Alternately, it could be used as an all-over pattern for a more fitted garment style.

Yarn: Laceweight to bulky

Multiple: 6 sts + 2

Row 1 (RS): K2, *p1, yo, k2togtbl, p1, k2; rep from * to end.

Row 2: *[P2, k1] twice; rep from * to last 2 sts, p2.

Row 3: K2, *p1, k2tog, yo, p1, k2; rep from * to end.

Row 4: Repeat Row 2.

Repeat: Rows 1–4

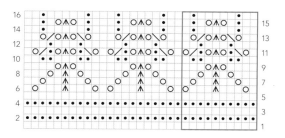

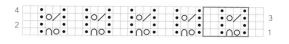

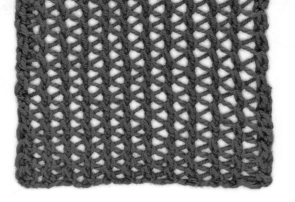

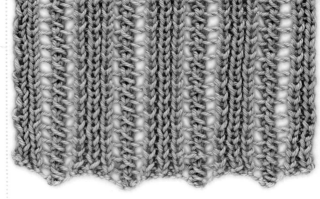

59 Faggoting Stitch

A very soft, open fabric is created with this simple, two-row pattern. Allow for the fact that it expands during knitting and is very stretchy.

Yarn: Cobweb to bulky

Multiple: 2 sts + 2

Row 1 (RS): K1, *ssk, yo; rep from * to last st, k1.

Row 2: P1, *p2togtbl, yo; rep from * to last st, p1.

Repeat: Rows 1–2

60 Rib and Lace

A great introduction to lace knitting, this simple pattern has a two-row pattern repeat and just eight stitches in the stitch repeat. It is quite open and fluid, and could be used as a soft rib for a delicate project where a standard rib would be too dominant.

Yarn: Laceweight to bulky

Multiple: 8 sts + 3

Row 1 (RS): *[P1, k1] twice, yo, sk2p, yo, k1; rep from * to last 3 sts, p1, k1, p1.

Row 2: K1, p1, k1, *p5, k1, p1, k1; rep from * to end.

Repeat: Rows 1–2

Abbreviation

Sk2p: Slip 1 as if to knit, k2tog, pass slipped st over.

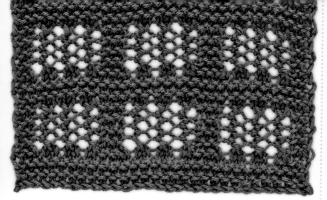

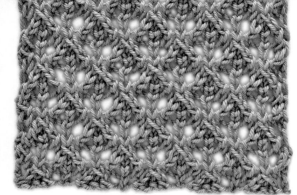

61 Faggoting Blocks

Straightforward blocks of lace faggoting are set in a framework of garter stitch for a richly textured, bold geometric pattern.

Yarn: Cobweb to bulky

Multiple: 9 sts + 3

Row 1 (WS): Knit.

Rows 2–4: Knit.

Row 5: K3, *p6, k3; rep from * to end.

Row 6: *K3, [yo, ssk] three times; rep from * to last 3 sts, k3.

Row 7: K3, *[yo, p2togtbl] three times, k3; rep from * to end.

Rows 8–11: Repeat Rows 6 & 7 twice.

Row 12: Repeat Row 6.

Row 13: K3, *p6, k3; rep from * to end.

Row 14: Knit.

Repeat: Rows 1–14

Abbreviation

Ssk: Slip, slip, knit. Slip 2 sts one at a time as if to knit, knit 2 slipped sts together.

62 Feather Lace

This is a really interesting pattern that has the appearance of interlocking cables, but is actually based on lacy yarn overs. It can be worked in a wide range of yarns—smooth yarns with good stitch definition will make the most of the textural qualities.

Yarn: Cobweb to bulky

Multiple: 6 sts + 7

Row 1 (RS): K1, *yo, k2togtbl, k1, k2tog, yo, k1; rep from * to end.

Row 2 and all WS rows: Purl.

Row 3: K1, *yo, k1, sk2p, k1, yo, k1; rep from * to end.

Row 5: K1, *k2tog, yo, k1, yo, k2togtbl, k1; rep from * to end.

Row 7: K2tog, *[k1, yo] twice, k1, sk2p; rep from * to last 5 sts, [k1, yo] twice, k1, k2togtbl.

Row 8: Purl.

Repeat: Rows 1–8

Abbreviation

Sk2p: Slip 1 as if to knit, k2tog, pass slipped st over.

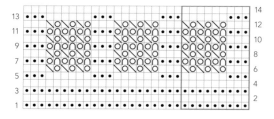

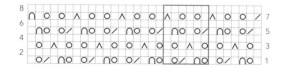

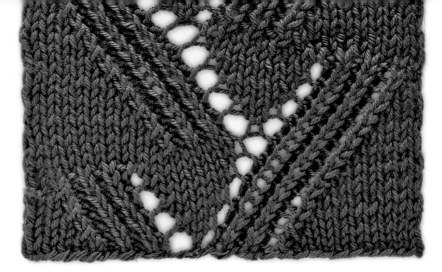

63 Vine Lace

Lines of eyelets are flanked by bold ribbed stripes in this dramatic stitch. It would look equally striking as a single panel or worked as an all-over pattern. This stitch is punchy enough to work in a wide range of yarns without losing its impact.

Yarn: Light fingering to bulky

Multiple: 26 sts + 4

Row 1 (RS): K2, *k8, k2tog, [k1tbl, p1] twice, k1tbl, yo, k1, yo, [k1tbl, p1] twice, k1tbl, k2tog, k3; rep from * to last 2 sts, k2.

Row 2: P2, *p4, [p1tbl, k1] twice, p1tbl, p3, [p1tbl, k1] twice, p1tbl, p9; rep from * to last 2 sts, p2.

Row 3: K2, *k7, k2tog, [k1tbl, p1] twice, k1tbl, yo, k3, yo, [k1tbl, p1] twice, k1tbl, k2tog, k2; rep from * to last 2 sts, k2.

Row 4: P2, *p3, [p1tbl, k1] twice, p1tbl, p5, [p1tbl, k1] twice, p1tbl, p8; rep from * to last 2 sts, p2.

Row 5: K2, *k6, k2tog, [k1tbl, p1] twice, k1tbl, yo, k5, yo, [k1tbl, p1] twice, k1tbl, k2tog, k1; rep from * to last 2 sts, k2.

Row 6: P2, *p2, [(p1tbl, k1) twice, p1tbl, p7] twice; rep from * to last 2 sts, p2.

Row 7: K2, *k5, k2tog, [k1tbl, p1] twice, k1tbl, yo, k7, yo, [k1tbl, p1] twice, k1tbl, k2tog; rep from * to last 2 sts, k2.

Row 8: P2, *p1, [p1tbl, k1] twice, p1tbl, p9, [p1tbl, k1] twice, p1tbl, p6; rep from * to last 2 sts, p2.

Row 9: K2, *k4, k2tog, [k1tbl, p1] twice, k1tbl, yo, k15; rep from * to last 2 sts, k2.

Row 10: P2, *p16, [p1tbl, k1] twice, p1tbl, p5; rep from * to last 2 sts, p2.

Row 11: K2, *k3, k2tog, [k1tbl, p1] twice, k1tbl, yo, k1, yo, [k1tbl, p1] twice, k1tbl, k2tog, k8; rep from * to last 2 sts, k2.

Row 12: P2, *p9, [p1tbl, k1] twice, p1tbl, p3, [p1tbl, k1] twice, p1tbl, p4; rep from * to last 2 sts, p2.

Row 13: K2, *k2, k2tog, [k1tbl, p1] twice, k1tbl, yo, k3, yo, [k1tbl, p1] twice, k1tbl, k2tog, k7; rep from * to last 2 sts, k2.

Row 14: P2, *p8, [p1tbl, k1] twice, p1tbl, p5, [p1tbl, k1] twice, p1tbl, p3; rep from * to last 2 sts, p2.

Row 15: K2, *k1, k2tog, [k1tbl, p1] twice, k1tbl, yo, k5, yo, [k1tbl, p1] twice, k1tbl, k2tog, k6; rep from * to last 2 sts, k2.

Row 16: P2, *[p7, (p1tbl, k1) twice, p1tbl] twice, p2; rep from * to last 2 sts, p2.

Row 17: K2, *k2tog, [k1tbl, p1] twice, k1tbl, yo, k7, yo, [k1tbl, p1] twice, k1tbl, k2tog, k5; rep from * to last 2 sts, k2.

Row 18: P2, *p6, [p1tbl, k1] twice, p1tbl, p9, [p1tbl, k1] twice, p1tbl, p1; rep from * to last 2 sts, p2.

Row 19: K2, *k15, yo, [k1tbl, p1] twice, k1tbl, k2tog, k4; rep from * to last 2 sts, k2.

Row 20: P2, *p5, [p1tbl, k1] twice, p1tbl, p16; rep from * to last 2 sts, p2.

Repeat: Rows 1–20

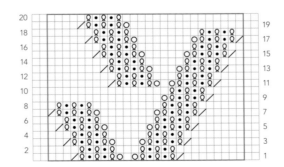

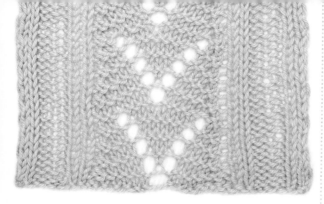

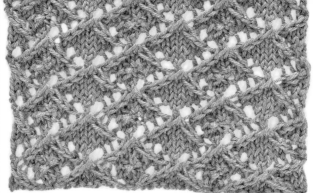

64 Garter Fan

This delicate lacy fan would make an interesting panel, an all-over fabric, or perhaps an interesting edging or hem. It would be straightforward to isolate the central lace panel and add a different border, or even place the panels together to create a more lacy fabric. For lighter yarns, a mohair or angora blend would be very attractive without distracting from the pattern.

Yarn: Laceweight to worsted

Multiple: 20 sts + 9

Row 1 (RS): K1, *k2, p3, k8, yo, k5, skp; rep from * to last 8 sts, k2, p3, k3.

Row 2 and all WS rows: P3, k3, p2, *k13, p2, k3, p2; rep from * to last st, p1.

Row 3: K1, *k2, p3, k2, k2tog, k4, yo, k1, yo, k4, skp; rep from * to last 8 sts, k2, p3, k3.

Row 5: K1, *k2, p3, k2, k2tog, [k3, yo] twice, k3, skp; rep from * to last 8 sts, k2, p3, k3.

Row 7: K1, *k2, p3, k2, k2tog, k2, yo, k5, yo, k2, skp; rep from * to last 8 sts, k2, p3, k3.

Row 9: K1, *k2, p3, k2, k2tog, k1, yo, k7, yo, k1, skp; rep from * to last 8 sts, k2, p3, k3.

Row 10: Repeat Row 2.

Repeat: Rows 1–10

Abbreviation

Skp: Slip 1 as if to knit, k1, pass slipped st over.

65 Lace Diamonds

This lace pattern produces an attractive, stable fabric suitable as an all-over pattern or as an interesting edging band or trim. The rows of knit stitches that arch to a point are a nice counter for the Estonian gathered stitches in the center and give the pattern balance.

Yarn: Light fingering to worsted

Multiple: 10 sts + 6

Row 1 (RS): K1, *yo, ssk, k5, k2tog, yo, k1; rep from * to last 5 sts, yo, ssk, k3.

Row 2: P2, p2togtbl, yo, *p3, yo, p2tog, p3, p2togtbl, yo; rep from * to last 2 sts, p2.

Row 3: K3, *yo, ssk, k1, k2tog, yo, k5; rep from * to last 3 sts, yo, ssk, k1.

Row 4: P2togtbl, yo, *p2, 3-3, p2, yo, p3tog, yo; rep from * to last 4 sts, p4.

Row 5: K3, k2tog, *yo, k1, yo, ssk, k5, k2tog; rep from * to last st, yo, k1.

Row 6: P2, yo, *p2tog, p3, p2togtbl, yo, p3, yo; rep from * to last 4 sts, p2tog, p2.

Row 7: K1, k2tog, *yo, k5, yo, ssk, k1, k2tog; rep from * to last 3 sts, yo, k3.

Row 8: P4, yo, *p3tog, yo, p7, yo; rep from * to last 2 sts, p2tog.

Repeat: Rows 1–8

Abbreviations

Ssk: Slip, slip, knit. Slip 2 sts one at a time as if to knit, knit 2 slipped sts together.

3-3: 3 into 3 gathered. K3tog, slip st back onto LH needle, [k1tbl, k1, k1tbl] in this st.

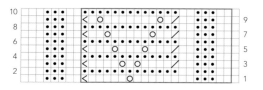

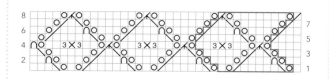

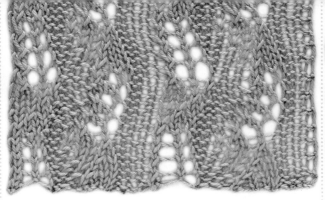

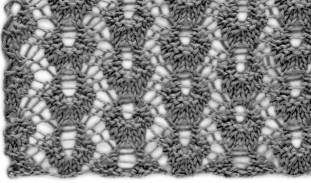

66 Traveling Leaves

Delicately swooping pairs of lacy eyelets make this a very attractive all-over pattern. Unlike some other traveling stitch patterns, this one has straight sides and flat lower and upper edges which makes it handy when you want a stitch with movement but don't want a scalloped edge.

Yarn: Light fingering to bulky

Multiple: 14 sts + 2

Row 1 (RS): K1, *p3, k3, k2tog, p3, yo, k1, yo, k2tog; rep from * to last st, k1.

Row 2 and all WS rows: P1, *p4, k3; rep from * to last st, p1.

Row 3: K1, *p3, k2, k2tog, k1, p3, yo, k1, yo, k2tog; rep from * to last st, k1.

Row 5: K1, *p3, k1, k2tog, k2, p3, yo, k1, yo, k2tog; rep from * to last st, k1.

Row 7: K1, *p3, k2tog, k3, p3, yo, k1, yo, k2tog; rep from * to last st, k1.

Row 9: K1, *p3, yo, k1, yo, k2tog, p3, k3, k2tog; rep from * to last st, k1.

Row 11: K1, *p3, yo, k1, yo, k2tog, p3, k2, k2tog, k1; rep from * to last st, k1.

Row 13: K1, *p3, yo, k1, yo, k2tog, p3, k1, k2tog, k2; rep from * to last st, k1.

Row 15: K1, *p3, yo, k1, yo, k2tog, p3, k2tog, k3; rep from * to last st, k1.

Row 16: Repeat Row 2.

Repeat: Rows 1–16

67 Scallop Lace Puff

The scallops in this pattern can be worked as single units, in a panel, or as an all-over pattern. The pattern is quite bulky so will work better in slightly lighter yarns but could be used on heavier yarns by going a couple of needle sizes larger than recommended for the yarn to open out the texture.

Yarn: Laceweight to worsted

Multiple: 12 sts + 2

Row 1 (RS): K1, *ssk, k3, yo, p2, yo, k3, k2tog; rep from * to last st, k1.

Row 2: K1, *k2tog, p2, yo, k4, yo, p2, ssk; rep from * to last st, k1.

Row 3: K1, *ssk, k1, yo, p6, yo, k1, k2tog; rep from * to last st, k1.

Row 4: P1, *k2tog, yo, k8, yo, ssk; rep from * to last st, p1.

Row 5: K1, *p1, yo, k3, k2tog, ssk, k3, yo, p1; rep from * to last st, k1.

Row 6: K1, *k2, yo, p2, ssk, k2tog, p2, yo, k2; rep from * to last st, k1.

Row 7: K1, *p3, yo, k1, k2tog, ssk, k1, yo, p3; rep from * to last st, k1.

Row 8: K1, *k4, yo, ssk, k2tog, yo, k4; rep from * to last st, k1.

Repeat: Rows 1–8

Abbreviation

Ssk: Slip, slip, knit. Slip 2 sts one at a time as if to knit, knit 2 slipped sts together.

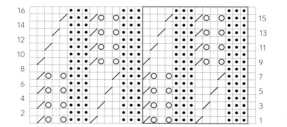

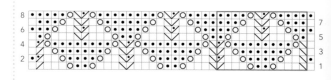

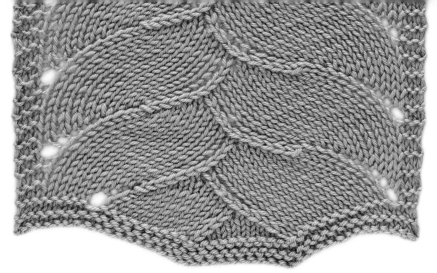

68 Undulating Waves

Carefully placed combinations of eyelets, increases, and decreases make this delightful pattern that has so much movement, yet is very stable and balanced. Work as a panel or combine a series of repeats for a beautiful all-over fabric.

Yarn: Sport to bulky

Multiple: 37 sts + 6

Row 1 (RS): Knit.

Rows 2–4: Knit.

Row 5: K3, *yo, k10, skp, k9, k2tog, k9, yo, k5; rep from * to last 3 sts, k3.

Row 6: K2, p1, *p6, yo, p9, p2tog, p7, p2togtbl, p10, yo, p1; rep from * to last 3 sts, p1, k2.

Row 7: K3, *k2, yo, k10, skp, k5, k2tog, k9, yo, k7; rep from * to last 3 sts, k3.

Row 8: K2, p1, *p8, yo, p9, p2tog, p3, p2togtbl, p10, yo, p3; rep from * to last 3 sts, p1, k2.

Row 9: K3, *k4, yo, k10, skp, k1, k2tog, k9, yo, k9; rep from * to last 3 sts, k3.

Row 10: K2, p1, *yo, p9, p2tog, p9, p2togtbl, p10, yo, p5; rep from * to last 3 sts, p1, k2.

Row 11: K3, *k6, yo, k10, skp, k7, k2tog, k9, yo, k1; rep from * to last 3 sts, k3.

Row 12: K2, p1, *p2, yo, p9, p2tog, p5, p2togtbl, p10, yo, p7; rep from * to last 3 sts, p1, k2.

Row 13: K3, *k8, yo, k10, skp, k3, k2tog, k9, yo, k3; rep from * to last 3 sts, k3.

Row 14: K2, p1, *p4, yo, p9, p2tog, p1, p2togtbl, p10, yo, p9; rep from * to last 3 sts, p1, k2.

Repeat: Rows 5–14

Abbreviation

Skp: Slip 1 as if to knit, k1, pass slipped st over.

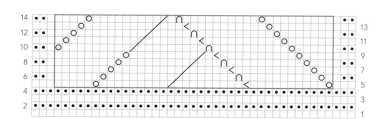

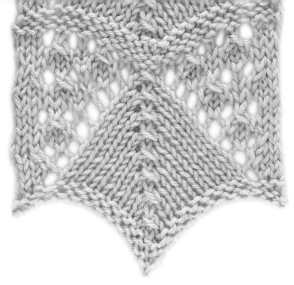

69 Madeira Lace

Striking and dramatic are the best descriptions for this stitch pattern. The strong points make it ideal for an edging or trim and it will look fantastic in any smooth yarn.

Yarn: Light fingering to bulky

Multiple: 25 sts

Row 1 (RS): Purl.

Row 2: Knit.

Row 3: *K3, yo, k8, sk2p, k8, yo, k3; rep from * to end.

Row 4 and all following WS rows: Purl.

Row 5: *K4, yo, k7, sk2p, k7, yo, k4; rep from * to end.

Row 7: *K2, k2tog, yo, k1, yo, k6, sk2p, k6, yo, k1, yo, ssk, k2; rep from * to end.

Row 9: *K6, yo, k5, sk2p, k5, yo, k6; rep from * to end.

Row 11: *K3, yo, sk2p, yo, k1, yo, k4, sk2p, k4, yo, k1, yo, sk2p, yo, k3; rep from * to end.

Row 13: *K8, yo, k3, sk2p, k3, yo, k8; rep from * to end.

Row 15: *K2, k2tog, yo, k1, yo, sk2p, yo, k1, yo, k2, sk2p, k2, [yo, k1] twice, yo, sk2p, yo, ssk, k2; rep from * to end.

Row 17: *K10, yo, k1, sk2p, k1, yo, k10; rep from * to end.

Row 19: *K3, [yo, sk2p, yo, k1] four times, yo, sk2p, yo, k3; rep from * to end.

Row 20: Knit.

Repeat: Rows 1–20

Abbreviations

Sk2p: Slip 1 as if to knit, k2tog, pass slipped st over.

Ssk: Slip, slip, knit. Slip 2 sts one at a time as if to knit, knit 2 slipped sts together.

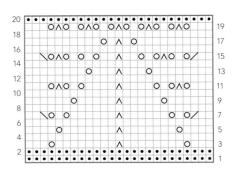

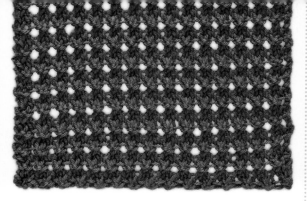

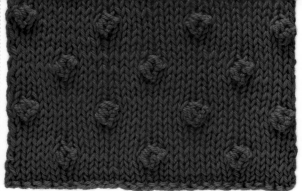

70 Petite Bobbles

Strictly not a traditional bobble technique, this stitch produces an effect like delicate little bobbles contained in an open, symmetrical mesh. It is open and soft, so is suitable for projects where drape is required, when worked in the standard range of needle sizes for the yarn.

Yarn: Cobweb to bulky

Multiple: 2 sts + 2

Repeat: Rows 1–4

Row 1 (RS): K1, *k2tog; rep from * to last st, k1.

Row 2: K1, *[k1, m1]; rep from * to last st, k1.

Row 3: Knit.

Row 4: Purl.

Abbreviation

M1: Make 1. Increase by 1 st by knitting into the front of the strand between the st just worked and the next st.

71 Bobbles

A classic bobble arranged in a symmetrical format for a balanced fabric that isn't distorted by the additional bulk of the bobbles. A single-height repeat would make a lovely border, and the structure of the fabric can be varied by changing the spacing between the bobbles.

Yarn: Fingering to bulky

Multiple: 8 sts + 5

Row 1 (RS): Knit.

Row 2: Purl.

Rows 3 & 4: Repeat Rows 1 & 2.

Row 5: *K6, mb, k1; rep from * to last 5 sts, k5.

Row 6: Purl.

Row 7: Knit.

Rows 8 & 9: Repeat Rows 6 & 7.

Row 10: Purl.

Row 11: *K2, mb, k5; rep from * to last 5 sts, k2, mb, k2.

Row 12: Purl.

Repeat: Rows 1–12

Abbreviation

Mb: Make bobble. [K1, yo, k1] in next st, turn; p1, p1tbl, k1, turn; [k1f&b] three times, pass 5 sts one at a time over first st.

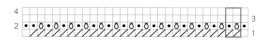

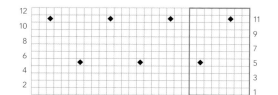

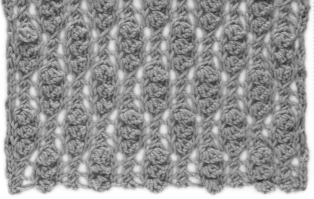

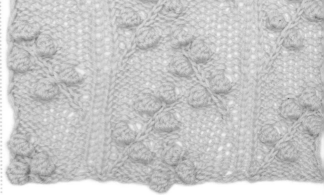

72 Harebell

Clustered trios of bobbles in an offset pattern make this a surprisingly open and delicate fabric, uncharacteristic of many bobble stitches. This stitch has body and texture but is not stiff, making it suitable for a wide range of yarns.

Yarn: Cobweb to worsted

Multiple: 6 sts + 7

Row 1 (RS): K2, *yo, p3tog, yo, k1, mb, k1; rep from * to last 5 sts, yo, p3tog, yo, k2.

Row 2 and all WS rows: Purl.

Row 3: Repeat Row 1.

Row 5: Repeat Row 1.

Row 7: K2tog, yo, *k1, mb, k1, yo, p3tog, yo; rep from * to last 5 sts, k1, mb, k1, yo, k2tog.

Row 9: Repeat Row 7.

Row 11: Repeat Row 7.
Row 12: Purl.

Repeat: Rows 1–12

Abbreviation

Mb: Make bobble. [K1, yo, k1] in next st, turn; p1, p1tbl, k1, turn; [k1f&b] three times, pass 5 sts one at a time over first st.

73 Buds

Sprigs of flower buds spring from their stockinette stitch stems on a background of reverse stockinette stitch. This stitch could be worked as an attractive border or as an all-over pattern. It would also make a nice edging down either side of a jacket front or down a sleeve.

Yarn: Fingering to bulky

Multiple: 14 sts + 4

Row 1 (RS): P2, *p5, k3, p3, 1/1 LPC, mb; rep from * to last 2 sts, p2.

Row 2: K2, *k1, p1, k4, p3, k5; rep from * to last 2 sts, k2.

Row 3: P2, *p4, 1/1 RPC, k2, p3, mb, 1/1 LPC; rep from * to last 2 sts, p2.

Row 4: K2, *p1, k5, p2, k1, p1, k4; rep from * to last 2 sts, k2.

Row 5: P2, *p2, mb, 1/1 RPC, p1, k2, p5, mb; rep from * to last 2 sts, p2.

Row 6: K2, *k6, p2, k2, p1, k3; rep from * to last 2 sts, k2.

Row 7: P2, *p2, 1/1 RPC, mb, p1, k2, p6; rep from * to last 2 sts, p2.

Row 8: K2, *k6, p2, k3, p1, k2; rep from * to last 2 sts, k2.

Row 9: P2, *mb, 1/1 RPC, p3, k3, p5; rep from * to last 2 sts, p2.

Row 10: K2, *k5, p3, k4, p1, k1; rep from * to last 2 sts, k2.

Row 11: P2, *1/1 RPC, mb, p3, k2, 1/1 LPC, p4; rep from * to last 2 sts, p2.

Row 12: K2, *k4, p1, k1, p2, k5, p1; rep from * to last 2 sts, k2.

Row 13: P2, *mb, p5, k2, p1, 1/1 LPC, mb, p2; rep from * to last 2 sts, p2.

Row 14: K2, *k3, p1, k2, p2, k6; rep from * to last 2 sts, k2.

Row 15: P2, *p6, k2, p1, mb, 1/1 LPC, p2; rep from * to last 2 sts, p2.

Row 16: K2, *k2, p1, k3, p2, k6; rep from * to last 2 sts, k2.

Repeat: Rows 1–16

Abbreviations

Mb: Make bobble. [(K1, p1) twice, k1] in next st, turn; p5, turn; pass 4 sts one at a time over first st, k1tbl.

1/1 LPC: 2-stitch left purl cable. Slip 1 st to cable needle and hold in front, p1, k1 from cable needle.

1/1 RPC: 2-stitch right purl cable. Slip 1 st to cable needle and hold in back, k1, p1 from cable needle.

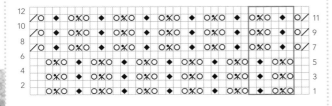

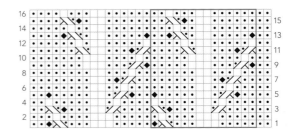

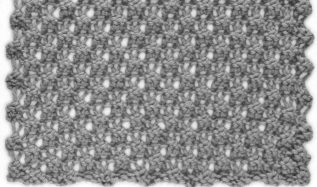

74 Trinity Stitch

A pretty, open mesh stitch with an interesting texture. Highly textured stitches are not always suitable for very fine yarns and lightweight fabrics, but this stitch is delicate enough for an all-over fabric even in fine yarns. For an even softer fabric, work on larger needles than normal for the yarn.

Yarn: Cobweb to worsted

Multiple: 4 sts

Repeat: Rows 1–4

Row 1 (RS): Purl.

Row 2: *Inc1to3, p3tog; rep from * to end.

Row 3: Purl.

Row 4: *P3tog, inc1to3; rep from * to end.

Abbreviation

Inc1to3: Make 3 sts from 1. [K1, p1, k1] in next st.

75 Ridged Trinity Stitch

This variant of trinity stitch creates interesting pattern blocks, divided by a purled stripe. Using knit and purl increases and decreases creates a firm fabric with lots of texture. For a softer fabric, this stitch can be worked on larger needles, and can be worked in a wide range of yarn weights.

Yarn: Cobweb to worsted

Multiple: 4 sts + 2

Repeat: Rows 1–4

Row 1 (RS): Purl.

Row 2: P1, *p3tog, Inc1to3; rep from * to last st, p1.

Row 3: K1, *k3togtbl, Inc1to3; rep from * to last st, k1.

Row 4: Purl.

Abbreviation

Inc1to3: Make 3 sts from 1. [K1, p1, k1] in next st.

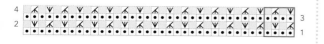

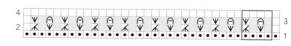

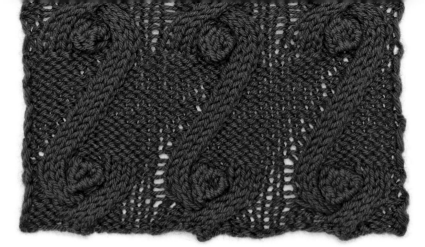

76 Twining Bobbles

This dramatic combination of interlocking cables studded with bold bobbles would make a stunning edging. It would also make an impression as part of a larger panel. To make the most of the strong cable lines, a smooth yarn with good stitch definition would be ideal.

Yarn: Fingering to bulky

Multiple: 13 sts + 2

Row 1 (WS): K1, *k3, p3, k1, p3, k3; rep from * to last st, k1.

Row 2: P1, *p3, 3/1/3 RPC, p3; rep from * to last st, p1.

Row 3: Repeat Row 1.

Row 4: P1, *p1, 3/2 RPC, p1, 3/2 LPC, p1; rep from * to last st, p1.

Row 5: K1, *k1, p3, k5, p3, k1; rep from * to last st, k1.

Row 6: P1, *p1, k3, p2, mb, p2, k3, p1; rep from * to last st, p1.

Row 7: Repeat Row 5.

Row 8: P1, *p8, 3/1 RPC, p1; rep from * to last st, p1.

Row 9: K1, *k2, p3, k8; rep from * to last st, k1.

Row 10: P1, *p7, 3/1 RPC, p2; rep from * to last st, p1.

Row 11: K1, *k3, p3, k7; rep from * to last st, k1.

Row 12: P1, *p6, 3/1 RPC, p3; rep from * to last st, p1.

Row 13: K1, *k4, p3, k6; rep from * to last st, k1.

Row 14: P1, *p5, 3/1 RPC, p4; rep from * to last st, p1.

Row 15: K1, *k5, p3, k5; rep from * to last st, k1.

Row 16: P1, *p4, 3/1 RPC, p5; rep from * to last st, p1.

Row 17: K1, *k6, p3, k4; rep from * to last st, k1.

Row 18: P1, *p3, 3/1 RPC, p6; rep from * to last st, p1.

Row 19: K1, *k7, p3, k3; rep from * to last st, k1.

Row 20: P1, *p2, 3/1 RPC, p7; rep from * to last st, p1.

Row 21: K1, *k1, p3, k4, p3, k2; rep from * to last st, k1.

Row 22: P1, *p1, 3/1 RPC, p4, k3, p1; rep from * to last st, p1.

Row 23: K1, *k1, p3, k5, p3, k1; rep from * to last st, k1.

Row 24: P1, *p1, k3, p2, mb, p2, k3, p1; rep from * to last st, p1.

Row 25: K1, *k1, p3, k5, p3, k1; rep from * to last st, k1.

Row 26: P1, *p1, 3/2 LPC, p1, 3/2 RPC, p1; rep from * to last st, p1.

Repeat: Rows 1–26

Abbreviations

3/1/3 RPC: 7-stitch right purl cable. Slip 4 sts to cable needle and hold in back, k3, slip last st on cable needle onto LH needle, p1, k3 from cable needle.

3/2 RPC: 5-stitch right purl cable. Slip 2 sts to cable needle and hold in back, k3, p2 from cable needle.

3/2 LPC: 5-stitch left purl cable. Slip 3 sts to cable needle and hold in front, p2, k3 from cable needle.

Mb: Make bobble. [(K1, p1) twice, k1] in next st, turn; p5, turn; k5, turn; p5, turn; pass 4 sts one at a time over first st, k1tbl.

3/1 RPC: 4-stitch right purl cable. Slip 1 st to cable needle and hold in back, k3, p1 from cable needle.

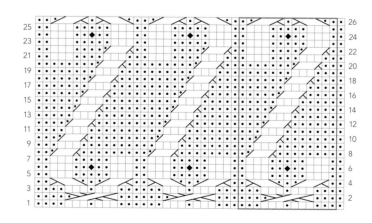

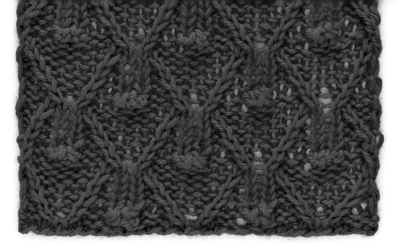

77 Diamond Bobble

Bold bobbles are set into a trellis of fine cables. This stitch would make an excellent all-over pattern and could be worked in a wide range of yarns. Smooth yarns will give maximum impact, but a softer yarn with a halo (angora or mohair, for example) would produce a more subtle effect.

Yarn: Fingering to bulky

Multiple: 10 sts + 10

Row 1 (WS): *K3, p4, k3; rep from * to last 10 sts, k3, p4, k3.

Row 2: K1, p2, 1/1 RPC, 1/1 LPC, p2, *mb, p2, 1/1 RPC, 1/1 LPC, p2; rep from * to last st, k1.

Row 3: *[P1, k2] three times, p1; rep from * to last 10 sts, [p1, k2] three times, p1.

Row 4: K1, p1, 1/1 RPC, p2, 1/1 LPC, p1, k1, *k1, p1, 1/1 RPC, p2, 1/1 LPC, p1, k1; rep from * to end.

Row 5: *P1, k1, p1, k4, p1, k1, p1; rep from * to last 10 sts, p1, k1, p1, k4, p1, k1, p1.

Row 6: K1, 1/1 RPC, p4, 1/1 LPC, k1, *k1, 1/1 RPC, p4, 1/1 LPC, k1; rep from * to end.

Row 7: *P2, k6, p2; rep from * to last 10 sts, p2, k6, p2.

Row 8: 1/1 LPC, p2, mb, p2, 1/1 RPC, *1/1 LPC, p2, mb, p2, 1/1 RPC; rep from * to end.

Row 9: *K1, p1, k2, p2, k2, p1, k1; rep from * to last 10 sts, k1, p1, k2, p2, k2, p1, k1.

Row 10: P1, 1/1 LPC, p1, k2, p1, 1/1 RPC, p1, *p1, 1/1 LPC, p1, k2, p1, 1/1 RPC, p1; rep from * to end.

Row 11: *K2, p1, k1, p2, k1, p1, k2; rep from * to last 10 sts, k2, p1, k1, p2, k1, p1, k2.

Row 12: P2, 1/1 LPC, k2, 1/1 RPC, p2, *p2, 1/1 LPC, k2, 1/1 RPC, p2; rep from * to end.

Repeat: Rows 1–12

Abbreviations

1/1 RPC: 2-stitch right purl cable. Slip 1 st to cable needle and hold in back, k1, p1 from cable needle.

1/1 LPC: 2-stitch left purl cable. Slip 1 st to cable needle and hold in front, p1, k1 from cable needle.

Mb: Make bobble. [K2, turn; p2, turn] twice, insert LH needle in top of st in first row of bobble, knit together this loop with next st twice.

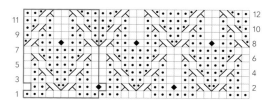

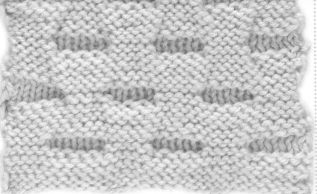

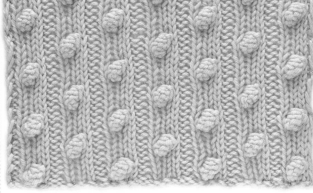

78 Honeycomb

Unlike a classic honeycomb, this pattern has a squared structure and the reverse side of the stockinette stitch is the right side, for added texture. Slipped stitches are worked on the knit (wrong) side. Try to keep these evenly tensioned for a nicely balanced fabric. The pattern works well as an all-over pattern in a wide range of yarns.

Yarn: Fingering to bulky

Multiple: 10 sts + 2

Row 1 (WS): P1, knit to last st, p1.

Row 2: K1, purl to last st, k1.

Rows 3 & 4: Repeat Rows 1 & 2.

Row 5: Repeat Row 1.

Row 6: K1, *k5, [sl1 wyib] five times; rep from * to last st, k1.

Row 7: P1, *[sl1 wyif] five times, p5; rep from * to last st, p1.

Rows 8 & 9: Repeat Rows 6 & 7.

Row 10: Repeat Row 6.

Rows 11–15: Repeat Rows 1–5.

Row 16: K1, *[sl1 wyib] five times, k5; rep from * to last st, k1.

Row 17: P1, *p5, [sl1 wyif] five times; rep from * to last st, p1.

Rows 18 & 19: Repeat Rows 16 & 17.

Row 20: Repeat Row 16.

Repeat: Rows 1–20

79 Bobble Rib

This classic 2 × 3 rib is given extra interest with carefully placed bobbles. It would make an exciting alternative to a standard rib for a cuff or trim, and can be worked in a wide range of yarns. Smooth yarns with good stitch definition will show off the stitch to its best.

Yarn: Fingering to bulky

Multiple: 10 sts + 7

Row 1 (RS): K1, p1, *[k3, p2] twice; rep from * to last 5 sts, k3, p1, k1.

Row 2: *K2, p3; rep from * to last 2 sts, k2.

Row 3: K1, p1, *k1, mb, k1, p2, k3, p2; rep from * to last 5 sts, k1, mb, k1, p1, k1.

Row 4: Repeat Row 2.

Row 5: Repeat Row 1.

Row 6: Repeat Row 2.

Row 7: K1, p1, *k3, p2, k1, mb, k1, p2; rep from * to last 5 sts, k3, p1, k1.

Row 8: Repeat Row 2.

Repeat: Rows 1–8

Abbreviation

Mb: Make bobble. [(K1, yo) twice, k1] in next st, turn; k5, turn; p5, pass 4 sts one at a time over first st.

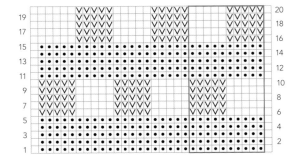

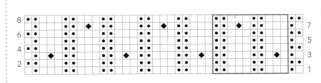

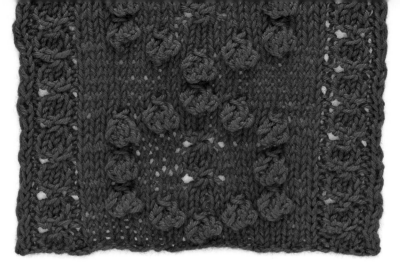

80 Nupp and Twist Bobble

Bold and sassy, bobbles always make a statement and are a fun way to "draw" on a knitted fabric. The added bands of nupps balance the pattern, making it more stylish and less kitsch. There is lots of scope to play with this pattern, taking elements as a motif or varying the bands.

Yarn: Fingering to worsted

Multiple: 24 sts + 9

Row 1 (RS): K2, *p1, k3, p1, k19; rep from * to last 7 sts, p1, k3, p1, k2.

Row 2 and all WS rows: P2, k1, p3, k1, *p19, k1, p3, k1; rep from * to last 2 sts, p2.

Row 3: K2, *p1, 3-3, p1, k9, mb, k9; rep from * to last 7 sts, p1, 3-3, p1, k2.

Row 5: K2, *p1, k3, p1, k6, mb, k5, mb, k6; rep from * to last 7 sts, p1, k3, p1, k2.

Row 7: K2, *p1, 3-3, p1, k3, mb, k11, mb, k3; rep from * to last 7 sts, p1, 3-3, p1, k2.

Row 9: K2, *p1, k3, p1, k8, 3-3, k8; rep from * to last 7 sts, p1, k3, p1, k2.

Row 11: Repeat Row 7.

Row 13: Repeat Row 9.

Row 15: Repeat Row 7.

Row 17: Repeat Row 5.

Row 19: Repeat Row 3.

Row 21: Repeat Row 1.

Repeat: Rows 2–21. End with rows 1–2.

Abbreviations

3-3: 3 into 3 gathered. K3tog, slip st back onto LH needle, [k1tbl, k1, k1tbl] in this st.

Mb: Make bobble. [(K1, yo) twice, k1] in next st, turn; p5, turn; k5, turn; p2tog, p1, p2tog, turn; slip 1, k2tog, pass slipped st over.

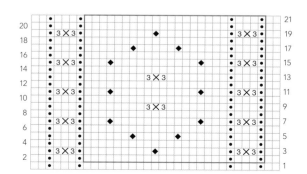

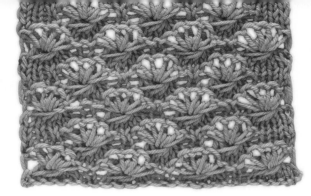

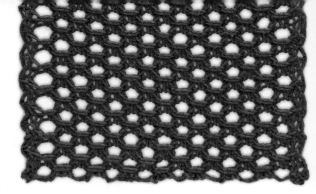

81 Oyster Stitch

A fascinating stitch created by taking long, wrapped stitches and combining them with a series of increases and decreases. Once the basic oyster has been mastered, it can be readily dropped into other patterns in single units, randomly placed over a fabric, or perhaps vertically aligned for a striking panel. For a flatter lower edge, work several rows of garter or stockinette stitch before the first oyster.

Yarn: Laceweight to worsted

Multiple: 6 sts + 7

Row 1 (RS): Knit.

Row 2: *P1, [w2p] five times; rep from * to last st, p1.

Row 3: K1, *[os5] five times, k1; rep from * to end.

Row 4: *K1, [k1, dropping extra wrap] five times; rep from * to last st, k1.

Row 5: Knit.

Row 6: P3, *p1, [w2p] five times; rep from * to last 4 sts, p4.

Row 7: K4, *[os5] five times, k1; rep from * to last 3 sts, k3.

Row 8: P3, *p1, [k1, dropping extra wrap] five times; rep from * to last 4 sts, p4.

Repeat: Rows 1–8

Abbreviations

W2p: Wrap 2 purl. Purl next st, wrapping yarn twice around needle.

Os5: Oyster over 5. Slip 5 sts to RH needle dropping extra wraps, slip them back to LH needle, [(k1, p1) twice, k1] into all 5 sts together, wrapping yarn twice around needle for each st.

82 Clustered Star

The wrapped clusters in this lacy fabric give it additional texture but also stability, reducing biasing and providing structure. It is well-suited to an all-over fabric and could be worked in a wide range of yarns.

Yarn: Light fingering to bulky

Multiple: 4 sts + 6

Row 1 (RS): K1, *k2tog, [yo] twice, k2togtbl; rep from * to last 5 sts, k2tog, [yo] twice, k2togtbl, k1.

Row 2: CL2, *p1, p1tbl, CL2; rep from * to last 4 sts, p1, p1tbl, p2.

Row 3: K3, *k2tog, [yo] twice, k2togtbl; rep from * to last 3 sts, k3.

Row 4: P2, *CL2, p1, p1tbl; rep from * to last 4 sts, CL2, p2.

Repeat: Rows 1–4

Abbreviation

CL2: Cluster 2 stitches, twice wrapped. Slip 2 sts wyib, bring yarn to front between needles, slip same 2 sts back to LH needle, pass yarn to back between needles, slip same 2 sts wyib again, bring yarn to front between needles, slip same 2 sts back to LH needle, k2 slipped sts.

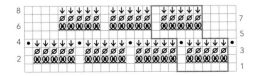

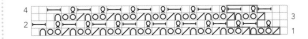

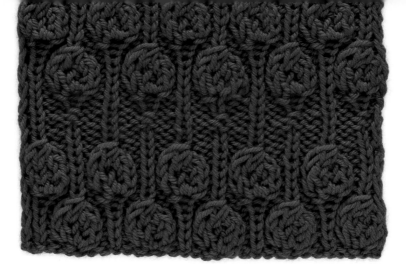

83 Puff Stitch

It may look like there are lots of complex stitches in this pattern but in fact they are straightforward repeats. To make it easier to visualize the puff motifs (and so you can put single motifs into other projects), they are shown in a separate chart. Simply insert the relevant row of the motif chart where the number appears in the main chart. There's lots of fun to be had with these motifs!

Yarn: Laceweight to bulky

Multiple: 6 sts + 2

Row 1 (RS): P1, *p1, mir1, p2, k1, p1; rep from * to last st, p1.

Row 2: K1, *k1, p1, k2, mir2, k1; rep from * to last st, k1.

Row 3: P1, *p1, mir3, p2, k1, p1; rep from * to last st, p1.

Row 4: K1, *k1, p1, k2, mir4, k1; rep from * to last st, k1.

Row 5: P1, *p1, mir5, p2, k1, p1; rep from * to last st, p1.

Row 6: K1, *k1, p1, k2, mir6, k1; rep from * to last st, k1.

Row 7: P1, *p1, k1, p2, mir1, p1; rep from * to last st, p1.

Row 8: K1, *k1, mir2, k2, p1, k1; rep from * to last st, k1.

Row 9: P1, *p1, k1, p2, mir3, p1; rep from * to last st, p1.

Row 10: K1, *k1, mir4, k2, p1, k1; rep from * to last st, k1.

Row 11: P1, *p1, k1, p2, mir5, p1; rep from * to last st, p1.

Row 12: K1, *k1, mir6, k2, p1, k1; rep from * to last st, k1.

Repeat: Rows 1–12

Puff motif: Insert when instructed by main chart.

Row 1 (RS): Inc1to4.

Row 2: [P1, yo] three times, p1.

Row 3: [K1, drop yo] three times, k1.

Row 4: [P1, yo] three times, p1.

Row 5: [K1, drop yo] three times, k1.

Row 6: P2, p4tog, p1.

Abbreviations

Mir1–mir6: Motif insert rows 1–6. Work the relevant row (1–6) from the motif chart below right.

Inc1to4: Make 4 sts from 1. [K1, p1, k1, p1] in next st.

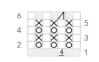

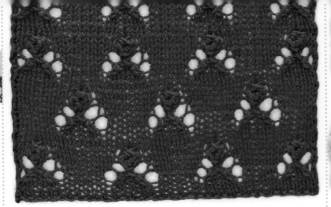

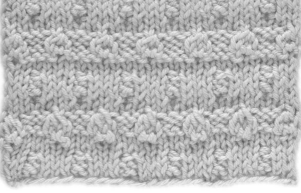

84 Lace Puffs

Set against a smooth stockinette stitch background, lacy chevrons are topped with delicate little bobbles. A smooth yarn would be a good choice for this stitch, but a halo yarn such as angora or mohair could also be used for a more delicate effect.

85 Hazelnut Stripes

Although the chart for this pattern may look complex, there are several "rest" rows (plain rows with no special techniques). Note that the stitch count varies throughout the repeat. The effort is worthwhile, as this is a very pretty pattern.

Yarn: Cobweb to bulky

Multiple: 10 sts + 7

Row 1 (RS): Knit.

Row 2 and all WS rows: Purl.

Row 3: Knit.

Row 5: K1, *yo, skp, k1, k2tog, yo, k5; rep from * to last 6 sts, yo, skp, k1, k2tog, yo, k1.

Row 7: K1, *k1, yo, sk2p, yo, k6; rep from * to last 6 sts, k1, yo, sk2p, yo, k2.

Row 9: K1, *k2, mb, k7; rep from * to last 6 sts, k2, mb, k3.

Rows 11 & 13: Knit.

Row 15: K1, *k5, yo, skp, k1, k2tog, yo; rep from * to last 6 sts, k6.

Row 17: K1, *k6, yo, sk2p, yo, k1; rep from * to last 6 sts, k6.

Row 19: K1, *k7, mb, k2; rep from * to last 6 sts, k6.

Row 20: Purl.

Repeat: Rows 1–20

Abbreviations

Skp: Slip 1 as if to knit, k1, pass slipped st over.

Sk2p: Slip 1 as if to knit, k2tog, pass slipped st over.

Mb: Make bobble. [(K1, yo) twice, k1] in next st, turn; p5, turn; k3, k2tog, pass 3 sts one at a time over k2tog.

Yarn: Laceweight to bulky

Multiple: 4 sts + 3

Row 1 (RS): *P3, m3; rep from * to last 3 sts, p3.

Row 2: K3, *p3, k3; rep from * to end.

Row 3: *P3, k3; rep from * to last 3 sts, p3.

Row 4: K3, *p3tog, k3; rep from * to end.

Row 5: Purl.

Row 6: Knit.

Row 7: *K1, m3p, k2; rep from * to last 3 sts, k1, m3p, k1.

Row 8: P1, k3, p1, *p2, k3, p1; rep from * to end.

Row 9: *K1, p3, k2; rep from * to last 5 sts, k1, p3, k1.

Row 10: P1, p3tog, p1, *p2, p3tog, p1; rep from * to end.

Row 11: Purl.

Row 12: Knit.

Repeat: Rows 1–12

Abbreviations

M3: Make 3 from 1 (increasing 2 sts). [K1, yo, k1] in next st.

M3p: Make 3 from 1 purlwise (increasing 2 sts). [P1, yo, p1] in next st.

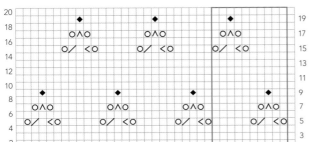

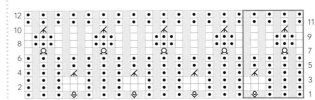

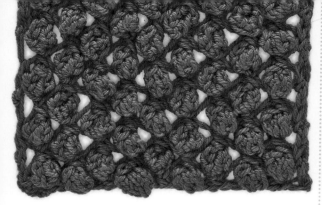

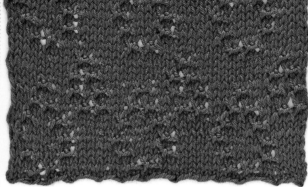

86 Lace Bobble Mesh

This very densely textured fabric would make a great edging or trim. If you have a lot of patience, it would be great as an all-over pattern for a floor cushion or soft furnishings, as it is springy and resilient. If worked in a bulky yarn, you may need to go a couple of needle sizes larger than normal to accommodate the bobbles. For a softer fabric, work the bobbles with more stitches in between or dot them across a fabric.

Yarn: Fingering to bulky

Multiple: 4 sts + 7

Row 1 (WS): Purl.

Row 2: K2, *yo, sk2p, yo, mb; rep from * to last 5 sts, yo, sk2p, yo, k2.

Row 3: Purl.

Row 4: K1, k2tog, *yo, mb, yo, sk2p; rep from * to last 4 sts, yo, mb, yo, skp, k1.

Repeat: Rows 1–4

Abbreviations

Sk2p: Slip 1 as if to knit, k2tog, pass slipped st over.

Mb: Make bobble. [(K1, yo) twice, k1] in next st, turn; p5, turn; k5, turn; p2tog, p1, p2tog, turn; slip 1, k2tog, pass slipped st over.

Skp: Slip 1 as if to knit, k1, pass slipped st over.

87 Ringlet Stitch

Ringlet stitches make lovely, delicate textures and can be arranged in any number of shapes. Here, offset ringlet shapes create an interesting all-over pattern that would work in a wide range of yarns.

Yarn: Light fingering to bulky

Multiple: 12 sts + 2

Row 1 (RS) and all RS rows: Knit.

Row 2: *P3, [ringlet] twice, p5; rep from * to last 2 sts, p2.

Row 4: *P2, ringlet, p3, ringlet, p3; rep from * to last 2 sts, p2.

Row 6: *P1, ringlet, p4, ringlet, p3; rep from * to last 2 sts, p2.

Row 8: *P2, ringlet, p2, ringlet, p4; rep from * to last 2 sts, p2.

Row 10: P1, *p2, [ringlet] twice, p2, [ringlet] twice; rep from * to last st, p1.

Row 12: P1, *p3, ringlet, p2, ringlet, p1, ringlet; rep from * to last st, p1.

Row 14: P1, *p7, [ringlet] twice, p1; rep from * to last st, p1.

Row 16: P1, *p8, ringlet, p2; rep from * to last st, p1.

Repeat: Rows 1–16. End with Row 1.

Abbreviation

Ringlet: P2, keeping yarn in front slip 2 purled sts back to LH needle. Take yarn from front to back and slip 2 purled sts back to RH needle.

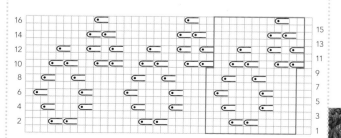

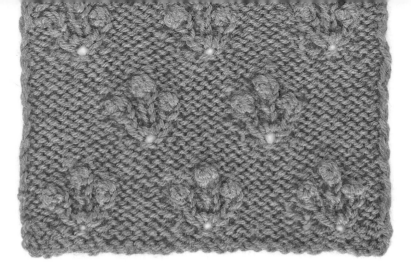

88 Spring Flowers

Dainty bobbles emerge from a reverse stockinette stitch background on delicate stockinette stitch stems like spring buds emerging from the frosty ground ready to burst into flower. This stitch will look particularly striking worked in a smooth yarn with good stitch definition.

Yarn: Sport to bulky

Multiple: 10 sts + 11

Row 1 (RS): Purl.

Row 2: Knit.

Row 3: P3, *p2tog, inc1to3, p2tog, p5; rep from * to last 8 sts, p2tog, inc1to3, p2tog, p3.

Row 4: K4, p3, k1, *k6, p3, k1; rep from * to last 3 sts, k3.

Row 5: P3, *1/1 RT, k1, 1/1 LT, p5; rep from * to last 8 sts, 1/1 RT, k1, 1/1 LT, p3.

Row 6: K3, [p1, k1] twice, p1, *k5, [p1, k1] twice, p1; rep from * to last 3 sts, k3.

Row 7: P3, *mb, p1, k1, p1, mb, p5; rep from * to last 8 sts, mb, p1, k1, p1, mb, p3.

Row 8: K3, k1tbl, k1, p1, k1, k1tbl, *k5, k1tbl, k1, p1, k1, k1tbl; rep from * to last 3 sts, k3.

Row 9: P3, *p2, mb, p7; rep from * to last 8 sts, p2, mb, p5.

Row 10: K5, k1tbl, k2, *k7, k1tbl, k2; rep from * to last 3 sts, k3.

Row 11: Purl.

Row 12: Knit.

Row 13: P3, *p5, p2tog, inc1to3, p2tog; rep from * to last 8 sts, p8.

Row 14: K8, *k1, p3, k6; rep from * to last 3 sts, k3.

Row 15: P3, *p5, 1/1 RT, k1, 1/1 LT; rep from * to last 8 sts, p8.

Row 16: K8, *[p1, k1] three times, k4; rep from * to last 3 sts, k3.

Row 17: P3, *p5, mb, p1, k1, p1, mb; rep from * to last 8 sts, p8.

Row 18: K8, *k1tbl, k1, p1, k1, k1tbl, k5; rep from * to last 3 sts, k3.

Row 19: P3, *p7, mb, p2; rep from * to last 8 sts, p8.

Row 20: K8, *k2, k1tbl, k7; rep from * to last 3 sts, k3.

Repeat: Rows 1–20

Abbreviations

Inc1to3: Make 3 sts from 1. [K1, p1, k1] in next st.

1/1 RT: 2-stitch right twist. Skip 1 st (leave on LH needle) and knit the second st in front loop, then knit the skipped st in front loop; slip both sts from needle together.

1/1 LT: 2-stitch left twist. Skip 1 st (leave on LH needle) and knit the second st in back loop, then knit the skipped st in front loop; slip both sts from needle together.

Mb: Make bobble. [(K1, p1) twice, k1] in next st, pass 4 sts one at a time over first st.

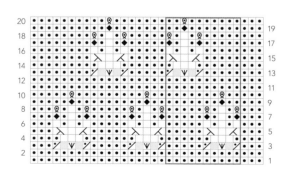

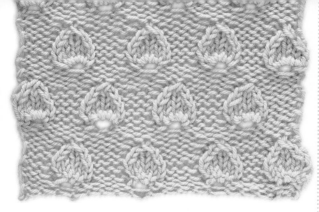
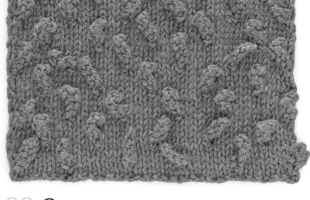

89 Teardrop Stitch

Teardrop motifs are formed by working several times into the same stitch, creating a small pouch in the fabric. The extra stitches are decreased on subsequent rows, making the pretty little droplet shapes. These motifs could be worked into many designs as single motifs or in a wide variety of patterns.

Yarn: Light fingering to bulky

Multiple: 5 sts + 1

Row 1 (RS): Purl.

Row 2: Knit.

Row 3: *P1, inc1to5, p3; rep from * to last st, p1.

Row 4: K1, *k3, p5, k1; rep from * to end.

Row 5: *P1, k5, p3; rep from * to last st, p1.

Row 6: Repeat Row 4.

Row 7: *P1, ssk, k1, k2tog, p3; rep from * to last st, p1.

Row 8: K1, *k3, p3, k1; rep from * to end.

Row 9: *P1, sk2p, p3; rep from * to last st, p1.

Row 10: Knit.

Row 11: Purl.

Row 12: K1, *inc1to5, k4; rep from * to end.

Row 13: *P4, k5; rep from * to last st, p1.

Row 14: K1, *p5, k4; rep from * to end.

Row 15: Repeat Row 13.

Row 16: K1, *p2tog, p1, p2togtbl, k4; rep from * to end.

Row 17: *P4, k3; rep from * to last st, p1.

Row 18: K1, *[sl1 wyif, p2togtbl, psso], k4; rep from * to end.

Repeat: Rows 1–18. End with Row 1.

Abbreviations

Inc1to5: Make 5 sts from 1. [(K1, p1) twice, k1] in next st.

Ssk: Slip, slip, knit. Slip 2 sts one at a time as if to knit, knit 2 slipped sts together.

Sk2p: Slip 1 as if to knit, k2tog, pass slipped st over.

90 Cocoon

Short cast-on "tails" create a fascinating, funky texture against a simple stockinette stitch background. This stitch could be worked in a wide range of yarns and there is lots of scope to play around with the placement of the tails to give a more or less densely textured fabric.

Yarn: Fingering to bulky

Multiple: 6 sts + 3

Row 1 (RS): Knit.

Row 2: Purl.

Row 3: *K1, MT, k4; rep from * to last 3 sts, k1, MT, k1.

Row 4: Purl.

Rows 5 & 6: Repeat Rows 1 & 2.

Row 7: *K4, MT, k1; rep from * to last 3 sts, k3.

Row 8: Purl.

Repeat: Rows 1–8

Abbreviation

MT: Make tail. K1, turn, cast on 5 sts using knitted method, bind off the same 5 sts, slip 1 st knitwise from RH needle to LH needle pushing tail to RS of work.

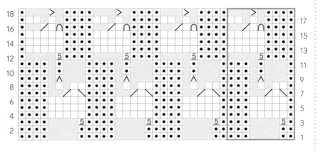

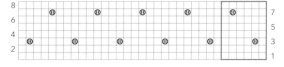

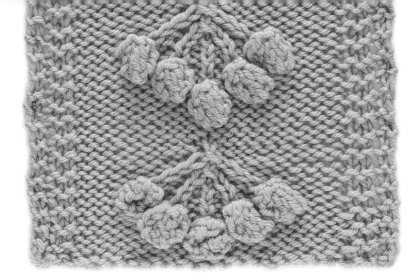

91 Tassel

There is a lot of fun to be had playing with bobbles, and this cute arrangement produces a lovely tassel design. Work as an individual motif, in a vertical series as shown here, or as part of a panel or border—whichever you choose, it will certainly turn heads.

Yarn: Fingering to bulky

Multiple: 25 sts + 2

Row 1 (RS): *P2, k2, p19, k2; rep from * to last 2 sts, p2.

Row 2: P2, *k23, p2; rep from * to end.

Row 3: *P2, k2, p9, mb, p9, k2; rep from * to last 2 sts, p2.

Row 4: P2, *k11, p1tbl, k11, p2; rep from * to end.

Row 5: *P2, k2, p6, mb, p2, k1tbl, p2, mb, p6, k2; rep from * to last 2 sts, p2.

Row 6: P2, *k8, p1tbl, k2, p1, k2, p1tbl, k8, p2; rep from * to end.

Row 7: *P2, k2, p4, mb, p1, 1/1 LPC, p1, k1tbl, p1, 1/1 RPC,

p1, mb, p4, k2; rep from * to last 2 sts, p2.

Row 8: P2, *k6, p1tbl, k2, [p1, k1] twice, p1, k2, p1tbl, k6, p2; rep from * to end.

Row 9: *P2, k2, p4, 1/1 LPC, p1, 1/1 LPC, k1tbl, 1/1 RPC, p1, 1/1 RPC, p4, k2; rep from * to last 2 sts, p2.

Row 10: P2, *k7, 1/1 RPC, k1, p3, k1, 1/1 LPC, k7, p2; rep from * to end.

Row 11: *P2, k2, p6, 1/1 LPC, m1p, sk2p, m1p, 1/1 RPC, p6, k2; rep from * to last 2 sts, p2.

Row 12: P2, *k9, 1/1 LPC, p1, 1/1 RPC, k9, p2; rep from * to end.

Row 13: *P2, k2, p8, m1p, sk2p, m1p, p8, k2; rep from * to last 2 sts, p2.

Row 14: P2, *k11, p1, k11, p2; rep from * to end.

Row 15: Repeat Row 1.

Row 16: Repeat Row 2.

Repeat: Rows 1–16

Abbreviations

Mb: Make bobble. [(K1, yo) twice, k1] in next st, turn; p5, turn; k5, turn; p5, turn; p2tog, p1, p2tog, turn; slip 1, k2tog, pass slipped st over.

1/1 LPC: 2-stitch left purl cable. Slip 1 st to cable needle and hold in front, p1, k1 from cable needle.

1/1 RPC: 2-stitch right purl cable. Slip 1 st to cable needle and hold in back, k1, p1 from cable needle.

M1p: Make 1 purlwise. Increase by 1 st purlwise by inserting RH needle under strand between st just worked and next st from back to front and purling.

Sk2p: Slip 1 as if to knit, k2tog, pass slipped st over.

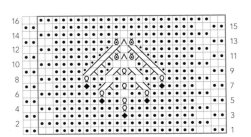

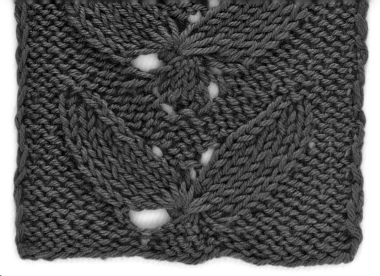

92 Twin Leaf

This is an advanced pattern with a nifty Estonian gathered stitch to create the center of the leaves (or maybe they look like alighting butterflies). A fun challenge and a lovely pattern for a panel or a single motif. As the stitch count varies, aim to end the pattern with Rows 1 and 2 for a neat finish.

Yarn: Laceweight to worsted

Multiple: 17 sts + 8

Row 1 (WS): Knit.

Row 2: Purl.

Row 3: K4, *k5, [p1 elongated twice] seven times, k5; rep from * to last 4 sts, k4.

Row 4: P4, *p2tog, p3, yo, 9 into 7 cluster, yo, p3, p2tog; rep from * to last 4 sts, p4.

Row 5: K4, *k4, p11, k4; rep from * to last 4 sts, k4.

Row 6: P4, *p3, k2tog, k4, yo, p1, yo, k4, ssk, p3; rep from * to last 4 sts, p4.

Row 7: K4, *k3, p5, k1tbl, k2, p5, k3; rep from * to last 4 sts, k4.

Row 8: P4, *p2, k2tog, k4, yo, p3, yo, k4, ssk, p2; rep from * to last 4 sts, p4.

Row 9: K4, *k2, p5, k1tbl, k4, p5, k2; rep from * to last 4 sts, k4.

Row 10: P4, *p1, k2tog, k4, yo, p5, yo, k4, ssk, p1; rep from * to last 4 sts, p4.

Row 11: K4, *k1, p5, k1tbl, k6, p5, k1; rep from * to last 4 sts, k4.

Row 12: P4, *k2tog, k2, k2tog, p3, yo, k1, yo, p3, ssk, k2, ssk; rep from * to last 4 sts, p4.

Row 13: K4, *p4, k3, p2, p1tbl, k3, p4; rep from * to last 4 sts, k4.

Row 14: P4, *k2, k2tog, p3, yo, k3, yo, p3, ssk, k2; rep from * to last 4 sts, p4.

Row 15: K4, *p3, k3, p4, p1tbl, k3, p3; rep from * to last 4 sts, k4.

Row 16: P4, *k1, k2tog, p3, yo, k5, yo, p3, ssk, k1; rep from * to last 4 sts, p4.

Repeat: Rows 3–16. End with Rows 1–2.

Abbreviations

P1 elongated twice: Purl a st wrapping yarn around needle three times. On next row drop the extra wraps from needle.

9 into 7 cluster: Knit together next 7 sts (these are the extra wrap sts from the previous row—drop the extra wraps), but do not remove sts from LH needle. Work [k7togtbl, k7tog] four times in same 7 sts. The result is 9 sts worked into 7 sts.

Ssk: Slip, slip, knit. Slip 2 sts one at a time as if to knit, knit 2 slipped sts together.

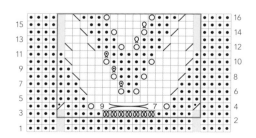

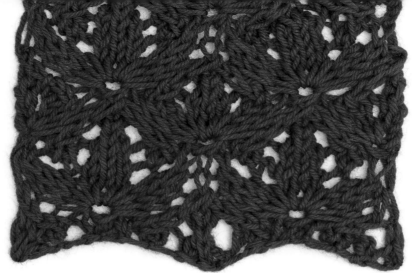

93 Cluster Flowers

This is a challenging pattern to knit but it makes a lovely, deeply textured fabric. The cluster stitches take a little practice, but the finished effect is well worth the effort. For a more open fabric, consider working with needles a couple of sizes larger than normal for the yarn being used.

Yarn: Laceweight to worsted

Multiple: 17 sts

Row 1 (RS): K2, yo, k1, yo, *[k3, yo, k1, yo] twice; rep from * to last 6 sts, k3, yo, k1, yo, k2.

Row 2: Purl.

Row 3: K2tog, yo, k1, k2tog, *cl 9 from 3, skp, k1, yo, s2kp, yo, k1, k2tog; rep from * to last 8sts, cl 9 from 3, skp, k1, yo, skp.

Row 4: P2, p2togtbl, p9, *p2tog, p3, p2togtbl, p9; rep from * to last 4 sts, p2tog, p2.

Row 5: K1, k2tog, *[k3, yo] twice, k3, skp, k1, k2tog; rep from * to last 12 sts, [k3, yo] twice, k3, skp, k1.

Row 6: P2togtbl, p11, *s2pp, p11; rep from * to last 2 sts, p2tog.

Row 7: *K1, s2kp, yo, k1, yo, k3, yo, k1, yo, s2kp; rep from * to last 13 sts, k1, s2kp, yo, k1, yo, k3, k1, yo, s2kp, k1.

Row 8: Purl.

Row 9: Cl 5 from 2, *skp, k1, yo, s2kp, yo, k1, k2tog, cl 9 from 3; rep from * to last 11 sts, skp, k1, yo, s2kp, yo, k1, k2tog, cl 5 from 2.

Row 10: P5, p2tog, p3, p2togtbl, *p9, p2tog, p3, p2togtbl; rep from * to last 5sts, p5.

Row 11: K2, yo, k3, *skp, k1, k2tog, [k3, yo] twice, k3; rep from * to last 10 sts, skp, k1, k2tog, k3, yo, k2.

Row 12: P6, s2pp, *p11, s2pp; rep from * to last 6 sts, p6.

Row 13: K2, yo, k1, yo, *s2kp, k1, s2kp, yo, k1, yo, k3, yo, k1, yo; rep from * to last 10 sts, s2kp, k1, ss2kp, yo, k1, yo, k2.

Row 14: Purl.

Row 15: K2tog, yo, k1, k2tog, *cl 9 from 3, skp, k1, yo, s2kp, yo, k1, k2tog; rep from * to last 8 sts, cl 9 from 3, skp, k1, yo, skp.

Row 16: P2, p2togtbl, p9, *p2tog, p3, p2togtbl, p9; rep from * to last 4 sts, p2tog, p2.

Row 17: K1, k2tog, *[k3, yo] twice, k3, skp, k1, k2tog; rep from * to last 12 sts, [k3, yo] twice, k3, skp, k1.

Row 18: P2togtbl, p11, *s2pp, p11; rep from * to last 2 sts, p2tog.

Repeat: Rows 7–18

Abbreviations

Cl 9 from 3: Knit the 3 sts from preceding row together, but keep all 3 sts on LH needle. [Yo, k1] four times into the 3 sts, then drop the 3 sts from LH needle.

Skp: Slip 1 as if to knit, k1, pass slipped st over.

S2kp: Slip 2 as if to k2tog, k1, pass 2 slipped sts over.

S2pp: Slip 2 sts, p1, pass slipped sts over.

Cl 5 from 2: Knit the 2 sts from preceding row together, but keep both sts on LH needle. [Yo, k1] twice into the 2 sts, then drop the 2 sts from LH needle.

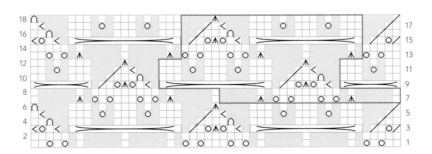

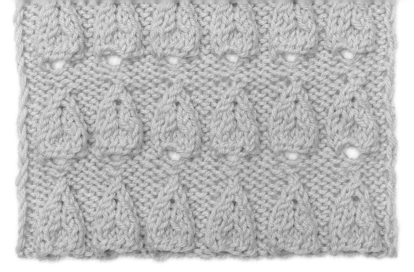

94 Bell Stitch

The bells in this motif-based stitch are created by casting on additional stitches and gradually decreasing them over several rows. The individual chart for a single bell is given and can be incorporated into a wide range of patterns.

Yarn: Fingering to bulky

Multiple: 4 sts + 4

Row 1 (RS): P2, *p2, back loop CO 6; rep from * to last 2 sts, p2.

Row 2: K2, *k2, mir1, k2; rep from * to last 2 sts, k2.

Row 3: P2, *p2, mir2, p2; rep from * to last 2 sts, p2.

Row 4: K2, *k2, mir3, k2; rep from * to last 2 sts, k2.

Row 5: P2, *p2, mir4, p2; rep from * to last 2 sts, p2.

Row 6: K2, *k2, mir5, k2; rep from * to last 2 sts, k2.

Row 7: P2, *p2, mir6, p2; rep from * to last 2 sts, p2.

Row 8: K2, *k2, mir7, k2; rep from * to last 2 sts, k2.

Row 9: P2, *p2, k2tog, p1; rep from * to last 2 sts, p2.

Row 10: Knit.

Repeat: Rows 1–10

Bell motif: Insert when instructed by main chart.

Row 1 (WS): Purl.

Row 2: Knit.

Row 3: Purl.

Row 4: K1, skp, k2tog, k1.

Row 5: Purl.

Row 6: Skp, k2tog.

Row 7: Purl.

Abbreviations

Back loop CO 6: Cast on 6 sts using backward loop method. Insert RH needle in back of loop on LH needle. Wrap yarn as if to knit, pull through loop, and transfer onto LH needle. 1 st cast on.

Mir1–mir7: Motif insert Rows 1–7. Work the relevant row (1–7) from the motif chart below right.

Skp: Slip 1 as if to knit, k1, pass slipped st over.

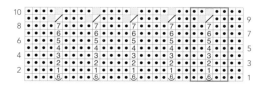

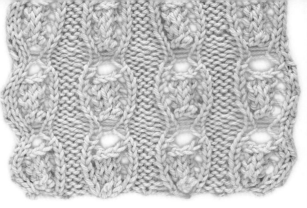

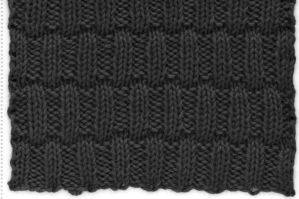

95 Fluted Pleats

This interesting pattern uses extra stitches that are cast on and bound off throughout the fabric to create small pleats. It could be varied by altering the background, spacing the pleats further apart or closer together. Note that the stitch count varies throughout the repeat.

Yarn: Light fingering to bulky

Multiple: 5 sts + 4

Row 1 (RS): K1, *k2, p3; rep from * to last 3 sts, k3.

Row 2: P2, CO 5, p1, *k3, p1, CO 5, p1; rep from * to last st, p1.

Row 3: K1, *k1, yo, k2tog, sl1 wyib, skp, k1, p3; rep from * to last 8 sts, k1, yo, k2tog, sl1 wyib, skp, yo, k2.

Row 4: P8, *k3, p7; rep from * to last st, p1.

Rows 5–8: Repeat Rows 3 & 4 twice.

Row 9: Repeat Row 3.

Row 10: P2, BO 5, p1, *k3, p1, BO 5, p1; rep from * to last st, p1.

Row 11: Repeat Row 1.

Row 12: P3, *k3, p2; rep from * to last st, p1.

Repeat: Rows 1–12

Abbreviations
CO: Cast on.

Skp: Slip 1 as if to knit, k1, pass slipped st over.

BO: Bind off.

96 Tucked Rib

There are many interesting patterns to be achieved with the simplest of stitches. This tucked rib offsets sections of 2 × 2 (double) rib divided by two rows of stockinette. It would be an interesting all-over fabric and could be worked in a wide range of yarns.

Yarn: Light fingering to bulky

Multiple: 4 sts + 2

Row 1 (RS): *K2, p2; rep from * to last 2 sts, k2.

Row 2: P2, *k2, p2; rep from * to end.

Rows 3–8: Repeat Rows 1 & 2 three times.

Row 9: Knit.

Row 10: Purl.

Row 11: *P2, k2; rep from * to last 2 sts, p2.

Row 12: K2, *p2, k2; rep from * to end.

Rows 13–18: Repeat Rows 11 & 12 three times.

Rows 19–20: Repeat Rows 9 & 10.

Repeat: Rows 1–20

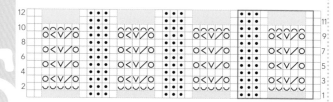

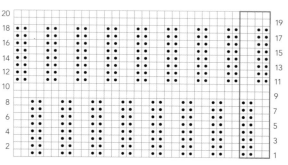

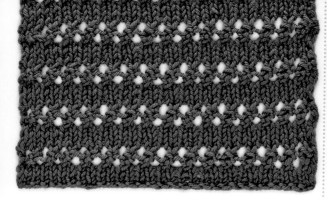

97 Ridged Eyelet

Alternating bands of smooth stockinette stitch and delicate lace create an interesting fabric with a lovely texture. A smooth yarn will emphasize the stitch structure. Using a halo yarn such as angora or mohair will soften the texture while retaining an interesting stitch pattern.

Yarn: Cobweb to bulky

Multiple: 2 sts + 2

Row 1 (RS): Knit.
Row 2: Purl.
Rows 3 & 4: Repeat Rows 1 & 2.
Row 5: P1, *yo, p2tog; rep from * to last st, p1.

Row 6: Knit.
Row 7: P1, *p2tog, yo; rep from * to last st, p1.
Row 8: Purl.

Repeat: Rows 1–8

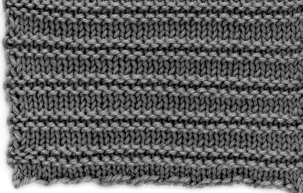

98 Garter Ridges

This pattern exploits the differences in texture and gauge between garter and stockinette stitch to create lovely, springy ridges. It can be used on a wide range of yarns and will look great in both textured and smooth yarns.

Yarn: Light fingering to bulky

Multiple: Any number of sts

Row 1 (RS): Knit.
Row 2: Purl.
Rows 3–6: Knit.

Repeat: Rows 1–6

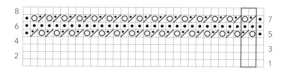

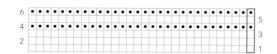

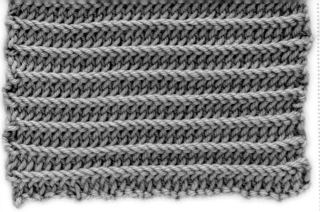

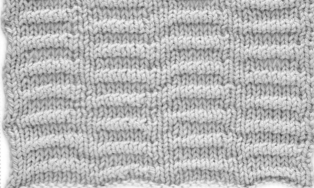

99 Double Garter Stitch

Double garter stitch makes a great pattern where a firm fabric is required. It is an interesting combination of elongated stitches and knit togethers that takes a little practice but gives a great texture.

Yarn: Fingering to bulky

Multiple: 2 sts

Row 1 (WS): P1 elongated to end.
Row 2: Dgs to last loop, knit wrapping yarn twice.

Repeat: Row 2.

Abbreviations

P1 elongated: Purl a st wrapping yarn around needle twice. On next row drop the extra wraps from needle.

Dgs: Double garter stitch. Knit first loop of first st only, leaving second loop on needle; *knit second loop together with first loop of next st, wrapping yarn twice and leaving second loop on needle; rep from *.

100 Wavy Tucks

Tucks are an interesting way to add texture and shape to an otherwise plain stockinette fabric. Experiment with different depths of tuck, widths, and spacing for some exciting effects, keeping in mind that tucks do shorten a fabric. A series of tucks in vertical lines would make an interesting ruched fabric.

Yarn: Laceweight to bulky

Multiple: 16 sts + 3

Row 1 (RS): Knit.
Row 2 and all WS rows: Purl.
Row 3: Knit.
Row 5: *K3, [k2 tuck] five times, k8; rep from * to last 3 sts, k3.
Row 7: *K11, [k2 tuck] five times; rep from * to last 3 sts, k3.
Row 9: Knit.
Row 11: Repeat Row 5.

Row 13: Repeat Row 7.

Repeat: Rows 2–13.

Abbreviation

K2 tuck: Knit 2 tuck. Insert LH needle into top of st 2 rows below on WS of work. Lift loop onto LH needle and knit the loop and next st together as 1 st, creating a tuck in the work.

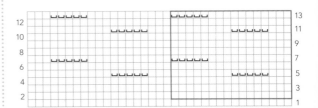

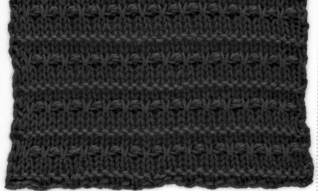

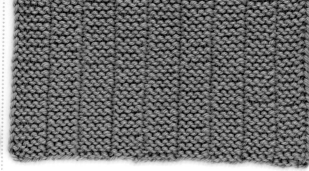

101 Little Ridged Knots

A delicate, textured pattern that is suitable for use as a band, trim, or an all-over fabric. A smooth yarn with good stitch definition will best emphasize the texture, and the pattern will work well on a wide range of yarns.

Yarn: Light fingering to bulky

Multiple: 2 sts + 2

Row 1 (RS): Knit.

Rows 2–4: Purl.

Row 5: Knit.

Row 6: Purl.

Row 7: K1, *m3, sl1 wyib; rep from * to last st, k1.

Row 8: P1, *sl1 wyib, k3togtbl; rep from * to last st, p1.

Repeat: Rows 1–8

Abbreviation

M3: Make 3 from 1 (increasing 2 sts). [K1, yo, k1] in next st.

102 Garter Rib Stitch

Simple offset panels of garter stitch and reversed garter stitch create a surprisingly interesting pattern. Vary the effect by making the panels wider or narrower. This pattern will work in a wide range of yarns.

Yarn: Light fingering to bulky

Multiple: 8 sts + 4

Row 1 (RS): *K4, p4; rep from * to last 4 sts, k4.

Row 2: K4, *p4, k4; rep from * to end.

Repeat: Rows 1–2

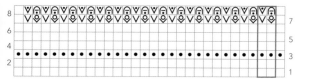

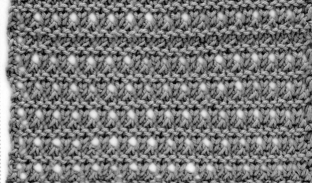

103 Tucked Garter Tubes

Tucked stitches create great textures in a knitted fabric. Try this pattern for a funky hat or interesting border. If using for a border, swatch with the main fabric as the stitch count may need to be adjusted to accommodate the slightly wider garter stitch.

Yarn: Light fingering to bulky

Multiple: Any number of sts

Row 1 (RS): Knit.

Row 2: Purl.

Row 3: Knit.

Rows 4–8: Purl.

Row 9: K4 tuck to end.

Row 10: Purl.

Repeat: Rows 1–10

Abbreviation

K4 tuck: Knit 4 tuck. Insert LH needle into top of st 4 rows below on WS of work. Lift loop onto LH needle and knit the loop and next st together as 1 st, creating a tuck in the work.

104 Ridged Openwork Reversed

A nicely textured stitch with scope for use as an all-over pattern. Or you could try using a couple of pattern repeats as a band to add interest to an otherwise plain garment. It would also make a nice alternative to a rib.

Yarn: Laceweight to bulky

Multiple: 2 sts + 1

Row 1 (WS): Purl.

Row 2: K1, *k2tog; rep from * to end.

Row 3: *P1, m1; rep from * to last st, p1.

Row 4: K2tog, *yo, k2tog; rep from * to last st, yo, k1.

Rows 5 & 6: Purl.

Repeat: Rows 1–6

Abbreviation

M1: Make 1. Increase by 1 st by knitting into the front of the strand between the st just worked and the next st.

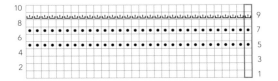

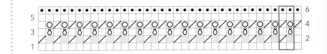

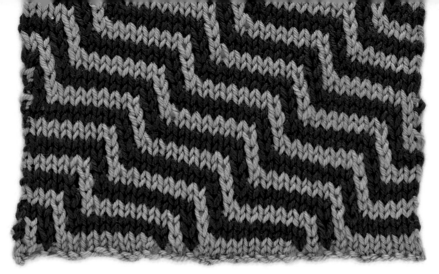

105 Striped Stepped Tucks

The chart for this pattern looks challenging but the main stitch is a simple stockinette. Once the pattern of brioche stitches is established, it quickly becomes a rhythm that is quite easy to follow. When worked in two-row stripes as here, the interesting stepped shape is emphasized and it looks great as an all-over fabric.

Yarn: Fingering to bulky

Multiple: 11 sts + 1

Cast on in color A.

Row 1 (RS): In color A, k1, *k7, [yf sl1yo, k1] twice; rep from * to end.

Row 2: *[P1, yf sl2yo] twice, p7; rep from * to last st, p1.

Row 3: In color B, k1, *k6, [yf sl1yo, k3tog] twice, k1; rep from * to end.

Row 4: *P2, yf sl2yo, p1, yf sl2yo, p6; rep from * to last st, p1.

Row 5: In color A, k1, *k5, [yf sl1yo, k3tog] twice, k2; rep from * to end.

Row 6: *P3, yf sl2yo, p1, yf sl2yo, p5; rep from * to last st, p1.

Row 7: In color B, k1, *k4, [yf sl1yo, k3tog] twice, k3; rep from * to end.

Row 8: *P4, yf sl2yo, p1, yf sl2yo, p4; rep from * to last st, p1.

Row 9: In color A, k1, *k3, [yf sl1yo, k3tog] twice, k4; rep from * to end.

Row 10: *P5, yf sl2yo, p1, yf sl2yo, p3; rep from * to last st, p1.

Row 11: In color B, k1, *k2, [yf sl1yo, k3tog] twice, k5; rep from * to end.

Row 12: *P6, yf sl2yo, p1, yf sl2yo, p2; rep from * to last st, p1.

Row 13: In color A, k1, *k1, [yf sl1yo, k3tog] twice, k6; rep from * to end.

Row 14: *P7, [yf sl2yo, p1] twice; rep from * to last st, p1.

Row 15: In color B, k1, *[yf sl1yo, k3tog] twice, k7; rep from * to end.

Row 16: *P8, yf sl2yo, p1, yf sl2yo; rep from * to last st, p1.

Row 17: In color A, k1, *k3tog, yf sl1yo, k3tog, k7, yf sl1yo; rep from * to end.

Row 18: *Yf sl2yo, p8, yf sl2yo, p1; rep from * to last st, p1.

Row 19: In color B, k1, *yf sl1yo, k3tog, k7, yf sl1yo, k3tog; rep from * to end.

Row 20: *P1, yf sl2yo, p8, yf sl2yo; rep from * to last st, p1.

Row 21: In color A, k1, *k3tog, k7, yf sl1yo, k3tog, yf sl1yo; rep from * to end.

Row 22: *Yf sl2yo, p1, yf sl2yo, p8; rep from * to last st, p1.

Row 23: In color B, k1, *k7, [yf sl1yo, k3tog] twice; rep from * to end.

Repeat: Rows 2–23, alternating colors every two rows.

Final repeat: After row 22, work row 23 but replace the yf sl1yo stitches with knit stitches to maintain the correct stitch count and a neat appearance.

Abbreviations

Yf sl1yo: Yarn forward, slip 1, yarn over. Bring yarn to the front, slip next st purlwise, then bring yarn to the back over the needle and the slipped st. The slipped st and yo are counted as 1 st.

Yf sl2yo: Yarn forward, slip 2, yarn over. Bring yarn to the front, slip the next 2 sts purlwise, then bring the yarn to the back over the needle and the slipped sts. There are now 2 slipped sts under 1 yo. This counts as 2 sts and the k3tog on next row is worked over these sts.

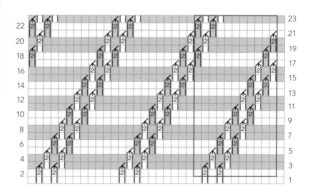

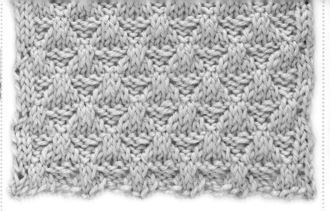

106 Interwoven Blocks

Offset four-stitch cables push the knit stitches forward in this richly textured woven basket pattern. A smooth yarn with good stitch definition will give this pattern maximum impact.

Yarn: Light fingering to bulky

Multiple: 6 sts + 6

Row 1 (RS): K1, *k4, p2; rep from * to last 5 sts, k4, p1.

Row 2: K1, p4, *k2, p4; rep from * to last st, p1.

Row 3: Repeat Row 1.

Row 4: K1, 1/2/1 RRC, *k2, 1/2/1 RRC; rep from * to last st, p1.

Row 5: K2, *p2, k4; rep from * to last 4 sts, p2, k2.

Row 6: P2, k2, *p4, k2; rep from * to last 2 sts, p2.

Row 7: Repeat Row 5.

Row 8: P2, k2, *1/2/1 LRC, k2; rep from * to last 2 sts, p2.

Repeat: Rows 1–8

Abbreviations

1/2/1 RRC: 4-stitch right ribbed cable. Slip 3 sts to cable needle and hold in back, k1, slip 2 left-most sts from cable needle to LH needle, move cable needle with remaining st to front, p2 from LH needle, then k1 from cable needle.

1/2/1 LRC: 4-stitch left ribbed cable. Slip 1 st to cable needle and hold in front, slip 2 sts to second cable needle and hold in back, k1, p2 from back cable needle, then k1 from front cable needle.

107 Sandwich Stitch

Blocks of slipped stitches draw up the fabric to create this lovely, textured pattern that is much simpler to work than it first appears. By offsetting the slipped sections, it balances out the pattern and prevents biasing or pulling up.

Yarn: Light fingering to bulky

Multiple: 16 sts + 1

Row 1 (RS): Knit.

Row 2: Knit.

Row 3: *[K1, sl1 wyib] four times, k8; rep from * to last st, k1.

Row 4: P1, *p8, [sl1 wyif, k1] three times, sl1 wyif, p1; rep from * to end.

Rows 5–8: Repeat Rows 1–4.

Row 9: Knit.

Row 10: Knit.

Row 11: *K9, [sl1 wyib, k1] three times, sl1 wyib; rep from * to last st, k1.

Row 12: P1, *[sl1 wyif, k1] three times, sl1 wyif, p9; rep from * to end.

Rows 13–16: Repeat Rows 9–12.

Repeat: Rows 1–16

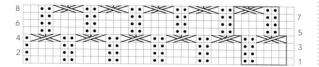

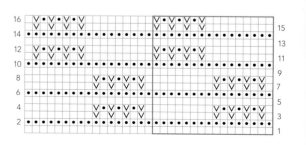

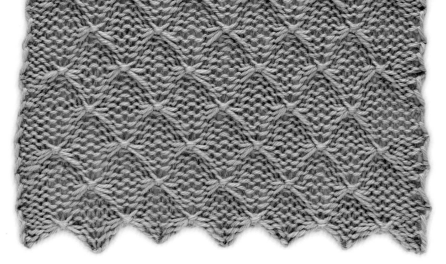

108 Tucked Slipped Honeycomb

This delicate honeycomb looks particularly lovely worked in a fine yarn, but is equally at home with a thicker yarn. By slipping long strands on three rows and then lifting these strands by drawing them up after a further three rows, gentle tucks are created. A background of reverse stockinette gives added textural interest.

Yarn: Light fingering to bulky

Multiple: 6 sts + 7

Row 1 (RS): Purl.

Row 2: K2, [sl1 wyib] three times, *k3, [sl1 wyib] three times; rep from * to last 2 sts, k2.

Row 3: P2, *[sl1 wyif] three times, p3; rep from * to last 5 sts, [sl1 wyif] three times, p2.

Row 4: Repeat Row 2.

Row 5: Purl.

Row 6: Knit.

Row 7: Purl.

Row 8: K3, Lst, k1, *k4, Lst, k1; rep from * to last 2 sts, k2.

Row 9: Purl.

Row 10: K5, *[sl1 wyib] three times, k3; rep from * to last 2 sts, k2.

Row 11: P2, *p3, [sl1 wyif] three times; rep from * to last 5 sts, p5.

Row 12: Repeat Row 10.

Rows 13–15: Repeat Rows 5–7.

Row 16: K5, *k1, Lst, k4; rep from * to last 2 sts, k2.

Repeat: Rows 1–16

Abbreviation

Lst: Lift strand/s. Insert needle under loose strand and knit next st, lifting st in front of strand. As the stitch is completed lift the strands over the st.

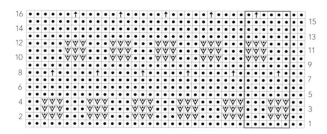

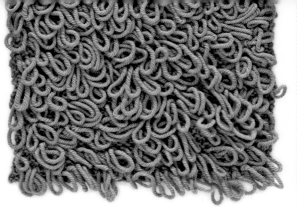

109 Fur Stitch

Fur stitch is nothing if not fun! It would be quite painstaking to make an entire garment in this stitch but when worked in a fuzzy, textured yarn you can create great cuffs or trims. It's also very useful for soft toys and decorations.

Yarn: Laceweight to bulky

Multiple: 1 st + 2

Row 1 (RS): Knit.
Row 2: Purl.
Row 3: K1, *Lsf; rep from * to last st, k1.
Row 4: Ktbl.

Repeat: Rows 1–4

Abbreviation

Lsf: Loop stitch front (loops to front of work). Knit in front of st but don't complete st. Bring yarn between needles (yf) and wrap clockwise around left thumb at front of work. Take yarn to back between needles. Knit loop on LH needle and drop off LH needle, completing the st. Yo taking yarn from back, around RH needle, and hold to back. Lift 2 sts just worked over yo.

110 Cut Fur Stitch

It can be unnerving to cut loops once they've been so carefully knitted, but provided the yarn has a little grip and has been knitted to a firm gauge (go down a needle size or two if necessary), it should be possible to produce this lovely fluffy "pile" fabric. It can be particularly fun to work this stitch in a variegated yarn for a really funky look.

Yarn: Fingering to bulky

Multiple: 1 st + 2

Row 1 (RS): Knit.
Row 2: P1, *Lsb; rep from * to last st, p1.
Row 3: Ktbl.

Repeat: Rows 2–3. When finished, hold loops and cut carefully. Trim to required length.

Abbreviation

Lsb: Loop stitch back (loops to back of work). Insert LH needle in st and wind yarn around needle as if to knit (below). Wind yarn around LH index finger. For a short loop wind once; to lengthen the loop, wind twice. Take yarn back around RH needle as if to knit (again) and form the st. It will be two or three strands wide, depending on how many times you have wound the yarn around your finger. To secure the loop, bring the working yarn between the needles to the front of the work and then over the needles, like a yo. Hold yo securely in place and bind off st over yo. This will secure the loop.

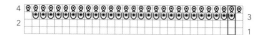

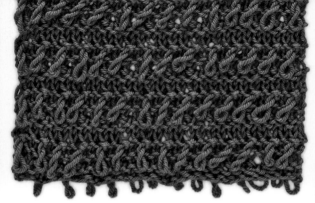
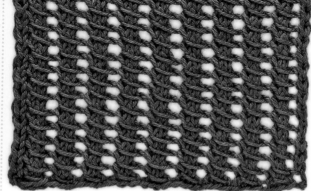

111 Double Faced Loop Stitch

This unusual pattern produces loops on both sides of the fabric. It would make a funky trim for a jacket edge or collar, or on a bag or tote. It's also a great pattern for a reversible scarf or cowl, and would look wonderful in a textured yarn.

Yarn: Light fingering to bulky

Multiple: 2 sts + 1

Row 1 (RS): Knit.

Row 2: Knit.

Row 3: *K1, Lsb; rep from * to last st, k1.

Row 4: Ktbl.

Row 5: Knit.

Repeat: Rows 1–5

Abbreviation

Lsb: Loop stitch back (loops to back of work). Insert LH needle in st and wind yarn around needle as if to knit (below). Wind yarn around LH index finger. For a short loop wind once; to lengthen the loop, wind twice. Take yarn back around RH needle as if to knit (again) and form the st. It will be two or three strands wide, depending on how many times you have wound the yarn around your finger. To secure the loop, bring the working yarn between the needles to the front of the work and then over the needles, like a yo. Hold yo securely in place and bind off st over yo. This will secure the loop.

112 Pillar Stitch

A simple but attractive fabric that makes an interesting alternative to a standard rib. This pattern does have a degree of bias so make and block a good-sized swatch before beginning.

Yarn: Laceweight to bulky

Multiple: 3 sts + 4

Row 1 (WS): Purl.

Row 2: K2, *yo, sl1 purlwise, k2, psso; rep from * to last 2 sts, k2.

Repeat: Rows 1–2. End with Row 1.

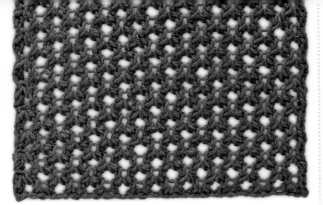

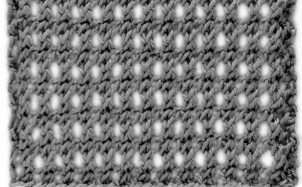

113 Cellular Stitch

This soft, open fabric has a good drape, making it suitable for a wide range of fabrics and yarns. Smooth yarns will allow the eyelets to be more visible; textured yarns may give a less open look but will still produce a soft fabric.

Yarn: Laceweight to bulky

Multiple: 3 sts + 3

Row 1 (WS): Purl.
Row 2: K2, *k2tog, yo, k1; rep from * to last st, k1.
Row 3: Purl.
Row 4: K2, *yo, k1, k2tog; rep from * to last st, k1.

Repeat: Rows 1–4. End with Row 1.

114 Ridged Openwork

This decorative pattern, although including yarn overs, produces a firm fabric that can tend to pull in so swatch carefully and check gauge.

Yarn: Laceweight to bulky

Multiple: 2 sts + 1

Row 1 (RS): Purl.
Row 2: P2tog to last st, p1.
Row 3: P1, *m1p, p1; rep from * to end.
Row 4: P1, *yo, p2tog; rep from * to end.

Repeat: Rows 1–4. End with Row 1.

Abbreviation

M1p: Make 1 purlwise. Increase by 1 st purlwise by inserting RH needle under strand between st just worked and next st from back to front and purling.

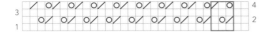

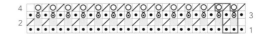

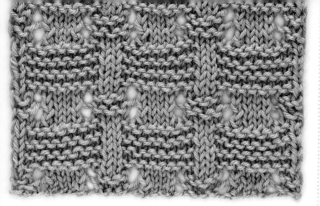

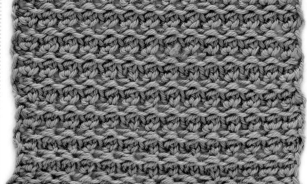

115 Open Basketweave

Two rows of eyelets inserted into this otherwise simple garter and stockinette pattern add interest and make it a good first lace project. It is suitable for use as an all-over pattern in a wide range of yarns.

Yarn: Laceweight to bulky

Multiple: 10 sts + 2

Row 1 (RS): P1, *p2, yo, k2tog, k2, ssk, yo, p2; rep from * to last st, p1.

Row 2: Purl.

Rows 3 & 4: Repeat Rows 1 & 2.

Row 5: K1, *k1, p8, k1; rep from * to last st, k1.

Row 6. Purl.

Rows 7–12: Repeat Rows 5 & 6 three times.

Repeat: Rows 1–12

Abbreviation

Ssk: Slip, slip, knit. Slip 2 sts one at a time as if to knit, knit 2 slipped sts together.

116 Granite Stitch

Softer than the name suggests, granite stitch forms a nubby, interesting, textured fabric. It makes a good all-over pattern and is simple to work. The stitch count varies with Row 2 halving the stitch count, and the original count being restored on Row 3.

Yarn: Laceweight to bulky

Multiple: 2 sts

Row 1 (RS): Knit.

Row 2: K2tog to end.

Row 3: Inc1to2 to end.

Row 4: Purl.

Repeat: Rows 1–4

Abbreviation

Inc1to2: Make 2 sts from 1. [K1, p1] in next st.

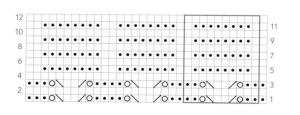

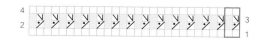

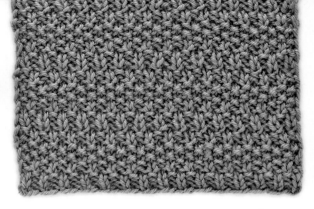

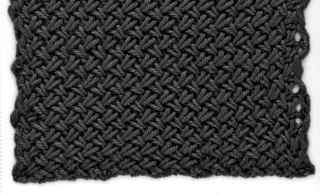

117 Ascending Seed Stitch

A series of seed stitches in a 3-3-2-2-1-1 formation gives an interesting, rhythmical pattern. A little concentration is required to maintain the progression of the stitches.

Yarn: Cobweb to super bulky

Multiple: 2 sts

Row 1 (RS): *P1, k1; rep from * to end.
Rows 2 & 3: Repeat Row 1.
Rows 4–6: *K1, p1; rep from * to end.

Rows 7 & 8: Repeat Row 1.
Rows 9 & 10: Repeat Row 4.
Row 11: Repeat Row 1.
Row 12: Repeat Row 4.

Repeat: Rows 1–12

118 Slipped Diagonal Basketweave

This pattern forms a firm, dense fabric that would make great outerwear or soft furnishings. The extensive use of twisted stitches makes it draw in and it is also quite slow to work. For a softer, more draping fabric, choose needles a couple of sizes larger than the recommended size for the yarn.

Yarn: Fingering to bulky

Multiple: 2 sts + 3

Row 1 (RS): Sl1 wyib, sl1 wyif, *1/1 LT; rep from * to last st, k1.
Row 2: [Sl1 wyif] twice, *1/1 RPT; rep from * to last st, p1.

Repeat: Rows 1–2

Abbreviations

1/1 LT: 2-stitch left twist. Skip 1 st (leave on LH needle) and knit the second st in back loop, then knit the skipped st in front loop; slip both sts from needle together.

1/1 RPT: 2-stitch right purl twist. Skip 1 st (leave on LH needle) and purl the second st in front loop, then purl the skipped st in front loop; slip both sts from needle together.

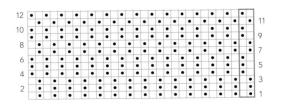

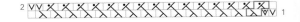

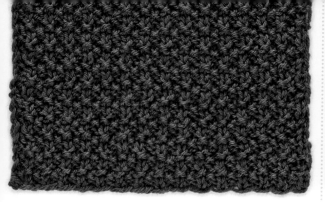

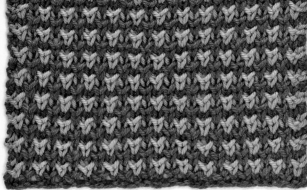

119 Broken Seed Stitch

A variant on the standard seed stitch, this pattern has an interesting, nubby texture, particularly attractive on chunkier knits. This stitch produces a flat, firm fabric with little or no curl at the edges.

Yarn: Cobweb to super bulky

Multiple: 2 sts

Row 1 (RS): *K1, p1; rep from * to end.

Row 2: *K1, p1; rep from * to end.

Row 3: *P1, k1; rep from * to end.

Row 4: *K1, p1; rep from * to end.

Row 5: *K1, p1; rep from * to end.

Row 6: *P1, k1; rep from * to end.

Repeat: Rows 1–6

120 Bee Stitch

This two-color slip stitch looks complex, but it's actually very easy to work. Surprisingly it only involves knit and knit in the row below stitches, and it is the knit in the row below that lifts the color from one row into another, to create the fascinating effect that requires no color changing within the row. At color changes, carry the yarn up the side of the work.

Yarn: Fingering to bulky

Multiple: 2 sts + 3

Cast on in color A.

Row 1 (RS): In color A, knit.

Row 2: Knit.

Row 3: In color B, k1, *k1b, k1; rep from * to end.

Row 4: Knit.

Row 5: In color A, k2, k1b, *k1, k1b; rep from * to last 2 sts, k2.

Row 6: Knit.

Repeat: Rows 3–6

Abbreviation

K1b: Knit 1 below. Insert RH needle from front to back into the st one row directly below the one on the LH needle. Knit this new st together with the st directly above it (the next st you would have been knitting) on LH needle.

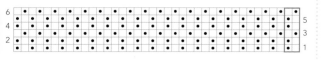

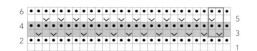

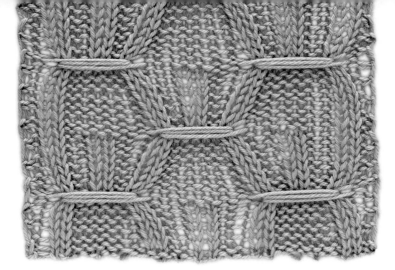

121 Jumping Jacks

This pattern is big and bold and looks great as an all-over pattern. For best results practice the ten-stitch wrap to make sure the gauge remains even. Once blocked this pattern will stand out from the crowd.

Yarn: Light fingering to worsted

Multiple: 16 sts + 14

Row 1 (RS): P2, *k2, p6, [k2, p2] twice; rep from * to last 12 sts, k2, p6, k2, p2.

Row 2: K2, p2, k6, p2, *[k2, p2] twice, k6, p2; rep from * to last 2 sts, k2.

Rows 3–6: Repeat Rows 1 & 2 twice.

Row 7: P2, *wr10, p6; rep from * to last 12 sts, wr10, p2.

Row 8: [K2, p2] three times, *k6, [p2, k2] twice, p2; rep from * to last 2 sts, k2.

Row 9: P2, *[k2, p2] twice, k2, p6; rep from * to last 12 sts, [k2, p2] three times.

Rows 10–13: Repeat Rows 8 & 9 twice.

Row 14: Repeat Row 8.

Row 15: P2, k2, *p6, wr10; rep from * to last 10 sts, p6, k2, p2.

Row 16: K2, p2, k6, *[p2, k2] twice, p2, k6; rep from * to last 4 sts, p2, k2.

Repeat: Rows 1–16

Abbreviation

Wr10: Wrap 10 stitches. Slip 10 sts onto cable needle and wrap yarn around sts three times going below the cable needle. Wraps should pull in slightly but not too tightly.

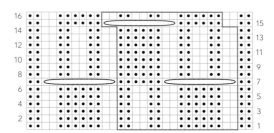

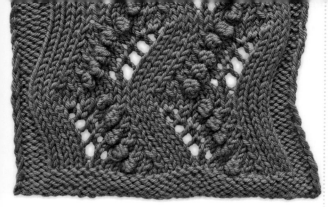

122 Grapevine

This delightful stitch incorporates yarn overs, bobbles, increases, and decreases. It looks complex to work but once the pattern has been established it is very rhythmical to follow. Worked as a single panel or as an all-over pattern, it will look lovely in a wide range of yarns. If you are using a heavier weight yarn, it may be more effective if the needle size is one or two sizes larger than the normal size for the yarn.

Yarn: Cobweb to worsted

Multiple: 13 sts + 10

Row 1 (RS): Purl.

Row 2: Knit.

Rows 3 & 4: Repeat Rows 1 & 2.

Row 5: P4, knit to last 4 sts, p4.

Row 6 and all following WS rows: K4, purl to last 4 sts, k4.

Row 7: P4, k1, *k1, skp, k2tog, k1, mb, k2, [yo, k1] twice, k2; rep from * to last 5 sts, k1, p4.

Rows 9, 11, 13 & 15: Repeat Row 7.

Row 17: Repeat Row 5.

Row 19: P4, k1, *k2, [yo, k1] twice, k1, mb, k1, skp, k2tog, k2; rep from * to last 5 sts, k1, p4.

Rows 21, 23, 25 & 27: Repeat Row 19.

Row 28: K4, purl to last 4 sts, k4.

Repeat: Rows 5–28

Abbreviations

Skp: Slip 1 as if to knit, k1, pass slipped st over.

Mb: Make bobble. [(K1, p1) twice, k1] in next st, pass 4 sts one at a time over first st.

123 Simple Open Mesh

A straightforward four-row repeat produces this very open, fluid fabric with lots of drape. It does spread, so swatch carefully as you may need fewer stitches than you think.

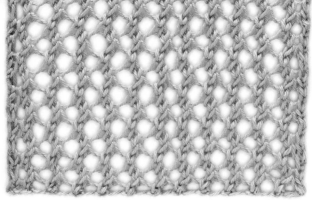

Yarn: Laceweight to bulky

Multiple: 2 sts + 4

Row 1 (RS): K2, *yo, k2tog; rep from * to last 2 sts, k2.

Row 2: Purl.

Row 3: K2, *k2tog, yo; rep from * to last 2 sts, k2.

Row 4: Purl.

Repeat: Rows 1–4

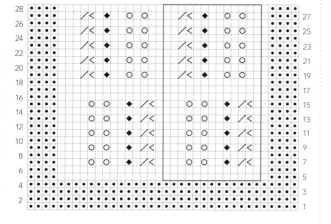

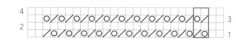

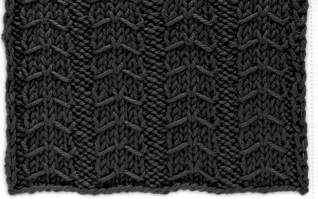

124 Little Tent Stitch

A lovely neat pattern that could be used as an unusual rib or as part of a panel. The lifted strand stitch is easy to work provided the slipped stitches aren't pulled too tight.

Yarn: Laceweight to bulky

Multiple: 8 sts + 1

Row 1 (WS): K1, *k1, p5, k2; rep from * to end.

Row 2: *K2, [sl1 wyif] five times, k1; rep from * to last st, k1.

Row 3: Repeat Row 1.

Row 4: *K4, Lst, k3; rep from * to last st, k1.

Repeat: Rows 1–4

Abbreviation

Lst: Lift strand/s. Insert needle under loose strand and knit next st, lifting st in front of strand. As the stitch is completed lift the strands over the st.

125 Knot Mesh

A softly springy stitch pattern with lots of stretch and texture. This pattern does spread so swatch carefully for finished size. Working into the yarn overs can take a little practice; however, the pattern only has two rows and a short repeat so is quick to master.

Yarn: Fingering to bulky

Multiple: 1 st

Row 1 (RS): *[Yo] twice, k1; rep from * to end.

Row 2: [K1, (k1, p1) in yo, pass 2 knit sts over] to end.

Repeat: Rows 1–2

Abbreviation

K1, (k1, p1) in yo, pass 2 knit sts over: Knit first stitch as normal.

Then, knit into the first yo and purl into the second (the yo from the previous row) to give 2 sts. Pass both the first knit st, and the st knitted in the yo, over the purled st.

Note: This pattern has a multiple of 1 st but the repeat shows 2 sts, as the yarn overs form part of the repeat but are not cast on.

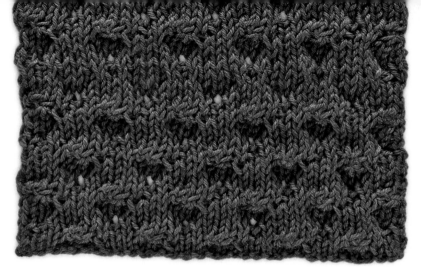

126 Nupps and Dimples

A richly textured pattern combining slipped stitch dimples interspersed with gathered nupps. Note that the strands from the slipped stitches should be taken across the right side of the work before being lifted. This is a lovely pattern for an all-over fabric. With heavier yarns it may be necessary to go up a needle size or two larger than normal for the yarn.

Yarn: Fingering to bulky

Multiple: 6 sts + 5

Row 1 (RS): Knit.

Row 2: P1, [sl1 wyif] three times, *p3, [sl1 wyif] three times; rep from * last st, p1.

Row 3: K1, *[sl1 wyib] three times, k3; rep from * to last 4 sts, [sl1] three times, k1.

Row 4: Repeat Row 2.

Row 5: K1, *k3, 3-3; rep from * to last 4 sts, k4.

Row 6: Purl.

Row 7: Knit.

Row 8: P2, Lst, p1, *p4, Lst, p1; rep from * to last st, p1.

Row 9: Knit.

Row 10: P4, *[sl1 wyif] three times, p3; rep from * to last st, p1.

Row 11: K1, *k3, [sl1 wyib] three times; rep from * to last 4 sts, k4.

Row 12: Repeat Row 10.

Row 13: K1, *3-3, k3; rep from * to last 4 sts, 3-3, k1.

Row 14: Purl.

Row 15: Knit.

Row 16: P4, *p1, Lst, p4; rep from * to last st, p1.

Repeat: Rows 1–16. End with Row 1.

Abbreviations

3-3: 3 into 3 gathered. K3tog, slip st back onto LH needle, [k1tbl, k1, k1tbl] in this st.

Lst: Lift strand/s. Insert needle under loose strand and knit next st, lifting st in front of strand. As the stitch is completed lift the strands over the st.

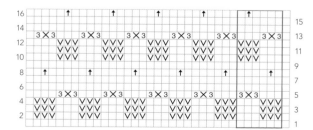

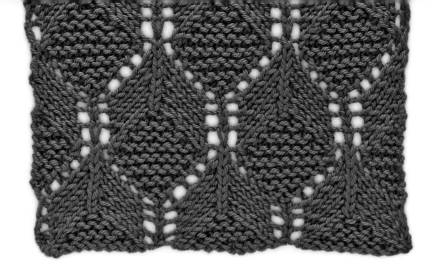

127 Garter Lace Cubes

This striking stitch makes a lovely all-over pattern. Simple stockinette stitch and garter stitch blocks are bounded by lace, opening the fabric and highlighting the strong shapes. Careful blocking will bring out the best in this fabric, and working with a smooth yarn will show it to its best advantage.

Yarn: Cobweb to worsted

Multiple: 12 sts + 13

Row 1 (RS): *K1, yo, skp, p7, k2tog, yo; rep from * to last st, k1.

Row 2 and all WS rows: Purl.

Row 3: *K1, yo, k1, skp, p5, k2tog, k1, yo; rep from * to last st, k1.

Row 5: *K1, yo, k2, skp, p3, k2tog, k2, yo; rep from * to last st, k1.

Row 7: *P1, yo, k3, skp, p1, k2tog, k3, yo; rep from * to last st, p1.

Row 9: *P2, yo, k3, s2kp, k3, yo, p1; rep from * to last st, p1.

Row 11: *P3, yo, k2, s2kp, k2, yo, p2; rep from * to last st, p1.

Row 13: *P4, yo, k1, s2kp, k1, yo, p3; rep from * to last st, p1.

Row 15: *P5, yo, s2kp, yo, p4; rep from * to last st, p1.

Row 17: *P4, k2tog, yo, k1, yo, skp, p3; rep from * to last st, p1.

Row 19: *P3, k2tog, k1, yo, k1, yo, k1, skp, p2; rep from * to last st, p1.

Row 21: *P2, k2tog, k2, yo, k1, yo, k2, skp, p1; rep from * to last st, p1.

Row 23: *P1, k2tog, k3, yo, p1, yo, k3, skp; rep from * to last st, p1.

Row 25: K2tog, k3, yo, p1, *p2, yo, k3, s2kp, k3, yo, p1; rep from * to last 7 sts, p2, yo, k3, skp.

Row 27: K2tog, k2, yo, p2, *p3, yo, k2, s2kp, k2, yo, p2; rep from * to last 7 sts, p3, yo, k2, skp.

Row 29: K2tog, k1, yo, p3, *p4, yo, k1, s2kp, k1, yo, p3; rep from * to last 7 sts, p4, yo, k1, skp.

Row 31: K2tog, yo, p4, *p5, yo, s2kp, yo, p4; rep from * to last 7 sts, p5, yo, skp.

Row 32: Purl.

Repeat: Rows 1–32

Abbreviations

Skp: Slip 1 as if to knit, k1, pass slipped st over.

S2kp: Slip 2 as if to k2tog, k1, pass 2 slipped sts over.

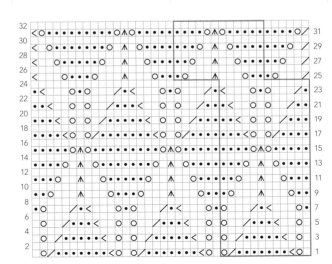

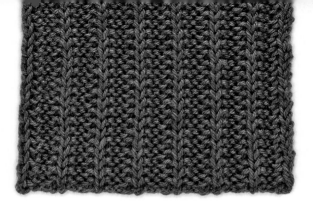
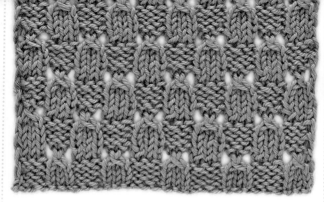

128 Cartridge Belt Rib

This is a strongly textured, deep rib. Slipped stitches give added fluidity and drape, making it suitable for the body of a fabric as well as for a standard ribbed edging.

Yarn: Laceweight to bulky

Multiple: 4 sts + 3

Row 1 (RS): K3, *sl1 wyif, k3; rep from * to end.

Row 2: K1, *sl1 wyif, k3; rep from * to last 2 sts, sl1 wyif, k1.

Repeat: Rows 1–2

129 Lacy Twist Blocks

Simple but effective, the clever combination of yarn overs and decreases in this pattern give the appearance of a cable without twists or cable needles. It is soft enough for an all-over pattern and suitable for a wide range of yarns.

Yarn: Laceweight to bulky

Multiple: 6 sts + 2

Row 1 (RS): P1, *k3, p3; rep from * to last st, p1.

Row 2: K1, *k3, p3; rep from * to last st, k1.

Rows 3 & 4: Repeat Rows 1 & 2.

Row 5: K1, *yo, sk2p, yo, k3; rep from * to last st, k1.

Row 6: Purl.

Row 7: P1, *p3, k3; rep from * to last st, p1.

Row 8: K1, *p3, k3; rep from * to last st, k1.

Rows 9 & 10: Repeat Rows 7 & 8.

Row 11: K1, *k3, yo, sk2p, yo; rep from * to last st, k1.

Row 12: Purl.

Repeat: Rows 1–12

Abbreviation

Sk2p: Slip 1 as if to knit, k2tog, pass slipped st over.

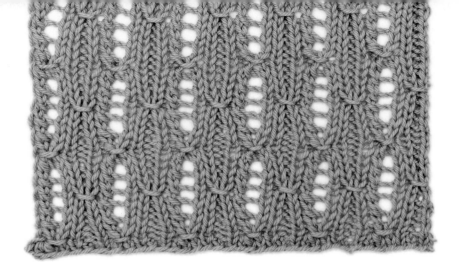

130 Stockinette Lacy Smocking

Stockinette blocks are linked together with cluster stitches to create a lacy, smocked effect. The lacy eyelets make the fabric lighter and softer, and it would be possible to use this as an all-over pattern in a lacy top or vest. It could also be used as an interesting large rib.

Yarn: Laceweight to worsted

Multiple: 6 sts + 2

Row 1 (RS): K1, *k1, p1, k4; rep from * to last st, k1.

Row 2: P1, *p2togtbl, yo, p2, k1, p1; rep from * to last st, p1.

Row 3: K1, *k1, p1, k1, CL3; rep from * to last st, k1.

Rows 4: Repeat Row 2.

Rows 5–8: Repeat Rows 1 & 2 twice.

Row 9: K1, *CL3, k3; rep from * to last st, k1.

Row 10: Repeat Row 2.

Rows 11 & 12: Repeat Rows 1 & 2.

Repeat: Rows 1–12

Abbreviation

CL3: Cluster 3 stitches. Slip 3 sts wyib, pass yarn to front, slip the 3 sts back to LH needle, return yarn to back then knit these 3 sts.

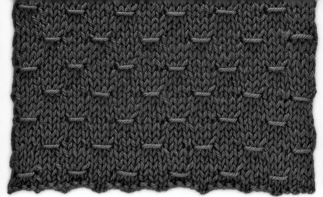

131 Stockinette Smocking

This is a delicate pattern that makes a lovely addition to a simple stockinette fabric. The clusters can be pulled in just a little, as here, or more firmly for a textured look. This pattern will work well in a wide range of yarn types and weights.

Yarn: Light fingering to bulky

Multiple: 6 sts + 2

Row 1 (RS): Knit.

Row 2 and all WS rows: Purl.

Row 3: K1, *k3, CL3; rep from * to last st, k1.

Row 5: Knit.

Row 7: K1, *CL3, k3; rep from * to last st, k1.

Row 8: Purl.

Repeat: Rows 1–8

Abbreviation

CL3: Cluster 3 stitches. Slip 3 sts wyib, pass yarn to front, slip the 3 sts back to LH needle, return yarn to back then knit these 3 sts.

132 Open Star Stitch

Deep, soft texture with strong diagonal lines characterize this pattern stitch. With only four rows and a simple three-stitch pattern, it is relatively quick to knit and unusually the diagonals do not create a particular bias in the fabric.

Yarn: Laceweight to bulky

Multiple: 3 sts + 3

Row 1 (WS): K2, *yo, k3p; rep from * to last st, k1.

Row 2: Knit.

Row 3: K1, *k3p, yo; rep from * to last 2 sts, k2.

Row 4: Knit.

Repeat: Rows 1–4

Abbreviation

K3p: K3, pass first st over second and third sts and drop off needle.

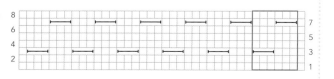

133 Dimple Stitch

This pattern with its deep, soft texture will work best with a smooth yarn. Keep the strands from the slipped stitches as even as possible for a neat result. Note that the slipped stitches are stranded across the front of the work. This pattern would make a lovely jacket as it has plenty of texture without being heavy. In a bulky yarn it would also make interesting soft furnishings.

Yarn: Laceweight to bulky

Multiple: 6 sts + 7

Row 1 (WS): Purl.

Row 2: K2, *[sl1 wyif] three times, k3; rep from * to last 5 sts, [sl1 wyif] three times, k2.

Row 3: P2, [sl1 wyib] three times, *p3, [sl1 wyib] three times; rep from * to last 2 sts, p2.

Row 4: Repeat Row 2.

Row 5: Purl.

Row 6: K2, *k1, Lst, k4; rep from * to last 5 sts, k1, Lst, k3.

Row 7: Purl.

Row 8: K2, *k3, [sl1 wyif] three times; rep from * to last 5 sts, k5.

Row 9: P5, *[sl1 wyib] three times, p3; rep from * to last 2 sts, p2.

Row 10: Repeat Row 8.

Row 11: Purl.

Row 12: K2, *k4, Lst, k1; rep from * to last 5 sts, k5.

Repeat: Rows 1–12

Abbreviation

Lst: Lift strand/s. Insert needle under loose strand and knit next st, lifting st in front of strand. As the stitch is completed lift the strands over the st.

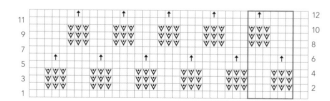

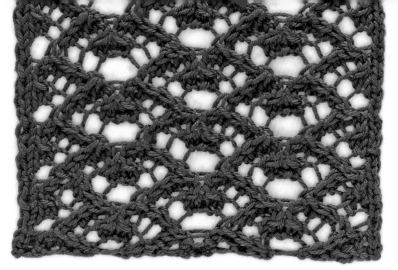

134 Shower Stitch

A combination of rich textures and eyelets make this a very dramatic pattern when blocked. The lacy eyelets reduce the density of the fabric, making it less heavy and adding some fluidity, while still retaining the depth of texturing. If you are working in a heavier yarn, a larger than normal needle may be used to give the fabric a softer feel.

Yarn: Laceweight to worsted

Multiple: 12 sts + 4

Row 1 (RS): K2, *k2tog, yo, k2, k2tog, [yo] twice, ssk, k2, yo, ssk; rep from * to last 2 sts, k2.

Row 2: P2, *p3, p2togtbl, yo, kpyo, yo, p2tog, p3; rep from * to last 2 sts, p2.

Row 3: K2, *k2, k2tog, yo, k4, yo, ssk, k2; rep from * to last 2 sts, k2.

Row 4: P2, *p3togtbl, yo, p1, yo, p4, yo, p1, yo, p3togtbl; rep from * to last 2 sts, p2.

Row 5: K2, *yo, ssk, k2, yo, ssk, k2tog, yo, k2, k2tog, yo; rep from * to last 2 sts, k2.

Row 6: P2, *k1, yo, p2tog, p6, p2togtbl, yo, p1; rep from * to last 2 sts, p2.

Row 7: K2, *k2, yo, ssk, k4, k2tog, yo, k2; rep from * to last 2 sts, k2.

Row 8: P2, *p2, yo, p1, yo, p3tog, p3togtbl, yo, p1, yo, p2; rep from * to last 2 sts, p2.

Repeat: Rows 1–8

Abbreviations

Ssk: Slip, slip, knit. Slip 2 sts one at a time as if to knit, knit 2 slipped sts together.

Kpyo: Knit into first yo, then purl into second yo.

Notes: To work p3tog in this stitch, first purl next 2 sts together, slip st back onto LH needle. Lift second st on LH needle over first, and slip remaining st onto RH needle.

The yos between repeats in Row 5 effectively form a double yo (as in Row 1). When working Row 6, the p1 at start of repeat and k1 at end of repeat are worked into the double yo (as in Row 2).

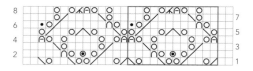

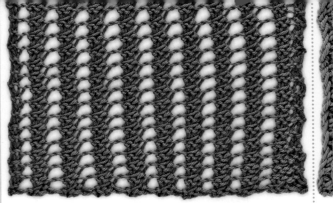

135 Rippled Pillar Stitch

A very open, fluid fabric that can bias, so it needs careful blocking. This pattern would look interesting with bands of stockinette or garter stitch between the repeats, or even as part of a cable panel.

Yarn: Light fingering to bulky

Multiple: 3 sts + 4

Row 1 (RS): Purl.
Row 2: P2, *yo, [sl1 purlwise, k2, psso]; rep from * to last st, p2.

Repeat: Rows 1–2. End with Row 1.

136 Lifted Ladder Rib

Dropping any stitch always feels a little scary but it's worth it for this interestingly textured fabric. It is soft but lofty, and so nice and warm. It could be worked as an all-over fabric, or one or two repeats could be used as a band or trim.

Yarn: Laceweight to bulky

Multiple: 3 sts + 2

Row 1 (WS): K2, *p1, k2; rep from * to end.
Row 2: *P2, k1; rep from * to last 2 sts, p2.
Rows 3 & 4: Repeat Rows 1 & 2.
Row 5: Repeat Row 1.
Row 6: *P2, d4; rep from * to last 2 sts, p2.

Repeat: Rows 1–6

Abbreviation

D4: Drop down 4 rows. Allow next st (a knit) to drop off the LH needle, and unravel it for 4 rows, so that there are 4 "ladder rungs" above it. Put LH needle into that st from front to back, and knit through that st. After you complete the st, you'll see that all of the "ladder rungs" are also caught up in the st, creating the lifted appearance.

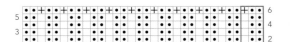

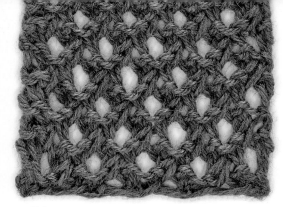

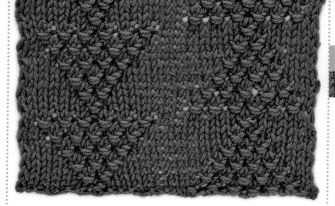

137 Lacy Diagonal Brioche

Diagonal brioche creates a delightful, open yet neatly structured and stable fabric. It is soft and fluid but retains its shape well. It can be worked in a wide range of yarn weights—smooth yarns will bring out the lacy texture best, but it could also be used with a textured yarn for a more subtly lacy effect.

Yarn: Light fingering to worsted

Multiple: 3 sts + 3

Row 1 (WS): P2, *sl1 wyib, yo, p1; rep from * to last st, p1.

Row 2: Sl1 wyib, p1, *sl1 wyib, p2; rep from * to last st, p1.

Row 3: P1, sl1 wyib, yo, *p2tog, sl1 wyib, yo; rep from * to last st, p1.

Row 4: P1, *sl1 wyib, p2; rep from * to end.

Row 5: Sl1 wyib, p2tog, *sl1 wyib, yo, p2tog; rep from * to last st, p1.

Repeat: Rows 2–5

138 Pyramid Clusters

Groupings of cluster stitches make this a lovely, stylish motif, set on a background of stockinette stitch. The pattern could be readily adapted and single motifs combined or rearranged to create many interesting variations.

Yarn: Laceweight to bulky

Multiple: 28 sts + 2

Row 1 (RS): K1, *k1, [CL2] six times, k7, CL2, k6; rep from * to last st, k1.

Row 2 and all WS rows: Purl.

Row 3: K1, *k2, [CL2] five times, k7, [CL2] twice, k5; rep from * to last st, k1.

Row 5: K1, *k3, [CL2] four times, k7, [CL2] three times, k4; rep from * to last st, k1.

Row 7: K1, *k4, [CL2] three times, k7, [CL2] four times, k3; rep from * to last st, k1.

Row 9: K1, *k5, [CL2] twice, k7, [CL2] five times, k2; rep from * to last st, k1.

Row 11: K1, *k6, CL2, k7, [CL2] six times, k1; rep from * to last st, k1.

Row 12: Purl.

Repeat: Rows 1–12

Abbreviation

CL2: Cluster 2 stitches, twice wrapped. Slip 2 sts wyib, bring yarn to front between needles, slip same 2 sts back to LH needle, pass yarn to back between needles, slip same 2 sts wyib again, bring yarn to front between needles, slip same 2 sts back to LH needle, k2 slipped sts.

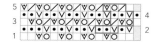

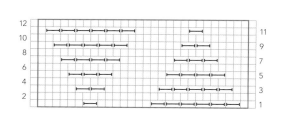

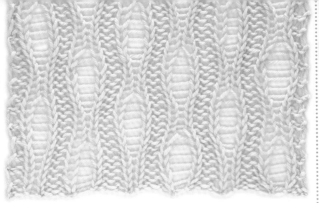

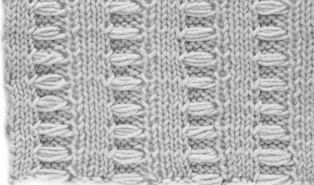

139 Vertical Drop Stitch

This pattern is big and bold, but the dropped stitches give it a light, open texture, making it look great as an all-over pattern. For best results, practice the dropped stitch technique to make sure you are happy with controlling the stitches. Once blocked this pattern reveals its true beauty.

Yarn: Light fingering to bulky

Multiple: 9 sts + 2

Note: Cast on a multiple of 8 sts + 2 to allow for increased sts in Row 1.

Row 1 (RS): P1, *p1, k1, yo, k1, p2, k2, p1; rep from * to last st, p1.

Row 2: K1, *k1, p2, k2, p3, k1; rep from * to last st, k1.

Row 3: P1, *p1, k3, p2, k2, p1; rep from * to last st, p1.

Rows 4 & 5: Repeat Rows 2 & 3.

Row 6: Repeat Row 2.

Row 7: P1, *p1, k1, d6, k1, p2, k1, yo, k1, p1; rep from * to last st, p1.

Row 8: K1, *k1, p3, k2, p2, k1; rep from * to last st, k1.

Row 9: P1, *p1, k2, p2, k3, p1; rep from * to last st, p1.

Rows 10 & 11: Repeat Rows 8 & 9.

Row 12: Repeat Row 8.

Row 13: P1, *p1, k1, yo, k1, p2, k1, d6, k1, p1; rep from * to last st, p1.

Repeat: Rows 2–13

Abbreviation

D6: Drop down 6 rows. Allow next st (a knit) to drop off the LH needle, and unravel it for 6 rows until it reaches the yo, so that there are 6 "ladder rungs" above it. Continue to follow pattern as set.

140 Bamboo Stitch

A fun variation on a basic 4 × 4 rib, created by wrapping the yarn around the purled sections of the rib. The wraps are worked quite loosely here, but for a different effect, experiment with tighter wraps to accentuate the texture and create a more pleated fabric.

Yarn: Fingering to bulky

Multiple: 8 sts + 4

Row 1 (RS): *K4, w4; rep from * to last 4 sts, k4.

Row 2: P4, *k4, p4; rep from * to end.

Row 3: *K4, p4; rep from * to last 4 sts, k4.

Row 4: Repeat Row 2.

Repeat: Rows 1–4

Abbreviation

W4: Wrap 4 stitches. Slip 4 sts to cable needle, wind yarn clockwise around these sts four times, slip sts to RH needle.

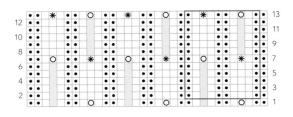

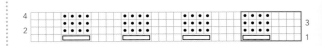

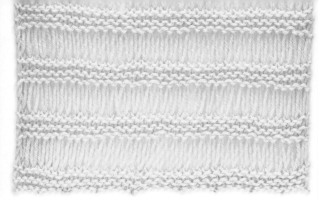

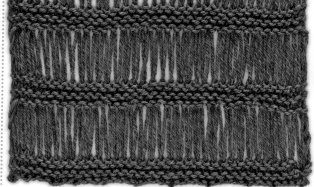

141 Short Drop Stitch

Elongated stitches are an interesting way to add bold, open textures. They create light fabrics and look particularly interesting worked in textured yarns. It is also fun to experiment with combinations of plain yarn for the garter stitch sections and textured yarn for the elongated stitches. Block elongated stitch patterns carefully to ensure an even finish.

Yarn: Light fingering to worsted

Multiple: 1 st + 2

Repeat: Rows 1–6

Row 1 (RS): Knit.

Rows 2–4: Knit.

Row 5: K1, *k1 elongated twice; rep from * to last st, k1.

Row 6: Knit.

Abbreviation

K1 elongated twice: Knit a st wrapping yarn around needle three times. On next row drop the extra wraps from needle.

142 Long Drop Stitch

Elongated stitches do have limits but in a thicker yarn it is possible to wrap the needle as many as six times and still retain the stitch structure and a useable fabric—as demonstrated in this pattern. Elongated stitch patterns look lovely in lightweight summer wear or decorative scarves.

Yarn: Fingering to bulky

Multiple: 1 st + 2

Repeat: Rows 1–6

Row 1 (RS): Knit.

Rows 2–4: Knit.

Row 5: K1, *k1 elongated five times; rep from * to last st, k1.

Row 6: Knit.

Abbreviation

K1 elongated five times: Knit a st wrapping yarn around needle six times. On next row drop the extra wraps from needle.

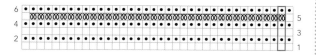

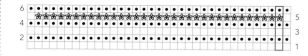

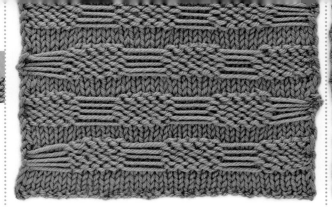

143 Rungs of the Ladder

Slipped stitches create the "rungs" bound by blocks of reverse stockinette stitch. Separating these with bands of stockinette creates a fabric that is both interesting and stylish. If you are not familiar with slipped stitches, it is worth practicing first as the strands need to be evenly tensioned for the best results.

Yarn: Fingering to bulky

Multiple: 10 sts + 2

Row 1 (RS): Knit.

Row 2: Purl.

Rows 3 & 4: Repeat Rows 1 & 2.

Row 5: Knit.

Row 6: K1, *[sl1 wyib] five times, k5; rep from * to last st, k1.

Row 7: P1, *p5, [sl1 wyif] five times; rep from * to last st, p1.

Rows 8 & 9: Repeat Rows 6 & 7.

Row 10: Repeat Row 6.

Rows 11–15: Repeat Rows 1–5.

Row 16: K1, *k5, [sl1 wyib] five times; rep from * to last st, k1.

Row 17: P1, *[sl1 wyif] five times, p5; rep from * to last st, p1.

Rows 18 & 19: Repeat Rows 16 & 17.

Row 20: Repeat Row 16.

Repeat: Rows 1–20

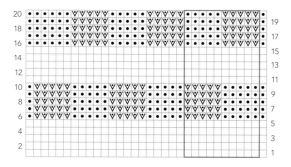

144 Ladder Rib

It's always nice to have a selection of interesting ribs to play with when designing as they add a touch of something different even on an otherwise simple garment. This ladder rib uses slipped stitches to create the "rungs." If you are new to slipped stitches, practice a little first, as the strands need to be evenly tensioned for best results.

Yarn: Light fingering to bulky

Multiple: 4 sts + 2

Row 1 (WS): K2, *p2, k2; rep from * to end.

Row 2: *P2, [sl1 wyif] twice; rep from * to last 2 sts, p2.

Repeat: Rows 1–2

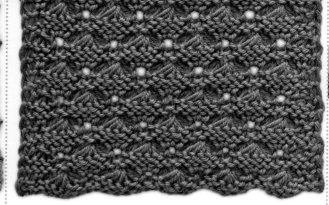

145 Zigzag Swag Stitch

Slipped stitches give this zigzag pattern real impact, while keeping it simple. Keeping the slipped strands even is important, but otherwise it is a quick, fun pattern that makes a great all-over fabric. To emphasize the strands, a smooth yarn will work best, but try it in different weight yarns for interesting effects.

Yarn: Light fingering to bulky

Multiple: 5 sts + 2

Row 1 (WS) and all WS rows: K1, purl to last st, k1.

Row 2: K1, *[sl1 wyif] three times, p2; rep from * to last st, k1.

Row 4: K1, *p1, [sl1 wyif] three times, p1; rep from * to last st, k1.

Row 6: K1, *p2, [sl1 wyif] three times; rep from * to last st, k1.

Row 8: K1, *sl1 wyif, p2, [sl1 wyif] twice; rep from * to last st, k1.

Row 10: K1, *[sl1 wyif] twice, p2, sl1 wyif; rep from * to last st, k1.

Row 12: Repeat Row 8.

Row 14: Repeat Row 6.

Row 16: Repeat Row 4.

Repeat: Rows 1–16

146 Dropped Garter Diamonds

This densely textured pattern would make an interesting border or, for the more ambitious knitter, a stunning all-over pattern. The garter ridges emphasize the gathers and increases. Worked in a light yarn it will produce a delicate fabric; if worked in a heavier yarn it may be necessary to go up a couple of needle sizes to achieve the desired softness in the fabric.

Yarn: Fingering to bulky

Multiple: 6 sts + 9

Row 1 (RS): Knit.

Row 2: Knit.

Row 3: K1, m3, [k1 elongated] twice, *[k1 elongated] three times, inc1to 5, [k1 elongated] twice; rep from * to last 5 sts, [k1 elongated] three times, m3, k1.

Row 4: K4, k5tog, *k5, k5tog; rep from * to last 4 sts, k4.

Rows 5 & 6: Knit.

Row 7: K1, [k1 elongated] three times, *inc1to5, [k1 elongated] five times; rep from * to last 5 sts, inc1to5, [k1 elongated] three times, k1.

Row 8: K1, p3tog, k3, *k2, k5tog, k3; rep from * to last 6 sts, k2, p3tog, k1.

Repeat: Rows 1–8

Abbreviations

M3: Make 3 from 1 (increasing 2 sts). [K1, yo, k1] in next st.

K1 elongated: Knit a st wrapping yarn around needle twice. On next row drop the extra wrap from needle.

Inc1to5: Make 5 sts from 1. [(K1, p1) twice, k1] in next st.

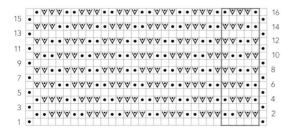

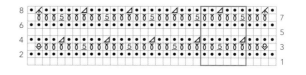

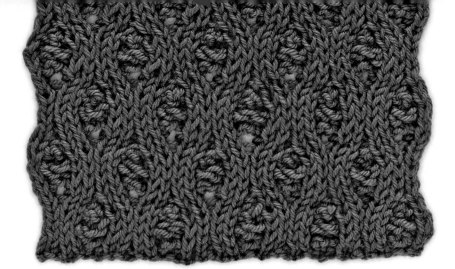

147 Knots in Bark

This pattern has the appearance of a cable or twist, but it is actually the multiple increases and decreases that create the lovely undulating effect. The motif "knots" are straightforward to work and could be readily inserted into other patterns for nubby texture.

Yarn: Light fingering to bulky

Multiple: 6 sts + 2

Row 1 (RS): K1, *k1, mir1, k2, p1, k1; rep from * to last st, k1.

Row 2: P1, *p1, k1, p2, mir2, p1; rep from * to last st, p1.

Row 3: K1, *k1, mir3, k2, p1, k1; rep from * to last st, k1.

Row 4: P1, *p1, k1, p2, mir4, p1; rep from * to last st, p1.

Row 5: K1, *k1, mir5, k2, p1, k1; rep from * to last st, k1.

Row 6: P1, *p1, k1, p2, mir6, p1; rep from * to last st, p1.

Row 7: K1, *k1, p1, k2, mir1, k1; rep from * to last st, k1.

Row 8: P1, *p1, mir2, p2, k1, p1; rep from * to last st, p1.

Row 9: K1, *k1, p1, k2, mir3, k1; rep from * to last st, k1.

Row 10: P1, *p1, mir4, p2, k1, p1; rep from * to last st, p1.

Row 11: K1, *k1, p1, k2, mir5, k1; rep from * to last st, k1.

Row 12: P1, *p1, mir6, p2, k1, p1; rep from * to last st, p1.

Repeat: Rows 1–12

Puff motif: Insert when instructed by main chart.

Row 1 (RS): Inc1to4.

Row 2: [K1, yo] three times, k1.

Row 3: [P1, dyo] three times, p1.

Row 4: [K1, yo] three times, k1.

Row 5: [P1, dyo] three times, p1.

Row 6: P4tog.

Abbreviations

Mir1–mir6: Motif insert Rows 1–6. Work the relevant row (1–6) from the motif chart below right.

Inc1to4: Make 4 sts from 1. [K1, p1, k1, p1] in next st.

Dyo: Drop yo from preceding row.

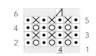

148 Crochet-Style Shell

The attractiveness of this pattern isn't truly appreciated until the swatch has been blocked. Once blocked the lovely shell shapes emerge and this makes a super all-over pattern.

Yarn: Light fingering to worsted

Multiple: 8 sts + 2

Row 1 (WS): K1, [yo, k1] to last st, k1.

Row 2: K1, [k1, dyo] to last st, k1.

Row 3: K1, *[yo] twice, k1, [yo] twice, k3tog; rep from * to last st, k1.

Row 4: K1, [k1, k1f&b] to last st, k1.

Row 5: K1, [yo, k1] to last st, k1.

Row 6: K1, [k1, dyo] to last st, k1.

Row 7: K1, *[yo] twice, s2k3p, [yo] twice, k1; rep from * to last st, k1.

Row 8: Repeat Row 4.

Repeat: Rows 1–8

Abbreviations

Dyo: Drop yo from preceding row.

K1f&b: Knit into front and back of the yo from the preceding row.

S2k3p: Slip 2 sts as if to k2tog, k3tog, pass 2 slipped sts over.

149 Crochet-Style Trellis

The trellis stitch in this pattern is a little fiddly, but it is well worth the effort as it produces a lovely interwoven pattern. A garter stitch band adds little nupps of texture for extra interest.

Yarn: Laceweight to bulky

Multiple: 4 sts + 6

Row 1 (WS): P1, [p1 elongated twice] to last st, p1.

Row 2: K4, [trellis 4] to last 2 sts, k2.

Row 3: Repeat Row 1.

Row 4: K3, [trellis 4] to last 3 sts, k3.

Rows 5 & 6: Knit.

Repeat: Rows 1–6

Abbreviations

P1 elongated twice: Purl a st wrapping yarn around needle three times. On next row drop the extra wraps from needle.

Trellis 4: 4-stitch trellis stitch. Slip 4 sts to RH needle, dropping the extra yos from preceding row to form a long loop. Slip 4 sts back to LH needle. Insert RH needle into sts 3 and 4 on LH needle and lift over sts 1 and 2 but keeping all sts on LH needle. Knit these 4 sts keeping sts in this order: 3, 4, 1, 2.

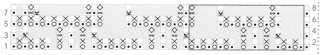

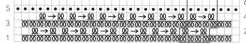

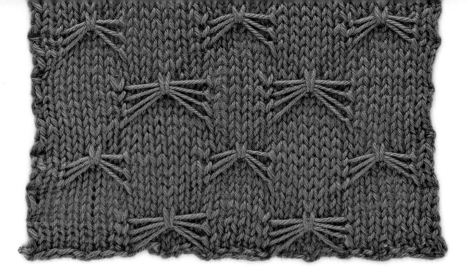

150 Bows

These pretty bows are simple to make and can be used as an all-over pattern or as single motifs. The basic structure of the bow is easily mastered and it is then possible to experiment with different sizes, positions, and yarns.

Yarn: Light fingering to bulky

Multiple: 12 sts + 9

Row 1 (RS): K2, *k5, [sl1 wyif] seven times; rep from * to last 7 sts, k7.

Row 2 and all WS rows: Purl.

Row 3: Repeat Row 1.

Row 5: Repeat Row 1.

Row 7: Repeat Row 1.

Row 9: K2, *k8, Lst, k3; rep from * to last 7 sts, k7.

Row 11: K2, *[sl1 wyif] five times, k7; rep from * to last 7 sts, [sl1 wyif] five times, k2.

Row 13: Repeat Row 11.

Row 15: Repeat Row 11.

Row 17: K2, *k2, Lst, k9; rep from * to last 7 sts, k2, Lst, k4.

Row 18: Purl.

Repeat: Rows 1–18

Abbreviation

Lst: Lift strand/s. Insert needle under loose strand and knit next st, lifting st in front of strand. As the st is completed lift the strands over the st.

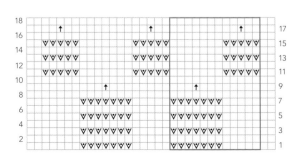

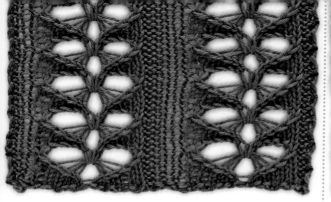

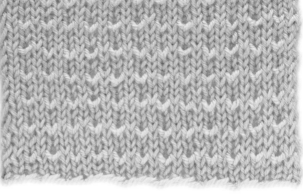

151 Honeybee

The honeybee motif is a lovely decorative pattern that can be used as an individual accent on a garment or in all manner of combinations in other designs. It looks lovely as a center panel in a cable or twist design, and can be worked in a wide range of yarns, including fluffy yarns such as mohair or angora.

Yarn: Light fingering to bulky

Multiple: 17 sts

Row 1 (RS): *P2, k12, p2; rep from * to end.

Row 2: *K2, p12, k2; rep from * to end.

Row 3: *P2, k4, k2tog, yo, ssk, k4, p2; rep from * to end.

Row 4: *K2, p3, p2togtbl, drop yo from Row 3, [yo] twice, p2tog, p3, k2; rep from * to end.

Row 5: *P2, k2, k2tog, drop yos from Row 4, [yo] three times, ssk, k2, p2; rep from * to end.

Row 6: *K2, p1, p2togtbl, drop yos from Row 5, [yo] four times, p2tog, p1, k2; rep from * to end.

Row 7: *P2, k2tog, drop yos from Row 6, CO 4, Lst, yo, Lst, CO 4, ssk, p2; rep from * to end.

Row 8: *K2, p5, p2tog, p6, k2; rep from * to end.

Repeat: Rows 2–8

Abbreviations

Ssk: Slip, slip, knit. Slip 2 sts one at a time as if to knit, knit 2 slipped sts together.

CO: Cast on using backward loop method. Insert RH needle in back of loop on LH needle. Wrap yarn as if to knit, pull through loop, and transfer onto LH needle. 1 st cast on.

Lst: Lift strand/s. Insert needle under loose strand and knit next st, lifting st in front of strand. As the st is completed lift the strands over the st.

152 Stockinette Waffle

This straightforward pattern can be worked in a wide range of yarns, and the simple purl below stitch adds a little bit of interest to an otherwise plain stockinette fabric.

Yarn: Light fingering to bulky

Multiple: 2 sts + 1

Row 1 (RS): Knit.

Row 2: Purl.

Row 3: Knit.

Row 4: *P1, p1b; rep from * to last st, p1.

Repeat: Rows 1–4

Abbreviation

P1b: Purl 1 below. P1 in row below, inserting RH needle from behind into the st in the row. Purl this st as well as the st above it on the LH needle.

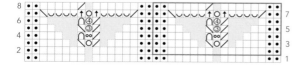

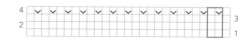

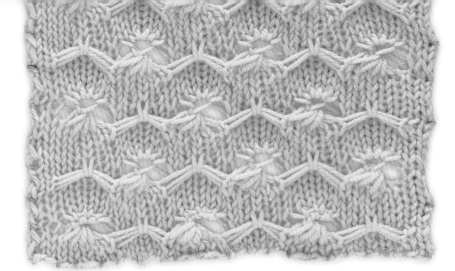

153 Dimpled Diamonds

There is a lot going on with this pattern, but it is worth the patience. It gives great texture and interest, and can be worked in a wide range of yarns into a fascinating all-over pattern.

Yarn: Light fingering to bulky

Multiple: 10 sts + 4

Row 1 (WS): Purl.

Row 2: K2, *[sl1 wyif] five times, k5; rep from * to last 2 sts, k2.

Row 3: P2, *p5, [sl1 wyib] five times; rep from * to last 2 sts, p2.

Row 4: K2, *[sl1 wyif] five times, [k1 elongated] five times; rep from * to last 2 sts, k2.

Row 5: P2, *g5, p5; rep from * to last 2 sts, p2.

Row 6: Knit.

Row 7: Purl.

Row 8: K2, *k2, Lst, k7; rep from * to last 2 sts, k2.

Row 9: Purl.

Row 10: K2, *k5, [sl1 wyif] five times; rep from * to last 2 sts, k2.

Row 11: P2, *[sl1 wyib] five times, p5; rep from * to last 2 sts, p2.

Row 12: K2, *[k1 elongated] five times, [sl1 wyif] five times; rep from * to last 2 sts, k2.

Row 13: P2, *p5, g5; rep from * to last 2 sts, p2.

Row 14: Knit.

Row 15: Purl.

Row 16: K2, *k7, Lst, k2; rep from * to last 2 sts, k2.

Repeat: Rows 1–16

Abbreviations

K1 elongated: Knit a st wrapping yarn around needle twice. On next row drop the extra wrap from needle.

G5: Gather 5 wrapped into 5. Slip 5 sts from LH to RH needle, dropping extra wraps from preceding row. Return 5 sts to LH needle. K5tog, slip st back to LH needle, [(k1tbl, k1, k1tbl, k1) twice, k1tbl] in this st.

Lst: Lift strand/s. Insert needle under loose strand and knit next st, lifting st in front of strand. As the st is completed lift the strands over the st.

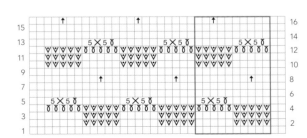

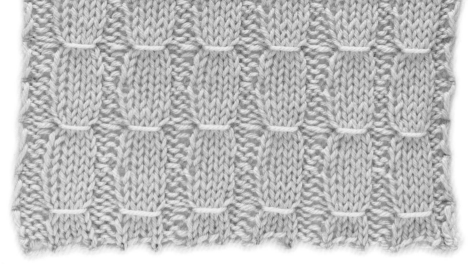

154 Offset Clusters

This stylish clustered panel is called offset because on the reverse are two-stitch clusters that sit between the larger four-stitch clusters on the front. These draw out the stockinette sections gently while the four-stitch clusters draw in the top and bottom of each section. This creates the hourglass shapes without significantly distorting the fabric.

Yarn: Light fingering to bulky

Multiple: 6 sts + 8

Row 1 (RS): P2, *k4, p2; rep from * to end.

Row 2: *K2, p4; rep from * to last 2 sts, k2.

Rows 3 & 4: Repeat Rows 1 & 2.

Row 5: P2, *CL4, p2; rep from * to end.

Row 6: Repeat Row 2.

Rows 7 & 8: Repeat Rows 1 & 2.

Row 9: Repeat Row 1.

Row 10: K2, p4, *CL2, p4; rep from * to last 2 sts, k2.

Repeat: Rows 1–10

Abbreviations

CL4: Cluster 4 stitches. Slip 4 sts wyib, pass yarn to front, slip the 4 sts back to LH needle, knit the 4 slipped sts.

CL2: Cluster 2 stitches, twice wrapped. Slip 2 sts wyib, bring yarn to front between needles, slip same 2 sts back to LH needle, pass yarn to back between needles, slip same 2 sts wyib again, bring yarn to front between needles, slip same 2 sts back to LH needle, knit the 2 slipped sts.

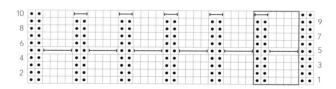

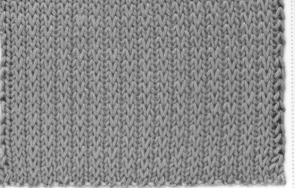

155 Heel Stitch

This simple two-row pattern produces a deep rib. The use of slipped stitches gives it a particularly springy texture, which is why it is often used for sock heels.

Yarn: Fingering to worsted

Multiple: 2 sts + 1

Row 1 (WS): Purl.
Row 2: K1, *sl1 wyib, k1; rep from * to end.

Repeat: Rows 1–2

156 Pine Cone

An interesting slip stitch pattern in which the strands are lifted and looped over to create the distinctive shape, like the overlapping scales of a pine cone. This stitch creates a springy rather than drapey fabric with good stretch.

Yarn: Fingering to worsted

Multiple: 4 sts + 5

Row 1 (WS) and all WS rows: Purl.
Row 2: K1, *[sl1 wyif] three times, k1; rep from * to end.
Row 4: Repeat Row 2.
Row 6: K1, *k1, Lst, k2; rep from * to end.
Row 8: K3, *[sl1 wyif] three times, k1; rep from * to last 2 sts, k2.
Row 10: Repeat Row 8.
Row 12: K3, *k1, Lst, k2; rep from * to last 2 sts, k2.

Repeat: Rows 1–12

Abbreviation

Lst: Lift strand/s. Insert needle under loose strand and knit next st, lifting st in front of strand. As the st is completed lift the strands over the st.

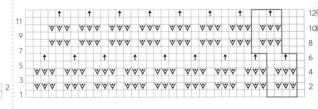

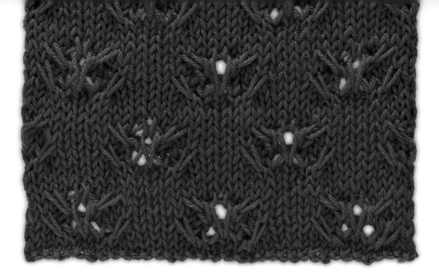

157 Flickering Flames

This richly textured pattern uses wraps to create elongated "flames" around lacy eyelets. The chart appears lengthy as it is worked with larger panels of offset flame clusters, but each cluster can be worked individually over nine stitches and five rows.

Yarn: Fingering to worsted

Multiple: 12 sts + 13

Row 1 (RS): Knit.

Row 2: Purl.

Row 3: K2, *k2, sl1 wyib, k1 elongated, k1 elongated twice, k1 elongated, sl1 wyib, k5; rep from * to last 11 sts, k2, sl1 wyib, k1 elongated, k1 elongated twice, k1 elongated, sl1 wyib, k4.

Row 4: P4, [sl1 wyif, p1] twice, sl1 wyif, p2, *p5, [sl1 wyif, p1] twice, sl1 wyif, p2; rep from * to last 2 sts, p2.

Row 5: K2, *1/2 RC, k1 elongated, sl1 wyib, k1 elongated, 1/2 LC, k3; rep from * to last 11 sts, 1/2 RC, k1 elongated, sl1 wyib, k1 elongated, 1/2 LC, k2.

Row 6: P6, p1 elongated, p4, *p7, p1 elongated, p4; rep from * to last 2 sts, p2.

Row 7: K2, *k1, 1/2 RC, sl1 wyib, 1/2 LC, k4; rep from * to last 11 sts, k1, 1/2 RC, sl1 wyib, 1/2 LC, k3.

Row 8: Purl.

Row 9: Knit.

Row 10: Purl.

Row 11: K1, k1 elongated, sl1 wyib, k2, *k5, sl1 wyib, k1 elongated, k1 elongated twice, k1 elongated, sl1 wyib, k2; rep from * to last 8 sts, k5, sl1 wyib, k1 elongated, k1.

Row 12: P2, sl1 wyif, p5, *p2, [sl1 wyif, p1] twice, sl1 wyif, p5; rep from * to last 5 sts, p2, sl1 wyif, p2.

Row 13: K1, k1 elongated, 1/2 LC, *k3, 1/2 RC, k1 elongated, sl1 wyib, k1 elongated, 1/2 LC; rep from * to last 8 sts, k3, 1/2 RC, k1 elongated, k1.

Row 14: P8, *p4, p1 elongated, p7; rep from * to last 5 sts, p5.

Row 15: K1, 1/2 LC, k1, *k4, 1/2 RC, sl1 wyib, 1/2 LC, k1; rep from * to last 8 sts, k4, 1/2 RC, k1.

Row 16: Purl.

Repeat: Rows 1–16

Abbreviations

K1 elongated: Knit a st wrapping yarn around needle twice. On next row drop the extra wrap from needle.

K1 elongated twice: Knit a st wrapping yarn around needle three times. On next row drop the extra wraps from needle.

1/2 RC: 3-stitch right cable. Slip 2 sts to cable needle and hold in back, k1, k2 from cable needle.

1/2 LC: 3-stitch left cable. Slip 1 st to cable needle and hold in front, k2, k1 from cable needle.

P1 elongated: Purl a st wrapping yarn around needle twice. On next row drop the extra wrap from needle.

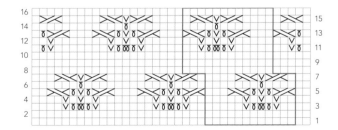

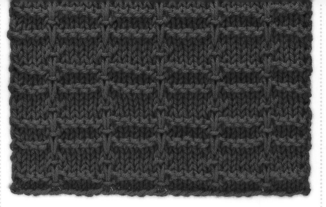

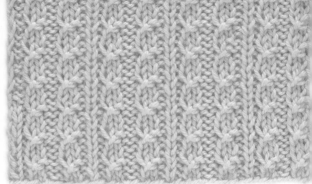

158 Ridged Slip Stitch

An interesting but not too bulky texture and nicely balanced blocks make this a good choice for an all-over pattern. Vary the pattern by reducing or increasing the size of the blocks.

Yarn: Fingering to bulky

Multiple: 6 sts + 5

Row 1 (WS): Purl.

Row 2: K5, *sl1 wyib, k5; rep from * to end.

Row 3: *P5, sl1 wyib; rep from * to last 5 sts, p5.

Row 4: P5, *sl1 wyib, p5; rep from * to end.

Row 5: *P5, sl1 wyif; rep from * to last 5 sts, p5.

Row 6: Knit.

Row 7: *P5, sl1 wyib; rep from * to last 5 sts, p5.

Row 8: K5, *k1 elongated, k5; rep from * to end.

Row 9: *P5, sl1 wyif; rep from * to last 5 sts, p5.

Row 10: P5, *sl1 wyib, p5; rep from * to end.

Repeat: Rows 1–10

Abbreviation

K1 elongated: Knit a st wrapping yarn around needle twice. On next row drop the extra wrap from needle.

159 Reverse Wrapped Rib Stitch

This very simple four-row pattern repeat is a series of three syncopated rib rows interspersed with just one wrap row. It creates an interesting pattern that is quite different but equally attractive on both sides. As it has good stretch, it could be used as an alternative welt, cuff, or neckline.

Yarn: Fingering to bulky

Multiple: 9 sts + 8

Row 1 (RS): *P1, k2, p2, k2, p1, k1; rep from * to last 8 sts, p1, k2, p2, k2, p1.

Row 2: K1, p2, k2, p2, k1, *p1, k1, p2, k2, p2, k1; rep from * to end.

Row 3: *P1, [sl wyif] twice, p2, [sl wyif] twice, p1, k1; rep from * to last 8 sts, p1, [sl wyif] twice, p2, [sl wyif] twice, p1.

Row 4: K1, p2, k2, p2, k1, *p1, k1, p2, k2, p2, k1; rep from * to end.

Repeat: Rows 1–4

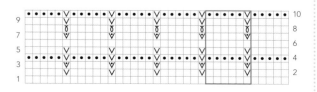

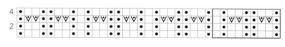

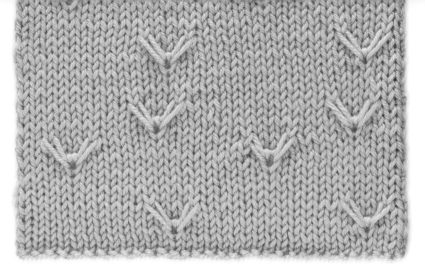

160 Birds in Flight

The birds in this slip stitch pattern are worked here to produce a motif that appears random but is actually a large pattern repeat. It is relatively straightforward to extract the bird element of the motif and place it in different locations for a range of effects.

Yarn: Fingering to worsted

Multiple: 16 sts + 2

Row 1 (RS): Knit.

Row 2: Purl.

Row 3: *K4, m3, k11; rep from * to last 2 sts, k2.

Row 4: P2, *p11, sl1 wyif, p1, sl1 wyif, p4; rep from * to end.

Row 5: *K3, sc2r, k1, slc2l, k10; rep from * to last 2 sts, k2.

Row 6: P2, *p10, [sl1 wyib, p3] twice; rep from * to end.

Row 7: *K2, k2tog, k3, ssk, k9; rep from * to last 2 sts, k2.

Row 8: Purl.

Row 9: Knit.

Row 10: Purl.

Row 11: *K12, m3, k3; rep from * to last 2 sts, k2.

Row 12: P2, *p3, sl1 wyif, p1, sl1 wyif, p12; rep from * to end.

Row 13: *K11, sc2r, k1, slc2l, k2; rep from * to last 2 sts, k2.

Row 14: P2, *p2, sl1 wyib, p3, sl1 wyib, p11; rep from * to end.

Row 15: *K5, m3, k4, k2tog, k3, ssk, k1; rep from * to last 2 sts, k2.

Row 16: P2, *p10, sl1 wyif, p1, sl1 wyif, p5; rep from * to end.

Row 17: *K4, sc2r, k1, slc2l, k9; rep from * to last 2 sts, k2.

Row 18: P2, *p9, sl1 wyib, p3, sl1 wyib, p4; rep from * to end.

Row 19: *K3, k2tog, k3, ssk, k8; rep from * to last 2 sts, k2.

Row 20: Purl.

Repeat: Rows 1–20

Abbreviations

M3: Make 3 from 1 (increasing 2 sts). [K1, yo, k1] in next st.

Sc2r: 2-stitch slipped cable right. Drop slipped st off LH needle and hold in front. Slip st just worked from RH to LH needle. Return slipped st to LH needle and knit. Slip st already knitted onto RH needle.

Slc2l: 2-stitch slipped cable left. Drop next st off LH needle, hold in front, k1, return dropped st to LH needle and knit.

Ssk: Slip, slip, knit. Slip 2 sts one at a time as if to knit, knit 2 slipped sts together.

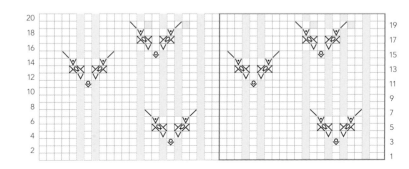

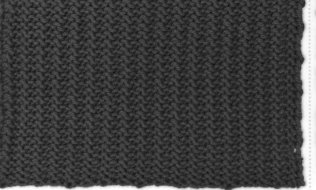

161 Garter Slip Stitch

A simple two-row pattern that produces a dense, richly textured fabric. It has a look of rib about it but is less stretchy. Like corn on the cob stitch, this pattern can also be very effective worked in two colors.

Yarn: Fingering to worsted

Multiple: 2 sts + 1

Row 1 (WS): Knit.
Row 2: *K1, sl1 wyib; rep from * to last st, k1.

Repeat: Rows 1–2

162 Garter Brick Stitch

Short blocks of garter stitch are offset and broken up with slip stitch uprights and stockinette "mortar," to create a balanced, springy fabric that is ideal for an all-over pattern and great for soft furnishings when worked in a bulky yarn on smaller needles.

Yarn: Fingering to bulky

Multiple: 6 sts + 5

Row 1 (RS): Knit.
Row 2: *K5, sl1 wyif; rep from * to last 5 sts, k5.
Row 3: K5, *sl1 wyib, k5; rep from * to end.
Row 4: Repeat Row 4.
Row 5: Knit.

Row 6: Purl.
Row 7: P3, sl1 wyib, p1, *p4, sl1 wyib, p1; rep from * to end.
Row 8: *P1, sl1 wyif, p4; rep from * to last 5 sts, p1, sl1 wyif, p3.
Row 9: Repeat Row 7.
Row 10: Purl.

Repeat: Rows 1–10

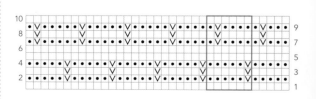

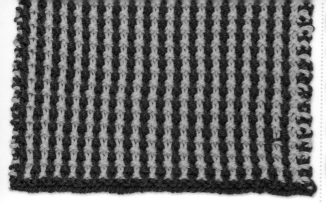

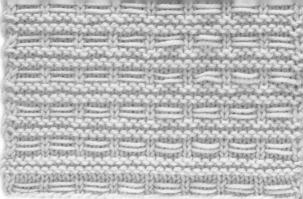

163 Corn On The Cob

Don't let the density of symbols in this chart put you off. This is actually a simple pattern that, once you have established the rhythm, will be easy to follow. It produces a lovely fabric that is firm with little drape.

Yarn: Fingering to worsted

Multiple: 2 sts + 2

Cast on in color A.

Row 1 (WS): In color A, knit.

Row 2: K1, *k1, sl1 wyib; rep from * to last st, k1.

Row 3: K1, *sl1 wyif, k1; rep from * to last st, k1.

Row 4: In color B, k1, *sl1 wyib, k1tbl; rep from * to last st, k1.

Row 5: K1, *k1, sl1 wyif; rep from * to last st, k1.

Repeat: Change color and repeat Rows 2–5, alternating 2 rows in color A, then 2 in color B.

164 Venetian Blind Lattice

A bold but straightforward pattern that would make an excellent band around a cuff or hemline. The firmness of the garter ridges also makes this pattern stitch a suitable edging for blankets, pillows, and other soft furnishings.

Yarn: Fingering to bulky

Multiple: 4 sts + 3

Row 1 (WS): Purl.

Row 2: K1, sl1 wyib, *[sl1 wyif] three times, sl1 wyib; rep from * to last st, k1.

Row 3: Purl.

Row 4: Repeat Row 2.

Rows 5–8: Purl.

Repeat: Rows 1–8

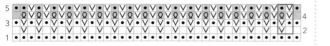

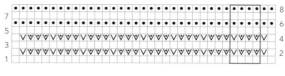

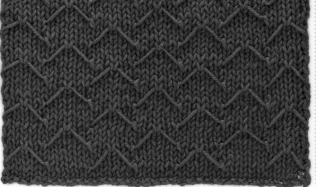

165 Mountain Peaks

By working a simple lifted strand slip stitch and offsetting the pattern repeat, you can create this interesting mountain landscape. Note that the pattern begins with four set-up rows that are worked only at the beginning and end of the piece. This balances the pattern.

Yarn: Fingering to bulky

Multiple: 10 sts + 2

Row 1 (RS): Knit.

Row 2: Purl.

Row 3: K1, *[sl1 wyif] five times, k5; rep from * to last 6 sts, [sl1 wyif] five times, k1.

Row 4: Purl.

Row 5: Knit.

Row 6: Purl.

Row 7: K1, *k2, Lst, k2, [sl1 wyif] five times; rep from * to last st, k1.

Rows 8–10: Repeat Rows 4–6.

Row 11: K1, *[sl1 wyif] five times, k2, Lst, k2; rep from * to last st, k1.

Row 12: Purl.

Repeat: Rows 5–12. End with Rows 1–4.

Abbreviation

Lst: Lift strand/s. Insert needle under loose strand and knit next st, lifting st in front of strand. As the st is completed lift the strands over the st.

166 Wicker Fence

A plump, textured fabric, created by combining slipped stitches. The slipped stitches shorten and pull the fabric up vertically to give the impression of a woven basket. With thicker yarns or for a different effect, add extra rows between the repeats.

Yarn: Fingering to worsted

Multiple: 10 sts + 8

Row 1 (RS): Knit.

Row 2: Knit.

Row 3: K2, *sl1 wyib, k5, sl1 wyib, k3; rep from * to last 6 sts, sl1 wyib, k5.

Row 4: K5, sl1 wyif, *p3, sl1 wyif, k5, sl1 wyif; rep from * to last 2 sts, p2.

Rows 5–8: Repeat Rows 3 & 4 twice.

Row 9: Repeat Row 3.

Row 10: Knit.

Row 11: K6, *sl1 wyib, k3, sl1 wyib, k5; rep from * to last 2 sts, sl1 wyib, k1.

Row 12: P1, sl1 wyif, *p5, sl1 wyif, k3, sl1 wyif; rep from * to last 6 sts, p6.

Rows 13–16: Repeat Rows 11 & 12 twice.

Row 17: Repeat Row 11.

Repeat: Rows 2–17

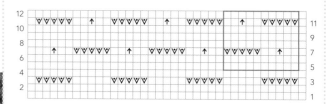

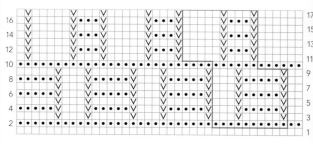

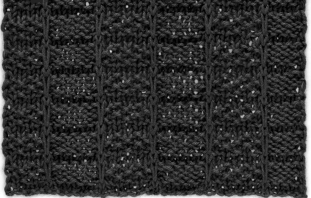

167 Woven Stitch

This simple wrapped stitch pattern can be used to great effect as an all-over fabric. Alternatively, it makes a good filling stitch for a cable or panel where something a little different to the more usual stockinette or reverse stockinette is required. The reverse of this stitch pattern is equally attractive.

Yarn: Fingering to bulky

Multiple: 2 sts + 2

Row 1 (WS): Purl.

Row 2: K1, *sl1 wyif, k1; rep from * to last st, k1.

Row 3: Purl.

Row 4: K1, *k1, sl1 wyif; rep from * to last st, k1.

Repeat: Rows 1–4

168 Reverse Stockinette and Seed Stitch Slipped Blocks

Blocks of reverse stockinette and seed stitch are divided with slip stitch chains to produce a richly textured pattern that retains good suppleness. Three blocks worked as a centerpiece for a sweater, or down a sleeve, would give a dramatic impact.

Yarn: Fingering to worsted

Multiple: 12 sts + 11

Row 1 (RS): Knit.

Row 2: Purl.

Row 3: *P5, sl1 wyib, [p1, k1] twice, p1, sl1 wyib; rep from * to last 11 sts, p5, sl1 wyib, [p1, k1] twice, p1.

Row 4: [P1, k1] twice, p1, sl1 wyif, k5, *sl1 wyif, [p1, k1] twice, p1, sl1 wyif, k5; rep from * to end.

Rows 5 & 6: Repeat Rows 3 & 4.

Repeat: Rows 1–6

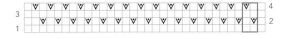

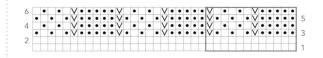

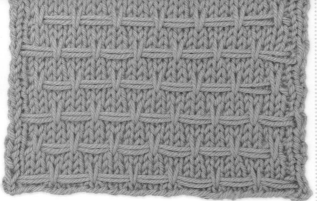

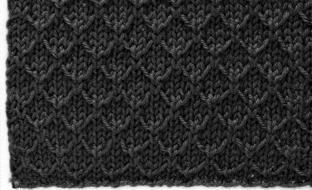

169 Wicker Basket Lattice

A delicate but distinctive lattice, this stitch is created by overlaying slipped stitches on a stockinette background, slipping the strands behind a vertical row of slipped stitches. A little care is required when gauging the slipped strands to make sure the fabric doesn't pucker.

Yarn: Fingering to bulky

Multiple: 4 sts + 7

Row 1 (WS): Purl.

Row 2: K1, *sl1 wyib, [sl1 wyif] three times; rep from * to last 2 sts, sl1 wyib, k1.

Row 3: P1, sl1 wyif, *p3, sl 1wyif; rep from * to last st, p1.

Rows 4 & 5: Repeat Rows 2 & 3.

Row 6: Knit.

Row 7: Purl.

Row 8: K3, *sl1 wyib, [sl1 wyif] three times; rep from * to last 4 sts, sl1 wyib, k3.

Row 9: *P3, sl1 wyif; rep from * to last 3 sts, p3.

Rows 10 & 11: Repeat Rows 8 & 9.

Row 12: Knit.

Repeat: Rows 1–12

170 Small Quilted Lattice

Delicate lattices meander across the fabric with this delightful pattern. The design offers enough drape and elasticity to be used as an all-over pattern, or it could be readily incorporated as a panel or combined with other stitches in a cable or similar pattern.

Yarn: Fingering to worsted

Multiple: 4 sts + 6

Row 1 (WS): Purl.

Row 2: K2, *[sl1 wyif] three times, k1; rep from * to end.

Row 3: Purl.

Row 4: K2, *k1, Lst, k2; rep from * to end.

Row 5: Purl.

Row 6: K4, *[sl1 wyif] three times, k1; rep from * to last 2 sts, k2.

Row 7: Purl.

Row 8: K4, *k1, Lst, k2; rep from * to last 2 sts, k2.

Repeat: Rows 1–8

Abbreviation

Lst: Lift strand/s. Insert needle under loose strand and knit next st, lifting st in front of strand. As the st is completed lift the strands over the st.

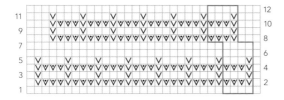

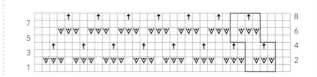

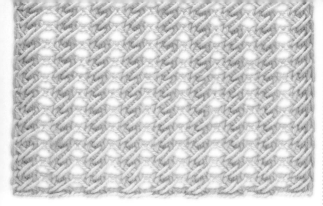

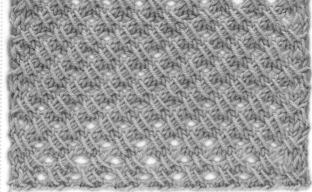

171 Right Cross Stitch

A versatile stitch that can be worked in a wide range of yarns. For an open texture, use larger needles than normal; for a more dense texture, use smaller than normal needles. This stitch is also attractive on the reverse so it is useful for scarves and similar projects where both sides will be visible.

Yarn: Fingering to bulky

Multiple: 4 sts + 2

Row 1 (WS): P1, *w2p; rep from * to last st, p1.

Row 2: K1, *R4C; rep from * to last st, k1.

Repeat: Rows 1–2

Abbreviations

W2p: Wrap 2 purl. Purl next st, wrapping yarn twice around needle.

R4C: Right 4 cross. Slip 4 sts purlwise, allowing loops to drop. Return sts to LH needle. Lift sts 3 and 4 over sts 1 and 2, bringing to front of LH needle. K4 (knitting sts 3 and 4 first).

172 Offset Left Cross Stitch

A variant on the standard cross stitch, this stitch creates a mesh rather than a ribbed-looking fabric. For an open texture, use larger needles than normal; for a more dense texture, use smaller than normal needles. The reverse of this stitch is equally attractive so it is great for projects where both sides will be visible.

Yarn: Fingering to bulky

Multiple: 4 sts + 6

Row 1 (WS): P1, *w2p; rep from * to last st, p1.

Row 2: K1, *L4C; rep from * to last st, k1.

Row 3: P1, *w2p; rep from * to last st, p1.

Row 4: K3, *L4C; rep from * to last 3 sts, k3.

Repeat: Rows 1–4

Abbreviations

W2p: Wrap 2 purl. Purl next st, wrapping yarn twice around needle.

L4C: Left 4 cross. Slip 4 sts wyib, dropping extra wraps. Insert LH needle into sts 1 and 2 and pass over sts 3 and 4 onto LH needle. Slip sts 3 and 4 onto LH needle. K4 (knitting sts 3 and 4 first).

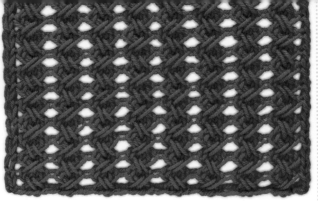

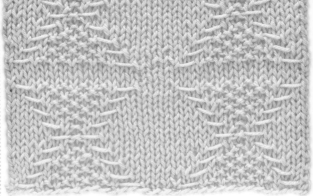

173 Alternating Cross Stitch

It can take a little practice to perfect the cross stitches for this pattern. Once mastered, however, it creates a lovely honeycomb with alternating left and right crosses worked over just four rows in a simple diamond formation. Consider using the reverse, too, which has great texture.

Yarn: Fingering to bulky

Multiple: 8 sts + 4

Row 1 (WS): P1, *w2p; rep from * to last st, p1.

Row 2: K2, *R4C, L4C; rep from * to last 2 sts, k2.

Row 3: P1, *w2p; rep from * to last st, p1.

Row 4: K2, *L4C, R4C; rep from * to last 2 sts, k2.

Repeat: Rows 1–4

Abbreviations

W2p: Wrap 2 purl. Purl next st, wrapping yarn twice around needle.

R4C: Right 4 cross. Slip 4 sts purlwise, allowing loops to drop. Return sts to LH needle. Lift sts 3 and 4 over sts 1 and 2, bringing to front of LH needle. K4 (knitting sts 3 and 4 first).

L4C: Left 4 cross. Slip 4 sts wyib, dropping extra wraps. Insert LH needle into sts 1 and 2 and pass over sts 3 and 4 onto LH needle. Slip sts 3 and 4 onto LH needle. K4 (knitting sts 3 and 4 first).

174 Crossed Seed Slip Stitch

Slip stitch "X"s are filled with seed stitch for an interesting variation on a more familiar slip stitch cross stitch. Swap the seed stitch for plain stockinette to give a completely different look. This is an interesting motif worked as a single, long panel or as an all-over pattern.

Yarn: Fingering to worsted

Multiple: 17 sts

Row 1 (WS): Purl.

Row 2: *K2, [sl1 wyif] twice, [k1, p1] four times, k1, [sl1 wyif] twice, k2; rep from * to end.

Row 3: *P6, [k1, p1] twice, k1, p6; rep from * to end.

Row 4: *K3, [sl1 wyif] twice, k2, p1, k1, p1, k2, [sl1 wyif] twice, k3; rep from * to end.

Row 5: Repeat Row 3.

Row 6: *K4, [sl1 wyif] twice, [k1, p1] twice, k1, [sl1 wyif] twice, k4; rep from * to end.

Row 7: *P8, k1, p8; rep from * to end.

Row 8: *K5, [sl1 wyif] twice, k3, [sl1 wyif] twice, k5; rep from * to end.

Row 9: Repeat Row 7.

Row 10: *K6, [sl1 wyif] twice, k1, [sl1 wyif] twice, k6; rep from * to end.

Rows 11 & 12: Repeat Rows 7 & 8.

Row 13: Repeat Row 7.

Row 14: Repeat Row 6.

Rows 15 & 16: Repeat Rows 3 & 4.

Row 17: Repeat Row 3.

Row 18: Repeat Row 2.

Row 19: Purl.

Row 20: Knit.

Repeat: Rows 1–20

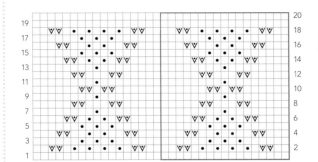

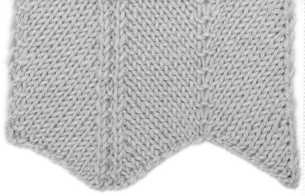

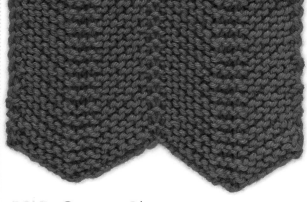

175 Stockinette Chevron

A classic chevron on a stockinette base. This pattern has only a two-row repeat so is easy to master and a great first chevron for a newer knitter to tackle. It can be worked on a wide range of yarns but be prepared to swatch a couple of times to achieve the very best results.

Yarn: Laceweight to bulky

Multiple: 22 sts + 13

Row 1 (RS): K1, *ssk, k8, m1r, k1, m1l, k8, k2tog, k1; rep from * to last st, k1.

Row 2: P1, *[k1, p10] twice; rep from * to last st, p1.

Repeat: Rows 1–2

Abbreviations

Ssk: Slip, slip, knit. Slip 2 sts one at a time as if to knit, knit 2 slipped sts together.

M1r: Make 1 knitwise (right leaning). Insert RH needle from front to back under strand between 2 sts and lift loop onto LH needle. Knit in back of loop to form new st.

M1l: Make 1 knitwise (left leaning). Insert RH needle from back to front under strand between 2 sts and lift loop onto LH needle. Knit in front of loop to form new st.

176 Garter Chevron

A simple, stylish chevron worked on a base of garter stitch. The decreases create striking raised spines down the center, giving the pattern a very distinctive look. With just two rows in the pattern repeat, it is a good beginner chevron pattern.

Yarn: Laceweight to bulky

Multiple: 18 sts + 1

Row 1 (RS): *K1, m1l, k6, k2tog, k1, ssk, k6, m1r; rep from * to last st, k1.

Row 2: Knit.

Repeat: Rows 1–2

Abbreviations

M1l: Make 1 knitwise (left leaning). Insert RH needle from back to front under strand between 2 sts and lift loop onto LH needle. Knit in front of loop to form new st.

Ssk: Slip, slip, knit. Slip 2 sts one at a time as if to knit, knit 2 slipped sts together.

M1r: Make 1 knitwise (right leaning). Insert RH needle from front to back under strand between 2 sts and lift loop onto LH needle. Knit in back of loop to form new st.

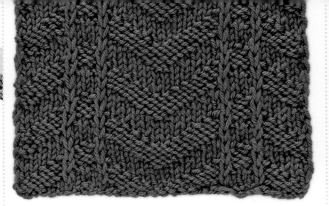

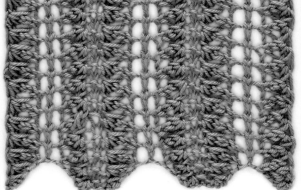

177 Embossed Chevron

If you're looking for a chevron pattern with a straight lower edge, this straightforward knit, purl, and slip stitch pattern fits the bill nicely. The slip stitch rows are bold, with the chevrons sitting neatly in the background.

Yarn: Fingering to bulky

Multiple: 17 sts

Row 1 (RS): *P4, k2, sl1 wyib, k1, p1, k1, sl1 wyib, k2, p4; rep from * to end.

Row 2: *P1, k4, p7, k4, p1; rep from * to end.

Row 3: *K2, p4, sl1 wyib, k3, sl1 wyib, p4, k2; rep from * to end.

Row 4: *P3, k3, p5, k3, p3; rep from * to end.

Row 5: *K4, p2, sl1 wyib, p1, k1, p1, sl1 wyib, p2, k4; rep from * to end.

Row 6: *K1, p4, k1, p1, k3, p1, k1, p4, k1; rep from * to end.

Row 7: *P2, k4, sl1 wyib, p3, sl1 wyib, k4, p2; rep from * to end.

Row 8: *[K3, p4] twice, k3; rep from * to end.

Repeat: Rows 1–8

178 Feather and Fan

No one will believe that this richly detailed pattern is just a two-row pattern repeat with simple yarn overs and decreases. The interesting points make a great edging or hem and, as the repeat is short, it can be readily worked at the bottom of a sweater or sleeve or as a decorative trim.

Yarn: Laceweight to bulky

Multiple: 14 sts

Row 1 (RS): *K4tog, [yo, k1] five times, yo, k4togtbl, p1; rep from * to end.

Row 2: Purl.

Repeat: Rows 1–2

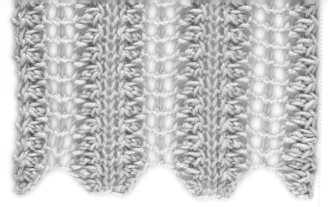

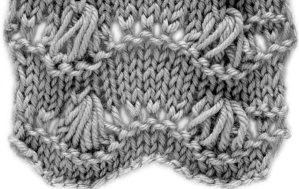

179 Ridged Feather and Fan

Feather and fan patterns have many variations, and this one is based on garter stitch interspersed with shaping rows. As with many feather and fan stitches, it has a lovely scalloped lower edge that makes it very pretty as a trim or edging.

Yarn: Laceweight to worsted

Multiple: 14 sts

Row 1 (RS): *K4tog, [yo, k1] five times, yo, k4togtbl, p1; rep from * to end.

Row 2: Knit.

Repeat: Rows 1–2

180 Waves at Sea

A more advanced stitch to work initially, once mastered the pattern is quite straightforward to follow. Yarn overs create ripples similar to those in a rippled chevron. Using elongated stitches creates interesting textured wave shapes. A smooth, medium-weight yarn would be ideal for this pattern.

Yarn: Fingering to worsted

Multiple: 10 sts + 1

Row 1 (RS): Knit.

Row 2: Purl.

Row 3: Knit.

Row 4: Knit.

Row 5: *[K1, yo] twice, k1, [k1 elongated twice] five times, [k1, yo] twice; rep from * to last st, k1.

Row 6: P1, *p4, [sl1 wyif] five times, p5; rep from * to end.

Row 7: *P5, [sl1 wyib] five times, k4; rep from * to last st, k1.

Row 8: P1, *p4, p5tog, p5; rep from * to end.

Row 9: Knit.

Row 10: Purl.

Row 11: Knit.

Row 12: Knit.

Repeat: Rows 5–12

Abbreviation

K1 elongated twice: Knit a st wrapping yarn around needle three times. On next row drop the extra wraps from needle.

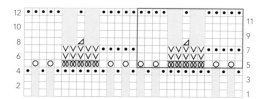

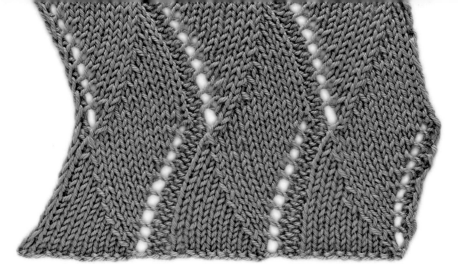

181 Lacy Wave

Deeply undulating waves are created on this simple stockinette fabric, by the rhythmic arrangement of lacy eyelets. Even though it has a long repeat, this pattern is not difficult and, with careful attention to the chart, it is quite straightforward to follow.

Yarn: Fingering to bulky

Multiple: 11 sts + 1

Row 1 (RS): *P1, yo, ssk, k8; rep from * to last st, p1.

Row 2 and all WS rows: K1, *p10, k1; rep from * to end.

Row 3: *P1, yo, k1, ssk, k7; rep from * to last st, p1.

Row 5: *P1, yo, k2, ssk, k6; rep from * to last st, p1.

Row 7: *P1, yo, k3, ssk, k5; rep from * to last st, p1.

Row 9: *P1, yo, k4, ssk, k4; rep from * to last st, p1.

Row 11: *P1, yo, k5, ssk, k3; rep from * to last st, p1.

Row 13: *P1, yo, k6, ssk, k2; rep from * to last st, p1.

Row 15: *P1, yo, k7, ssk, k1; rep from * to last st, p1.

Row 17: *P1, yo, k8, ssk; rep from * to last st, p1.

Row 19: *P1, k8, k2tog, yo; rep from * to last st, p1.

Row 21: *P1, k7, k2tog, k1, yo; rep from * to last st, p1.

Row 23: *P1, k6, k2tog, k2, yo; rep from * to last st, p1.

Row 25: *P1, k5, k2tog, k3, yo; rep from * to last st, p1.

Row 27: *P1, k4, k2tog, k4, yo; rep from * to last st, p1.

Row 29: *P1, k3, k2tog, k5, yo; rep from * to last st, p1.

Row 31: *P1, k2, k2tog, k6, yo; rep from * to last st, p1.

Row 33: *P1, k1, k2tog, k7, yo; rep from * to last st, p1.

Row 35: *P1, k2tog, k8, yo; rep from * to last st, p1.

Repeat: Rows 1–35

Abbreviation

Ssk: Slip, slip, knit. Slip 2 sts one at a time as if to knit, knit 2 slipped sts together.

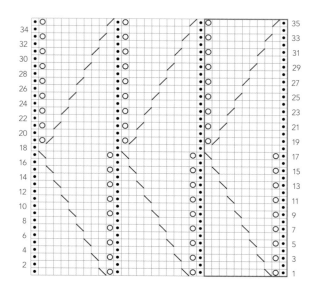

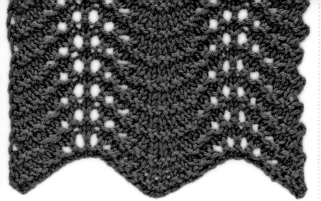

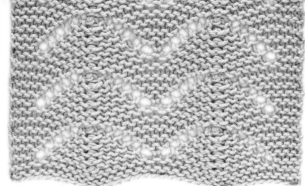

182 Garter Old Shale

Rich texturing is achieved on this pattern by inserting rows of simple garter stitch at regular intervals. The paired increases and decreases create a softly rippled edge, ideal for trims, hems, and decorative edges. With a four-row repeat and just one pattern row, this is a design that is simple to master.

Yarn: Fingering to bulky

Multiple: 18 sts

Row 1 (RS): Knit.

Row 2: Knit.

Row 3: *[K2tog] three times, [yo, k1] six times, [k2tog] three times; rep from * to end.

Row 4: Purl.

Repeat: Rows 1–4

183 Lacy Garter Ripple

Dainty little garter stitch fans are formed by creating yarn overs and central decreases in a chevron pattern. The gentle curves occur due to the supple nature of garter stitch spreading to accommodate the shaping. This stitch looks super in a wide range of yarns and a smooth yarn is particularly effective in bringing out the curving shapes and textures.

Yarn: Cobweb to bulky

Multiple: 14 sts + 7

Row 1 (RS) and all RS rows: Purl.

Row 2: Purl.

Row 4: P4, *yo, p5, s2kp, p5, yo, p1; rep from * to last 3 sts, p3.

Row 6: P4, *p1, yo, p4, s2kp, p4, yo, p2; rep from * to last 3 sts, p3.

Row 8: P4, *p2, yo, p3, s2kp, p3, yo, p3; rep from * to last 3 sts, p3.

Row 10: P4, *p3, yo, p2, s2kp, p2, yo, p4; rep from * to last 3 sts, p3.

Row 12: P4, *p4, yo, p1, s2kp, p1, yo, p5; rep from * to last 3 sts, p3.

Row 14: P4, *p5, yo, s2kp, yo, p6; rep from * to last 3 sts, p3.

Repeat: Rows 3–14. End with Row 1.

Abbreviation

S2kp: Slip 2 as if to k2tog, k1, pass 2 slipped sts over.

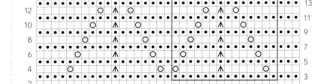

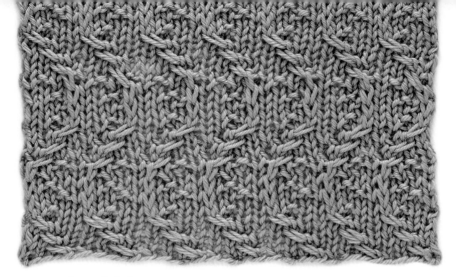

184 Waves and Pebbles

A subtly textured pattern that looks great as an all-over design. Alternatively, a pair of repeats on either side of a panel or along a sleeve would look very striking. To get the most out of the textural qualities, choose a smooth yarn.

Yarn: Laceweight to bulky

Multiple: 5 sts + 2

Row 1 (WS): Purl.

Row 2: K1, *1/2 LC, k2; rep from * to last st, k1.

Row 3: Purl.

Row 4: K1, *k1, 1/2 LC, k1; rep from * to last st, k1.

Row 5: Purl.

Row 6: K1, *k2, 1/2 LC; rep from * to last st, k1.

Row 7: P1, *p2, k1, p2; rep from * to last st, p1.

Row 8: K1, *k4, sl1 wyib; rep from * to last st, k1.

Row 9: P1, *p3, k1, p1; rep from * to last st, p1.

Row 10: K1, *k2, p1, k1, sl1 wyib; rep from * to last st, k1.

Row 11: Purl.

Row 12: K1, *k3, p1, sl1 wyib; rep from * to last st, k1.

Row 13: P1, *p3, k1, p1; rep from * to last st, p1.

Row 14: K1, *k2, 1/2 RC; rep from * to last st, k1.

Row 15: Purl.

Row 16: K1, *k1, 1/2 RC, k1; rep from * to last st, k1.

Row 17: Purl.

Row 18: K1, *1/2 RC, k2; rep from * to last st, k1.

Row 19: P1, *p2, k1, p2; rep from * to last st, p1.

Row 20: K1, *sl1 wyib, k4; rep from * to last st, k1.

Row 21: P1, *p3, k1, p1; rep from * to last st, p1.

Row 22: K1, *sl1 wyib, k1, p1, k2; rep from * to last st, k1.

Row 23: Purl.

Row 24: K1, *sl1 wyib, k2, p1, k1; rep from * to last st, k1.

Row 25: P1, *p3, k1, p1; rep from * to last st, p1.

Repeat: Rows 2–25

Abbreviations

1/2 LC: 3-stitch left cable. Slip 1 st to cable needle and hold in front, k2, k1 from cable needle.

1/2 RC: 3-stitch right cable. Slip 2 sts to cable needle and hold in back, k1, k2 from cable needle.

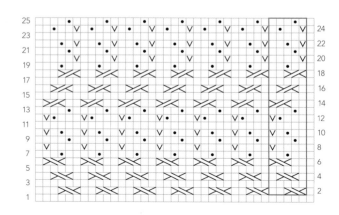

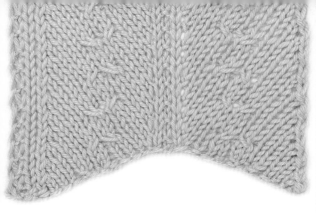

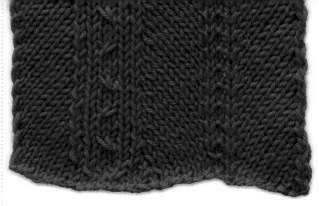

185 Cabled Chevron

Pairs of twists create a delicate, birdlike pattern around a central spine of stockinette and garter stitch.

Yarn: Fingering to bulky

Multiple: 30 sts + 1

Row 1 (RS): *K1, ssk, k3, 1/1 RC, 1/1 LC, k3, m1r, k3, m1l, k3, 1/1 RC, 1/1 LC, k3, k2tog, k2; rep from * to last st, k1.

Row 2 and all WS rows: P1, *[k1, p14] twice; rep from * to end.

Row 3: *K1, ssk, k10, m1r, k3, m1l, k10, k2tog, k2; rep from * to last st, k1.

Row 5: *K1, ssk, k3, 1/1 LC, 1/1 RC, k3, m1r, k3, m1l, k3, 1/1 LC, 1/1 RC, k3, k2tog, k2; rep from * to last st, k1.

Row 7: Repeat Row 3.

Row 8: P1, *[k1, p14] twice; rep from * to end.

Repeat: Rows 1–8

Abbreviations

Ssk: Slip, slip, knit. Slip 2 sts one at a time as if to knit, knit 2 slipped sts together.

1/1 RC: 2-stitch right cable. Slip 1 st to cable needle and hold in back, k1, k1 from cable needle.

1/1 LC: 2-stitch left cable. Slip 1 st to cable needle and hold in front, k1, k1 from cable needle.

M1r: Make 1 knitwise (right leaning). Insert RH needle from front to back under strand between 2 sts and lift loop onto LH needle. Knit in back of loop to form new st.

M1l: Make 1 knitwise (left leaning). Insert RH needle from back to front under strand between 2 sts and lift loop onto LH needle. Knit in front of loop to form new st.

186 Cabled Chevron 2

Two distinct chevron sections, a delicate cable, and a bolder garter stitch with stockinette border make this an interesting stitch. Work over a larger width to maximize its impact.

Yarn: Fingering to bulky

Multiple: 21 sts + 9

Row 1 (RS): Knit.

Row 2 and all WS rows: P9, *p11, k1, p9; rep from * to end.

Row 3: *K1, ssk, k5, m1r, k3, m1l, k5, k2tog, k1, 1/1 RC; rep from * to last 9 sts, k1, ssk, k5, m1r, k1.

Row 5: *K1, ssk, k5, m1r, k3, m1l, k5, k2tog, k3; rep from * to last 9 sts, k1, ssk, k5, m1r, k1.

Row 7: *K1, ssk, k5, m1r, k3, m1l, k5, k2tog, k1, 1/1 LC; rep from * to last 9 sts, k1, ssk, k5, m1r, k1.

Row 9: Repeat Row 5.

Repeat: Rows 2–9

Abbreviations

Ssk: Slip, slip, knit. Slip 2 sts one at a time as if to knit, knit 2 slipped sts together.

M1r: Make 1 knitwise (right leaning). Insert RH needle from front to back under strand between 2 sts and lift loop onto LH needle. Knit in back of loop to form new st.

M1l: Make 1 knitwise (left leaning). Insert RH needle from back to front under strand between 2 sts and lift loop onto LH needle. Knit in front of loop to form new st.

1/1 RC: 2-stitch right cable. Slip 1 st to cable needle and hold in back, k1, k1 from cable needle.

1/1 LC: 2-stitch left cable. Slip 1 st to cable needle and hold in front, k1, k1 from cable needle.

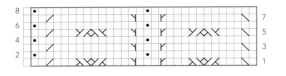

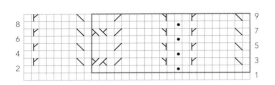

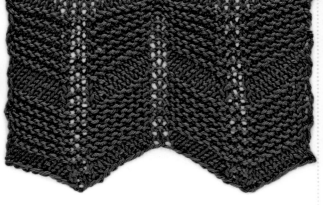

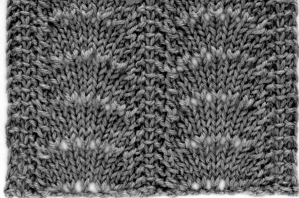

187 Ripple Chevron

Blocks of stockinette and garter stitch add an interesting twist to this classic chevron pattern, without adding to the difficulty. This stitch benefits from a yarn with good stitch definition to make the most of the textures in the design.

Yarn: Laceweight to bulky

Multiple: 18 sts + 1

Row 1 (RS) and all RS rows: *K1, m1l, k6, k2tog, k1, ssk, k6, m1r; rep from * to last st, k1.

Row 2: K1, *[p8, k1] twice; rep from * to end.

Row 4 and all following WS rows: Knit.

Row 14: Knit.

Repeat: Rows 1–14

Abbreviations

M1l: Make 1 knitwise (left leaning). Insert RH needle from back to front under strand between 2 sts and lift loop onto LH needle. Knit in front of loop to form new st.

Ssk: Slip, slip, knit. Slip 2 sts one at a time as if to knit, knit 2 slipped sts together.

M1r: Make 1 knitwise (right leaning). Insert RH needle from front to back under strand between 2 sts and lift loop onto LH needle. Knit in back of loop to form new st.

188 Vertical Ripple

The yarn over row in this pattern creates a ripple in the fabric that is then reduced with decreases in later rows (meaning that not all rows have the same number of stitches). It creates a lovely, richly textured fabric that can be used as an accent feature or an all-over pattern.

Yarn: Laceweight to bulky

Multiple: 12 sts + 3

Row 1 (RS): *K1, sl1 wyif, k1, k2tog, [yo, k1] five times, yo, ssk; rep from * to last 3 sts, k1, sl1 wyif, k1.

Row 2: K1, p1, k1, *p13, k1, p1, k1; rep from * to end.

Row 3: *K1, sl1 wyif, k1, k2tog, k9, ssk; rep from * to last 3 sts, k1, sl1 wyif, k1.

Row 4: K1, p1, k1, *p11, k1, p1, k1; rep from * to end.

Row 5: *K1, sl1 wyif, k1, k2tog, k7, ssk; rep from * to last 3 sts, k1, sl1 wyif, k1.

Row 6: K1, p1, k1, *p9, k1, p1, k1; rep from * to end.

Repeat: Rows 1–6

Abbreviation

Ssk: Slip, slip, knit. Slip 2 sts one at a time as if to knit, knit 2 slipped sts together.

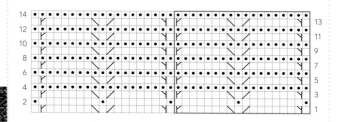

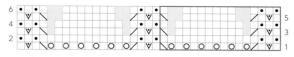

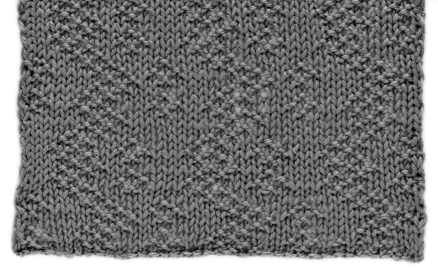

189 Seed Stitch Zigzag

A straightforward yet striking pattern using just knit and purl stitches, this is ideal as an all-over fabric in a yarn with good stitch definition. Alternatively, it would work well as a panel in a larger design or even as a single panel down a sleeve.

Yarn: Fingering to bulky

Multiple: 12 sts + 2

Row 1 (RS): K1, *k2, p1, k1, p1, k7; rep from * to last st, k1.

Row 2: P1, *p1, k1, p4, k1, p1, k1, p3; rep from * to last st, p1.

Row 3: K1, *k4, p1, k1, p1, k2, p1, k1, p1; rep from * to last st, k1.

Row 4: Repeat Row 2.

Row 5: Repeat Row 1.

Row 6: P1, *p1, k1, p6, [k1, p1] twice; rep from * to last st, p1.

Row 7: K1, *k2, p1, k1, p1, k4, p1, k1, p1; rep from * to last st, k1.

Row 8: Repeat Row 2.

Row 9: K1, *k4, p1, k1, p1, k5; rep from * to last st, k1.

Row 10: P1, *p4, k1, p1, k1, p3, k1, p1; rep from * to last st, p1.

Row 11: K1, *[p1, k1, p1, k3] twice; rep from * to last st, k1.

Row 12: Repeat Row 10.

Row 13: Repeat Row 9.

Row 14: Repeat Row 10.

Row 15: Repeat Row 11.

Row 16: Repeat Row 10.

Row 17: Repeat Row 9.

Row 18: P1, *p6, k1, p1, k1, p3; rep from * to last st, p1.

Repeat: Rows 1–18

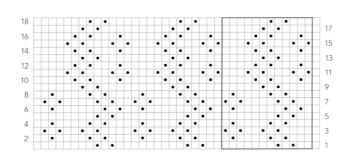

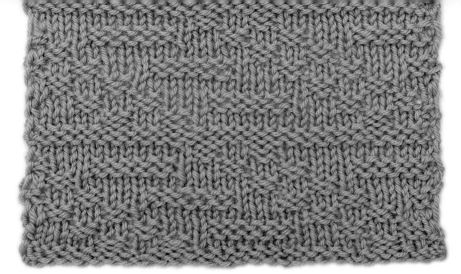

190 Traveling Steps

This is a great pattern for achieving exciting texture and dramatic shapes exploiting just knit and purl stitches. It is best worked over a large number of stitches for maximum impact and with a yarn that offers good stitch definition.

Yarn: Laceweight to bulky

Multiple: 18 sts + 12

Row 1 (RS): Purl.

Row 2: Knit.

Row 3: P2, k2, *p2, k12, p2, k2; rep from * to last 8 sts, p2, k6.

Row 4: P6, k2, *p2, k2, p12, k2; rep from * to last 4 sts, p2, k2.

Row 5: K2, p2, *k2, p2, k3, p6, k3, p2; rep from * to last 8 sts, k2, p2, k3, p1.

Row 6: K1, p3, k2, p2, *k2, p3, k6, p3, k2, p2; rep from * to last 4 sts, k2, p2.

Row 7: K4, *p2, k2, p2, k12; rep from * to last 8 sts, [p2, k2] twice.

Row 8: [P2, k2] twice, *p12, k2, p2, k2; rep from * to last 4 sts, p4.

Row 9: P3, k1, *[k2, p2] twice, k3, p6, k1; rep from * to last 8 sts, [k2, p2] twice.

Row 10: [K2, p2] twice, *p1, k6, p3, [k2, p2] twice; rep from * to last 4 sts, p1, k3.

Row 11: K4, *k4, p2, k2, p2, k8; rep from * to last 8 sts, k4, p2, k2.

Row 12: P2, k2, p4, *p8, k2, p2, k2, p4; rep from * to last 4 sts, p4.

Row 13: K1, p3, *p3, k3, p2, k2, p2, k3, p3; rep from * to last 8 sts, p3, k3, p2.

Row 14: K2, p3, k3, *k3, p3, k2, p2, k2, p3, k3; rep from * to last 4 sts, k3, p1.

Row 15: K4, *k8, p2, k2, p2, k4; rep from * to last 8 sts, k8.

Row 16: P8, *p4, k2, p2, k2, p8; rep from * to last 4 sts, p4.

Repeat: Rows 1–16

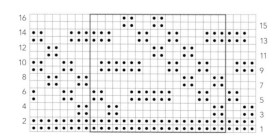

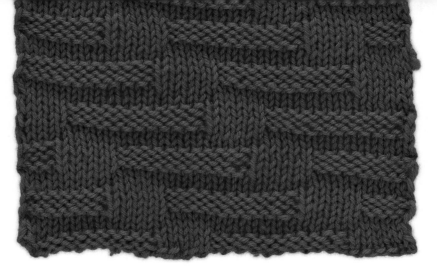

191 Traveling Garter Blocks

This pattern has a long repeat but is actually simple to follow and, once you've established the set of the rows, it progresses quickly. As the repeat is quite large it looks best as an all-over pattern, and is particularly striking in a bulky yarn with good stitch definition.

Yarn: Light fingering to bulky

Multiple: 16 sts

Row 1 (RS): *K5, p11; rep from * to end.

Row 2: *K11, p5; rep from * to end.

Row 3: Repeat Row 1.

Row 4: Purl.

Row 5: Knit.

Row 6: Purl.

Row 7: *P4, k5, p7; rep from * to end.

Row 8: *K7, p5, k4; rep from * to end.

Row 9: Repeat Row 7.

Rows 10–12: Repeat Rows 4–6.

Row 13: *P8, k5, p3; rep from * to end.

Row 14: *K3, p5, k8; rep from * to end.

Row 15: Repeat Row 13.

Rows 16–18: Repeat Rows 4–6.

Row 19: *K1, p11, k4; rep from * to end.

Row 20: *P4, k11, p1; rep from * to end.

Row 21: Repeat Row 19.

Rows 22–24: Repeat Rows 4–6.

Repeat: Rows 1–24

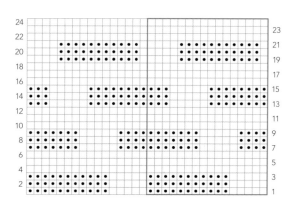

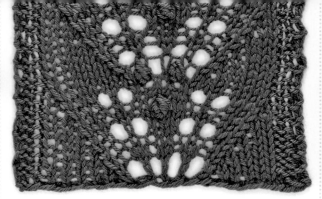

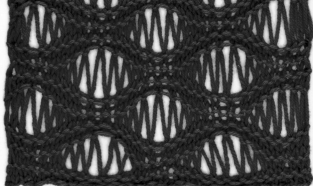

192 Crashing Waves

Seaspray eyelets and small bobble splashes make a dramatic stitch with lots of activity and movement. Worked across a wide repeat, particularly good for a long border, this stitch is lively and vibrant. A yarn such as angora or mohair blend, particularly a tonal yarn, will soften the effect but give a lovely feeling of the misty haze of crashing waves.

Yarn: Cobweb to worsted

Multiple: 20 sts + 3

Row 1 (WS): *K3, p17; rep from * to last 3 sts, k3.

Row 2: P3, *k5, k2tog, [yo, k1] three times, yo, skp, k5, p3; rep from * to end.

Row 3: *K3, p19; rep from * to last 3 sts, k3.

Row 4: P3, *k4, k2tog, k7, skp, k4, p3; rep from * to end

Row 5: Repeat Row 1.

Row 6: P3, *k3, k2tog, [k1, yo] twice, k3, [yo, k1] twice, skp, k3, p3; rep from * to end.

Row 7: Repeat Row 3.

Row 8: P3, *k2, k2tog, k5, mb, k5, skp, k2, p3; rep from * to end.

Row 9: Repeat Row 1.

Row 10: P3, *k1, k2tog, k2, [yo, k1] twice, k3, [k1, yo] twice, k2, skp, k1, p3; rep from * to end.

Row 11: Repeat Row 3.

Row 12: P3, *k2tog, k6, mb, k1, mb, k6, skp, p3; rep from * to end.

Repeat: Rows 1–12

Abbreviations

Skp: Slip 1 as if to knit, k1, pass slipped st over.

Mb: Make bobble. [(K1, p1) twice k1] in next st, pass 2nd, 3rd, 4th, and 5th sts over first st.

193 Seafoam

This pattern is like magic—when it comes off the needles it looks like a wrinkled mass of threads; after a bit of blocking, see the amazing foaming waves emerge. It does take a little while to get used to the extra wraps but they follow a rhythmical pattern so once you've done a couple you'll find them straightforward. Blocking significantly increases the size so block carefully when swatching before measuring.

Yarn: Fingering to worsted

Multiple: 11 sts + 7

Row 1 (RS): Knit.

Row 2: Knit.

Row 3: *K6, [yo] twice, k1, [yo] three times, k1, [yo] four times, k1, [yo] three times, k1, [yo] twice, k1; rep from * to last 7 sts, k7.

Rows 4–6: Knit.

Row 7: *K1, [yo] twice, k1, [yo] three times, k1, [yo] four times, k1, [yo] three times, k1, [yo] twice, k6; rep from * to last 7 sts, k1, [yo] twice, k1, [yo] three times, k1, [yo] four times, k1, [yo] three times, k1, [yo] twice, k2.

Row 8: Knit.

Repeat: Rows 1–8

Abbreviations

[Yo] twice/three times/four times: Wrap yarn around needle the number of times specified. On next row allow extra wraps to drop off needle.

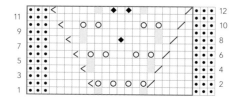

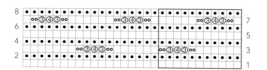

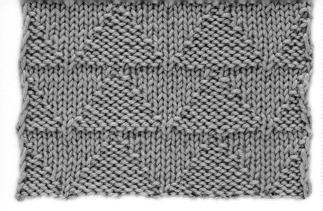

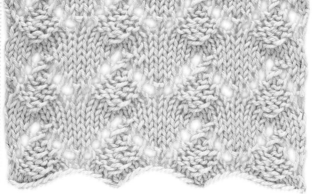

194 Teepees

This simple pattern packs in plenty of texture using just simple knit and purl stitches. It could be readily worked as a band, all-over pattern, or as a motif set in a background of reverse stockinette stitch for downward "V"s. A background of stockinette stitch will highlight the upward "V"s.

Yarn: Laceweight to bulky

Multiple: 10 sts + 1

Row 1 (RS): *P5, k1, p4; rep from * to last st, p1.

Row 2: K1, *k4, p1, k5; rep from * to end.

Row 3: *P4, k3, p3; rep from * to last st, p1.

Row 4: K1, *k3, p3, k4; rep from * to end.

Row 5: *P3, k5, p2; rep from * to last st, p1.

Row 6: K1, *k2, p5, k3; rep from * to end.

Row 7: *P2, k7, p1; rep from * to last st, p1.

Row 8: K1, *k1, p7, k2; rep from * to end.

Row 9: *P1, k9; rep from * to last st, p1.

Row 10: K1, *p9, k1; rep from * to end.

Repeat: Rows 1–10

195 Lacy Teepees

A delicately textured fabric with a pretty scalloped edge that would make a lovely trim on a cuff or hem. To maximize the lacy effect, choose a smooth yarn, or, for a softer effect, a mohair or angora yarn would also look very attractive.

Yarn: Laceweight to bulky

Multiple: 8 sts + 1

Row 1 (RS): Purl.

Row 2: Knit.

Row 3: *K1, yo, k2, k3tog, k2, yo; rep from * to last st, k1.

Row 4: K1, *k1, p5, k2; rep from * to end.

Row 5: *P2, yo, k1, k3tog, k1, yo, p1; rep from * to last st, p1.

Row 6: K1, *k2, p3, k1tbl, k2; rep from * to end.

Row 7: *P3, yo, k3tog, yo, p2; rep from * to last st, p1.

Row 8: K1, *k3, p1, k1tbl, k3; rep from * to end.

Row 9: *P4, yo, k2tog, p2; rep from * to last st, p1.

Row 10: K1, *k3, k1tbl, k4; rep from * to end.

Repeat: Rows 1–10

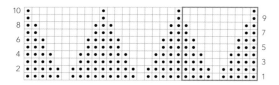

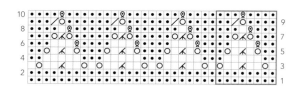

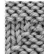

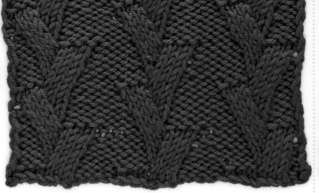

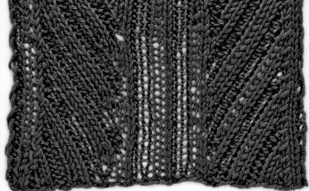

196 Wobbly Peaks

This interesting combination of stockinette stitch and reverse stockinette stitch creates a bold pattern that looks great worked in a yarn with good stitch definition, to give crisp edges and dramatic lines. It works well as an all-over pattern or could be incorporated into a panel or edging.

Yarn: Light fingering to bulky

Multiple: 11 sts

Row 1 (WS): *K4, p6, k1; rep from * to end.

Row 2: *P1, 3/1 LPC, k2, p4; rep from * to end.

Row 3: *K4, p5, k2; rep from * to end.

Row 4: *P2, 3/1 LPC, k1, p4; rep from * to end.

Row 5: *K4, p4, k3; rep from * to end.

Row 6: *P3, 3/1 LPC, k3, p1; rep from * to end.

Row 7: *K1, p6, k4; rep from * to end.

Row 8: *P4, k2, 3/1 RPC, p1; rep from * to end.

Row 9: *K2, p5, k4; rep from * to end.

Row 10: *P4, k1, 3/1 RPC, p2; rep from * to end.

Row 11: *K3, p4, k4; rep from * to end.

Row 12: *P1, k3, 3/1 RPC, p3; rep from * to end.

Repeat: Rows 1–12

Abbreviations

3/1 LPC: 4-stitch left purl cable. Slip 3 sts to cable needle and hold in front, p1, k3 from cable needle.

3/1 RPC: 4-stitch right purl cable. Slip 1 st to cable needle and hold in back, k3, p1 from cable needle.

197 Herringbone Leaf

This stitch is more complex, with lots going on in each row. The result, however, is worth the effort. A strong central line of stockinette stitch is flanked by leaf "veins" to create detailed texture and a striking pattern. A smooth yarn with good stitch definition will show off this stitch to best effect.

Yarn: Light fingering to worsted

Panel: 36 sts + 2

Row 1 (RS): *K2, p1, p2tog, k1, p2, k2, p2, k1, k1f&b, [p2, k2] twice, p1, p1f&b, [k2, p2] twice, k1, p2tog, p1; rep from * to last 2 sts, k2.

Row 2: P2, *k2, p1, [k2, p2] twice, k3, p2, k2, p2, k3, [p2, k2] twice, p1, k2, p2; rep from * to end.

Row 3: *K2, p1, p2tog, p2, k2, p2, k1, k1f&b, p3, [k2, p2] twice, p1f&b, [k2, p2] twice, p2tog, p1; rep from * to last 2 sts, k2.

Row 4: *P2, [k4, p2, k2, p2] three times, k4, p2; rep from * to end.

Row 5: *K2, p1, p2tog, p1, [k2, p2] twice, k1f&b, p1, [k2, p2] twice, k1f&b, p1, k2, p2, k2, p1, p2tog, p1; rep from * to last 2 sts, k2.

Row 6: P2, *k3, [p2, k2] twice, p1, [k2, p2] twice, k2, p1, [k2, p2] twice, k3, p2; rep from * to end.

Row 7: *K2, p1, p2tog, [k2, p2] twice, k1, k1f&b, p1, k2, p2, k2, p1, p1f&b, k1, [k2, p2] twice, p2tog, p1; rep from * to last 2 sts, k2.

Row 8: P2, *[k2, p2], eight times, k2, p2; rep from * to end.

Repeat: Rows 1–8

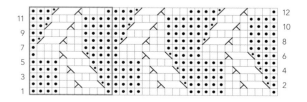

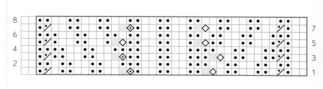

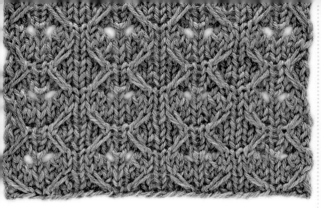

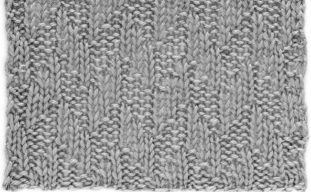

198 Deep Rippled Waves

Pairs of twisted stitches create textured waves and form a deep honeycomb. This will work well as a panel or looks equally great as an all-over pattern.

Yarn: Laceweight to bulky

Multiple: 8 sts + 1

Row 1 (WS): Purl.

Row 2: *K3, sl1 wyib, k1, sl1 wyib, k2; rep from * to last st, k1.

Row 3: P1, *p2, sl1 wyif, p1, sl1 wyif, p3; rep from * to end.

Row 4: *K1, 1/2 RC, k1, 1/2 LC; rep from * to last st, k1.

Row 5: Purl.

Row 6: *K2, ssk, yo, k1, yo, k2tog, k1; rep from * to last st, k1.

Row 7: Purl.

Row 8: *K1, sl1 wyib, k5, sl1 wyib; rep from * to last st, k1.

Row 9: P1, *sl1 wyif, p5, sl1 wyif, p1; rep from * to end.

Row 10: *K1, 1/2 LC, k1, 1/2 RC; rep from * to last st, k1.

Repeat: Rows 1–10

Abbreviations

1/2 RC: 3-stitch right cable. Slip 2 sts to cable needle and hold in back, k1, k2 from cable needle.

1/2 LC: 3-stitch left cable. Slip 1 st to cable needle and hold in front, k2, k1 from cable needle.

Ssk: Slip, slip, knit. Slip 2 sts one at a time as if to knit, knit 2 slipped sts together.

199 Chevron and Feather

Simple knits and purls make up this softly undulating series of gentle curving feathers. This pattern is particularly effective when worked in a smooth yarn with crisp stitch definition.

Yarn: Fingering to bulky

Multiple: 6 sts

Rows 1 (RS) & 2: *K3, p3; rep from * to end.

Rows 3 & 4: *K2, p1, k1, p2; rep from * to end.

Rows 5 & 6: *K1, p2, k2, p1; rep from * to end.

Rows 7 & 8: *P3, k3; rep from * to end.

Rows 9 & 10: *P2, k1, p1, k2; rep from * to end.

Rows 11 & 12: *P1, k2, p2, k1; rep from * to end.

Repeat: Rows 1–12

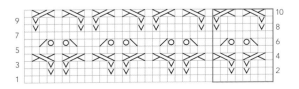

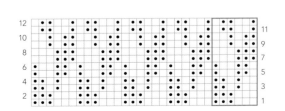

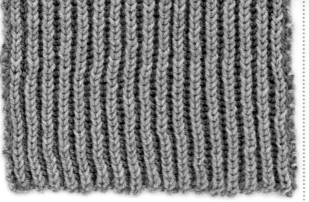

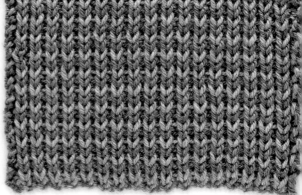

200 Two-Color Brioche Rib

Brioche is a fascinating technique worked flat on double-pointed needles. It produces a thick, deeply ribbed, reversible fabric with the colors reversed on each side. It takes practice but the resulting fabric is well worth the effort.

Yarn: Fingering to worsted

Multiple: 2 sts + 3

Cast on in color A.

Row 1 (RS): In color A, p1 *yf sl1yo, p1; rep from * to end. Do not turn work but slide sts to opposite end of needle and work a second RS row.

Row 2 (RS): In color B, sl1, *brk, yf sl1yo; rep from * to last 2 sts, brk, sl1. Turn work.

Row 3 (WS): In color A, k1, yf sl1yo, *brk, yf sl1yo; rep from * to last st, k1. Do not turn work but slide sts to opposite end of needle and work a second WS row.

Row 4 (WS): In color B, sl1, brp, *yf sl1yo, brp; rep from * to last st, sl1. Turn work.

Row 5 (RS): In color A, p1, *yf sl1yo, brp; rep from * to last 2 sts, yf sl1yo, p1.

Repeat: Rows 2–5

Final row: In the final repeat, work rows 2–4 as above and then work the final row as: p1, *p1, brp; rep from * to last 2 sts, p2.

Abbreviations

Yf sl1yo: Yarn forward, slip 1, yarn over. Bring yarn to the front, slip next st purlwise, then bring yarn to the back over the needle and the slipped st. The slipped st and yo are counted as 1 st.

Brk: Knit the st that was slipped in the previous row together with its yo.

Brp: Purl the st that was slipped in the previous row together with its yo.

201 Two-Color Half Brioche Rib

Half brioche, like its counterpart brioche stitch, takes a little practice but once mastered makes a bouncy, springy fabric that is warm but light and a delight to wear. As the fabric is quite dense, it is best worked in a medium-weight yarn. Working in pairs of colors but with just one color per row, half brioche rib creates this very attractive checkerboard rib.

Yarn: Fingering to worsted

Multiple: 2 sts + 2

Cast on in color A.

Row 1 (RS): In color A, p2, *yf sl1yo, p1; rep from * to end.

Row 2: *K1, brp; rep from * to last 2 sts, k2.

Rows 3 & 4: In color B, repeat Rows 1 & 2.

Repeat: Rows 1–4

Abbreviations

Yf sl1yo: Yarn forward, slip 1, yarn over. Bring yarn to the front, slip next st purlwise, then bring yarn to the back over the needle and the slipped st. The slipped st and yo are counted as 1 st.

Brp: Purl the st that was slipped in the previous row together with its yo.

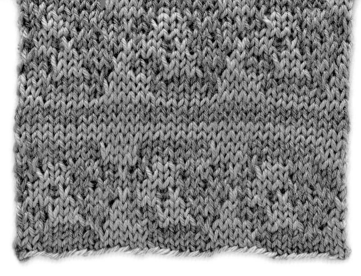

202 Yin Yang

A simple mosaic slip stitch pattern that would work as a band or as a single motif. Slip stitch patterns are worked with just one color per row but they are stranded, so if you are new to this technique then practice first, as the strands need to be even to get the best results. If the swatch looks untidy, block and dry it first as you will be surprised how much the work evens out.

Yarn: Fingering to bulky

Multiple: 11 sts + 3

Cast on in color A.

Row 1 (WS): In color A, purl.

Row 2: In color B, k1, *[sl1 wyib] three times, k6, [sl1 wyib] twice; rep from * to last 2 sts, sl1 wyib, k1.

Row 3: P1, sl1 wyif, *[sl1 wyif] twice, p6, [sl1 wyif] three times; rep from * to last st, p1.

Row 4: In color A, k1, *k3, sl1 wyib, k4, sl1 wyib, k2; rep from * to last 2 sts, k2.

Row 5: P2, *p2, sl1 wyif, p4, sl1 wyif, p3; rep from * to last st, p1.

Row 6: In color B, k1, *[sl1 wyib] twice, k3, [sl1 wyib] three times, k3; rep from * to last 2 sts, k2.

Row 7: P2, *p3, [sl1 wyif] three times, p3, [sl1 wyif] twice; rep from * to last st, p1.

Row 8: In color A, k1, *k2, [sl1 wyib] three times, k5, sl1 wyib; rep from * to last 2 sts, k2.

Row 9: P2, *sl1 wyif, p5, [sl1 wyif] three times, p2; rep from * to last st, p1.

Row 10: In color B, k1, *sl1 wyib, k5, sl1 wyib, k1, [sl1 wyib] twice, k1; rep from * to last 2 sts, sl1 wyib, k1.

Row 11: P1, sl1 wyif, *p1, [sl1 wyif] twice, p1, sl1 wyif, p5, sl1 wyif; rep from * to last st, p1.

Row 12: In color A, k1, *[k1, (sl1 wyib) twice] twice, k4, sl1 wyib; rep from * to last 2 sts, k2.

Row 13: P2, *sl1 wyif, p4, [(sl1 wyif) twice, p1] twice; rep from * to last st, p1.

Row 14: In color B, k1, *sl1 wyib, k5, [sl1 wyib] three times, k2; rep from * to last 2 sts, sl1 wyib, k1.

Row 15: P1, sl1 wyif, *p2, [sl1 wyif] three times, p5, sl1 wyif; rep from * to last st, p1.

Row 16: In color A, k1, *k3, [sl1 wyib] three times, k3, sl1 wyib, k1; rep from * to last 2 sts, k2.

Row 17: P2, *p1, sl1 wyif, p3, [sl1 wyif] three times, p3; rep from * to last st, p1.

Row 18: In color B, k1, *[sl1 wyib] three times, k7, sl1 wyib; rep from * to last 2 sts, sl1 wyib, k1.

Row 19: P1, sl1 wyif, *sl1 wyif, p7, [sl1 wyif] three times; rep from * to last st, p1.

Row 20: In color A, knit.

Row 21: Purl.

Rows 22 & 23: In color B, repeat Rows 20 & 21.

Rows 24 & 25: Repeat Rows 20 & 21.

Repeat: Rows 2–25

Mosaic/slip stitch colorwork

Mosaic (also referred to as slip stitch) colorwork is a fascinating technique that produces intricate patterns without having to use more than one color per row. The colorwork patterns are achieved by working in pairs of colors: two rows of A, two rows of B, and so on. The second color is incorporated into the row by slipping a stitch worked in the opposite color from the row below.

Mosaic pattern charts are easy to follow with a little practice. The color to be worked is indicated by the first square on the chart. The entire row is then worked in that color, slipping the stitches where the second color is shown. On the right side, the working yarn is slipped in back; on the wrong side, the working yarn is slipped in front. Once the first row of the pair has been worked, the second row simply follows the first, purling the worked stitches and slipping the slipped stitches with yarn in front.

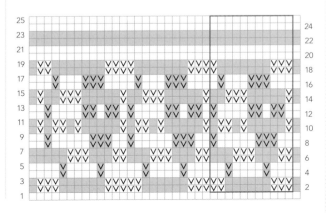

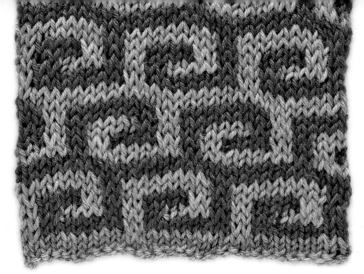

203 Greek Key Fretwork

This design is based on the Greek key pattern, so called because the design looks a little like a key. This sample uses just stockinette and slip stitches to create a stepped effect. As only one color is used per row, this technique is a simple way to create a really impressive two-color pattern.

Yarn: Fingering to worsted

Multiple: 10 sts + 2

Cast on in color A.

Row 1 (RS): In color A, knit.

Row 2: Purl.

Row 3: In color B, k1, *k8, [sl1 wyib] twice; rep from * to last st, k1.

Row 4: P1, *[sl1 wyif] twice, p8; rep from * to last st, p1.

Row 5: In color A, k1, *[sl1 wyib] twice, k4, [sl1 wyib] twice, k2; rep from * to last st, k1.

Row 6: P1, *p2, [sl1 wyif] twice, p4, [sl1 wyif] twice; rep from * to last st, p1.

Row 7: In color B, k1, *k2, [sl1 wyib] twice, k4, [sl1 wyib] twice; rep from * to last st, k1.

Row 8: P1, *[sl1 wyif] twice, p4, [sl1 wyif] twice, p2; rep from * to last st, p1.

Row 9: In color A, k1, *[sl1 wyib] twice, k8; rep from * to last st, k1.

Row 10: P1, *p8, [sl1 wyif] twice; rep from * to last st, p1.

Row 11: In color B, knit.

Row 12: Purl.

Row 13: In color A, k1, *k3, [sl1 wyib] twice, k5; rep from * to last st, k1.

Row 14: P1, *p5, [sl1 wyif] twice, p3; rep from * to last st, p1.

Row 15: In color B, k1, *k1, [sl1 wyib] twice, k2, [sl1 wyib] twice, k3; rep from * to last st, k1.

Row 16: P1, *p3, [sl1 wyif] twice, p2, [sl1 wyif] twice, p1; rep from * to last st, p1.

Row 17: In color A, k1, *k3, [sl1 wyib] twice, k2, [sl1 wyib] twice, k1; rep from * to last st, k1.

Row 18: P1, *p1, [sl1 wyif] twice, p2, [sl1 wyif] twice, p3; rep from * to last st, p1.

Row 19: In color B, k1, *k5, [sl1 wyif] twice, k3; rep from * to last st, k1.

Row 20: P1, *p3, [sl1 wyif] twice, p5; rep from * to last st, p1.

Repeat: Rows 1–20

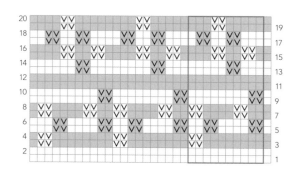

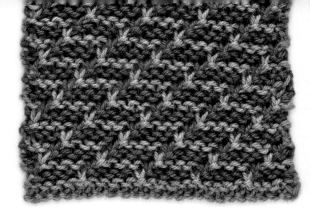

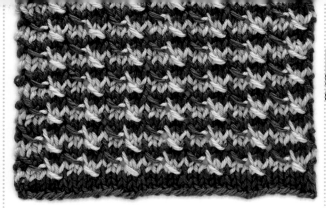

204 Two-Color Garter Steps

This is an interesting and simple pattern that uses just knit and slip stitches to create a stepped effect. Only one color is used per row, with two rows of each between color changes. This means that the yarns not in use can simply be carried up the side of the work.

Yarn: Light fingering to worsted

Multiple: 5 sts

Cast on in color A.

Row 1 (RS): In color A, knit.

Row 2: Knit.

Row 3: In color B, *k4, sl1 wyib; rep from * to end.

Row 4: *Sl1 wyif, k4; rep from * to end.

Row 5: In color A, *k3, sl1 wyib, k1; rep from * to end.

Row 6: *K1, sl1 wyif, k3; rep from * to end.

Row 7: In color B, *k2, sl1 wyib, k2; rep from * to end.

Row 8: *K2, sl1 wyif, k2; rep from * to end.

Row 9: In color A, *k1, sl1 wyib, k3; rep from * to end.

Row 10: *K3, sl1 wyif, k1; rep from * to end.

Row 11: In color B, *sl1 wyib, k4; rep from * to end.

Row 12: *K4, sl1 wyif; rep from * to end.

Repeat: Change color and repeat Rows 3–12, alternating 2 rows in color A and 2 rows in color B.

205 Two-Color Diagonal Dropped Stitch

The interesting shapes in this straightforward pattern are created by lifting up a strand in the opposite color from the row below. It gives a firm fabric that would make an attractive all-over pattern. Additional colors could also be added, or perhaps a plain yarn could be used with a variegated contrast yarn.

Yarn: Light fingering to worsted

Multiple: 4 sts + 2

Cast on in color A.

Row 1 (WS): In color A, purl.

Row 2: Knit.

Row 3: In color B, purl.

Row 4: K1, *Lk2p, k2; rep from * to last st, k1.

Row 5: In color A, purl.

Row 6: K1, *k2, Lk2p; rep from * to last st, k1.

Repeat: Rows 3–6

Abbreviation

Lk2p: Insert RH needle from front to back below strand between st just worked and next st. Put onto RH needle. Knit next 2 sts. Lift strand over 2 sts just knitted and drop off RH needle.

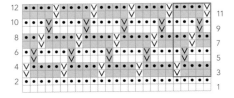

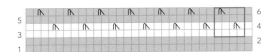

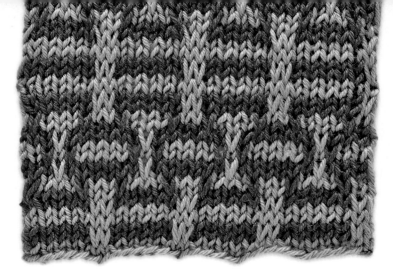

206 Woven Band

A striking mosaic pattern that could be worked as a band or as an all-over design. For best results, mosaic patterns benefit from a medium-weight yarn that plumps up when blocked. This nicely evens out the stitches and gives a smooth finish. Mosaic patterns are particularly effective when worked in a plain and contrasting variegated yarn.

Yarn: Fingering to worsted

Multiple: 7 sts + 2

Cast on in color A.

Row 1 (RS): In color A, knit.

Row 2: Purl.

Row 3: In color B, k1, *sl1 wyib, k5, sl1 wyib; rep from * to last st, k1.

Row 4: P1, *sl1 wyif, p5, sl1 wyif; rep from * to last st, p1.

Rows 5–8: Repeat Rows 1–4.

Row 9: In color A, k1, *k1, sl1 wyib, k3, sl1 wyib, k1; rep from * to last st, k1.

Row 10: P1, *p1, sl1 wyif, p3, sl1 wyif, p1; rep from * to last st, p1.

Row 11: In color B, k1, *k3, sl1 wyib, k3; rep from * to last st, k1.

Row 12: P1, *p3, sl1 wyif, p3; rep from * to last st, p1.

Row 13: In color A, k1, *k2, sl1 wyib, k1, sl1 wyib, k2; rep from * to last st, k1.

Row 14: P1, *p2, sl1 wyif, p1, sl1 wyif, p2; rep from * to last st, p1.

Rows 15–16: Repeat Rows 11–12.

Rows 17–18: Repeat Rows 9–10.

Rows 19–20: Repeat Rows 3–4.

Rows 21–24: Repeat Rows 1–4.

Repeat: Rows 1–24

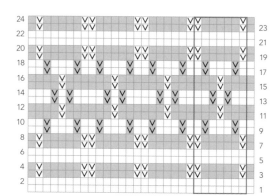

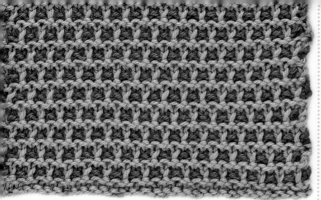

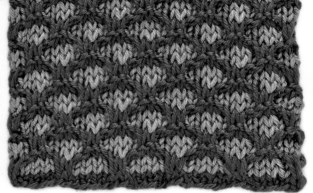

207 Waffle Check

Worked entirely in garter stitch, and exploiting slip stitches to create the little windows in the second color, this is a richly textured but supple fabric that lends itself to a wide variety of projects and yarns. Worked in two colors here, a third or even fourth color could be added.

Yarn: Fingering to worsted

Multiple: 2 sts + 1

Cast on in color A.

Row 1 (RS): In color A, knit.

Row 2: Knit.

Row 3: In color B, *k1, sl1 wyib; rep from * to last st, k1.

Row 4: K1, *sl1 wyif, k1; rep from * to end.

Rows 5 & 6: Repeat Rows 1 & 2.

Row 7: In color B, *sl1 wyib, k1; rep from * to last st, sl1 wyib.

Row 8: Sl1 wyif, *k1, sl1 wyif; rep from * to end

Repeat: Rows 1–8

208 Diamond Window Lattice

This lattice pattern produces a very attractive, springy fabric that works well as either an all-over fabric on a garment or on homewares. Experiment with a light color for A and a dark color for B, then try the reverse and see how different the effect is on the pattern.

Yarn: Fingering to worsted

Multiple: 6 sts + 2

Cast on in color A.

Row 1 (WS): In color A, purl.

Row 2: In color B, k1, *sl1 wyib, k4, sl1 wyib; rep from * to last st, k1.

Row 3: P1, *sl1 wyif, p4, sl1 wyif; rep from * to last st, p1.

Row 4: In color A, repeat Row 2.

Row 5: P1, *sl1 wyif, k4, sl1 wyif; rep from * to last st, p1.

Row 6: In color B, k1, *k2, [sl1 wyib] twice, k2; rep from * to last st, k1.

Row 7: P1, *p2, [sl1 wyif] twice, p2; rep from * to last st, p1.

Row 8: In color A, repeat Row 6.

Row 9: P1, *k2, [sl1 wyif] twice, k2; rep from * to last st, p1.

Repeat: Rows 2–9

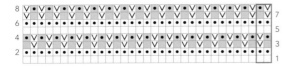

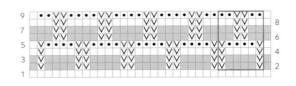

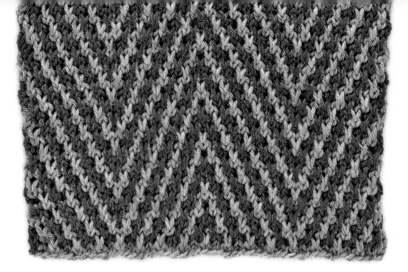

209 Two-Color Zebra Chevron

This bold, striking pattern produces a firm fabric that is amazing for totes and soft furnishings. For a softer feel, it can be worked on slightly larger than normal needles but swatch, block, and finish first to check that the fabric doesn't develop gaps where the slip stitches are.

Yarn: Fingering to worsted

Multiple: 24 sts + 2

Cast on in color A.

Row 1 (WS): In color A, purl.

Row 2: In color B, k1, *[sl1 wyib, k2] eight times; rep from * to last st, k1.

Row 3: P1, *[p2, sl1 wyif] eight times; rep from * to last st, p1.

Row 4: In color A, k1, *k1, [sl1 wyib, k2] three times, sl1 wyib, k3, [sl1 wyib, k2] three times, sl1 wyib; rep from * to last st, k1.

Row 5: P1, *[sl1 wyif, p2] three times, sl1 wyif, p3, [sl1 wyif, p2] three times, sl1 wyif, p1; rep from * to last st, p1.

Row 6: In color B, k1, *k2, [(sl1 wyib, k2) three times, sl1 wyib, k1] twice; rep from * to last st, k1.

Row 7: P1, *[p1, (sl1 wyif, p2) three times, sl1 wyif] twice, p2; rep from * to last st, p1.

Rows 8 & 9: In color A, repeat Rows 2 & 3.

Rows 10 & 11: In color B, repeat Rows 4 & 5.

Rows 12 & 13: In color A, repeat Rows 6 & 7.

Repeat: Rows 2–13

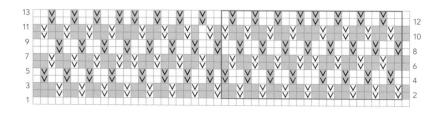

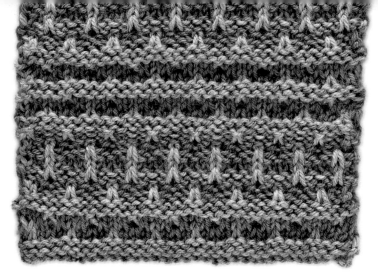

210 Macedonian Stitch

Mosaic knitting isn't limited to stockinette. Here, garter stitch has been incorporated to add texture as well as color. This pattern combines a series of meander patterns to make a large repeat. It could be readily separated into sections or recombined to make attractive bands or larger patterns.

Yarn: Fingering to worsted

Multiple: 4 sts + 2

Cast on in color A.

Row 1 (RS): In color A, purl.

Row 2: In color B, sl1 wyif, *p3, sl1 wyif; rep from * to last st, p1.

Row 3: K1, *sl1 wyib, k3; rep from * to last st, sl1 wyib.

Row 4: In color A, p1, *[sl1 wyif, p1] twice; rep from * to last st, p1.

Row 5: K1, *[k1, sl1 wyib] twice; rep from * to last st, k1.

Row 6: In color B, p1, *p1, sl1 wyif, p2; rep from * to last st, p1.

Row 7: K1, *k2, sl1 wyib, k1; rep from * to last st, k1.

Row 8: In color A, knit.

Row 9: Purl.

Row 10: In color B, sl1 wyif, *k3, sl1 wyif; rep from * to last st, p1.

Row 11: K1, *sl1 wyib, p3; rep from * to last st, sl1 wyib.

Rows 12 & 13: Repeat Rows 4 & 5.

Row 14: In color B, k1, *k1, sl1 wyif, k2; rep from * to last st, p1.

Row 15: K1, *p2, sl1 wyib, p1; rep from * to last st, p1.

Row 16: In color A, purl.

Row 17: Knit.

Rows 18 & 19: Repeat Rows 14 & 15.

Rows 20 & 21: Repeat Rows 4 & 5.

Rows 22 & 23: Repeat Rows 10 & 11.

Rows 24 & 25: Repeat Rows 8 & 9.

Rows 26 & 27: Repeat Rows 6 & 7.

Rows 28 & 29: Repeat Rows 4 & 5.

Rows 30 & 31: Repeat Rows 2 & 3.

Rows 32 & 33: Repeat Rows 8 & 9.

Repeat: Rows 2–33

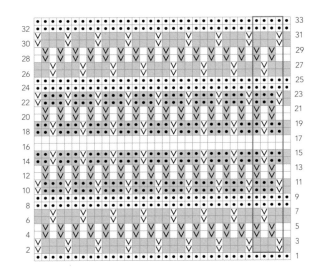

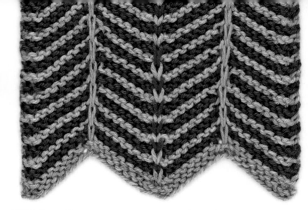

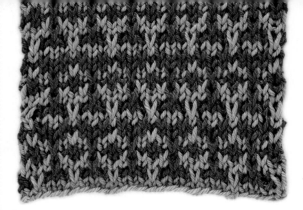

211 Garter Striped Chevron

Richly textured chevrons with slip stitch spines to accent the chevron shapes. Working in colors in garter stitch gives a pattern with lots of impact. For a more subtle look this pattern would work equally well in a single color.

Yarn: Fingering to bulky

Multiple: 18 sts + 1

Cast on in color A.

Row 1 (RS): In color A, k1, *ssk, k6, m1r, k1, m1l, k6, k2tog, k1; rep from * to end.

Row 2: K9, sl1 wyif, k8, *[sl1 wyif, k8] twice; rep from * to last st, k1.

Row 3: In color B, k1, *ssk, k6, m1r, sl1 wyib, m1l, k6, k2tog, k1; rep from * to end.

Row 4: K9, sl1 wyif, k8, *[sl1 wyif, k8] twice; rep from * to last st, k1.

Repeat: Rows 1–4

Abbreviations

Ssk: Slip, slip, knit. Slip 2 sts one at a time as if to knit, knit 2 slipped sts together.

M1r: Make 1 knitwise (right leaning). Insert RH needle from front to back under strand between 2 sts and lift loop onto LH needle. Knit in back of loop to form new st.

M1l: Make 1 knitwise (left leaning). Insert RH needle from back to front under strand between 2 sts and lift loop onto LH needle. Knit in front of loop to form new st.

212 Cloisters

This attractive slip stitch colorwork pattern is produced by working pairs of rows in alternating colors. As only one color is used per row it is possible to produce intricate, detailed patterns without the complexity of Fair Isle techniques. A medium-weight yarn is best for this technique, ideally one that plumps up when blocked and finished, as this evens out the stitches.

Yarn: Fingering to worsted

Multiple: 4 sts + 5

Cast on in color A.

Row 1 (WS): In color A, purl.

Row 2: In color B, k2, sl1 wyib, k1, *k2, sl1 wyib, k1; rep from * to last st, k1.

Row 3: P1, *p1, sl1 wyif, p2; rep from * to end.

Row 4: In color A, k4, *sl1 wyib, k3; rep from * to last st, k1.

Row 5: P1, *p3, sl1 wyif; rep from * to last 4 sts, p4.

Row 6: In color B, *k1, sl1 wyib; rep from * to last st, k1.

Row 7: Purl.

Row 8: In color A, k2, *sl1 wyib, k1; rep from * to last st, k1.

Row 9: Repeat Row 5.

Row 10: Repeat Row 2.

Row 11: Purl.

Row 12: In color A, repeat Row 6.

Repeat: Rows 1–12

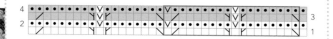

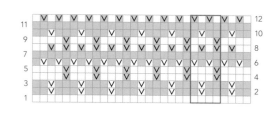

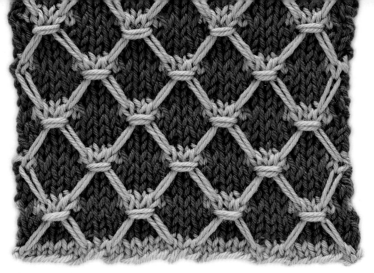

213 Drop Stitch Quilting

Shown here worked in two colors, this pattern works equally well worked in a single color. Clustered stitches emphasize the intersections of the quilting pattern and elongated stitches are stretched up the work to create the surface diamonds. Take care with the pattern repeats as the final two rows must be worked differently to ensure that the final elongated stitches are properly anchored in place.

Yarn: Light fingering to bulky

Multiple: 8 sts + 9

Cast on in color A.

Row 1 (WS): In color A, *p1, p1 elongated, p5, p1 elongated; rep from * to last st, p1.

Row 2: In color B, k1, sl1 wyib, *k5, sl1 wyib, k1, sl1 wyib; rep from * to last 7 sts, k5, sl1 wyib, k1.

Row 3: P1, sl1 wyif, p5, *sl1 wyif, p1, sl1 wyif, p5; rep from * to last 2 sts, sl1 wyif, p1.

Row 4: K1, sl1 wyib, *k5, sl1 wyib, k1, sl1 wyib; rep from * to last 7 sts, k5, sl1 wyib, k1.

Row 5: P1, drop 1 to RS, p5, *drop 1 to RS, p1, drop 1 to RS, p5; rep from * to last 2 sts, drop 1 to RS, p1.

Row 6: In color A, k1, sl1 wyib, *k1, pick up and knit dropped st, k1, pick up and knit dropped st, wr3, k1, [sl1 wyib] three times; rep from * to last 7 sts, k1, pick up and knit dropped st, k1, pick up and knit dropped st, wr3, k1, sl1 wyib, k1.

Row 7: P1, sl1 wyif, [p1, p1 elongated] twice, p1, *[sl1 wyif] three times, [p1, p1 elongated] twice, p1; rep from * to last 2 sts, sl1 wyif, p1.

Row 8: In color B, k2, *[k1, sl1 wyib] twice, k4; rep from * to last 7 sts, [k1, sl1 wyib] twice, k3.

Row 9: P3, [sl1 wyif, p1] twice, *p4, [sl1 wyif, p1] twice; rep from * to last 2 sts, p2.

Row 10: K2, *[k1, sl1 wyib] twice, k4; rep from * to last 7 sts, [k1, sl1 wyib] twice, k3.

Row 11: P3, [drop 1 to RS, p1] twice, *p4, [drop 1 to RS, p1] twice; rep from * to last 2 sts, p2.

Row 12: In color A, k1, pick up and knit dropped st, *k1, [sl1 wyib] three times, k1, pick up and knit dropped st, k1, pick up and knit dropped st, wr3; rep from * to last 7 sts, k1, [sl1 wyib] three times, k1, pick up and knit dropped st, k1.

Row 13: P1, p1 elongated, p1, [sl1 wyif] three times, p1, *[p1 elongated, p1] twice, [sl1 wyif] three times, p1; rep from * to last 2 sts, p1 elongated, p1.

Repeat: Rows 2–13. On final repeat, replace Rows 12 & 13 with Row 14, right.

Row 14: In color B, k2, *k1, [sl1 wyif] three times, k4; rep from * to last 7 sts, k1, [sl1 wyif] three times, k3.

Abbreviations

P1 elongated: Purl a st wrapping yarn around needle twice. On next row drop the extra wrap from needle.

Wr3: Wrap 3 stitches. Bring yarn to front between needles and slip 3 sts onto LH needle. Take yarn across front of work and between needles to back. Slip sts to RH needle. Bring yarn across back of work and between needles to front. Slip sts to LH needle and take yarn between needles. Take yarn across front of work, between needles, and hold in back. Transfer sts to RH needle.

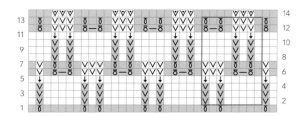

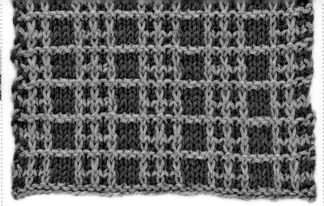

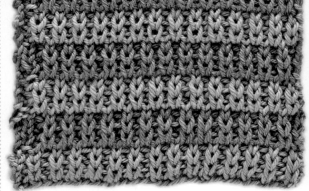

214 Block Check

Mosaic colorwork produces beautiful patterns but only requires the knitter to work with one color per row. The second color is brought into the row by slipping the stitch from the previous row. As with illusion knitting, the colors are worked in paired stripes and the two yarns can be carried easily up the side of the work, reducing the number of ends to weave in later. This pattern produces an interesting check, ideally suited to an all-over pattern.

Yarn: Fingering to bulky

Multiple: 8 sts + 5

Cast on in color A.

Row 1 (RS): In color A, knit.

Row 2: Knit.

Row 3: In color B, k1, *[k1, sl1 wyib] twice, k3, sl1 wyib; rep from * to last 4 sts, k1, sl1 wyib, k2.

Row 4: P2, sl1 wyif, p1, *sl1 wyif, p3, [sl1 wyif, p1] twice; rep from * to last st, p1.

Row 5: In color A, k1, *k4, [sl1 wyib] three times, k1; rep from * to last 4 sts, k4.

Row 6: P4, *p1, [sl1 wyif] three times, p4; rep from * to last st, p1.

Rows 7 & 8: Repeat Rows 3 & 4.

Repeat: Rows 3–8

215 Striped Half Brioche

This variation on a traditional ribbed brioche offsets the rib every six rows and coincides this with a color change to give deep stripes with a slightly stepped effect. As with all brioche stitches, the fabric is plump and bouncy, and lovely as an all-over fabric or for a particularly stretchy, thick rib. As this is a half brioche it is worked on straight needles (not backward and forward on double-pointed needles as a full brioche). Choose a medium-weight yarn for best effect.

Yarn: Fingering to worsted

Multiple: 2 sts + 4

Cast on in color A.

Row 1 (RS): In color A, k1, *k1, yo, sl1 wyib; rep from * to last 3 sts, k1, yo, sl1 wyib, k1.

Row 2: P1, k tog sl st and yo, p1, *k tog sl st and yo, p1; rep from * to last st, p1.

Rows 3–6: Repeat Rows 1 & 2 twice.

Row 7: In color B, k2, *k1, yo, sl1 wyib; rep from * to last 2 sts, k2.

Row 8: P2, *k tog sl st and yo, p1; rep from * to last 2 sts, k1, p1.

Row 9: K1, p1, *k1, yo, sl1 wyib; rep from * to last 2 sts, k2.

Row 10: Repeat Row 8.

Rows 11 & 12: Repeat Rows 9 & 10.

Repeat: Rows 1–12

Abbreviation

Yo, sl1 wyib: Take yarn around RH needle and slip next st purlwise with yarn held at back of work.

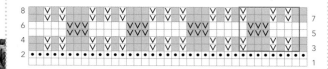

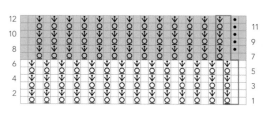

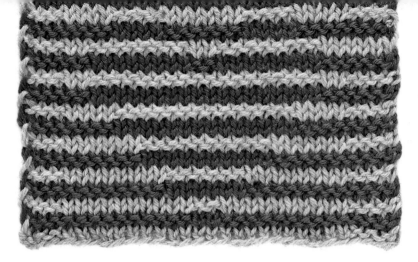

216 Illusion Knit Heart Motif

Illusion knitting relies on a clever (but deceptively simple) interplay between knit and purl stitches, and stripes knitted in two-row pairs (sometimes with the first row worked as a single color). There are no color changes within rows so it's an easy way to achieve a great colorwork pattern. If you can't see the effect immediately, tilt the work and wait for the magic to appear.

Yarn: Fingering to bulky

Motif: 30 sts

Cast on in color A.

Row 1 (WS): In color A, *k4, p22, k4.

Row 2: In color B, knit.

Row 3: K14, p2, k14.

Row 4: In color A, knit.

Row 5: *K4, p10, k2, p10, k4; rep from * to end.

Row 6: In color B, knit.

Row 7: K12, p6, k12.

Row 8: In color A, knit.

Row 9: K4, p8, k6, p8, k4.

Row 10: In color B, knit.

Row 11: K10, p10, k10.

Row 12: In color A, knit.

Row 13: K4, p6, k10, p6, k4.

Row 14: In color B, knit.

Row 15: K8, p14, k8.

Row 16: In color A, knit.

Row 17: K4, p4, k14, p4, k4.

Row 18: In color B, knit.

Row 19: K6, p18, k6.

Row 20: In color A, knit.

Row 21: K4, p2, k18, p2, k4.

Row 22: In color B, knit.

Row 23: K6, p8, k2, p8, k6.

Row 24: In color A, knit.

Row 25: K4, [p2, k8] twice.

Row 26: In color B, knit.

Row 27: K8, p4, k6, p4, k8.

Row 28: In color A, knit.

Row 29: K4, p4, k4, p6, k4, p4, k4.

Row 30: In color B, knit.

Row 31: Purl.

Repeat: Rows 1–31

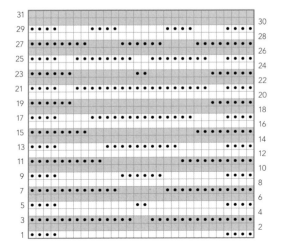

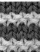

217 Illusion Knit Star Motif

Illusion knitting patterns are like magic in the way that they use such simple combinations of colored stripes, knits, and purls to produce amazing "hidden" designs. Illusion patterns are best worked with smooth yarns to make the most of the special effects they create.

Yarn: Fingering to bulky

Motif: 33 sts

Cast on in color A.
Row 1 (RS): In color A, knit.
Row 2: Knit.
Row 3: In color B, knit.
Row 4: Purl.
Row 5: In color A, knit.
Row 6: K11, p1, k9, p1, k11.
Row 7: In color B, knit.
Row 8: P11, k1, p9, k1, p11.
Row 9: In color A, knit.
Row 10: K12, p2, k5, p2, k12.
Row 11: In color B, knit.
Row 12: P12, k2, p5, k2, p12.
Row 13: In color A, knit.
Row 14: K12, p4, k1, p4, k12.
Row 15: In color B, knit.
Row 16: P12, k4, p1, k4, p12.
Row 17: In color A, knit.
Row 18: K13, p7, k13.
Row 19: In color B, knit.
Row 20: P13, k7, p13.
Row 21: In color A, knit.
Row 22: K13, p7, k13.
Row 23: In color B, knit.
Row 24: P13, k7, p13.

Row 25: In color A, knit.
Row 26: K10, p12, k11.
Row 27: In color B, knit.
Row 28: P10, k12, p11.
Row 29: In color A, knit.
Row 30: K9, p15, k9.
Row 31: In color B, knit.
Row 32: P9, k15, p9.
Row 33: In color A, knit.
Row 34: K14, p5, k14.
Row 35: In color B, knit.
Row 36: P14, k5, p14.
Row 37: In color A, knit.
Row 38: K15, p3, k15.
Row 39: In color B, knit.
Row 40: P15, k3, p15.
Row 41: In color A, knit.
Row 42: K16, p1, k16.
Row 43: In color B, knit.
Row 44: P16, k1, p16.
Row 45: In color A, knit.
Row 46: Knit.
Row 47: In color B, knit.
Row 48: Purl.

Repeat: Rows 1–48

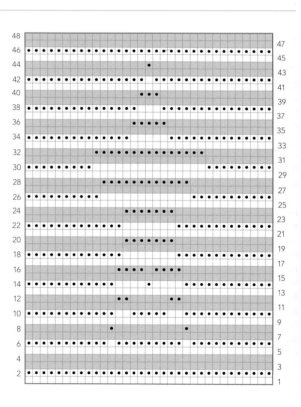

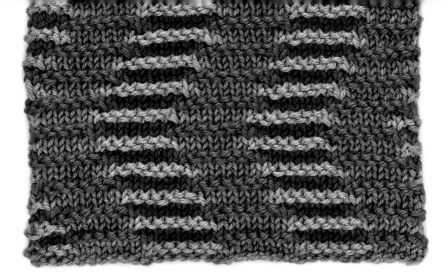

218 Illusion Knit Zigzag

This fascinating illusion knitting pattern has a surprise in store. Tilt the fabric and view it from different angles and it will reveal its secret. It can be worked in a wide range of yarns and would make a great tote, or perhaps work in a bulky yarn for a rug or throw. Watch people's faces when they see the pattern magically appear.

Yarn: Fingering to bulky

Multiple: 13 sts + 10

Cast on in color A.

Row 1 (RS): In color A, knit.

Row 2: K4, *p7, k6; rep from * to last 6 sts, p6.

Row 3: In color B, knit.

Row 4: P4, *k6, p7; rep from * to last 6 sts, k6.

Row 5: In color A, knit.

Row 6: K3, *p7, k6; rep from * to last 7 sts, p7.

Row 7: In color B, knit.

Row 8: P3, *k6, p7; rep from * to last 7 sts, k6, p1.

Row 9: In color A, knit.

Row 10: K2, *p7, k6; rep from * to last 8 sts, p7, k1.

Row 11: In color B, knit.

Row 12: P2, *k6, p7; rep from * to last 8 sts, k6, p2.

Row 13: In color A, knit.

Row 14: K1, *p7, k6; rep from * to last 9 sts, p7, k2.

Row 15: In color B, knit.

Row 16: P1, *k6, p7; rep from * to last 9 sts, k6, p3.

Row 17: In color A, knit.

Row 18: *P7, k6; rep from * to last 10 sts, p7, k3.

Row 19: In color B, knit.

Row 20: *K6, p7; rep from * to last 10 sts, k6, p4.

Row 21: In color A, knit.

Row 22: *P7, k6; rep from * to last 10 sts, p7, k3.

Rows 23 & 24: Repeat Rows 15 & 16.

Rows 25 & 26: Repeat Rows 13 & 14.

Rows 27 & 28: Repeat Rows 11 & 12.

Rows 29 & 30: Repeat Rows 9 & 10.

Rows 31 & 32: Repeat Rows 7 & 8.

Rows 33 & 34: Repeat Rows 5 & 6.

Rows 35 & 36: Repeat Rows 3 & 4.

Repeat: Rows 1–36

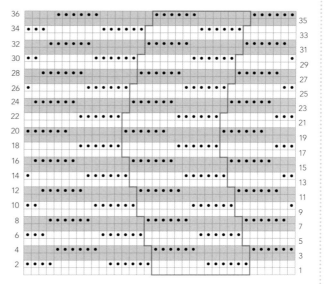

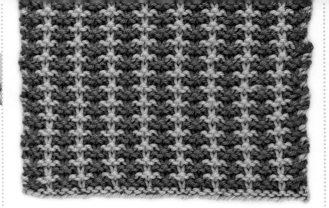

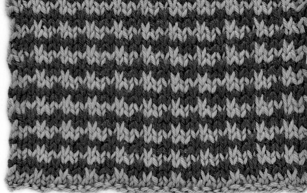

219 Jacob's Ladder

A garter stitch base with offset slip stitches creates a richly textured, striking stitch. Choose two plain colors, as here, or combine a plain color with a variegated one for a very different look. Smooth yarns in a light to medium weight are ideal for this springy, plump fabric.

Yarn: Fingering to worsted

Multiple: 4 sts + 3

Cast on in color A.

Row 1 (WS): In color A, knit.

Row 2: In color B, *k3, sl1 wyib; rep from * to last 3 sts, k3.

Row 3: K3, *sl1 wyif, k3; rep from * to end.

Row 4: In color A, *k1, sl1 wyib, k2; rep from * to last 3 sts, k1, sl1 wyib, k1.

Row 5: K1, sl1 wyif, k1, *k2, sl1 wyif, k1; rep from * to end.

Repeat: Rows 2–5

220 Houndstooth Check

The beauty of slip stitch colorwork is that it allows you to create fabrics that look like complex Fair Isle but using only one color per row. This makes for a quick knit and stunning effects—an ideal combination! Slip stitch worked on stockinette stitch, as here, needs to be carefully blocked to achieve a smooth surface.

Yarn: Fingering to worsted

Multiple: 3 sts + 2

Cast on in color A.

Row 1 (RS): In color A, k1, *sl1 wyib, k2; rep from * to last st, k1.

Row 2: K1, purl to last st, k1.

Row 3: In color B, k1, *k2, sl1 wyib; rep from * to last st, k1.

Row 4: K1, purl to last st, k1.

Repeat: Rows 1–4

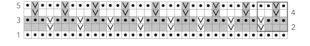

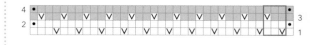

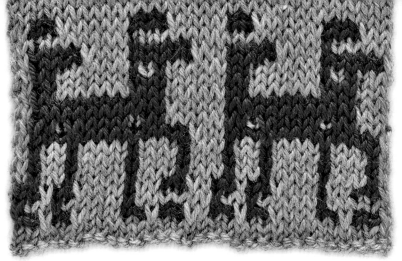

221 Llamas

Mosaic knitting is a fun technique for motif knitting that avoids intarsia or the complexities of Fair Isle stranding. This cute pair of llamas is easy to work and would make a great pattern on a garment as a motif, as a band, or around a neckline. It would also make a great tote or pillow.

Yarn: Fingering to worsted

Multiple: 16 sts + 2

Cast on in color A.

Row 1 (RS): In color A, knit.

Row 2: Purl.

Row 3: In color B, k1, *[sl1 wyib, k2] twice, [sl1 wyib] four times, [k2, sl1 wyib] twice; rep from * to last st, k1.

Row 4: P1, *[sl1 wyif, p2] twice, [sl1 wyif] four times, [p2, sl1 wyif] twice; rep from * to last st, p1.

Row 5: In color A, k1, *[k5, sl1 wyib] twice, k2, sl1 wyib, k1; rep from * to last st, k1.

Row 6: P1, *p1, sl1 wyif, p2, [sl1 wyif, p5] twice; rep from * to last st, p1.

Row 7: In color B, k1, *sl1 wyib, k2, [sl1 wyib] twice, k1, [sl1 wyib] four times, k2, sl1 wyib, k2, sl1 wyib; rep from * to last st, k1.

Row 8: P1, *[sl1 wyif, p2] twice, [sl1 wyif] four times, p1, [sl1 wyif] twice, p2, sl1 wyif; rep from * to last st, p1.

Row 9: In color A, k1, *k1, sl1 wyib, k3, sl1 wyib, k4, [sl1 wyib, k2] twice; rep from * to last st, k1.

Row 10: P1, *[p2, sl1 wyif] twice, p4, sl1 wyif, p3, sl1 wyif, p1; rep from * to last st, p1.

Row 11: In color B, k1, *sl1 wyib, k1, sl1 wyib, k3, [sl1 wyib] four times, [k1, (sl1 wyib) twice] twice; rep from * to last st, k1.

Row 12: P1, *[(sl1 wyif) twice, p1] twice, [sl1 wyif] four times, p1, [sl1 wyif] three times, p1, sl1 wyif; rep from * to last st, p1.

Rows 13 & 14: Repeat Rows 9 & 10.

Row 15: In color B, k1, *sl1 wyib, k13, [sl1 wyib] twice; rep from * to last st, k1.

Row 16: P1, *[sl1 wyif] twice, p13, sl1 wyif; rep from * to last st, p1.

Row 17: In color A, k1, *k3, [sl1 wyib] twice, k1, [sl1 wyib] five times, k1, [sl1 wyib] twice, k2; rep from * to last st, k1.

Row 18: P1, *p2, [sl1 wyif] twice, p1, [sl1 wyif] five times, p1, [sl1 wyif] twice, p3; rep from * to last st, p1.

Row 19: In color B, k1, *[sl1 wyib] three times, k11, [sl1 wyib] twice; rep from * to last st, k1.

Row 20: P1, *[sl1 wyif] twice, p11, [sl1 wyif] three times; rep from * to last st, p1.

Row 21: In color A, k1, *k3, [sl1 wyib] three times, k6, [sl1 wyib] twice, k2; rep from * to last st, k1.

Row 22: P1, *p2, [sl1 wyif] twice, p6, [sl1 wyif] three times, p3; rep from * to last st, p1.

Row 23: In color B, k1, *[sl1 wyib] three times, k3, [(sl1 wyib) twice, k2] twice, [sl1 wyib] twice; rep from * to last st, k1.

Row 24: P1, *[(sl1 wyif) twice, p2] twice, [sl1 wyif] twice, p3, [sl1 wyif] three times; rep from * to last st, p1.

Row 25: In color A, k1, *k3, sl1 wyib, k1, sl1 wyib, k6, [sl1 wyib] twice, k2; rep from * to last st, k1.

Row 26: P1, *p2, [sl1 wyif] twice, p6, sl1 wyif, p1, sl1 wyif, p3; rep from * to last st, p1.

Row 27: In color B, k1, *sl1 wyib, k5, [sl1 wyib] four times, k4, [sl1 wyib] twice; rep from * to last st, k1.

Row 28: P1, *[sl1 wyif] twice, p4, [sl1 wyif] four times, p5, sl1 wyif; rep from * to last st, p1.

Row 29: In color A, k1, *k5, sl1 wyib, k10; rep from * to last st, k1.

Row 30: P1, *p10, sl1 wyif, p5; rep from * to last st, p1.

Row 31: In color B, k1, *[sl1 wyib] three times, k3, [sl1 wyib] six times, k2, [sl1 wyib] twice; rep from * to last st, k1.

Row 32: P1, *[sl1 wyif] twice, p2, [sl1 wyif] six times, p3, [sl1 wyif] three times; rep from * to last st, p1.

Row 33: In color A, knit.

Row 34: Purl.

Repeat: Rows 1–34

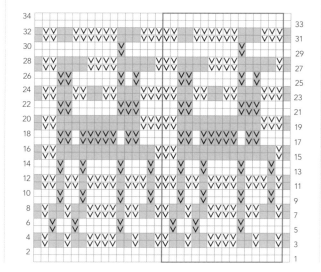

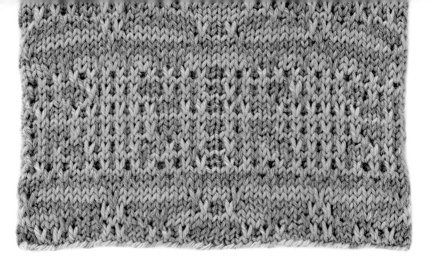

222 Moroccan Lattice

This large mosaic colorwork pattern is worked entirely in stockinette with slipped stitches, which lift the stitches in one color up into the row of stitches in the opposite color. Each row is knitted in a single color. Colors are worked in pairs of two rows. Yarn can be carried up the side of the work.

Yarn: Fingering to worsted

Multiple: 25 sts

Cast on in color A.

Row 1 (WS): In color A, purl.

Row 2: In color B, *k3, [sl1 wyib, k1] three times, k2, [sl1 wyib, k1] twice, k2, [sl1 wyib, k1] three times, k2; rep from * to end.

Row 3: *P3, [sl1 wyif, p1] three times, p2, [sl1 wyif, p1] twice, p2, [sl1 wyif, p1] three times, p2; rep from * to end.

Row 4: In color A, *k6, [sl1 wyib, k1] three times, k2, [sl1 wyib, k1] three times, k5; rep from * to end.

Row 5: *P6, [sl1 wyif, p1] twice, sl1 wyif, p3, [sl1 wyif, p1] twice, sl1 wyif, p6; rep from * to end.

Row 6: In color B, *[k1, sl1 wyib, k9, sl1 wyib] twice, k1; rep from * to end.

Row 7: *[P1, sl1 wyif, p9, sl1 wyif] twice, p1; rep from * to end.

Row 8: In color A, *k2, [sl1 wyib, k9] twice, sl1 wyib, k2; rep from * to end.

Row 9: *P2, [sl1 wyif, p9] twice, sl1 wyif, p2; rep from * to end.

Row 10: In color B, knit.

Row 11: Purl.

Row 12: In color A, *k4, sl1 wyib, k1, [sl1 wyib, k3] three times, sl1 wyib, k1, sl1 wyib, k4; rep from * to end.

Row 13: *P4, sl1 wyif, p1, [sl1 wyif, p3] three times, sl1 wyif, p1, sl1 wyif, p4; rep from * to end.

Row 14: In color B, *[k1, sl1 wyib] twelve times, k1; rep from * to end.

Row 15: *P1, [sl1 wyif, p1] twelve times; rep from * to end.

Row 16: In color A, *k2, sl1 wyib, k5, [sl1 wyib, k3] twice, sl1 wyib, k5, sl1 wyib, k2; rep from * to end.

Row 17: *P2, sl1 wyif, p5, [sl1 wyif, p3] twice, sl1 wyif, p5, sl1 wyif, p2; rep from * to end.

Row 18: In color B, *[(k1, sl1 wyib) three times, k3, sl1 wyib] twice, [k1, sl1 wyib] twice, k1; rep from * to end.

Row 19: *[(P1, sl1 wyif) three times, p3, sl1 wyif] twice, [p1, sl1 wyif] twice, p1; rep from * to end.

Row 20: In color A, *k2, [sl1 wyib, k1] twice, [sl1 wyib, k3] three times, [sl1 wyib, k1] twice, k1; rep from * to end.

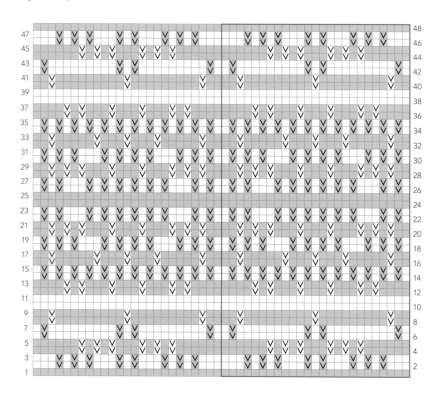

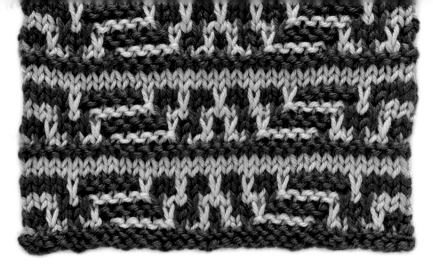

223 Mini Chevrons

This pattern combines mosaic knitting with garter stitch to give an interesting blend of color, shape, and texture. It's a simple pattern with just one color per row (worked in pairs: two rows of color A, two rows of color B, and so on), making it easy to carry the color that is not in use up the side of the work, and reducing weaving in ends.

Yarn: Fingering to worsted

Row 21: *P2, *[sl1 wyif, p1] twice, [sl1 wyif, p3] three times, [sl1 wyif, p1] twice, sl1 wyif, p2; rep from * to end.

Row 22: In color B, *[k1, sl1 wyib] twice, k3, [sl1 wyib, k1] five times, sl1 wyib, k3, [sl1 wyib, k1] twice; rep from * to end.

Row 23: *[P1, sl1 wyif] twice, p3, [sl1 wyif, p1] five times, sl1 wyif, p3, [sl1 wyif, p1] twice; rep from * to end.

Rows 24 & 25: In color A, repeat Rows 10 & 11.

Rows 26 & 27: Repeat Rows 22 & 23.

Rows 28 & 29: Repeat Rows 20 & 21.

Rows 30 & 31: Repeat Rows 18 & 19.

Rows 32 & 33: Repeat Rows 16 & 17.

Rows 34 & 35: Repeat Rows 14 & 15.

Rows 36 & 37: Repeat Rows 12 & 13.

Rows 38 & 39: Repeat Rows 10 & 11.

Rows 40 & 41: Repeat Rows 8 & 9.

Rows 42 & 43: Repeat Rows 6 & 7.

Rows 44 & 45: Repeat Rows 4 & 5.

Rows 46 & 47: Repeat Rows 2 & 3.

Row 48: In color A, knit.

Repeat: Rows 1–48

Multiple: 33 sts + 2

Cast on in color A.

Row 1 (RS): In color A, knit.

Row 2: Knit.

Row 3: In color B, *k2, [(sl1 wyib, k2) twice, sl1 wyib, k5] twice, [sl1 wyib, k2] twice, sl1 wyib; rep from * to last 2 sts, k2.

Row 4: P2, *[(sl1 wyif, p2) twice, sl1 wyif, k5] twice, [sl1 wyif, p2] three times; rep from * to end.

Row 5: In color A, *[k3, sl1 wyib] twice, k5, sl1 wyib, k2, sl1 wyib, k1,

sl1 wyib, k2, sl1 wyib, k5, sl1 wyib, k3, sl1 wyib, k1; rep from * to last 2 sts, k2.

Row 6: P2, *p1, sl1 wyif, p3, sl1 wyif, k5, sl1 wyif, p2, sl1 wyif, p1, sl1 wyif, p2, sl1 wyif, k5, [sl1 wyif, p3] twice; rep from * to end.

Row 7: In color B, *k4, sl1 wyib, k1, sl1 wyib, k5, sl1 wyib, k2, sl1 wyib, k3, sl1 wyib, k2, sl1 wyib, k5, sl1 wyib, k1, sl1 wyib, k2; rep from * to last 2 sts, k2.

Row 8: P2, *p2, sl1 wyif, p1, sl1 wyif, k5, sl1 wyif, p2, sl1 wyif,

p3, sl1 wyif, p2, sl1 wyif, k5, sl1 wyif, p1, sl1 wyif, p4; rep from * to end.

Row 9: In color A, *[k5, sl1 wyib] twice, [k2, sl1 wyib] four times, k5, sl1 wyib, k3; rep from * to last 2 sts, k2.

Row 10: P2, *p3, sl1 wyif, k5, [sl1 wyif, p2] four times, sl1 wyif, k5, sl1 wyif, p5; rep from * to end.

Row 11: In color B, knit.

Row 12: Purl.

Repeat: Rows 1–12

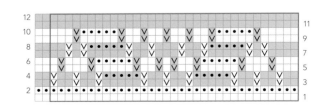

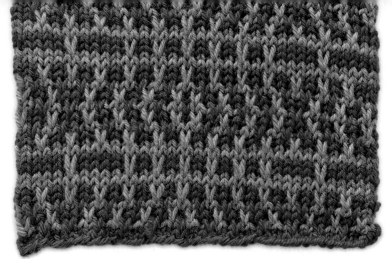

224 Persian Rug

This is a more challenging pattern, but not because of the complexity of the stitches—there are just a lot of rows and it takes a little concentration to follow! Why not use a sticky note to underline the row you are working on. Like all mosaic colorwork, the pattern is worked in one color per row and the color changes are achieved by slipping stitches to lift up the second color from the row below.

Yarn: Fingering to worsted

Multiple: 24 sts + 13

Cast on in color A.

Row 1 (WS): In color A, purl.

Row 2: In color B, k1, *[k2, sl1 wyib]; rep from * to last 3 sts, k3.

Row 3: P3, *[sl1 wyif, p2]; rep from * to last st, p1.

Row 4: In color A, k1, *sl1 wyib, k2, sl1 wyib, k3, [sl1 wyib, k2] three times, sl1 wyib, k1, [sl1 wyib, k2] twice; rep from * to last 12 sts, sl1 wyib, k2, sl1 wyib, k3, sl1 wyib, k2, sl1 wyib, k1.

Row 5: P1, sl1 wyif, p2, sl1 wyif, p3, sl1 wyif, p2, sl1 wyif, *[p2, sl1 wyif] twice, p1, [sl1 wyif, p2] three times, sl1 wyif, p3, sl1 wyif, p2, sl1 wyif; rep from * to last st, p1.

Row 6: In color A, k1, *[k1, sl1 wyib, k2, sl1 wyib] twice, [k2, sl1 wyib] twice, k3, sl1 wyib, k2, sl1 wyib, k1; rep from * to last 12 sts, [k1, sl1 wyib, k2, sl1 wyib] twice, k2.

Row 7: P2, [sl1 wyif, p2, sl1 wyif, p1] twice, *p1, sl1 wyif, p2, sl1 wyif, p3, [sl1 wyif, p2] twice, [sl1 wyif, p2, sl1 wyif, p1] twice; rep from * to last st, p1.

Rows 8 & 9: In color A, repeat Rows 2 & 3.

Row 10: In color B, knit.

Row 11: Purl.

Row 12: In color A, k1, *k2, sl1 wyib, k5, [sl1 wyib, k2] five times, sl1 wyib; rep from * to last 12 sts, k2, sl1 wyib, k5, sl1 wyib, k3.

Row 13: P3, sl1 wyif, p5, sl1 wyif, p2, *[sl1 wyif, p2] five times, sl1 wyif, p5, sl1 wyif, p2; rep from * to last st, p1.

Rows 14 & 15: Repeat Rows 10 & 11.

Rows 16 & 17: In color A, repeat Rows 2 & 3.

Rows 18 & 19: Repeat Rows 6 & 7.

Rows 20 & 21: Repeat Rows 4 & 5.

Repeat: Rows 2–21

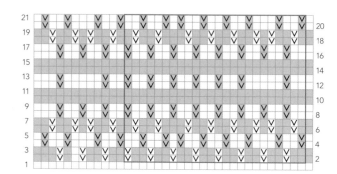

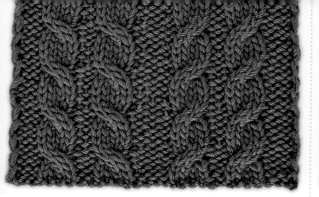

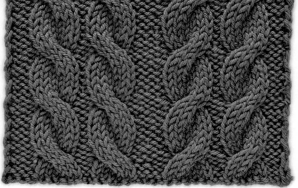

225 Single 4-Stitch Cable

Work this easy single cable as a striking panel down a sleeve or the front of a garment. By using the left and right twist it can be mirrored to create a balanced panel. Try placing additional plain rows between the cable rows to produce a more elongated, soft cable. Here the cable is demonstrated on a background of reverse stockinette stitch.

Yarn: Fingering to bulky

4-Stitch Cable Right Twist

Panel: 4 sts

Row 1 (RS): K4.
Row 2: P4.
Rows 3 & 4: Repeat Rows 1 & 2.
Row 5: 2/2 RC.
Row 6: P4.

Repeat: Rows 1–6

4-Stitch Cable Left Twist

Panel: 4 sts

Row 1 (RS): K4.
Row 2: P4.

Rows 3 & 4: Repeat Rows 1 & 2.
Row 5: 2/2 LC.
Row 6: P4.

Repeat: Rows 1–6

Abbreviations

2/2 RC: 4-stitch right cable. Slip 2 sts to cable needle and hold in back, k2, k2 from cable needle.

2/2 LC: 4-stitch left cable. Slip 2 sts to cable needle and hold in front, k2, k2 from cable needle.

226 Single 6-Stitch Cable

Here shown on a background of reverse stockinette stitch, this simple, mid-width cable is strong enough to be a statement piece but could also be incorporated with other stitches to create a larger panel. This cable looks great in a wide range of yarns from fingering to bulky.

Yarn: Fingering to bulky

6-Stitch Cable Right Twist

Panel: 6 sts

Row 1 (RS): K6.
Row 2: P6.
Rows 3 & 4: Repeat Rows 1 & 2.
Row 5: 3/3 RC.
Row 6: P6.
Row 7: K6.
Row 8: P6.

Repeat: Rows 1–8

6-Stitch Cable Left Twist

Panel: 6 sts

Row 1 (RS): K6.
Row 2: P6.

Rows 3 & 4: Repeat Rows 1 & 2.
Row 5: 3/3 LC.
Row 6: P6.
Row 7: K6.
Row 8: P6.

Repeat: Rows 1–8

Abbreviations

3/3 RC: 6-stitch right cable. Slip 3 sts to cable needle and hold in back, k3, k3 from cable needle.

3/3 LC: 6-stitch left cable. Slip 3 sts to cable needle and hold in front, k3, k3 from cable needle.

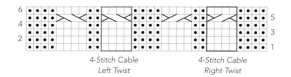

4-Stitch Cable Left Twist 4-Stitch Cable Right Twist

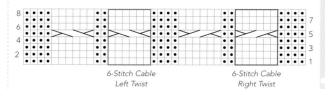

6-Stitch Cable Left Twist 6-Stitch Cable Right Twist

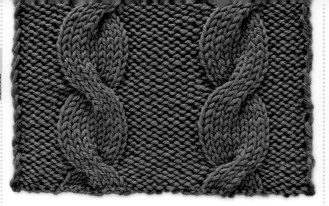

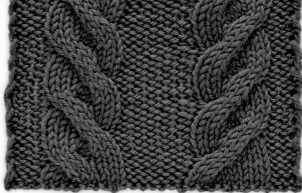

227 Single 8-Stitch Cable

This broad, bold cable is simple to work but looks great. Worked here with nine rows between each cable row, it has a relaxed, flowing feel that retains the softness of the fabric. For a more dense look, reduce the number of plain rows but keep in mind that this will affect drape.

Yarn: Fingering to bulky

8-Stitch Cable Right Twist

Panel: 8 sts

Row 1 (RS): K8.
Row 2: P8.
Rows 3 & 4: Repeat Rows 1 & 2.
Row 5: 4/4 RC.
Row 6: P8.
Row 7: K8.
Rows 8 & 9: Repeat Rows 6 & 7.
Row 10: P8.

Repeat: Rows 1–10

8-Stitch Cable Left Twist

Panel: 8 sts

Row 1 (RS): K8.
Row 2: P8.
Rows 3 & 4: Repeat Rows 1 & 2.
Row 5: 4/4 LC.
Row 6: P8.
Row 7: K8.
Rows 8 & 9: Repeat Rows 6 & 7.
Row 10: P8.

Repeat: Rows 1–10

Abbreviations

4/4 RC: 8-stitch right cable. Slip 4 sts to cable needle and hold in back, k4, k4 from cable needle.

4/4 LC: 8-stitch left cable. Slip 4 sts to cable needle and hold in front, k4, k4 from cable needle.

228 Braided 9-Stitch Cable

Offsetting the cable rows creates the attractive braided effect seen in this swatch. Setting the cable panel on a background of reverse stockinette stitch gives it impact, but it is still delicate enough to be worked in a wide range of yarns from sport to bulky.

Yarn: Sport to bulky

9-Stitch Cable Right Twist

Panel: 9 sts

Row 1 (RS): K9.
Row 2: P9.
Row 3: K3, 3/3 RC.
Row 4: P9.
Row 5: K9.
Row 6: P9.
Row 7: 3/3 RC, k3.
Row 8: P9.

Repeat: Rows 1–8

9-Stitch Cable Left Twist

Panel: 9 sts

Row 1 (RS): K9.
Row 2: P9.
Row 3: K3, 3/3 LC.
Row 4: P9.
Row 5: K9.
Row 6: P9.
Row 7: 3/3 LC, k3.
Row 8: P9.

Repeat: Rows 1–8

Abbreviations

3/3 RC: 6-stitch right cable. Slip 3 sts to cable needle and hold in back, k3, k3 from cable needle.

3/3 LC: 6-stitch left cable. Slip 3 sts to cable needle and hold in front, k3, k3 from cable needle.

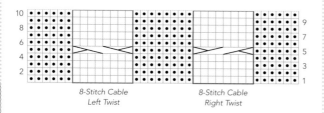

8-Stitch Cable Left Twist 8-Stitch Cable Right Twist

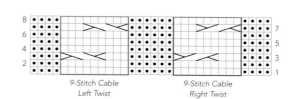

9-Stitch Cable Left Twist 9-Stitch Cable Right Twist

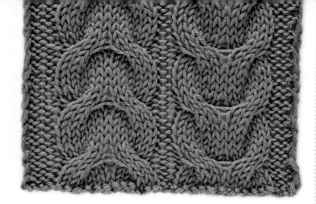

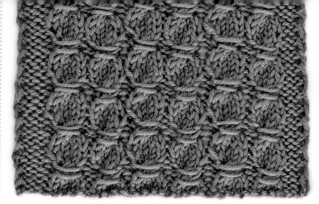

229 Double and Inverted Double Cable

This rich cable is worked over twelve stitches but uses just two simple cable stitches. A reverse stockinette background enhances the textural qualities. Reversing the stitches inverts the cable to give a completely different look. Reduce the plain rows between the cable rows for a much denser fabric.

Yarn: Sport to bulky

Double Cable

Panel: 12 sts

Row 1 (RS): K12.
Row 2: P12.
Row 3: 3/3 RC, 3/3 LC.
Row 4: P12.
Row 5: K12.
Rows 6 & 7: Repeat Rows 4 & 5.
Row 8: P12.

Repeat: Rows 1–8

Inverted Double Cable

Panel: 12 sts

Row 1 (RS): K12.
Row 2: P12.
Row 3: 3/3 LC, 3/3 RC.
Row 4: P12.
Row 5: K12.
Rows 6 & 7: Repeat Rows 4 & 5.
Row 8: P12.

Repeat: Rows 1–8

Abbreviations

3/3 RC: 6-stitch right cable. Slip 3 sts to cable needle and hold in back, k3, k3 from cable needle.
3/3 LC: 6-stitch left cable. Slip 3 sts to cable needle and hold in front, k3, k3 from cable needle.

230 10-Stitch Corded Cable

Based around a simple four-stitch cable, with wraps above and below the cable rows and two offset sets of cables, this panel is soft enough to use as an all-over pattern or as a smaller insertion panel in a larger design. For a different, much denser fabric, draw up the wraps more tightly.

Yarn: Fingering to bulky

Multiple: 10 sts + 7

Row 1 (RS): P4, *[k4, p1]; rep from * to last 3 sts, p3.
Row 2: K3, *[k1, p4]; rep from * to last 4 sts, k4.
Row 3: P4, *[w4k, p1, k4, p1]; rep from * to last 3 sts, p3.
Row 4: K3, *[k1, w4p, k1, 2/2 RC]; rep from * to last 4 sts, k4.
Row 5: P4, *[w4k, p1, 2/2 RC, p1]; rep from * to last 3 sts, p3.
Row 6: K3, *[k1, w4p, k1, p4]; rep from * to last 4 sts, k4.
Row 7: P4, *[k4, p1]; rep from * to last 3 sts, p3.

Repeat: Rows 2–7

Abbreviations

W4k: Hold yarn to back, slip 4 sts purlwise, bring yarn to front, return 4 slipped sts to LH needle, k4.

W4p: Hold yarn to back, slip 4 sts purlwise, bring yarn to front, return 4 slipped sts to LH needle, p4.

2/2 RC: 4-stitch right cable. Slip 2 sts to cable needle and hold in back. On RS, k2, k2 from cable needle. On WS, p2, p2 from cable needle.

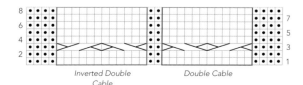

Inverted Double Cable Double Cable

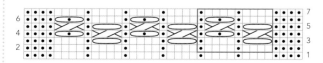

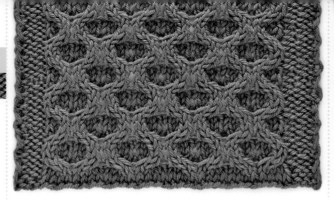

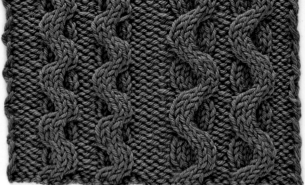

231 Honeycomb Cable

This richly textured fabric is not as complex as it appears. It is essentially a series of narrow cable panels repeated across the row without background stitches between the repeats. This fabric can be heavy when worked over a large area.

Yarn: Sport to bulky

Multiple: 8 sts + 8

Row 1 (RS): P4, knit to last 4 sts, p4.

Row 2 and all WS rows: K4, purl to last 4 sts, k4.

Row 3: P4, *2/2 RC, 2/2 LC; rep from * to last 4 sts, p4.

Row 5: Repeat Row 1.

Row 7: P4, *2/2 LC, 2/2 RC; rep from * to last 4 sts, p4.

Row 8: K4, purl to last 4 sts, k4.

Repeat: Rows 1–8

Abbreviations

2/2 RC: 4-stitch right cable. Slip 2 sts to cable needle and hold in back, k2, k2 from cable needle.

2/2 LC: 4-stitch left cable. Slip 2 sts to cable needle and hold in front, k2, k2 from cable needle.

232 6-Stitch Wiggle Cable

Two versions of this easy cable pattern are produced by varying the number of plain rows between the cable rows. By working the twist in alternating directions one cable appears to snake over the top of the other, creating a deep texturing.

Yarn: Fingering to bulky

Mid-Length Wiggle Cable
Panel: 6 sts

Row 1 (RS): K6.
Row 2: P6.
Row 3: 3/3 RC.
Row 4: P6.
Row 5: K6.
Rows 6 & 7: Repeat Rows 4 & 5.
Row 8: P6.
Row 9: 3/3 LC.
Row 10: P6.
Row 11: K6.
Row 12: P6.

Repeat: Rows 1–12

Short-Length Wiggle Cable
Panel: 6 sts

Row 1 (RS): K6.
Row 2: P6.
Row 3: 3/3 RC.
Row 4: P6.
Row 5: K6.
Row 6: P6.
Row 7: 3/3 LC.
Row 8: P6.

Repeat: Rows 1–8

Abbreviations

3/3 RC: 6-stitch right cable. Slip 3 sts to cable needle and hold in back, k3, k3 from cable needle.

3/3 LC: 6-stitch left cable. Slip 3 sts to cable needle and hold in front, k3, k3 from cable needle.

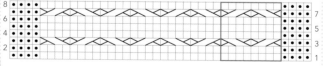

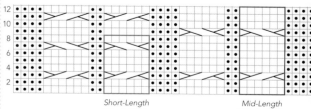

Short-Length Wiggle Cable　　　　*Mid-Length Wiggle Cable*

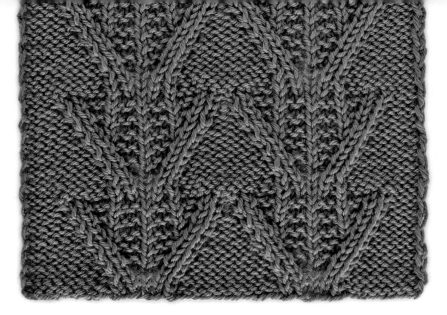

233 Chevron Rib Cable

This detailed and more complex cable incorporates ribbed "V"-shaped cables with garter stitch ladders running through the center. Dramatic when worked alone as a single panel, it is also a great centerpiece to combine with other cables or stitches for a wider pattern.

Yarn: Sport to bulky

Panel: 19 sts

Row 1 (WS): K6, p1, k1, p3, k1, p1, k6.

Row 2: P6, k1, p1, k3, p1, k1, p6.

Row 3: Repeat Row 1.

Row 4: P5, RRC, k1, LRC, p5.

Row 5: K5, [p1, k1] five times, k4.

Row 6: P4, RRC, k3, LRC, p4.

Row 7: K4, p1, [k1, p1, k1] three times, p1, k4.

Row 8: P3, RRC, k5, LRC, p3.

Row 9: K3, p1, k1, p2, k2, p1, k2, p2, k1, p1, k3.

Row 10: P2, RRC, k7, LRC, p2.

Row 11: K2, [p1, k1] three times, [k1, p1, k1] twice, [p1, k1] twice, k1.

Row 12: P1, RRC, k9, LRC, p1.

Row 13: [K1, p1] twice, [k2, p1] four times, k1, p1, k1.

Row 14: RRC, k11, LRC.

Repeat: Rows 1–14

Abbreviations

RRC: Right rib cross (right back cross). Slip 1 st to cable needle and hold in back, [k1, p1, k1], then k1 from cable needle.

LRC: Left rib cross (left front cross). Slip 3 sts to cable needle and hold in front, k1, then [k1, p1, k1] from cable needle.

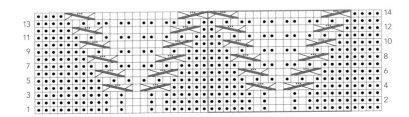

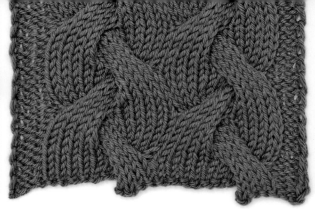

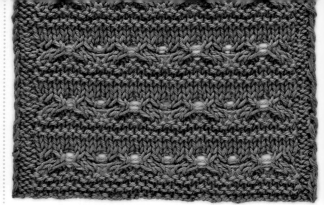

234 Ocean Waves

The deep texturing and intricate shapes in this cable are actually surprisingly easy to make, with just two cable rows and one cable type per pattern repeat. Ideally suited to a bold, all-over pattern, it is also great for bulkier yarns.

Yarn: Fingering to worsted

Panel: 15 sts

Row 1 (RS): K15.

Row 2: P15.

Rows 3 & 4: Repeat Rows 1 & 2.

Row 5: 5/5 LC, k5.

Row 6: Repeat Row 2.

Rows 7–10: Repeat Rows 1 & 2 twice.

Row 11: K5, 5/5 RC.

Row 12: Repeat Row 2.

Rows 13 & 14: Repeat Rows 1 & 2.

Repeat: Rows 3–14

Abbreviations

5/5 LC: 10-stitch left cable. Slip 5 sts to cable needle and hold in front, k5, k5 from cable needle.

5/5 RC: 10-stitch right cable. Slip 5 sts to cable needle and hold in back, k5, k5 from cable needle.

235 Ridged Cable

With only two cable rows and a nine-row pattern repeat, this is an interesting but quite straightforward cable. For a less dense fabric, additional stockinette stitch rows could be introduced between Rows 4 and 7.

Yarn: Fingering to worsted

Multiple: 8 sts + 6

Row 1 (RS): P3, knit to last 3 sts, p3.

Row 2: Knit.

Rows 3 & 4: Repeat Rows 1 & 2.

Row 5: Repeat Row 1.

Row 6: K3, purl to last 3 sts, k3.

Row 7: P3, *2/2 LC, 2/2 RC; rep from * to last 3 sts, p3.

Row 8: Repeat Row 6.

Row 9: P3, *1/1 LC, 1/1 RC; rep from * to last 3 sts, p3.

Repeat: Rows 1–9

Abbreviations

2/2 LC: 4-stitch left cable. Slip 2 sts to cable needle and hold in front, k2, k2 from cable needle.

2/2 RC: 4-stitch right cable. Slip 2 sts to cable needle and hold in back, k2, k2 from cable needle.

1/1 LC: 2-stitch left cable. Slip 1 st to cable needle and hold in front, k1, k1 from cable needle.

1/1 RC: 2-stitch right cable. Slip 1 st to cable needle and hold in back, k1, k1 from cable needle.

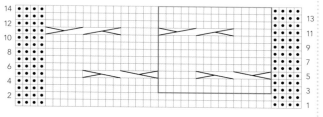

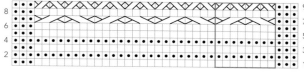

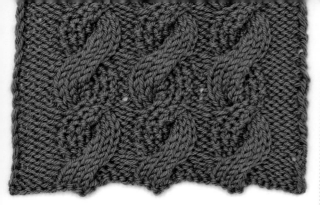

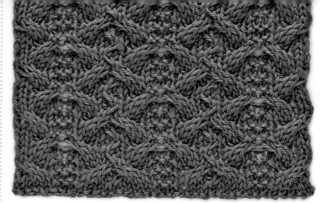

236 Seed Stitch Cable

A great statement cable, worked as a single panel or as part of a larger piece. Lots of texture and interest make it seem more complex than it is, but there are actually only two straightforward cable rows per repeat.

Yarn: Fingering to worsted

Panel: 8 sts

Row 1 (RS): [P1, k1] twice, k4.

Row 2: P4, [k1, p1] twice.

Rows 3 & 4: Repeat Rows 1 & 2.

Row 5: 4/4 RC St st over Seed cable.

Row 6: [K1, p1] twice, p4.

Row 7: K4, [p1, k1] twice.

Rows 8–11: Repeat Rows 6 & 7 twice.

Row 12: Repeat Row 6.

Row 13: 4/4 RC Seed over St st cable.

Row 14: Repeat Row 2.

Rows 15 & 16: Repeat Rows 1 & 2.

Repeat: Rows 1–16

Abbreviations

4/4 RC St st over Seed cable: Slip 4 sts to cable needle and hold in back, k4, then [p1, k1] twice from cable needle.

4/4 RC Seed over St st cable: Slip 4 sts to cable needle and hold in back, [p1, k1] twice, then k4 from cable needle.

237 Chutes and Ladders

Two-stitch cable "chutes" surround garter stitch ladders to create a dense, detailed cable pattern. This pattern requires a little additional attention as there are several different cables being worked at once, but is quite manageable.

Yarn: Fingering to worsted

Multiple: 12 sts + 2

Row 1 (RS): Knit.

Row 2: P2, *p4, k2, p6; rep from * to end.

Row 3: *1/1 RC, k10; rep from * to last 2 sts, 1/1 RC.

Row 4: *P6, k2, p4; rep from * to last 2 sts, p2.

Row 5: K1, *2/2 RC, k4, 2/2 LC; rep from * to last st, k1.

Row 6: Repeat Row 4.

Row 7: *1/1 LC, k10; rep from * to last 2 sts, 1/1 LC.

Row 8: Repeat Row 4.

Row 9: *1/1 RC, k1, 2/2 LC, 2/2 RC, k1; rep from * to last 2 sts, 1/1 RC.

Row 10: Repeat Row 4.

Repeat: Rows 3–10

Abbreviations

1/1 RC: 2-stitch right cable. Slip 1 st to cable needle and hold in back, k1, k1 from cable needle.

2/2 RC: 4-stitch right cable. Slip 2 sts to cable needle and hold in back, k2, k2 from cable needle.

2/2 LC: 4-stitch left cable. Slip 2 sts to cable needle and hold in front, k2, k2 from cable needle.

1/1 LC: 2-stitch left cable. Slip 1 st to cable needle and hold in front, k1, k1 from cable needle.

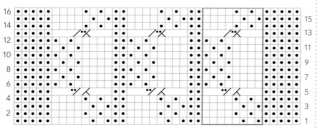

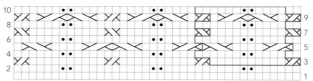

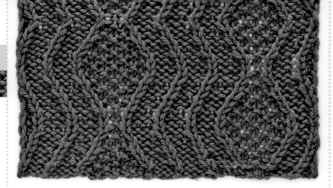

238 Filled Chain Cable

This pattern looks complex, but it is simply two identical panels with one worked offset. To work as a single panel, splitting at stitch 17 produces a filled cable with a single cable band at either side. Work just stitches 5–13 for a single filled cable.

Yarn: Fingering to bulky

Multiple: 34 sts + 4

Row 1 (RS): *P3, k1, p3, k3, [p3, k1] twice, p3, [k1, p1] four times, k1, p3, k1; rep from * to last 4 sts, p3, k1.

Row 2: P1, k3, *p1, k3, p2, [k1, p1] twice, k1, p2, [k3, p1] three times, k1, [p1, k3] twice; rep from * to end.

Row 3: *[P2, 1/1 RPC] twice, k1, [1/1 LPC, p2] three times, 1/1 LPC, [k1, p1] twice, k1, 1/1 RPC, p2, 1/1 RPC; rep from * to last 4 sts, p2, 1/1 RPC.

Row 4: K1, p1, k2, *k1, p1, k3, [p1, k1] three times, [p1, k3] three times, p2, k1, p2, k3, p1, k2; rep from * to end.

Row 5: *P1, 1/1 RPC, p2, 1/1 RPC, p1, k1, p1, [1/1 LPC, p2] three times, 1/1 LPC, p1, k1, p1, 1/1 RPC, p2, 1/1 RPC, p1; rep from * to last 4 sts, 1/1 RPC, p2.

Row 6: K2, p1, k1, *k2, p1, k3, p2, k1, p2, [k3, p1] three times, [k1, p1] three times, k3, p1, k1; rep from * to end.

Row 7: *1/1 RPC, p2, 1/1 RPC, [k1, p1] twice, k1, [1/1 LPC, p2] three times, 1/1 LPC, k1, [1/1 RPC, p2] twice; rep from * to last 4 sts, 1/1 RPC, p2.

Row 8: K3, p1, *[k3, p1] twice, k1, [p1, k3] three times, p2, [k1, p1] twice, k1, p2, k3, p1; rep from * to end.

Row 9: *K1, p3, [k1, p1] four times, [k1, p3] three times, k3, p3, k1, p3; rep from * to last 4 sts, k1, p3.

Row 10: Repeat Row 8.

Row 11: *1/1 LPC, p2, 1/1 LPC, [k1, p1] twice, k1, [1/1 RPC, p2] three times, 1/1 RPC, k1, [1/1 LPC, p2] twice; rep from * to last 4 sts, 1/1 LPC, p2.

Row 12: Repeat Row 6.

Row 13: *P1, 1/1 LPC, p2, 1/1 LPC, p1, k1, p1, [1/1 RPC, p2] three times, 1/1 RPC, p1, k1, p1, 1/1 LPC, p2, 1/1 LPC, p1; rep from * to last 4 sts, p1, 1/1 LPC, p1.

Row 14: Repeat Row 4.

Row 15: *[P2, 1/1 LPC] twice, k1, [1/1 RPC, p2] three times, 1/1 RPC, [k1, p1] twice, k1, 1/1 LPC, p2, 1/1 LPC; rep from * to last 4 sts, p2, 1/1 LPC.

Row 16: Repeat Row 2.

Repeat: Rows 1–16

Abbreviations

1/1 RPC: 2-stitch right purl cable. Slip 1 st to cable needle and hold in back, k1, p1 from cable needle.

1/1 LPC: 2-stitch left purl cable. Slip 1 st to cable needle and hold in front, p1, k1 from cable needle.

239 Rib-Eye Cable

This deeply textured cable with bold lines is in fact a simple construction with just two basic six-stitch cables. Setting it against a background of reverse stockinette stitch, as in this swatch, makes the rich texturing all the more dramatic.

Yarn: Fingering to bulky

Panel: 12 sts

Row 1 (RS): K12.

Row 2: P12.

Row 3: 3/3 RC, 3/3 LC.

Row 4: P12.

Rows 5–8: Repeat Rows 1 & 2 twice.

Row 9: 3/3 LC, 3/3 RC.

Row 10: P12.

Row 11: K12.

Row 12: P12.

Repeat: Rows 1–12

Abbreviations

3/3 RC: 6-stitch right cable. Slip 3 sts to cable needle and hold in back, k3, k3 from cable needle.

3/3 LC: 6-stitch left cable. Slip 3 sts to cable needle and hold in front, k3, k3 from cable needle.

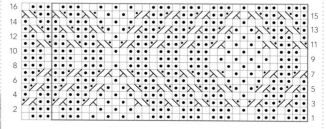

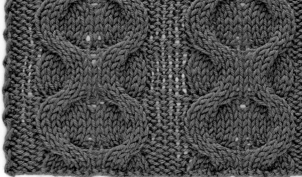

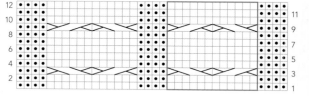

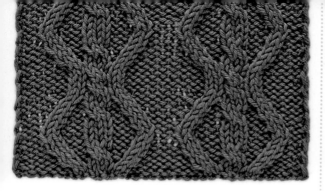

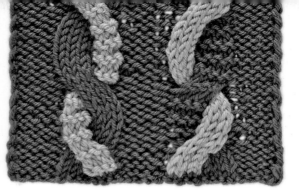

240 Chain and Rope Cable

Chains of medallions are linked by a simple three-stitch rope cable. For a different, more open look, the rope element can be extended between the medallions. Placing repeats adjacent to each other will produce a dense, honeycomb effect.

Yarn: Fingering to bulky

Panel: 15 sts

Row 1 (RS): P4, k2, 2/1 LC, k2, p4.

Row 2: K4, p7, k4.

Row 3: P2, 2/2 RPC, k3, 2/2 LPC, p2.

Row 4: K2, p2, k2, p3, k2, p2, k2.

Row 5: P1, 2/1 RPC, p2, 2/1 LC, p2, 2/1 LPC, p1.

Row 6: K1, p2, k3, p3, k3, p2, k1.

Row 7: 2/1 RPC, p3, k3, p3, 2/1 LPC.

Row 8: P2, k4, p3, k4, p2.

Row 9: 2/1 LPC, p3, k3, p3, 2/1 RPC.

Row 10: Repeat Row 6.

Row 11: P1, 2/1 LPC, p2, 2/1 LC, p2, 2/1 RPC, p1.

Row 12: Repeat Row 4.

Row 13: P2, 2/2 LPC, k3, 2/2 RPC, p2.

Row 14: Repeat Row 2.

Rows 15 & 16: Repeat Rows 1 & 2.

Repeat: Rows 1–16

Abbreviations

2/1 LC: 3-stitch left cable. Slip 2 sts to cable needle and hold in front, k1, k2 from cable needle.

2/2 RPC: 4-stitch right purl cable. Slip 2 sts to cable needle and hold in back, k2, p2 from cable needle.

2/2 LPC: 4-stitch left purl cable. Slip 2 sts to cable needle and hold in front, p2, k2 from cable needle.

2/1 RPC: 3-stitch right purl cable. Slip 1 st to cable needle and hold in back, k2, p1 from cable needle.

2/1 LPC: 3-stitch left purl cable. Slip 2 sts to cable needle and hold in front, p1, k2 from cable needle.

241 Two-Color Garter and Stockinette Cable

Two cables entwine a garter stitch band with a stockinette stitch one, swapping the two over to emphasize certain elements.

Yarn: Fingering to worsted

Two-Color Cable Right Twist

Panel: 8 sts

Row 1 (RS): In color A, k4, in color B, k4.

Row 2: In color B, p4, in color A, k4.

Rows 3 & 4: Repeat Rows 1 & 2.

Row 5: Slip 4 sts to cable needle and hold in back, in color B, k4, in color A, k4 from cable needle.

Row 6: In color A, k4, in color B, p4.

Row 7: In color B, k4, in color A, k4.

Rows 8–13: Repeat Rows 6 & 7 three times.

Row 14: Repeat Row 6.

Row 15: Slip 4 sts to cable needle and hold in front, in color A, k4, in color B, k4 from cable needle.

Row 16: Repeat Row 2.

Rows 17–20: Repeat Rows 1–4.

Repeat: Rows 1–20

Two-Color Cable Left Twist

Panel: 8 sts

Row 1 (RS) In color B, k4, in color A, k4.

Row 2: In color A, p4, in color B, k4.

Rows 3 & 4: Repeat Rows 1 & 2.

Row 5: Slip 4 sts to cable needle and hold in front, in color A, k4, in color B, k4 from cable needle.

Row 6: In color B, k4, in color A, p4.

Row 7: In color A, k4, in color B, k4.

Rows 8–13: Repeat Rows 6 & 7 three times.

Row 14: Repeat Row 6.

Row 15: Slip 4 sts to cable needle and hold in front, in color B, k4, in color A, k4 from cable needle.

Row 16: Repeat Row 2.

Rows 17–20: Repeat Rows 1–4.

Repeat: Rows 1–20

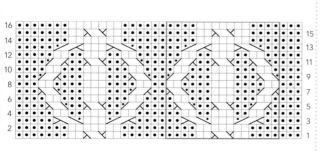

Two-Color Cable Left Twist *Two-Color Cable Right Twist*

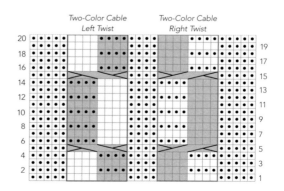

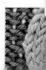

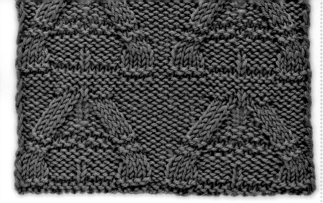

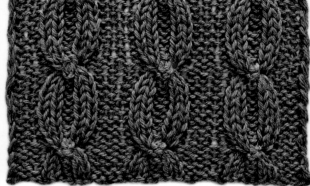

242 Cathedral Windows Cable

This cable looks complex but uses just two basic traveling cables. The window effect is produced by adding elements of stockinette to the reverse stockinette background, creating light and shadow.

Yarn: Fingering to bulky

Panel: 17 sts

Row 1 (RS): K4, p9, k4.

Row 2: Repeat Row 1.

Row 3: K4, p4, k1, p4, k4.

Row 4: P4, k4, p1, k4, p4.

Row 5: Repeat Row 3.

Row 6: P4, k9, p4.

Row 7: 3/1 LPC, p9, 3/1 RPC.

Row 8: Repeat Row 3.

Row 9: P1, 3/1 LPC, p3, k1, p3, 3/1 RPC, p1.

Row 10: K5, p3, k1, p3, k5.

Row 11: P2, k3, p7, k3, p2.

Row 12: K2, p3, k7, p3, k2.

Row 13: P2, 3/1 LPC, p2, k1, p2, 3/1 RPC, p2.

Row 14: K3, p3, k2, p1, k2, p3, k3.

Row 15: P3, 3/1 LPC, p1, k1, p1, 3/1 RPC, p3.

Row 16: K4, p3, k1, p1, k1, p3, k4.

Row 17: P4, 3/1 LPC, k1, 3/1 RPC, p4.

Row 18: K7, p3, k7.

Row 19: P8, k1, p8.

Row 20: K17.

Repeat: Rows 1–20

Abbreviations

3/1 LPC: 4-stitch left purl cable. Slip 3 sts to cable needle and hold in front, p1, k3 from cable needle.

3/1 RPC: 4-stitch right purl cable. Slip 1 st to cable needle and hold in back, k3, p1 from cable needle.

243 Knotted Cable

Shown here on a background of reverse stockinette stitch, the knot in this extended cable is worked as a six-stitch twist, with three pairs of two stitches. With nine intervening plain rows, the cable is lean and straight, making it a good choice for an edging or border. Vary the shape by adjusting the number of plain rows that divide the twists.

Yarn: Fingering to worsted

Panel: 6 sts

Row 1 (RS): K2, p2, k2.

Row 2: P2, k2, p2.

Rows 3 & 4: Repeat Rows 1 & 2.

Row 5: 2/2/2 LPC.

Row 6: P2, k2, p2.

Rows 7–10: Repeat Rows 1 & 2 twice.

Repeat: Rows 1–10

Abbreviation

2/2/2 LPC: 6-stitch left ribbed cable. Slip 2 sts to cable needle and hold in front, slip next 2 sts to second cable needle and hold in back, k2 from LH needle, p2 from back cable needle, k2 from front cable needle.

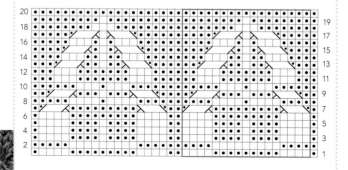

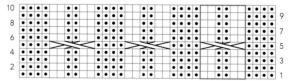

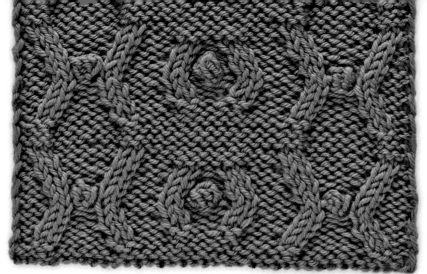

244 Acrobats Cable

There are lots of possibilities for fun combinations with these easy cable and bobble motifs. Stacking the "X"s and "O"s produces a pattern rather like a pyramid of acrobats. An entirely different look can be achieved with rows of "X"s, rows of "O"s, or alternating bands of "X"s and "O"s. Omit the bobbles for even more variations.

Yarn: Fingering to worsted

"X" motif

Motif: 11 sts

Row 1 (RS): 2/1 LPC, p5, 2/1 RPC.
Row 2: K1, p2, k5, p2, k1.
Row 3: P1, 2/1 LPC, p3, 2/1 RPC, p1.
Row 4: K2, p2, k3, p2, k2.
Row 5: P2, 2/1 LPC, p1, 2/1 RPC, p2.
Row 6: K3, p2, mb, p2, k3.
Row 7: P2, 2/1 RPC, p1, 2/1 LPC, p2.

Row 8: Repeat Row 4.
Row 9: P1, 2/1 RPC, p3, 2/1 LPC, p1.
Row 10: Repeat Row 2.
Row 11: 2/1 RPC, p5, 2/1 LPC.

Repeat: Rows 1–11

"O" motif

Motif: 9 sts

Row 1 (RS): P1, 2/1 RPC, p1, 2/1 LPC, p1.

Row 2: K1, p2, k3, p2, k1.
Row 3: 2/1 RPC, p3, 2/1 LPC.
Row 4: P2, k2, mb, k2, p2.
Row 5: 2/1 LPC, p3, 2/1 RPC.
Row 6: K1, p2, k3, p2, k1.
Row 7: P1, 2/1 LPC, p1, 2/1 RPC, p1.

Repeat: Rows 1–7

Abbreviations

2/1 LPC: 3-stitch left purl cable. Slip 2 sts to cable needle and hold in front, p1, k2 from cable needle.

2/1 RPC: 3-stitch right purl cable. Slip 1 st to cable needle and hold in back, k2, p1 from cable needle.

Mb: Make bobble. [(K1, yo) twice k1] in next st, turn; p5, turn; k5, turn; p2tog, p1, p2tog, turn; sl1, k2tog, psso.

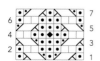

"O" Motif "X" Motif

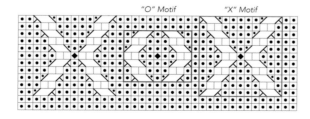

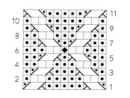

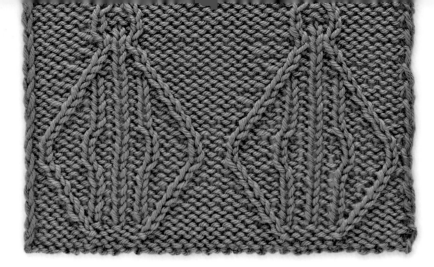

245 Lantern Cable

Work this bold cable as a statement panel, either alone or as part of a larger pattern. A series of single traveling cables sit around a ribbed center with a small medallion to create the "lamp" in the center. Replace the central medallion and continue the plain rib for an alternative effect or shorten the design by omitting the "handle" (Rows 25–29 of panel repeat).

Yarn: Fingering to bulky

Panel: 15 sts

Row 1 (RS): P4, 1/1 RPC, p3, 1/1 LPC, p4.

Row 2: K4, p2, k1, p1, k1, p2, k4.

Row 3: P3, 1/1 RPC, [k1, p1] twice, k1, 1/1 LPC, p3.

Row 4: K3, [p1, k1] four times, p1, k3.

Row 5: P2, 1/1 RPC, [p1, k1] three times, p1, 1/1 LPC, p2.

Row 6: [K2, p1] twice, [k1, p1] twice, k2, p1, k2.

Row 7: P1, 1/1 RPC, p2, [k1, p1] twice, k1, p2, 1/1 LPC, p1.

Row 8: K1, p1, k3, [p1, k1] twice, p1, k3, p1, k1.

Row 9: 1/1 RPC, p2, 1/1 RPC, p1, k1, p1, 1/1 LPC, p2, 1/1 LPC.

Row 10: P1, k3, [p1, k2] twice, p1, k3, p1.

Row 11: K1, p3, [k1, p2] twice, k1, p3, k1.

Row 12: Repeat Row 10.

Row 13: 1/1 LPC, p2, 1/1 LPC, p1, k1, p1, 1/1 RPC, p2, 1/1 RPC.

Row 14: Repeat Row 8.

Row 15: P1, 1/1 LPC, p2, [k1, p1] twice, k1, p2, 1/1 RPC, p1.

Row 16: Repeat Row 6.

Row 17: P2, 1/1 LPC, [p1, k1] three times, p1, 1/1 RPC, p2.

Row 18: Repeat Row 4.

Row 19: P3, 1/1 LPC, [k1, p1] twice, k1, 1/1 RPC, p3.

Row 20: K4, [p1, k2] twice, p1, k4.

Row 21: P4, 1/1 LPC, p1, k1, p1, 1/1 RPC, p4.

Row 22: K5, [p1, k1] twice, p1, k5.

Row 23: P5, 1/1 LPC, k1, 1/1 RPC, p5.

Row 24: K6, p3, k6.

Row 25: P5, 1/1 RPC, k1, 1/1 LPC, p5.

Row 26: K5, p1, k3, p1, k5.

Row 27: P5, k1, p3, k1, p5.

Row 28: K5, 1/1 RPC, p1, 1/1 LPC, k5.

Row 29: P6, k3, p6.

Repeat: Rows 1–29

Abbreviations

1/1 RPC: 2-stitch right purl cable. Slip 1 st to cable needle and hold in back, k1, p1 from cable needle.

1/1 LPC: 2-stitch left purl cable. Slip 1 st to cable needle and hold in front, p1, k1 from cable needle.

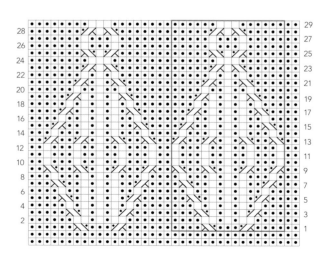

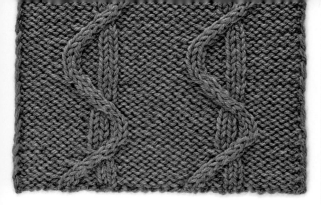

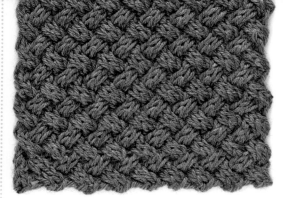

246 10-Stitch Slalom Cable

A simple cable with a gently undulating, syncopated swing. Work a single repeat on either side of a panel as a border, or try placing repeats close together to produce an interesting all-over fabric.

Yarn: Fingering to bulky

Panel: 10 sts

Row 1 (RS): P2, k2, p4, k2.
Row 2: P2, k4, p2, k2.
Row 3: P2, k2, p2, 2/2 RPC.
Row 4: [K2, p2] twice, k2.
Row 5: P2, k2, 2/2 RPC, p2.
Row 6: K4, p4, k2.
Row 7: P2, 2/2 RC, p4.
Row 8: Repeat Row 6.
Row 9: 2/2 RPC, k2, p4.
Row 10: K4, p2, k2, p2.
Row 11: K2, p2, k2, p4.
Row 12: Repeat Row 10.
Row 13: 2/2 LPC, k2, p4.
Row 14: Repeat Row 6.
Row 15: P2, 2/2 LC, p4.
Row 16: Repeat Row 6.
Row 17: P2, k2, 2/2 LPC, p2.
Row 18: Repeat Row 4.

Row 19: P2, k2, p2, 2/2 LPC.
Row 20: Repeat Row 2.
Rows 21 & 22: Repeat Rows 1 & 2.

Repeat: Rows 1–22

Abbreviations

2/2 RPC: 4-stitch right purl cable. Slip 2 sts to cable needle and hold in back, k2, p2 from cable needle.

2/2 RC: 4-stitch right cable. Slip 2 sts to cable needle and hold in back, k2, k2 from cable needle.

2/2 LPC: 4-stitch left purl cable. Slip 2 sts to cable needle and hold in front, p2, k2 from cable needle.

2/2 LC: 4-stitch left cable. Slip 2 sts to cable needle and hold in front, k2, k2 from cable needle.

247 Basketweave Cable

A simple four-stitch cable worked over four rows creates this very dense, firm fabric. For a softer drape and more open weave effect, work three plain rows between the cables. If you are using a thicker yarn, swatch carefully as the fabric quickly becomes very rigid with bulkier yarns.

Yarn: Fingering to worsted

Multiple: 8 sts

Row 1 (RS): *2/2 LC; rep from * to end.
Row 2: Purl.
Row 3: K2, *2/2 RC; rep from * to last 2 sts, k2.
Row 4: Purl.

Repeat: Rows 1–4

Abbreviations

2/2 LC: 4-stitch left cable. Slip 2 sts to cable needle and hold in front, k2, k2 from cable needle.

2/2 RC: 4-stitch right cable. Slip 2 sts to cable needle and hold in back, k2, k2 from cable needle.

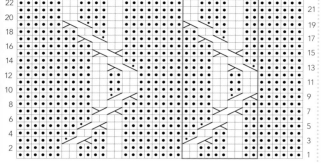

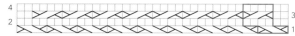

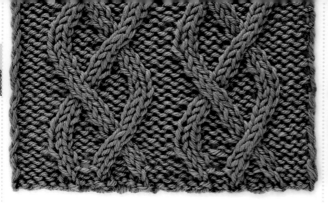

248 Braided Triple Cable

Three separate cables interlock to create an open, soft braid that meanders across the fabric. The reverse stockinette background used here could be replaced with garter stitch for a different effect.

Yarn: Fingering to bulky

Panel: 12 sts

Row 1 (RS): 2/1 LPC, p2, 2/1 RPC, 2/1 LPC, p1.

Row 2: [K1, p2, k1] three times.

Row 3: P1, 2/1 LPC, 2/1 RPC, p2, 2/1 LPC.

Row 4: P2, k4, p4, k2.

Row 5: P2, 2/2 RC, p4, k2.

Row 6: Repeat Row 4.

Row 7: P1, 2/1 RPC, 2/1 LPC, p2, 2/1 RPC.

Row 8: Repeat Row 2.

Row 9: 2/1 RPC, p2, 2/1 LPC, 2/1 RPC, p1.

Row 10: K2, p4, k4, p2.

Row 11: K2, p4, 2/2 LC, p2.

Row 12: Repeat Row 10.

Repeat: Rows 1–12

Abbreviations

2/1 LPC: 3-stitch left purl cable. Slip 2 sts to cable needle and hold in front, p1, k2 from cable needle.

2/1 RPC: 3-stitch right purl cable. Slip 1 st to cable needle and hold in back, k2, p1 from cable needle.

2/2 RC: 4-stitch right cable. Slip 2 sts to cable needle and hold in back, k2, k2 from cable needle.

2/2 LC: 4-stitch left cable. Slip 2 sts to cable needle and hold in front, k2, k2 from cable needle.

249 Diamond Cable

A straightforward, bold cable with lots of possibilities for variation by simply adding or reducing the rows (allow for adjustment in width). Alternatively, fill with seed or garter stitch.

Yarn: Fingering to bulky

Panel: 12 sts

Row 1 (RS): P4, 2/2 LC, p4.

Row 2: K4, p4, k4.

Row 3: P3, 2/1 RPC, 2/1 LPC, p3.

Row 4: K3, p2, k2, p2, k3.

Row 5: P2, 2/1 RPC, p2, 2/1 LPC, p2.

Row 6: K2, p2, k4, p2, k2.

Row 7: P1, 2/1 RPC, p4, 2/1 LPC, p1.

Row 8: K1, p2, k6, p2, k1.

Row 9: 2/1 RPC, p6, 2/1 LPC.

Row 10: P2, k8, p2.

Row 11: 2/1 LPC, p6, 2/1 RPC.

Row 12: Repeat Row 8.

Row 13: P1, 2/1 LPC, p4, 2/1 RPC, p1.

Row 14: Repeat Row 6.

Row 15: P2, 2/1 LPC, p2, 2/1 RPC, p2.

Row 16: Repeat Row 4.

Row 17: P3, 2/1 LPC, 2/1 RPC, p3.

Row 18: Repeat Row 2.

Repeat: Rows 1–18

Abbreviations

2/2 LC: 4-stitch left cable. Slip 2 sts to cable needle and hold in front, k2, k2 from cable needle.

2/1 RPC: 3-stitch right purl cable. Slip 1 st to cable needle and hold in back, k2, p1 from cable needle.

2/1 LPC: 3-stitch left purl cable. Slip 2 sts to cable needle and hold in front, p1, k2 from cable needle.

Note: To overlap the cables the opposite way, as on the left-hand half of the swatch, replace the 2/2 LC in Row 1 with 2/2 RC. Work as: Slip 2 sts to cable needle and hold in back, k2, k2 from cable needle.

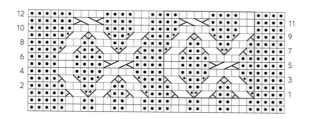

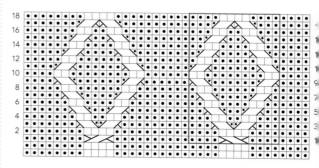

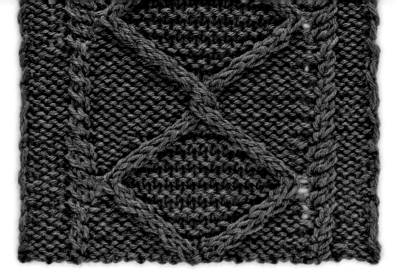

250 Rope and Diamond Cable

A detailed cable panel, formed by pairing two ropes around a central diamond filled with garter stitch. There's plenty to challenge the more experienced knitter here, but the pattern could be simplified by omitting the rope bands or removing the garter stitch center of the diamonds.

Yarn: Fingering to bulky

Panel: 29 sts

Row 1 (RS): P1, 1/1 RC, p9, 2/3 LC, p9, 1/1 LC, p1.

Row 2: K1, p2, k9, p5, k9, p2, k1.

Row 3: P1, 1/1 RC, p7, 2/2 RC, k1, 2/2 LC, p7, 1/1 LC, p1.

Row 4: K1, p2, k7, p2, k5, p2, k7, p2, k1.

Row 5: P1, 1/1 RC, p5, 2/2 RC, k5, 2/2 LC, p5, 1/1 LC, p1.

Row 6: K1, p2, k5, p2, k9, p2, k5, p2, k1.

Row 7: 2/2 RC, p2, 2/2 RC, k9, 2/2 LC, p2, 2/2 LC.

Row 8: P4, k2, p2, k13, p2, k2, p4.

Row 9: [2/2 RC] twice, k13, [2/2 LC] twice.

Row 10: P6, k17, p6.

Row 11: 2/2 RC, 2/2 LPC, k13, 2/2 RPC, 2/2 LC.

Row 12: P4, k2, p2, k13, p2, k2, p4.

Row 13: 2/2 RC, p2, 2/2 LPC, k9, 2/2 RPC, p2, 2/2 LC.

Row 14: P4, k4, p2, k9, p2, k4, p4.

Row 15: 2/2 RC, p4, 2/2 LPC, k5, 2/2 RPC, p4, 2/2 LC.

Row 16: K1, p2, k7, p2, k5, p2, k7, p2, k1.

Row 17: P1, 1/1 RC, p7, 2/2 LPC, k1, 2/2 RPC, p7, 1/1 LC, p1.

Row 18: K1, p2, k9, p5, k9, p2, k1.

Row 19: P1, 1/1 RC, p9, 2/3 LC, p9, 1/1 LC, p1.

Row 20: K1, p2, k9, p5, k9, p2, k1.

Repeat: Rows 1–20

Abbreviations

1/1 RC: 2-stitch right cable. Slip 1 st to cable needle and hold in back, k1, k1 from cable needle.

2/3 LC: 5-stitch left cable. Slip 2 sts to cable needle and hold in front, k3, k2 from cable needle.

1/1 LC: 2-stitch left cable. Slip 1 st to cable needle and hold in front, k1, k1 from cable needle.

2/2 RC: 4-stitch right cable. Slip 2 sts to cable needle and hold in back, k2, k2 from cable needle.

2/2 LC: 4-stitch left cable. Slip 2 sts to cable needle and hold in front, k2, k2 from cable needle.

2/2 LPC: 4-stitch left purl cable. Slip 2 sts to cable needle and hold in front, p2, k2 from cable needle.

2/2 RPC: 4-stitch right purl cable. Slip 2 sts to cable needle and hold in back, k2, p2 from cable needle.

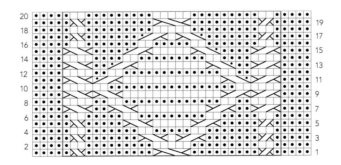

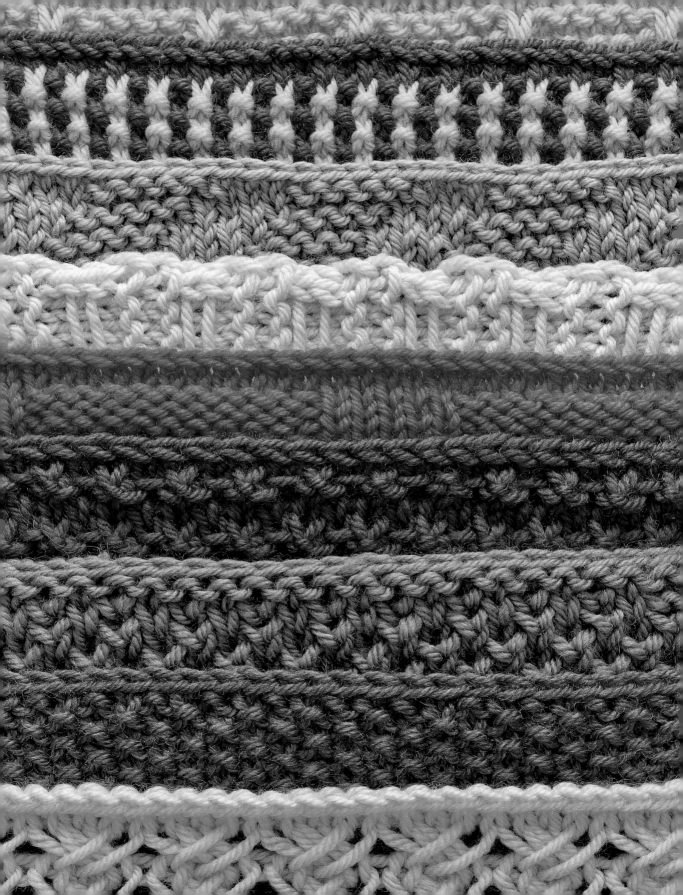

Glossary of Techniques

Here's where you can refresh your knowledge of the essentials of knitting. Learn about choosing your yarn and needles, reading charts, measuring gauge, and more. Remind yourself of basic stitches, master new techniques, and expand your knitting skill set through written step-by-step instructions and illustrations.

The Language of Yarn

Knitters around the globe may share a love of knitting, but they have many and varied ways of describing the yarns they work with.

It is really more correct to use the term "yarn" to describe all the different types of "string" we knit with. Of course "wool" is a term many knitters associate with any type of knitting yarn, regardless of the fiber from which it is made. Strictly speaking, however, the term "wool" only applies when the actual fiber content of the yarn is processed sheep's fleece. It is therefore more correct to use the term "yarn" to separate it from the idea of fiber content, which describes the raw material, or materials, from which a yarn is made.

A further aspect of any yarn description is its quality. This may be described in different ways depending on the country of origin of the yarn (or indeed of the pattern or the designer). In this context quality doesn't usually refer to how good the yarn is—that would generate a lengthy debate among any group of knitters!

YARN GLOSSARY

There are a myriad technical words in the world of yarn. Here's a rundown of some of the key terms and their meaning in the context of knitting.

Yarn

The basic material used to create a knitted fabric. This includes the many commercially produced yarns available from yarn stores and other shops, but also includes handspun or handmade yarns, yarns made from wire, plastic, strips of fabric, or other materials.

Fiber content

Yarn fiber could come from an animal (for example, sheep, alpaca, camel, goat), from a plant (for example, cotton, hemp, linen, nettle, bamboo, soy), or from a manmade source (for example, acrylic, polyamide, wire, plastic). Regenerated fibers such as viscose, tencel, and rayon are made from wood pulp. Recycled fibers may include fabric or even plastic bottles. The choice of fiber content will influence the use, handle, appearance, and suitability of a yarn for particular projects.

Yarn quality

A broad term used to describe the nature of the yarn. This will often incorporate, among other things, yarn weight, yardage, how many plies the yarn has, and yarn count.

■ **Weight** In the context of yarn quality, weight refers to the thickness of the yarn, not the actual weight of the ball/skein. Terms to describe yarn weight vary and there is (rather confusingly) some overlap with plies and yarn count. US terminology, for example, includes fingering, sport, worsted, and bulky. Equivalent UK terms refer to the thickness of a yarn by ply—2-ply, 4-ply, and so on.

■ **Plies** This refers to the way a yarn is made. Yarn starts out life as one strand, referred to as a singles thread or singles. It is then plied (either by twisting or by folding) with one or more other threads to create a thicker yarn. A 2-ply yarn is made from two strands, a 4-ply from four strands, and so on. Depending on the thickness of the original strand, this determines the thickness of the finished yarn and therefore its quality.

Traditionally, in the UK, a 2-ply would describe a fine (laceweight) yarn but, of course, if the yarn begins life as a single, thick strand, a 2-ply of this yarn could be much thicker, so arguably using plies to describe yarn thickness can be misleading.

■ **Yardage/meterage** This is a useful guide when deciding the amount of yarn needed for a project. Some fibers are heavier than others so there are fewer yards per ounce with, for example, a silk than a cashmere yarn. However, 100 yards (92m) of fingering quality silk should knit the same number of stitches as 100 yards (92m) of fingering quality cashmere, making this a useful measure when substituting yarns.

■ **Yarn count** This term is closely linked to yarn thickness and plies. The yarn count is the number of yards of yarn in a given weight (actual weight) of finished yarn. Rather unhelpfully there are many systems for arriving at a yarn count, including worsted count, linen count, cotton count, Yorkshire count, and tex.

1 100% silk
2 100% bamboo
3 100% Aran wool
4 100% merino wool
5 100% baby merino wool
6 Organic cotton
7 69% silk, 31% stainless steel
8 Mercerized cotton
9 Naturally dyed crisp linen lace
10 Ribbon ball yarn
11 70% super kid mohair, 30% silk
12 50% merino wool, 50% cotton
13 Chunky alpaca

Know Your Needles

The right tools are an important part of any project, and knitting is no exception. Fortunately, getting started with good-quality materials need not be expensive and, with a few basic tools, you will be creating wonderful projects in no time.

To begin your knitting journey all you will need to get started is a pair of knitting needles, some yarn, a tape measure, and a pair of scissors. A suitable pair of knitting needles is your first requirement.

NEEDLE TYPES

Knitting needles are available in a wide range of materials, shapes, and sizes, from practical plastic or metal to wood, bamboo, and even glass. When it comes to choosing your first needles, try as many different types as you can. Ask friends who knit or visit a local yarn store. Try needles of different lengths, shapes, and materials if you can. Remember that you may need at least two pairs for your first project, so consider your budget when making your first purchases. If your budget limits you to buying inexpensive plastic or metal needles, that's fine; you will still be able to complete any knitting project. You can often pick up needles from thrift stores, on upcycling websites such as Craig's List, Freegle, or Freecycle, or from yard sales.

Single-pointed pairs of needles

Widely available and commonly used, single-pointed needles are sold in pairs and have a point at one end and a knurl, knob, or other stopper at the other end to prevent the stitches from sliding off. Use these needles for knitting flat fabrics.

Double-pointed needles

These needles have points at both ends and are sold in sets of four or five needles. Often referred to as DPNs, they are used for knitting tubular fabrics, for example, socks, sweater sleeves, and seamless sweaters (also called knitting in the round). Extra-long DPNs can be used with a knitting belt or sheath for traditional Fair Isle knitting.

Circular needles

A circular needle comprises two short, single-pointed needles, joined to each other by a flexible cord. The cord may be permanently attached but sets are also available with interchangeable needles (tips) and cords of different lengths. Circular needles are versatile because they can be used for knitting flat fabrics as an alternative to single-pointed needles, or for knitting tubular fabrics in place of DPNs.

NEEDLE LENGTHS

The most common lengths for standard single-pointed needles are 12in (30cm) and 14in (35cm) and these will suit most knitters. For small projects (toys, accessories, etc.) and for working with children, shorter needles of around 6–8in (15–20cm) are available.

5in (12.5cm), 7½in (19cm), and 10in (25cm) DPNs Choose the length you find most comfortable to work with, keeping in mind that the more stitches you have and the thicker the yarn, the longer your DPNs will likely need to be.

Extra-long, 16in (40cm) DPNs Very long needles are used for some traditional Fair Isle techniques, where the needles are stuck into a leather belt or wooden sheath worn around the waist. This isn't a commonly used technique today but was once popular in Europe, and allows for fast knitting.

Circular needle tips and cords The tip of a circular needle refers to the actual needle; the cord joins the two needles together. Tips are normally short, around 4in (10cm). Cords range from 8in (20cm) to 60in (150cm). The length of the cord should be chosen to give a circumference slightly smaller than that of the tube being knitted.

NEEDLE SHAPES

Round

This is far and away the most common needle shape on the market, easy to use and available in all formats, sizes, and materials.

Square

Many knitters with dexterity problems report that these needles are a much easier shape to grip and manipulate—worth a try if you find traditional round needles uncomfortable. Square needles are currently not available in all materials and are more expensive than round, but prices will no doubt become competitive with time.

Hexagonal

A newcomer to the knitting market, these needles are at the upper end of the price scale but are pretty and comfortable to use. The shape also makes them less likely to roll off the table. They are currently only available in wood.

NEEDLE MATERIALS

Plastic needles

Plastic needles are inexpensive and are readily available in a wide range of sizes. Plastic needles are the first choice for many knitters, beginners and experienced alike. Flexible and light in use, you can buy a pair at a time or choose a pre-packaged set with a range of sizes.

Bamboo

Bamboo needles are flexible, lightweight, and warm to the touch, making them popular with knitters who have arthritis or rheumatism. Budget bamboo needles can split with use, so buy the best pair within your budget. They can be lightly sanded with emery paper if they develop rough spots over time.

Wood

There are many beautiful wooden needles on the market and many knitters

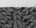

find these the most comfortable to work with because they are warm, light, and easy on the hands. Like bamboo they can break but can be sanded with care.

Metal

Many knitters prefer metal needles because they are virtually indestructible. They are the needles of choice for many lace knitters because they have the sharpest points for fine work. The smooth finish also makes them a popular choice for knitting at speed. Prices vary significantly for metal needles.

Glass

Glass needles are a luxury choice: they are lovely to use and very beautiful. They are more durable than you may imagine since most are made from Pyrex, although naturally they are best kept away from the rough and tumble you may subject your normal needles to. They are not available in as wide a range of sizes, particularly small sizes, but they are now available in single-pointed, double-pointed, and circular formats.

TIPS

■ Build your needle collection gradually, buying needles only as you need them for each project. It will save you money and you can try different needle types until you find the ones that are most suited to you and work best with the project you are working on.

■ Look after your needles by keeping them in a needle roll or case, or store them flat in a sturdy plastic tube. Check wooden and bamboo needles for snags and gently file with emery paper as required. Clean plastic and metal needles with warm, soapy water and dry thoroughly.

The following sizes are given in length and US needle size, with UK/Canadian/Australian and European sizes in parentheses.

1 *Rosewood, 14in (35cm) long, size 15 (000/10mm)*

2 *Birch, 14in (35cm) long, size 19 (000/15mm)*

3 *Wooden, 10in (25cm) long, size 11 (0/8mm)*

4 *Bamboo, 14in (35cm) long, size 10½ (2/7mm)*

5 *Metal circular, 29½in (75cm) long, size 7 (7/4.5mm)*

6 *Birch DPNs, 5in (12.5cm) long, size 8 (6/5mm)*

7 *Birch DPNs, 7½in (19cm) long, size 8 (6/5mm)*

8 *Birch DPNs, 10in (25cm) long, size 8 (6/5mm)*

9 *Metal DPNs, 7½in (19cm) long, size 2 (11/2.75mm)*

10 *Kids' aluminum, 7½in (19cm) long, size 7 (8/4.5mm)*

11 *Aluminum, 12in (30cm) long, size 6 (8/4mm)*

12 *Aluminum, 14in (35cm) long, size 6 (8/4mm)*

13 *Plastic, 16in (40cm) long, size 10¾ (2/7mm)*

Essential Techniques

If you're a new knitter, you will find here all the information you need to get started and with practice you'll soon be able to master even the more challenging stitches.

SLIPKNOT

1 Knitting begins with casting on, and a slipknot makes the first stitch of the cast-on. Loop the yarn around two fingers of the left hand, the ball end on top. Dip the needle into the loop, catch the ball end of the yarn, and pull it through the loop.

2 Pull the ends of the yarn to tighten the knot. Tighten the ball end to bring the knot up to the needle. The slipknot should be snug but not tight.

LONG-TAIL CAST-ON

This versatile, straightforward cast-on uses a single needle and produces a reasonably elastic knitted edge like a row of garter stitch.

1 Leaving an end about three times the length of the required cast-on, put a slipknot on the needle, and hold the needle in the right hand. Holding the yarn end in the left hand, take the left thumb under the yarn and upward. Insert the needle into the front of the loop just made on the thumb.

2 Use the ball end of the yarn (also called the working yarn) to make a knit stitch, slipping the loop off the thumb. Pull the yarn end to close the stitch up to the needle. Continue making stitches in this way until you have cast on the number of stitches stated in the pattern. The slipknot counts as the first stitch.

CHAIN BIND-OFF

A simple knit stitch (chain) bind-off is used in most of the stitches featured. It is easy to work, neat, and reasonably elastic. Knit two stitches. *With the left needle, lift the first stitch over the second and off the needle. Knit the next stitch. Repeat from * until one stitch remains. Break the yarn, take the end through this stitch, and tighten.

To bind off in pattern, simply work knit or purl stitches along the bind-off row as they would occur in the stitch pattern.

ENDS

The end of yarn left after casting on should be a reasonable length so that it can be used for sewing up. The same applies to the end left after binding off. Ends left when a new color is joined in should be woven in along a seam or row end on the wrong side and can also be very useful for covering up imperfections, such as awkward color changes. Ends left while working a motif are better woven in behind the motif. Use a blunt-pointed tapestry needle for weaving in.

KNIT STITCH (k)

Choose to hold the yarn and needles in whichever way you feel most comfortable. For comfort and for neat results, the yarn needs to be tensioned slightly by wrapping it around the fingers of the hand holding the yarn. The yarn should move smoothly through the fingers but not be too loose. Practice wrapping in different ways until you feel comfortable. Continuous rows of knit stitch create garter stitch (see page 14), which produces a springy, nubbly fabric with alternating rows of bumps and troughs. A single row of knit stitches produces a smooth "V" on the front of the work and a bump on the reverse.

1 Insert the right needle into the first stitch on the left needle. Make sure it goes from left to right into the front of the stitch.

2 Taking the yarn behind, bring it up and around the right needle clockwise.

3 Using the tip of the right needle, draw a loop of the working yarn through the stitch.

4 Slip the stitch off the left needle. There is now a new stitch on the right needle.

PURL STITCH (p)

Hold the yarn and needles in the same way as for making a knit stitch. A purl stitch is the opposite of a knit stitch, producing a bumpy stitch on the front and smooth "V"-like knit stitches on the reverse of the work. Alternate rows of knit and purl produce stockinette stitch (see page 14) when viewed from the smooth (knit) side. When viewed from the bumpy (purl) side, this produces reverse stockinette stitch (see page 14). Either may be used as the right side of a fabric.

1 Insert the right needle into the first stitch on the left needle. Make sure it goes into the stitch from right to left up into the front of the stitch.

2 Bringing the yarn to the front, loop it around the right needle counter clockwise.

3 Lower the tip of the right needle, taking it away from you to draw a loop of the working yarn through the stitch.

4 Slip the stitch off the left needle. There is now a new stitch on the right needle.

DECREASES

Decreases have two basic functions. They can be used to reduce the number of stitches in a row, as in armholes and necklines, and combined with increases, they can create stitch patterns.

Right-slanting single decrease (k2tog)

Knitting two stitches together makes a smooth shaping, with the second stitch lying on top of the first. For k3tog, knit the next three stitches as one, for k4tog, the next four stitches, and so on. A p2tog is worked in the same way, with two (or three for p3tog, four for p4tog, etc.) stitches purled as one.

Left-slanting single decrease (skp)

Slipping a stitch, knitting a stitch, then lifting the slipped stitch over the knitted stitch makes a decrease, with the first stitch lying on top of the second.

Left-slanting double decrease (sk2p)

For a double decrease that slants to the left, worked on a right-side row, you'll need to take the first stitch over a single decrease. For a similar-looking decrease worked on a wrong-side row, purl three together through the back of the loop (p3togtbl).

1 Insert the right needle through the front of the first two stitches on the left needle, then take the yarn around the needle.

1 Insert the right needle knitwise (as if to knit the next stitch) through the front of the next stitch on the left needle, and slip it on to the right. Knit the next stitch.

1 Insert the right needle knitwise through the front of the next stitch on the left needle, and slip it on to the right needle.

2 Draw the loop through and drop the two stitches off the left needle. One stitch decreased.

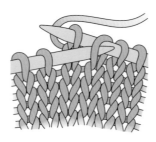

2 Use the tip of the left needle to lift the slipped stitch over the knitted stitch and off the right needle. One stitch decreased.

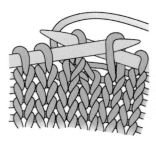

2 Knit the next two stitches together, then lift the first stitch over as shown. To make a right-slanting double decrease, simply knit three stitches together (k3tog), see left.

Balanced double decrease (s2kp)
Working a decrease that takes one stitch from each side and leaves the center stitch on top has lots of potential for shaping and for working beautiful stitch patterns.

CABLES

Knitting groups of stitches out of sequence creates exciting stitch patterns. Cables can be worked with two or more stitches and crossed to the front or the back.

Front cable (2/2 LC)
The stitches in this example are knitted, and this four-stitch cable crosses at the front. A four-stitch back cable (2/2 RC) is worked in exactly the same way, except that the cable needle is held at the back, so that the cable crosses in the opposite direction. More complex cables may include slipped, purled, or twisted stitches, but once you understand the basics, it is easy to progress to more complex stitches.

YARN OVER (yo)

It's essential to take the yarn over the needle so that the strand lies in the same direction as the other stitches. Working into this strand on the next row makes a hole, but if the strand is twisted, the hole will close up.

When the stitch before a yarn over is purl, the yarn will already be at the front, ready to go over the needle.

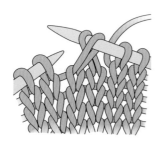

1 Insert the right needle into the second and then the first stitch, and slip these stitches on to the right needle. The slipped stitches will be out of sequence but this is okay.

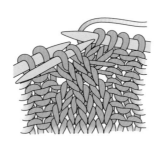

1 Slip the first two stitches on to a cable needle and hold at the front of the work, then knit the next two stitches from the left needle.

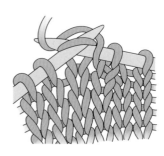

1 To make a yarn over between knit stitches, bring the yarn to the front as if to purl, then take it over the needle to knit the next stitch.

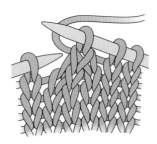

2 Knit the next stitch, then lift the two slipped stitches over.

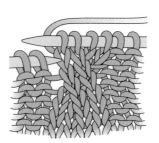

2 Knit the two stitches from the cable needle.

2 To make a yarn over between a knit and a purl, bring the yarn to the front as if to purl, take it over the needle, and bring it to the front again, ready to purl.

INCREASES

Here are two commonly used methods of increasing a single stitch—bar increase and lifted strand increase.

Bar increase on a knit row (k1f&b)

Knitting into the front and the back of a stitch is the most common increase. It's a neat, firm increase, which makes a little bar on the right side of the work at the base of the new stitch and doesn't leave a hole.

1 Knit into the front of the stitch and pull the loop through, but leave the stitch on the left needle.

2 Knit into the back of the stitch on the left needle.

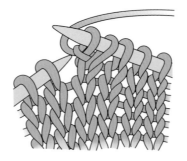

3 Slip the stitch off the left needle, making two stitches on the right needle. Note that the bar of the new stitch lies on the left.

Lifted strand increase to the left (m1 or m1l)

Making a stitch from the strand between stitches is a very neat way to increase.

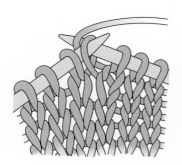

From the front, insert the left needle under the strand between stitches. Make sure the strand lies on the needle in the same direction as the other stitches, then knit into the back of it.

Double increase (m3)

Also known as a wrapped increase, this is one of the simplest ways to make three stitches out of one.

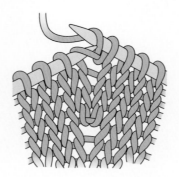

Knit one stitch without slipping it off, take the yarn over the right needle from front to back, then knit the same stitch again. A small but decorative hole is left in the fabric.

Lifted strand increase to the right (m1r)

This right-slanting increase balances the lifted strand increase to the left.

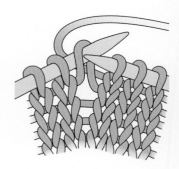

From the back, insert the left needle under the strand between the stitches. It will not lie in the same direction as the other stitches, so knit into the front of it.

TWISTS

Twisting stitches is working two or three stitches out of sequence, but without using a cable needle. This is an easy way to create patterns where lines of stitches travel over the surface of the knitting.

Left twist (1/1 LT)

This twist is worked on a right-side row. As the stitches change place, the first stitch lies on top and slants to the left, while the stitch behind is worked through the back of the loop.

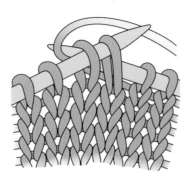

1 Knit into the back of the second stitch.

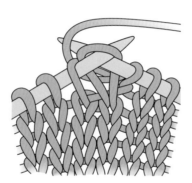

2 Knit into the front of the first stitch.

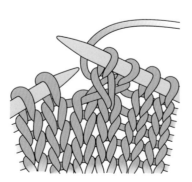

3 Slip both stitches off the left needle together.

Right twist (1/1 RT)

In this right-side row twist, the second stitch lies on top and slants to the right, while the stitch behind is worked through the back of the loop.

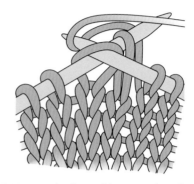

1 Knit into the front of the second stitch.

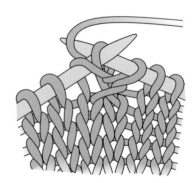

2 Knit into the back of the first stitch.

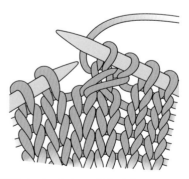

3 Slip both stitches off the left needle together.

Gauge

A knitter's best friend, but also, arguably, the part of a project that knitters like the least—gauge. Mention gauge swatches (or gauge squares) to most knitters and wait for the groans! But, while they may seem like an annoyance that only serves to keep you away from your precious knitting project, they can save a lot of disappointment.

Gauge is simply the size (length x width) of a knitting stitch knitted on a specific size of needle using a specified technique. Because stitches form the basis of a knitted fabric, it stands to reason that if your stitches are larger or smaller than the ones knitted by the designer (usually if you knit more loosely or tighter), you may not produce a piece of knitting the same size as the one the designer knitted. If you doubt that this is the case, ask three of your knitting friends to each make a square using the same needles, rows, and stitches and compare the finished sizes. They will almost certainly be different.

But does this matter? Small differences over a small square may not seem significant, but if your stitches are just an eighth bigger than the designer's, for every 100 stitches the designer casts on, your work will measure the equivalent of 12 stitches larger. On a shawl with 400 stitches, that's the equivalent of an extra 50 stitches without your having cast on a single extra stitch. Equally, if your square is smaller than the designer's, your garment will be correspondingly smaller—and the greater the difference, the smaller the garment will be.

So, on balance, as much as a gauge swatch seems like an obstacle designed to prevent you from getting stuck into your project, knitting one is a worthwhile exercise.

NON-MATCHING GAUGE

There are occasions when it is not possible to match both the number of rows and the number of stitches simultaneously. With one set of needles your rows are correct but you have too few stitches. However, when you go down a needle size, the stitch numbers are correct, but there are too few rows.

Because we all knit differently, it is quite common to find that you can't

exactly match the gauge stated in a given pattern. If, having tried a couple of needle sizes, you find that you can't match both stitches and rows, it is generally advisable to ensure that the number of stitches is correct, even if this means that the number of rows is different from the pattern. Where the number of rows is different from the stated gauge, you may need to work either fewer or more rows to achieve the correct dimensions. If the pattern gives measurements—for example, "knit until the work measures Xin/cm"—the number of rows isn't usually important, although you may not end in the same place on

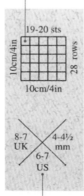

Yarn manufacturers will often give a guide to the appropriate gauge for the yarn on the ball band. The number of rows and stitches to a given measurement, together with the needle size and the stitch used, will be given.

Additional information may be included, such as the manufacturer's recommended range of needle sizes for the yarn.

TIPS

- If you are working with textured yarns it can be difficult to measure stitches and rows accurately. To remedy this, use a piece of smooth, contrasting thread and add it during knitting by inserting a lifeline after four or five rows. Lay a second piece of thread between the fourth and fifth stitches to mark out the edge and again after the number of stitches stated to be the correct gauge in the pattern. Run these threads up the sides of the work like a running stitch by taking them to the back after two rows and bringing them forward after a further two rows, and so on. Once the stated number of rows has been knitted, add a further lifeline. Use these lines to measure your work.

- Label swatches and keep them for future reference in a folder or box. They may come in handy if you knit the project or use the same yarn again.

- Swatches can be made into projects such as coasters, mats, or small purses. They can also be sewn together to create a blanket—a wonderful history of your knitting projects.

- If a pattern is to be knitted in the round, make sure you knit your gauge swatch in the round, since gauge is often different when comparing circular to flat knitting.

- Use the same needles as you did for your correct swatch and remember to adjust any smaller or larger needles for ribs or bands correspondingly.

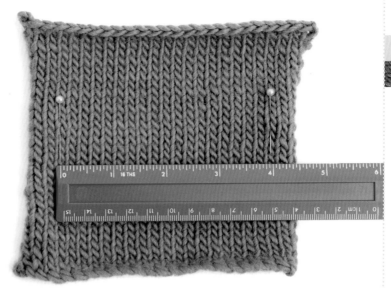

the pattern repeat. Where the pattern requires a specific number of rows, calculate what the length will be based on the stated gauge. Compare this to the length if you used your own gauge and aim to work more/fewer rows to match the original length. If it is a close measurement over a small length this may not be necessary, but over a long length, adjustments will be needed. Aim to adjust length in areas where there is no shaping, if at all possible. If adjusting rows in an area where stitches will be picked up, you may need to adjust the number of stitches being picked up accordingly.

MEASURING GAUGE

Knit your swatch exactly according to the pattern, keeping in mind that you may be asked to work in a pattern stitch or in a simple stockinette stitch. Knit the swatch 10 or so stitches larger and work an extra 10 rows more than the stated gauge. This allows you to measure in the center of the swatch, which is more accurate since edge stitches are rarely the same size as the main body of the garment and can distort your calculations.

1 Bind off, wash, and block your swatch. Ideally, leave it overnight to allow the stitches to settle. Measuring in the center of the swatch, mark a line vertically, straight up one column of stitches, with a large-headed pin. Use a ruler to measure the stated width, usually 4in (10cm). Measure across the center of the swatch to avoid distortions. Mark this measurement with a second pin. Count the stitches between the two pins. Include any half, quarter, or partial stitches.

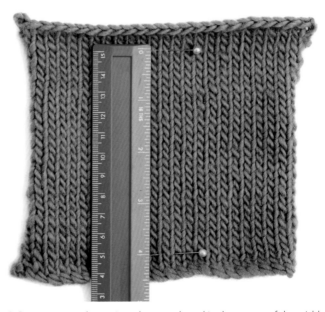

NOTE

This information is a guide only and does not take into account any unique features of your pattern, such as pattern stitch, required drape, etc. You will still need to check your own gauge and compare it to the gauge stated in the pattern. The ball-band information is, however, a useful indicator, particularly if substituting a different yarn for the one in your pattern.

2 Starting several rows into the swatch and in the center of the width, place a pin horizontally, straight along a row of stitches. Measure the stated length in a straight vertical line and mark this point with a second pin. Count the rows between the two pins including any partial rows. If your finished measurements match the pattern, you can start knitting with the needles you have been using. If the square is too small, repeat the process using needles a size larger. If the square is too large, try again with smaller needles.

How to Read a Chart

Charts are a way of depicting pattern information in a graphic form. They are often used to depict the more complex parts of a design, for example, a Fair Isle or lace design. Many knitters and designers find them helpful because it is possible to see the pattern structure at a glance.

Charts may be written using symbols or by using different colors to represent different stitches or colors. Symbols are more commonly used for lace, cables, and other stitch patterns, whereas colored charts are generally restricted to Fair Isle and other colorwork designs. Charts are read from the bottom to the top following the direction of the knitting. Each square represents a stitch and each horizontal line of squares a row of knitting.

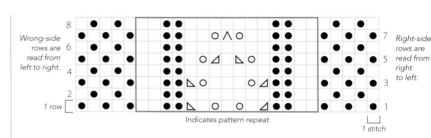

Wrong-side rows are read from left to right.

Right-side rows are read from right to left.

1 row

Indicates pattern repeat

1 stitch

SYMBOL-BASED CHART

The symbols represent an instruction and, where possible, are designed to resemble the appearance of the knitting. Before you start knitting, familiarize yourself with the symbols and techniques of the chart you are going to work from, making a note of them for quick reference if desired.

COLOR-BASED CHART

Color charts are read in the same way as symbol-based charts, with each square representing a stitch of knitting. As most colorwork uses stockinette stitch, sometimes stitch symbols are replaced with colored squares, each color representing a different yarn color.

End stitches to balance the pattern

Multiple of 8 sts + 1

KEY

Each chart is accompanied by a key; always read the key before you begin because there is no standard set of symbols and designers and publishers follow different conventions when producing charted patterns. Take particular care to note any symbols that have a double use. For example, a blank white square will often be used to depict a knit stitch on a RS row and a purl stitch on a WS row. In other words, this would produce a series of stockinette stitches. Purl stitches worked on a RS row may then have a separate symbol (often •), so don't worry if you see what are apparently two instructions for a single stitch type. A key might look something like this:

☐	On RS, knit, on WS, purl
●	On RS, purl, on WS, knit
ℚ	On RS, k1tbl, on WS, p1tbl
╱	k2tog
╲	skp
╱	p2tog
⋀	s2kp
⋉	k3tog
⋀	sk2p
♉	m1
♉	m1p
⅄	m1l
Ⱶ	m1r
◯	yarn over

ANATOMY OF A CHART

10-stitch repeat

10-stitch repeat

Multiple of 4 sts

Squares and spans

Each square of a chart represents one stitch of knitting. Combinations of stitches, such as cables or decreases, may span over a number of squares. This means that these stitches are worked as a unit. The chart above would read as follows:

- **Row 1 (RS):** P3, knit to last 3 sts, p3.
- **Row 2:** Knit.
- **Rows 3 & 4:** Repeat Rows 1 & 2.
- **Row 5:** Repeat Row 1.
- **Row 6:** K3, purl to last 3 sts, k3.
- **Row 7:** P3, *2/2 LC, 2/2 RC; rep from * to last 3 sts, p3.
- **Row 8:** Repeat Row 6.
- **Row 9:** P3, *1/1 LC, 1/1 RC; rep from * to last 3 sts, p3.
These 9 rows form the pattern.

Pattern repeats and multiples

Where a pattern is repeated several times across a row, the designer will often chart the pattern section just once (the pattern repeat). Any odd stitches at the beginning or end of the row are shown at either side of the pattern repeat and the section to be repeated is bordered with a bold line or clearly demarcated in another way. This chart, for example, would read:

- **Row 1 (RS):** [P2, k8] to last 2 sts, p2.
- **Row 2:** K2, [p8, k2] to end.
- **Row 3:** [P2, 2/2 RC, 2/2 LC] to last 2 sts, p2.
- **Row 4:** Repeat Row 2.
These 4 rows form the pattern.

When calculating how many stitches to cast on, this will be the number of stitches in the repeat (the multiple), plus any additional stitches. So a chart that asks for a multiple of 10 sts + 2 (as above) will have 12 sts for one repeat, 22 for two repeats, 32 for three repeats, and so on. The additional sts are only added once. For patterns with "no stitch" in the first row, use the stitch multiple and any additional stitches, ignoring any "no stitches."

No stitch

To make charts easier to produce, where a stitch is decreased—and so does not exist for the remainder of the section—a black or grayed-out square is often used to depict "no stitch."

In this example using blackberry stitch, the chart is read straight across, ignoring the grayed-out squares. Note that the number of stitches cast on is 4; the grayed-out stitches are ignored. So the equivalent written pattern would read:

- **Row 1 (RS):** Purl.
- **Row 2:** [Inc1to3, p3tog] to end.
- **Row 3:** Purl.
- **Row 4:** [P3tog, inc1to3] to end.
These 4 rows form the pattern.

MULTIPLE CHARTS

It is rare for a chart to show an entire garment due to the size of chart this would require. Therefore, where there are several areas of pattern in a piece, there will be several small charts. You will be instructed on which chart to follow at the appropriate part in the text.

SUPPLEMENTARY CHARTS

Where a motif (a bell or leaf, for example) is added part way through a chart, this may be shown separately to save space. In this case, where a row has a number it will correspond to the row number in the supplementary chart.

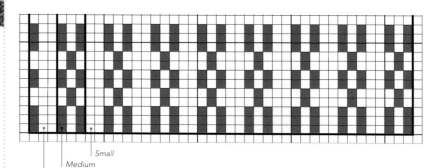

Small
Medium
Large

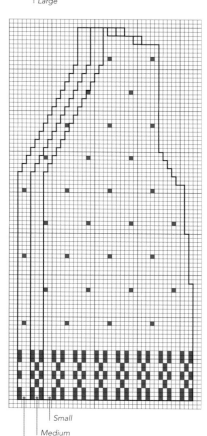

Small
Medium
Large

Sizing

A chart may have additional boxed-out or demarcated sections to depict the different instructions for different sizes. Follow the correct section for your size. Here, if you were making the small size of the left front (knitted flat as a separate piece), you would work the first three rows as follows:

- **Row 1 (RS):** *P1, k1, p1, k2; rep from * to end.
- **Row 2:** *P2, k1, p1, k1; rep from * to end.
- **Row 3:** Repeat Row 1.

The medium size would read:
- **Row 1 (RS):** *P1, k1, p1, k2; rep from * to last 3 sts, p1, k1, p1.
- **Row 2:** K1, p1, k1, *p2, k1, p1, k1; rep from * to end.
- **Row 3:** Repeat Row 1.

And the large size would read:
- **Row 1 (RS):** *P1, k1, p1, k2; rep from * to last st, p1.
- **Row 2:** K1, *p2, k1, p1, k1; rep from * to end.
- **Row 3:** Repeat Row 1.

Row numbering

To save printing space and to make patterns easier to visualize, designs where alternate rows are all identical may not be shown on the chart. This will be clear from the row numbering (usually printed vertically up the side of the chart) where only every other row will be numbered. Alternatively, the key may have instructions to treat every alternate row as, for example, a purl row.

TIPS

- Photocopy (and enlarge if necessary) your charts and use a sticky note to mark the row that you are on.

- Mark off rows as you complete them with a highlighter pen. If you reuse the chart, use a different color highlighter. A highlighter can also be used to mark out your size, if appropriate.

- Don't be tempted to cross out completed lines—just in case you make a mistake.

- Photocopy the key and keep it next to you for easy reference.

- Copy the color chart and attach a small piece of the relevant yarn color next to each color on the chart for easy reference.

KNITTING DIRECTION—FLAT VS CIRCULAR KNITTING

Charts are used for both flat and circular knitting. The key difference in following these charts is in the direction of knitting and the order in which to read the chart.

Flat knitting

Where a pattern starts on a right-side row, the rows are normally worked starting at the bottom right corner and read from right to left for the first row. The next row then starts at the left and is read from left to right. However, if a pattern starts with a wrong-side row, the first row will be worked from left to right.

When converting a chart for knitting in the round, it may be necessary to adjust the additional stitches that are worked once at the beginning and end of rows to ensure that any repeats are correctly aligned. Using the guide below, try out the chart on a circular knitted swatch, adjusting as required to get a good pattern match. This will be indicated by the row numbers at the sides of the chart.

Circular knitting

With projects knitted in the round, all rows (rounds) are read in the same direction, usually starting at the bottom right corner and reading from right to left. This may seem confusing, but if you visualize your knitting as you hold it, a flat piece is knitted from the right-hand edge to the left, swapped back into the left hand, and then knitted from the left edge to the right. By contrast, with a circular knit you are always knitting in the same direction, usually from right to left, and the work never swaps hands.

Flat knitting

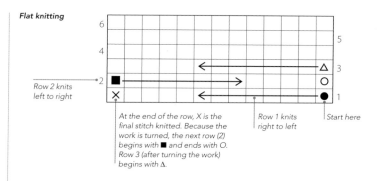

Row 2 knits left to right

At the end of the row, X is the final stitch knitted. Because the work is turned, the next row (2) begins with ■ and ends with O. Row 3 (after turning the work) begins with Δ.

Row 1 knits right to left

Start here

Flat knitting—wrong side

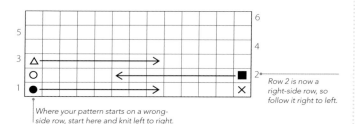

Row 2 is now a right-side row, so follow it right to left.

Where your pattern starts on a wrong-side row, start here and knit left to right.

Circular knitting

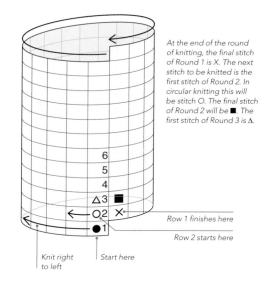

At the end of the round of knitting, the final stitch of Round 1 is X. The next stitch to be knitted is the first stitch of Round 2. In circular knitting this will be stitch O. The final stitch of Round 2 will be ■. The first stitch of Round 3 is Δ.

Row 1 finishes here

Row 2 starts here

Knit right to left

Start here

Symbols and Abbreviations

On RS, **knit**. On WS, **purl**.

On RS, **purl**. On WS, **knit**.

Yarn over.

Yo twice: Wrap yarn around needle twice.

Yo three times: Wrap yarn around needle three times.

Yo four times: Wrap yarn around needle four times.

CO: Cast on.

BO: Bind off.

Back loop CO 6: Cast on 6 sts using backward loop method. Insert RH needle in back of loop on LH needle. Wrap yarn as if to knit, pull through loop, and transfer onto LH needle. 1 st cast on.

On RS, **k1tbl:** Knit 1 st, through the back loop. On WS, **p1tbl:** Purl 1 st, through the back loop.

On RS, **p1tbl:** Purl 1 st, through the back loop. On WS, **k1tbl:** Knit 1 st, through the back loop.

On RS, **sl1 wyib:** Slip 1 st, with yarn in back. On WS, **sl1 wyif:** Slip 1 st, with yarn in front.

On RS, **sl1 wyif:** Slip 1 st, with yarn in front. On WS, **sl1 wyib:** Slip 1 st, with yarn in back.

Skp: Slip 1 as if to knit, k1, pass slipped st over.

Sk2p: Slip 1 as if to knit, k2tog, pass slipped st over.

On RS, **s2kp:** Slip 2 as if to k2tog, k1, pass 2 slipped sts over. On WS, **s2pp:** Slip 2 sts, p1, pass slipped sts over.

Ssk: Slip, slip, knit. Slip 2 sts one at a time as if to knit, knit 2 slipped sts together.

On RS, **k2tog:** Knit 2 sts together. On WS, **p2tog:** Purl 2 sts together.

On RS, **p2tog:** Purl 2 sts together. On WS, **k2tog:** Knit 2 sts together.

On RS, **k3tog:** Knit 3 sts together. On WS, **p3tog:** Purl 3 sts together.

On RS, **p3tog:** Purl 3 sts together. On WS, **k3tog:** Knit 3 sts together.

On RS, **k4tog:** Knit 4 sts together. On WS, **p4tog:** Purl 4 sts together.

On RS, **k5tog:** Knit 5 sts together. On WS, **p5tog:** Purl 5 sts together.

K1f&b: Knit into front and back of next st.

P1f&b: Purl into front and back of next st.

Inc1to2: Make 2 sts from 1. [K1, p1] in next st.

Inc1to3: Make 3 sts from 1. [K1, p1, k1] in next st.

Inc1to4: Make 4 sts from 1. [K1, p1, k1, p1] in next st.

Inc1to5: Make 5 sts from 1. [(K1, p1) twice, k1] in next st.

M1: Make 1. Increase by 1 st by knitting into the front of the strand between the st just worked and the next st.

M1p: Make 1 purlwise. Increase by 1 st purlwise by inserting RH needle under strand between st just worked and next st from back to front and purling.

M1r: Make 1 knitwise (right leaning). Insert RH needle from front to back under strand between 2 sts and lift loop onto LH needle. Knit in back of loop to form new st.

M1l: Make 1 knitwise (left leaning). Insert RH needle from back to front under strand between 2 sts and lift loop onto LH needle. Knit in front of loop to form new st.

M3: Make 3 from 1 (increasing 2 sts). [K1, yo, k1] in next st.

M3p: Make 3 from 1 purlwise (increasing 2 sts). [P1, yo, p1] in next st.

On RS, **k1 elongated:** Knit a st wrapping yarn around needle twice. On next row drop the extra wrap from needle. On WS, **p1 elongated:** Purl a st wrapping yarn around needle twice. On next row drop the extra wrap from needle.

On RS, **k1 elongated twice:** Knit a st wrapping yarn around needle three times. On next row drop the extra wraps from needle. On WS, **p1 elongated twice:** Purl a st wrapping yarn around needle three times. On next row drop the extra wraps from needle.

K1 elongated five times: Knit a st wrapping yarn around needle six times. On next row drop the extra wraps from needle.

Lst: Lift strand/s. Insert needle under loose strand and knit next st, lifting st in front of strand. As the st is completed lift the strands over the st.

Mb: Make bobble. See individual stitches for specific bobble instructions.

MT: Make tail. K1, turn, cast on 5 sts using knitted method, bind off the same 5 sts, slip 1 st knitwise from RH needle to LH needle pushing tail to RS of work.

On RS, **k2togtbl:** Knit 2 sts together, through the back loop.
On WS, **p2togtbl:** Purl 2 sts together, through the back loop.

On RS, **k3togtbl:** Knit 3 sts together, through the back loop.
On WS, **p3togtbl:** Purl 3 sts together, through the back loop.

On WS, **k3togtbl:** Knit 3 sts together, through the back loop.

K4togtbl: Knit 4 sts together, through the back loop.

Mir 1: Motif insert Row 1. Work the relevant row from the motif chart.

Mir 2: Motif insert Row 2. Work the relevant row from the motif chart.

Mir 3: Motif insert Row 3. Work the relevant row from the motif chart.

Mir 4: Motif insert Row 4. Work the relevant row from the motif chart.

Mir 5: Motif insert Row 5. Work the relevant row from the motif chart.

Mir 6: Motif insert Row 6. Work the relevant row from the motif chart.

Mir 7: Motif insert Row 7. Work the relevant row from the motif chart.

K1, dropping extra wrap.

On RS, **k1b:** Knit 1 below. Insert RH needle from front to back into the st one row directly below the one on the LH needle. Knit this new st together with the st directly above it (the next st you would have been knitting) on LH needle. On WS, **p1b:** Purl 1 below. P1 in row below, inserting RH needle from behind into the st in the row. Purl this st as well as the st above it on the LH needle.

Dyo: Drop yo from preceding row.

Sl1 wyif, p2togtbl, psso: Slip 1 st, purl 2 sts together through the back loop, pass slipped st over.

S2k3p: Slip 2 sts as if to k2tog, k3tog, pass slipped sts over.

Yo, sl1 wyib: Take yarn around RH needle and slip next st purlwise with yarn held at back of work.

Knit tog sl st and yo.

K2, p1, pass 2 knit sts over.

K2 tuck: Knit 2 tuck. Insert LH needle into top of st 2 rows below on WS of work. Lift loop onto LH needle and knit the loop and next st together as 1 st, creating a tuck in the work.

K4 tuck: Knit 4 tuck. Insert LH needle into top of st 4 rows below on WS of work. Lift loop onto LH needle and knit the loop and next st together as 1 st, creating a tuck in the work.

Drop 1 to RS.

Pick up and knit dropped stitch.

D4: Drop down 4 rows. Allow next st (a knit) to drop off the LH needle, and unravel it for 4 rows, so that there are 4 "ladder rungs" above it. Put LH needle into that st from front to back, and knit through that st. After you complete the st, you'll see that all of the "ladder rungs" are also caught up in the st, creating the lifted appearance.

D6: Drop down 6 rows. Allow next st (a knit) to drop off the LH needle, and unravel it for 6 rows until it reaches the yo, so that there are 6 "ladder rungs" above it. Continue to follow pattern as set.

Yf sl1yo: Yarn forward, slip 1, yarn over. Bring yarn to the front, slip next st purlwise, then bring yarn to the back over the needle and the slipped st. The slipped st and yo are counted as 1 st.

Yf sl2yo: Yarn forward, slip 2, yarn over. Bring yarn to the front, slip the next 2 sts purlwise, then bring the yarn to the back over the needle and the slipped sts. There are now 2 slipped sts under 1 yo. This counts as 2 sts and the k3tog on next row is worked over these sts.

W2p: Wrap 2 purl. Purl next st, wrapping yarn twice around needle.

Os5: Oyster over 5. Slip 5 sts to RH needle dropping extra wraps, slip them back to LH needle, [(k1, p1) twice, k1] into all 5 sts together, wrapping yarn twice around needle for each st.

Brk: Knit the st that was slipped in the previous row together with its yo.

Brp: Purl the st that was slipped in the previous row together with its yo.

Lsf: Loop stitch front (loops to front of work). Knit in front of st but don't complete st. Bring yarn between needles (yf) and wrap clockwise around left thumb at front of work. Take yarn to back between needles. Knit loop on LH needle and drop off LH needle, completing the st. Yo taking yarn from back, around RH needle, and hold to back. Lift 2 sts just worked over yo.

Lsb: Loop stitch back (loops to back of work). Insert LH needle in st and wind yarn around needle as if to knit. Wind yarn around LH index finger. For a short loop wind once; to lengthen the loop, wind twice. Take yarn back around RH needle as if to knit (again) and form the st. To secure the loop, bring the working yarn between the needles to the front of the work and then over the needles, like a yo. Hold yo securely in place and bind off st over yo. This will secure the loop.

Sl1 purlwise, k2, psso.

K3p: K3, pass first st over second and third sts and drop off needle.

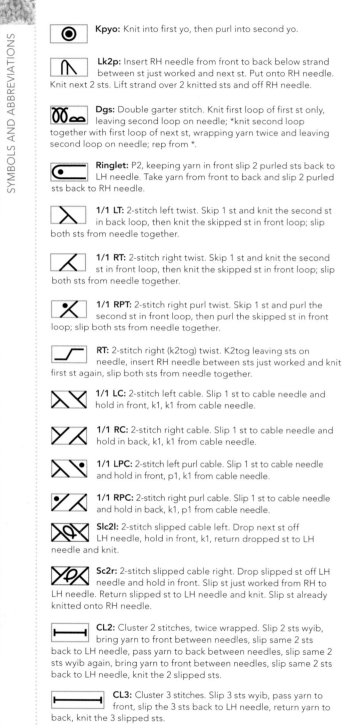

Kpyo: Knit into first yo, then purl into second yo.

Lk2p: Insert RH needle from front to back below strand between st just worked and next st. Put onto RH needle. Knit next 2 sts. Lift strand over 2 knitted sts and off RH needle.

Dgs: Double garter stitch. Knit first loop of first st only, leaving second loop on needle; *knit second loop together with first loop of next st, wrapping yarn twice and leaving second loop on needle; rep from *.

Ringlet: P2, keeping yarn in front slip 2 purled sts back to LH needle. Take yarn from front to back and slip 2 purled sts back to RH needle.

1/1 LT: 2-stitch left twist. Skip 1 st and knit the second st in back loop, then knit the skipped st in front loop; slip both sts from needle together.

1/1 RT: 2-stitch right twist. Skip 1 st and knit the second st in front loop, then knit the skipped st in front loop; slip both sts from needle together.

1/1 RPT: 2-stitch right purl twist. Skip 1 st and purl the second st in front loop, then purl the skipped st in front loop; slip both sts from needle together.

RT: 2-stitch right (k2tog) twist. K2tog leaving sts on needle, insert RH needle between sts just worked and knit first st again, slip both sts from needle together.

1/1 LC: 2-stitch left cable. Slip 1 st to cable needle and hold in front, k1, k1 from cable needle.

1/1 RC: 2-stitch right cable. Slip 1 st to cable needle and hold in back, k1, k1 from cable needle.

1/1 LPC: 2-stitch left purl cable. Slip 1 st to cable needle and hold in front, p1, k1 from cable needle.

1/1 RPC: 2-stitch right purl cable. Slip 1 st to cable needle and hold in back, k1, p1 from cable needle.

Slc2l: 2-stitch slipped cable left. Drop next st off LH needle, hold in front, k1, return dropped st to LH needle and knit.

Sc2r: 2-stitch slipped cable right. Drop slipped st off LH needle and hold in front. Slip st just worked from RH to LH needle. Return slipped st to LH needle and knit. Slip st already knitted onto RH needle.

CL2: Cluster 2 stitches, twice wrapped. Slip 2 sts wyib, bring yarn to front between needles, slip same 2 sts back to LH needle, pass yarn to back between needles, slip same 2 sts wyib again, bring yarn to front between needles, slip same 2 sts back to LH needle, knit the 2 slipped sts.

CL3: Cluster 3 stitches. Slip 3 sts wyib, pass yarn to front, slip the 3 sts back to LH needle, return yarn to back, knit the 3 slipped sts.

CL4: Cluster 4 stitches. Slip 4 sts wyib, pass yarn to front, slip the 4 sts back to LH needle, knit the 4 slipped sts.

3-3: 3 into 3 gathered. K3tog, slip st back onto LH needle, [k1tbl, k1, k1tbl] in this st.

Dst: Daisy stitch. P3tog but keep the sts on LH needle. Yo, then purl the same 3 sts together again to complete the st.

3CL: 3-stitch cluster. Slip 3 sts letting extra wraps drop. Place slipped sts back onto LH needle, [k1, p1, k1] into all 3 sts.

Wr3: Wrap 3 stitches. Bring yarn to front between needles and slip 3 sts onto LH needle. Take yarn across front of work and between needles to back. Slip sts to RH needle. Bring yarn across back of work and between needles to front. Slip sts to LH needle and take yarn between needles. Take yarn across front of work, between needles, and hold in back. Transfer sts to RH needle.

1/2 LC: 3-stitch left cable. Slip 1 st to cable needle and hold in front, k2, k1 from cable needle.

1/2 RC: 3-stitch right cable. Slip 2 sts to cable needle and hold in back, k1, k2 from cable needle.

2/1 LC: 3-stitch left cable. Slip 2 sts to cable needle and hold in front, k1, k2 from cable needle.

2/1 LPC: 3-stitch left purl cable. Slip 2 sts to cable needle and hold in front, p1, k2 from cable needle.

2/1 RPC: 3-stitch right purl cable. Slip 1 st to cable needle and hold in back, k2, p1 from cable needle.

Trellis 4: 4-stitch trellis stitch. Slip 4 sts to RH needle, dropping the extra yos from preceding row to form a long loop. Slip 4 sts back to LH needle. Insert RH needle into sts 3 and 4 on LH needle and lift over sts 1 and 2 but keeping all sts on LH needle. Knit these 4 sts keeping sts in this order: 3, 4, 1, 2.

2/2 LC: 4-stitch left cable. Slip 2 sts to cable needle and hold in front, k2, k2 from cable needle.

2/2 RC: 4-stitch right cable. Slip 2 sts to cable needle and hold in back, k2, k2 from cable needle.

2/2 LPC: 4-stitch left purl cable. Slip 2 sts to cable needle and hold in front, p2, k2 from cable needle.

2/2 RPC: 4-stitch right purl cable. Slip 2 sts to cable needle and hold in back, k2, p2 from cable needle.

3/1 LPC: 4-stitch left purl cable. Slip 3 sts to cable needle and hold in front, p1, k3 from cable needle.

3/1 RPC: 4-stitch right purl cable. Slip 1 st to cable needle and hold in back, k3, p1 from cable needle.

1/2/1 LRC: 4-stitch left ribbed cable. Slip 1 st to cable needle and hold in front, slip 2 sts to second cable needle and hold in back, k1, p2 from back cable needle, then k1 from front cable needle.

 1/2/1 RRC: 4-stitch right ribbed cable. Slip 3 sts to cable needle and hold in back, k1, slip 2 left-most sts from cable needle to LH needle, move cable needle with remaining st to front, p2 from LH needle, then k1 from cable needle.

 L4C: Left 4 cross. Slip 4 sts wyib, dropping extra wraps. Insert LH needle into sts 1 and 2 and pass over sts 3 and 4 onto LH needle. Slip sts 3 and 4 onto LH needle. K4 (knitting sts 3 and 4 first).

 R4C: Right 4 cross. Slip 4 sts purlwise, allowing loops to drop. Return sts to LH needle. Lift sts 3 and 4 over sts 1 and 2, bringing to front of LH needle. K4 (knitting sts 3 and 4 first).

 LRC: Left rib cross (left front cross). Slip 3 sts to cable needle and hold in front, k1, then [k1, p1, k1] from cable needle.

 RRC: Right rib cross (right back cross). Slip 1 st to cable needle and hold in back, [k1, p1, k1], then k1 from cable needle.

 W4: Wrap 4 stitches. Slip 4 sts to cable needle, wind yarn clockwise around these sts four times, slip sts to RH needle.

 W4k: Hold yarn to back, slip 4 sts purlwise, bring yarn to front, return 4 slipped sts to LH needle, k4.

 W4p: Hold yarn to back, slip 4 sts purlwise, bring yarn to front, return 4 slipped sts to LH needle, p4.

5 ✕ 5 ᑕ **G5:** Gather 5 wrapped into 5. Slip 5 sts from LH to RH needle, dropping extra wraps from preceding row. Return 5 sts to LH needle. K5tog, slip st back to LH needle, [(k1tbl, k1, k1tbl, k1) twice, k1tbl] in this st.

 2/3 LC: 5-stitch left cable. Slip 2 sts to cable needle and hold in front, k3, k2 from cable needle.

 3/2 LPC: 5-stitch left purl cable. Slip 3 sts to cable needle and hold in front, p2, k3 from cable needle.

3/2 RPC: 5-stitch right purl cable. Slip 2 sts to cable needle and hold in back, k3, p2 from cable needle.

Cl 5 from 2: Knit the 2 sts from preceding row together, but keep both sts on LH needle. [Yo, k1] twice into the 2 sts, then drop the 2 sts from LH needle.

Cl 9 from 3: Knit the 3 sts from preceding row together, but keep all 3 sts on LH needle. [Yo, k1] four times into the 3 sts, then drop the 3 sts from LH needle.

3/3 LC: 6-stitch left cable. Slip 3 sts to cable needle and hold in front, k3, k3 from cable needle.

 3/3 RC: 6-stitch right cable. Slip 3 sts to cable needle and hold in back, k3, k3 from cable needle.

2/2/2 LPC: 6-stitch left ribbed cable. Slip 2 sts to cable needle and hold in front, slip next 2 sts to second cable needle and hold in back, k2 from LH needle, p2 from back cable needle, k2 from front cable needle.

3/1/3 RPC: 7-stitch right purl cable. Slip 4 sts to cable needle and hold in back, k3, slip last st on cable needle onto LH needle, p1, k3 from cable needle.

4/4 LC: 8-stitch left cable. Slip 4 sts to cable needle and hold in front, k4, k4 from cable needle.

4/4 RC: 8-stitch right cable. Slip 4 sts to cable needle and hold in back, k4, k4 from cable needle.

 4/4 RC Seed over St st cable: Slip 4 sts to cable needle and hold in back, [p1, k1] twice, then k4 from cable needle.

 4/4 RC St st over Seed cable: Slip 4 sts to cable needle and hold in back, k4, then [p1, k1] twice from cable needle.

9 ⟷ 7 **9 into 7 cluster:** Knit together next 7 sts (these are the extra wrap sts from the previous row—drop the extra wraps), but do not remove sts from LH needle. Work [k7togtbl, k7tog] four times in same 7 sts. The result is 9 sts worked into 7 sts.

5/5 LC: 10-stitch left cable. Slip 5 sts to cable needle and hold in front, k5, k5 from cable needle.

5/5 RC: 10-stitch right cable. Slip 5 sts to cable needle and hold in back, k5, k5 from cable needle.

5/5 RPRC: 10-stitch right purl ribbed cable. Slip 5 sts to cable needle and hold in back, p5 from LH needle, k2, p1, k2 from cable needle.

Wr10: Wrap 10 stitches. Slip 10 sts onto cable needle and wrap yarn around sts three times going below the cable needle. Wraps should pull in slightly but not too tightly.

Index

A

abbreviations 186–189
Acrobats Cable 163
Alternating Cross Stitch 118
Ascending Seed Stitch 84
Ascending Squares 26
Asymmetric Cable 24

B

Bamboo Stitch 98
basketweave stitches
 Basketweave 17
 Basketweave Cable 165
 Open Basketweave 83
 Slipped Diagonal
 Basketweave 84
 Wicker Basket Lattice 116
Bee Stitch 85
Beehive Waffle 28
Bell Stitch 71
binding off 174
Birds in Flight 111
block stitches
 Block Check 144
 Blocks 18
 Faggoting Blocks 49
 Interwoven Blocks 78
 Lacy Twist Blocks 91
 Reverse Stockinette and
 Seed Stitch Slipped Blocks
 115
 Traveling Garter Blocks 129
bobble stitches
 Bobble Rib 60
 Bobbles 55
 Diamond Bobble 59
 Harebell 56
 Lace Bobble Mesh 65
 Nupp and Twist Bobble 61
 Petite Bobbles 55
 Twining Bobbles 58
Bows 104
Braided 9-Stitch Cable 154
Braided Triple Cable 166
Brick Stitch 18
brioche stitches
 Diagonal Brioche 31
 Lacy Diagonal Brioche 97
 Striped Half Brioche 144
 Two-Color Brioche Rib 134
 Two-Color Half Brioche Rib
 134
Broken Seed Stitch 85
Buds 56
Bunting 27

C

cable stitches
 6-Stitch Wiggle Cable 156
 10-Stitch Corded Cable 155
 10-Stitch Slalom Cable 165
 Acrobats Cable 163
 Asymmetric Cable 24
 Basketweave Cable 165
 Braided 9-Stitch Cable 154
 Braided Triple Cable 166
 Cabled Chevron 125
 Cabled Chevron 2 125
 Cathedral Windows Cable
 162
 Chain and Rope Cable 161

Chained Cable 24
Chevron Rib Cable 157
Diamond Cable 166
Double and Inverted
 Double Cable 155
Filled Chain Cable 160
Honeycomb Cable 156
Knotted Cable 162
Lantern Cable 164
Rib-Eye Cable 160
Ridged Cable 158
Rope and Diamond Cable
 167
Seed Stitch Cable 159
Single 4-Stitch Cable 153
Single 6-Stitch Cable 153
Single 8-Stitch Cable 154
Threaded Cable 35
Two-Color Garter and
 Stockinette Cable 161
cables 177
Cartridge Belt Rib 91
casting on 174
Cat's Eyes 42
Cathedral Windows Cable 162
Cellular Stitch 82
Chain and Rope Cable 161
Chained Cable 24
charts 182
 anatomy of a chart 183
 color-based charts 182
 keys 182
 knitting direction 185
 multiple charts 183
 no stitches 182
 pattern repeats and
 multiples 183
 row numbering 184
 sizing 184
 symbol-based charts 182
Checkerboard 17
Checkerboard Twist 25
chevron stitches
 Cabled Chevron 125
 Cabled Chevron 2 125
 Chevron and Feather 133
 Chevron Rib Cable 157
 Embossed Chevron 120
 Flame Chevron 44
 Garter Chevron 119
 Garter Striped Chevron 142
 Mini Chevrons 151
 Ripple Chevron 126
 Stockinette Chevron 119
 Two-Color Zebra Chevron
 140
Chutes and Ladders 159
circular knitting 185
circular needles 172
 tips and cords 172
Cloisters 142
cluster stitches
 Cluster Flowers 70
 Clustered Star 62
 Offset Clusters 107
 Pyramid Clusters 97
Cocoon 67
Corn on the Cob 113
Crashing Waves 130
Crochet-Style Shell 103
Crochet-Style Trellis 103

Crossed Seed Slip Stitch 118
Cut Fur Stitch 80

D

Daisy Stitch 36
decreases 176
Deep Rippled Waves 133
Diagonal Brioche 31
Diagonal Moss Stitch 23
Diamond and Leaf 29
Diamond Bobble 59
Diamond Cable 166
Diamond Window Lattice 139
Diamonds 21
Dimple Stitch 94
Dimpled Diamonds 106
Double and Inverted Double
 Cable 155
Double Faced Loop Stitch 81
Double Garter Stitch 74
Double Rib 15
Double Seed Stitch 16
double-pointed needles 172
Dragon's Teeth 22
drop stitches
 Drop Stitch Quilting 143
 Dropped Garter Diamonds
 101
 Long Drop Stitch 99
 Short Drop Stitch 99
 Two-Color Diagonal
 Dropped Stitch 137
 Vertical Drop Stitch 98

E

Embossed Chevron 120
eyelet stitches
 Cat's Eyes 42
 Garter Inverted V Eyelets 40
 Nested V Eyelets 40
 Ridged Eyelet 73
 Simple Eyelet Lace 39
 V Eyelets Lace 39

F

Faggoting Blocks 49
Faggoting Stitch 48
fan stitches
 Feather and Fan 120
 Garter Fan 51
 Ridged Feather and Fan 121
feather stitches
 Chevron and Feather 133
 Feather and Fan 120
 Feather Lace 49
 Ridged Feather and Fan 121
Filled Chain Cable 160
Fisherman's Rib 15
Flame Chevron 44
flat knitting 185
Flickering Flames 109
Fluted Pleats 72
Fur Stitch 80
 Cut Fur Stitch 80

G

garter stitches
 Double Garter Stitch 74
 Dropped Garter Diamonds
 101
 Garter Brick Stitch 112

Garter Chevron 119
Garter Diagonals 21
Garter Fan 51
Garter Inverted V Eyelets 40
Garter Lace Cubes 90
Garter Old Shale 123
Garter Rib Stitch 75
Garter Ridges 73
Garter Slip Stitch 112
Garter Stitch 14
Garter Striped Chevron 142
Lacy Garter Ripple 123
Traveling Garter Blocks
 129
Tucked Garter Tubes 76
Two-Color Garter and
 Stockinette Cable 161
Two-Color Garter Steps 137
gauge 180
 finishing swatch 181
 knitting in the round 180
 measuring gauge 181
 needles 180
 non-matching gauge
 180–181
 reference swatches 180
 textured yarns 180
 uses for swatches 180
Granite Stitch 83
Grapevine 87
Greek Key Fretwork 136

H

Harebell 56
Hazelnut Stripes 64
Heel Stitch 108
Herringbone Leaf 132
Honeybee 105
Honeycomb 105
Honeycomb Cable 156
Houndstooth Check 148

I

Illusion Knit Heart Motif 145
Illusion Knit Star Motif 146
Illusion Knit Zigzag 147
increases 178
Interwoven Blocks 78

J

Jacob's Ladder 148
Jumping Jacks 86

K

Knit Stitch (k) 175
Knot Mesh 88
Knots in Bark 102
Knotted Cable 162

L

lace stitches
 Feather Lace 49
 Garter Lace Cubes 90
 Lace Bobble Mesh 65
 Lace Daisy Stitch 37
 Lace Diamonds 51
 Lace Puffs 64
 Lacy Bear Paw 46
 Lacy Diagonal Brioche 97
 Lacy Garter Ripple 123
 Lacy Sails 38

Lacy Stockinette Scallops 42
Lacy Teepees 131
Lacy Twist Blocks 91
Lacy Wave 122
Madeira Lace 54
Milanese Lace 44
Rib and Lace 48
Scallop Lace Puff 52
Seed Stitch-Filled Lace
 Diamonds 41
Simple Eyelet Lace 39
Simple Lacy Rib 47
Snowflake Lace Motif 43
Stockinette Lacy Smocking
 92
Twisted Leaf Lace 45
V Eyelets Lace 39
Vine Lace 50
Ladder Rib 100
Lantern Cable 164
Lifted Ladder Rib 96
Little Crown Stitch 37
Little Ridged Knots 75
Little Tent Stitch 88
Llamas 149
Long Drop Stitch 99
Lozenges and Triangles 19

M

Macedonian Stitch 141
Madeira Lace 54
mesh stitches
 Knot Mesh 88
 Lace Bobble Mesh 65
 Simple Open Mesh 87
Milanese Lace 44
Mini Chevrons 151
Mistake Rib 15
Moroccan Lattice 150
moss stitches
 Diagonal Moss Stitch 23
 Moss Stitch Zigzags 20
Mountain Peaks 114

N

needles 172–173
 gauge 180
 needle lengths 172
 needle materials 172–173
 needle types 172
 storage 173
Nested V Eyelets 40
Nupp and Twist Bobble 61
Nupps and Dimples 89

O

Ocean Waves 158
Offset Clusters 107
Offset Left Cross Stitch 117
Open Basketweave 83
Open Star Stitch 93
openwork stitches
 Ridged Openwork 82
 Ridged Openwork
 Reversed 76
Oyster Stitch 62

P

Pennants 23
Persian Rug 152
Petite Bobbles 55

Credits

Pillar Stitch 81
Rippled Pillar Stitch 96
Pine Cone 108
puff stitches
Lace Puffs 64
Puff Stitch 63
Scallop Lace Puff 52
Purl Stitch (p) 175
Pyramid Clusters 97

R

Reverse Stockinette and Seed Stitch Slipped Blocks 115
Reverse Stockinette Stitch 14
Reverse Wrapped Rib Stitch 110
rib stitches
1 x 1 Rib 14
2 x 1 Rib 15
Bobble Rib 60
Cartridge Belt Rib 91
Chevron Rib Cable 157
Double Rib 15
Fisherman's Rib 15
Ladder Rib 100
Lifted Ladder Rib 96
Mistake Rib 15
Reverse Wrapped Rib Stitch 110
Rib and Lace 48
Rib-Eye Cable 160
Ribbed Leaf 32
Rick-Rack Rib 33
Simple Lacy Rib 47
Traveling Rib 36
Tucked Rib 72
Two-Color Brioche Rib 134
Two-Color Half Brioche Rib 134
Zigzag Rib 33
Rick-Rack Rib 33
ridge stitches
Garter Ridges 73
Ridged Cable 158
Ridged Eyelet 73
Ridged Feather and Fan 121
Ridged Openwork 82
Ridged Openwork Reversed 76
Ridged Slip Stitch 110
Ridged Trinity Stitch 57
Right Cross Stitch 117
Ringlet Stitch 65
ripple stitches
Deep Rippled Waves 133
Lacy Garter Ripple 123
Ripple Chevron 126
Ripple Twist 27
Rippled Pillar Stitch 96
Vertical Ripple 126
Rope and Diamond Cable 167
Rungs of the Ladder 100

S

Sandwich Stitch 78
Scallop Lace Puff 52
Seafoam 130
seed stitches
Ascending Seed Stitch 84
Broken Seed Stitch 85
Crossed Seed Slip Stitch 118

Double Seed Stitch 16
Reverse Stockinette and Seed Stitch Slipped Blocks 115
Seed Stitch 16
Seed Stitch Cable 159
Seed Stitch Zigzag 127
Seed Stitch-Filled Lacy Diamonds 41
Short Drop Stitch 99
Shower Stitch 95
Simple Eyelet Lace 39
Simple Lacy Rib 47
Simple Open Mesh 87
Single 4-Stitch Cable 153
Single 6-Stitch Cable 153
Single 8-Stitch Cable 154
slip stitches
Crossed Seed Slip Stitch 118
Garter Slip Stitch 112
Reverse Stockinette and Seed Stitch Slipped Blocks 115
Ridged Slip Stitch 110
Slipped Diagonal Basketweave 84
Tucked Slipped Honeycomb 79
slipknots 174
Small Quilted Lattice 116
Snowflake Lace Motif 43
Spring Flowers 66
Steps 22
Stockinette Chevron 119
Stockinette Lacy Smocking 92
Stockinette Smocking 93
Stockinette Stitch 14
Stockinette Waffle 105
Striped Half Brioche 144
Striped Stepped Tucks 77
symbols 186–189

T

Tassel 68
Teardrop Stitch 67
techniques 174–179
cables 177
chain bind-off 174
decreases 176–177
ends 174
increases 178
knit stitch (k) 175
long-tail cast-on 174
purl stitch (p) 175
slipknots 174
twists 179
yarn over (yo) 177
Teepees 131
Lacy Teepees 131
Thistle 47
Threaded Cable 35
Traveling Garter Blocks 129
Traveling Leaves 52
Traveling Rib 36
Traveling Steps 128
Trellis Stitch 34
Crochet-Style Trellis 103
Trinity Stitch 57
Ridged Trinity Stitch 57
tuck stitches
Striped Stepped Tucks 77

Tucked Garter Tubes 76
Tucked Rib 72
Tucked Slipped Honeycomb 79
Wavy Tucks 74
Twin Leaf 69
Twining Bobbles 58
twisted stitches
Checkerboard Twist 25
Lacy Twist Blocks 91
Nupp and Twist Bobble 61
Ripple Twist 27
Twisted Leaf Lace 45
twists 179
Two-Color Brioche Rib 134
Two-Color Diagonal Dropped Stitch 137
Two-Color Garter and Stockinette Cable 161
Two-Color Garter Steps 137
Two-Color Half Brioche Rib 134
Two-Color Zebra Chevron 140

U

Undulating Waves 53

V

V Eyelets Lace 39
Venetian Blind Lattice 113
Vertical Drop Stitch 98
Vertical Herringbone 31
Vertical Ripple 126
Vine Lace 50

W

Waffle Check 139
Waffle Stitch 28
Waves and Pebbles 124
Waves at Sea 121
Wavy Tucks 74
Wicker Basket Lattice 116
Wicker Fence 114
Wide Horizontal Herringbone 30
Wobbly Peaks 132
Woven Band 138
Woven Stitch 115

Y

yarn over (yo) 177
yarns 170–171
fiber content 170
plies 170
weight 170
yardage/meterage 170
Yin Yang 135

Z

zigzag stitches
Illusion Knit Zigzag 147
Moss Stitch Zigzags 20
Seed Stitch Zigzag 127
Zigzag Rib 33
Zigzag Swag Stitch 101

My sincere thanks go to the fabulous test-knitters and proofreaders—Julia Hewitt, Vicky Jeffrey, Leonie Morgan, and Helen Wherrett—who made sense of my squiggles and notes, and turned them into some of the lovely swatches you see in the book. Thanks also to Jools Yeo and Sophie Scott for their help with the pinning of swatches.

Thanks to my husband, Pete, for holding the fort and not minding the mess while I was busy knitting, researching, and charting. Thanks also to Quarto for commissioning me to write what has been a most enjoyable book and, last but by no means least, to Lily and the team at Quarto who have been such a pleasure to work with.

All photographs and illustrations are the copyright of Quarto Publishing plc. While every effort has been made to credit contributors, Quarto would like to apologize should there be any omissions or errors—and would be pleased to make the appropriate correction for future editions of the book.

With special thanks to Cascade Yarns for providing the yarns used in this book.
www.cascadeyarns.com

Customize your closet

with more inspired patterns and stitches when you add these Interweave resources to your collection

The Crochet Stitch Dictionary
*200 Essential Stitches
with Step-by-Step Photos*
Sarah Hazell
ISBN 978-1-62033-129-3, $22.95

**The Knitter's Handy Book
of Top-Down Sweaters**
*Basic Designs in Multiple
Sizes and Gauges*
Ann Budd
ISBN 978-1-59668-483-6, $29.95

Knitwear Design Workshop
A Comprehensive Guide to Handknits
Shirley Paden
ISBN 978-1-59668-796-7, $26.95

Join Knittingdaily.com, an online community that shares your passion for knitting. You'll get a free e-newsletter, free patterns, projects store, a daily blog, event updates, galleries, tips and techniques, and more. Sign up for *Knitting Daily* at **Knittingdaily.com.**

INTERWEAVE KNITS

From cover to cover, *Interweave Knits* magazine presents great projects for the beginner to the advanced knitter. Every issue is packed full of captivating smart designs, step-by-step instructions, easy-to-understand illustrations, plus well-written, lively articles sure to inspire. **Interweaveknits.com**

Available at your favorite retailer or

shop.knittingdaily.com